What the Butler Saw

Selected Writings by Stuart Morgan

What the Butler Saw

Selected Writings by Stuart Morgan

Edited by Ian Hunt

Foreword by Thomas McEvilley

Durian Publications Ltd., London

Published by Durian Publications Ltd.,
21 Denmark Street, London WC2H 8NA
Tel: 0171 379 1533 Fax: 0171 379 1521

ISBN 0 9527414 0 7
A catalogue record for this book is available from the British Library.

Edited by Ian Hunt
Designed by Harry Crumb
Printed and Bound in England by Smart Arts Ltd.

Available through Art Data Ltd., 12 Bell Industrial Estate, 50 Cunnington Street, London W4 5HB Tel: 0181 747 1061 Fax: 0181 742 2319
and D.A.P./Distributed Art Publishers, 636 Broadway, 12th Floor, New York, N.Y. 10012 Tel: (212) 473 5119 Fax: (212) 673 2887

This publication has been made possible by the generous financial support of the Arts Council of England.

Contents

9
Author's Note
Stuart Morgan

11
Editor's Note
Ian Hunt

13
Stuart Morgan: Earnest Wit
Thomas McEvilley

18
Telethon

23
Dennis Oppenheim: Gut Reaction

32
An Art Against Itself: Robert Smithson's Drawings

41
Alice Aycock: Structures, Stories and the History of
Man-Powered Flight

55
Everything You Wanted To Know About William Wegman
But Didn't Dare Ask

60
What The Papers Say: Dick Jewell, Genesis P-Orridge, Denis Masi

72
An interview with Boyd Webb

76
Boyd Webb: Tableaux

79
The Burgeoning Paradigm: Glen Baxter's Drawings 1970-80

87
Marc Camille Chaimowicz: Design for Living

98
Breaking the Contract: a conversation with Peter Greenaway

105
Losing Battles: a conversation with Richard Wentworth

110
Soup's On: an audience with Steven Campbell

116
Steven Campbell: The Case of the Waggling Leg

122
The Death and Rebirth of British Performance

131
An interview with Joseph Beuys

136
Edward Allington: Getting It Wrong

142
Eric Bainbridge: Dumb Insolence

146
Colin McCahon: The Leap of Faith

151
Terra Incognita: an interview with Simon Lewty

156
Under the Sign of Saturn

159
Louise Bourgeois: Nature Study

165
Taking Cover: an interview with Louise Bourgeois

171
Simon Linke: Twilight Zone

174
Andy and Andy, the Warhol Twins: a Theme and Variations

180
Double Vision: an interview with Thérèse Oulton

185
Thérèse Oulton: Sub Rosa

188
Pepe Espaliú: Cat's Cradle

192
Robert Mapplethorpe: Chiaroscuro

195
Little Christians: a conversation with Christian Boltanski

202
Tell Me Everything: an interview with Richard Prince

208
A Summer Place

Contents

217
Ansuya Blom: The Secret Life of Belly and Bone

226
Thomas Grünfeld: Dead On Arrival

233
Homage to the Half-Truth

239
Body

244
Fiona Rae: Playing for Time

247
Damien Hirst: The Butterfly Effect

254
Rachel Whiteread: Inside Out

257
Grenville Davey: The Story of the Eye

262
Doubletake: Thanks for the Memories

269
Deep and Low: Madonna & Jeff Koons

273
First there is a mountain: an interview with Bill Viola

281
Niek Kemps: Playing Blind

286
Piotr Nathan: English Versions

291
Steven Pippin: The Waiting Game

295
Rudolf Schwarzkogler: The Mystery of St. Rudolf

298
Rebecca Horn: The Bastille Interviews II

305
Miroslaw Balka: Last Rites

310
Paul Thek: The Man Who Couldn't Get Up

Author's Note

No one works alone. These are only some of the people who have inspired, helped and supported me over the years. In Brighton: Frances Walker, Penny Sparke, Mike Tucker and Simon Watney. In New York: Richard Martin on *Arts Magazine*. In London, on *Artscribe*: James Faure-Walker; for a long time Matthew Collings; Ian Brunskill; Matthew Hale; Clair Joy and Adrian Searle. In New York: Dennis Oppenheim, Alice Aycock, Louise Bourgeois, Jerry Gorovoy, Monroe Denton, and at *Artforum* Ingrid Sischy, Anthony Korner and in particular my old friend David Frankel. In Paris, Alain Cueff during his time at *Beaux Arts*; in Zürich, Bice Curiger and the editors of *Parkett*; in London, Patricia Bickers at *Art Monthly*. I have had the great good fortune to meet Juan Vicente Aliaga; Piotr Nathan; David Dye; Rebecca Michael; Mark Glynne and Ansuya Blom; Chris Hill and Sarah Mackenzie and Suzanne Hutchinson and Tony Haase. All of them have put up with me, helped me and persuaded me to carry on. In Oxford so many people have made me welcome that it is impossible to name them all: Maria Chevska, Brian Catling, Jeff Dennis, Malcolm Bull, Bridget and Janet, Paul Bonaventura but in particular Steven Farthing, the Ruskin Master. My greatest thanks go to my family: my parents Roy and Thora Morgan, my aunt and uncle Gil and Gloria Williams and their family, my cousins Peter and Marilyn Stanley, my cousins Lynne and Judy and the others who have never grumbled about my odd profession and have wished for nothing but to see me happy.

My life would have been very different without *frieze* magazine, the editors of which have published this, their first book. For years now I have been lucky enough to enjoy the help and support of Tom Gidley; Amanda Sharp, who works so hard to make my life easier; and Matthew Slotover, who from the first has listened to my suggestions, tolerated my criticisms and been patient with my eccentricities. I am grateful to Tom McEvilley for his introduction, and will try to live up to his praise.

Stuart Morgan, January 1996

Editor's Note

This is a personal selection, covering a long period of writing from a prolific critic, but the word 'personal' should not mislead. In that a collection of Stuart Morgan's writings is so long overdue, I have endeavoured to include as wide a range as possible, but the selection had to be made from the point of view of present needs as I sensed them, and to follow what we thought were more or less pressing or rewarding groupings as they emerged in discussion. The heap from which this book is drawn had a habit of growing as each month added new essays that I wanted to consider, and as further things emerged from the archive. Some appositions I had expected from the beginning aren't here, because they were finally disallowed by one of us, or by restrictions of space. Each decision affected the articulation of the whole, making subsequent decisions more like trying to fix semi animate creatures in place than worrying about which of them would get on with which. Local areas of agreement do emerge, particularly at the beginning with the focus on a group of American artists and at the end, on European ones; but the book is not arranged in a way that insists on a valuation of themes in the writing over the specificities it wishes to address.

Short reviews, survey articles and more polemical pieces, though useful for the wider historical context, are under-represented in favour of essays. Whole caches of writing (for *Beaux Arts*, Paris, for example) did not receive fair consideration because of the way the articles were commissioned to be written to illustrations. When there has been much writing on an artist – all to particular occasions and without the thought of being collected – we have very often chosen the first, shorter, more immediate response. A few changes were made where we thought them appropriate, and in order to limit repetitions.

Ian Hunt, January 1996

Stuart Morgan: Earnest Wit

Thomas McEvilley

> The real summer song would go round in circles, like that irritating one I
> used to hear as a child; once you began humming it you couldn't stop. With
> every repetition you became a little more vexed; what had begun as a
> glorified advertising jingle was turning into one of the circles of Dante's Hell.
> – 'A Summer Place'

Stuart Morgan is a phenomenon in British culture. His extraordinary personality
and charismatic presence seem to make a difference in everything around him.
To tune in and out and in and out of his stream of witticisms, observations and
ravings is a special pleasure. His highly focused yet almost raucous wit has lit up
the art discourse with an eerie yet seemingly friendly light for years. (It is surely
arguable that he has been the pre-eminent British art critic for perhaps 15 years
now.) Yet not much has been said about his practice, which goes down as easily
as an iced drink and leaves satisfaction, not questions, in its wake.

This collection of 50 writings from 1977 till 1995 presents an amazingly
insightful entrée to the art of the eighties and early nineties. Most of the texts are
essays from both art magazines and museum and gallery catalogues, but many of
them are interviews, in which Morgan's terse style of editing ensures a lively
repartee. A picture of the landscape of the period is yielded up from a particular
and precise point of view.

In 'Homage to the Half-Truth', a conference paper from 1990, Morgan
provides a seemingly straightforward account of what he thinks criticism is, or
should be, and what he thinks the critic is, or should be, doing. All textual
meaning, it would seem, is woven from the discourse of the past, and in this text
one can hear various voices from the past speaking through the web, voices that
mark out a certain lineage. When, for example, Morgan writes, 'Criticism means
reserving the right to take any side at all,' I hear distant and mediated echoes of
Sir Karl Popper saying, 'The scientific method means criticising *everything*'.
There is, as the statement suggests, no programmatic or doctrinaire rigidity to
Morgan's writings. He deals with each artist or issue *ad hoc*.

Similarly, when Morgan speaks of the 'essential gesture of criticism' being 'an

act of recognition,' I hear not the influence of but a similar feeling to that expressed by Edmund Wilson in *The Shock of Recognition*. Wilson was also an author who, while he stressed clarity and did not write as an eccentric (however he lived), remained relentlessly himself.

Above all, in the crucial early paragraphs of 'Homage to the Half-Truth', one has to hear the influence of Oscar Wilde's classic essay 'The Critic As Artist'. 'Critics should be respected,' Morgan writes, 'for their capacity for intuition, sympathy and imagination... And no definition of criticism should omit this element of artistic inspiration.' Such a position has been regarded by some as suspect in its apparent attempt to reverse the hierarchy of the art system. With such utterances the critic seems to attempt to usurp the glorified stature traditionally accorded to the artist. Isn't criticism, after all, just an appendage to art, or a footnote to it, or at least dependent on it? Morgan deals with this objection with a light touch. 'That criticism refers to another art,' he writes, 'does not prevent its existing as an artform in its own right. (We don't despise ballet because it needs music.)'

It does seem obviously true (doesn't it?) that criticism has an intuitive and art-like component – it is, after all, a genre of literature. But, at the same time that it has this art-like component, some would see it as ultimately overlapping more with such disciplines as philology and philosophy than with the visual arts *per se*. Art criticism is really its own genre of literature, not exactly following the rules of any other. By its privileged position in between art, philosophy, philology, poetry, essay-writing, society, and other things, criticism is a specially versatile area in which an individual writer can mark out his or her turf in any number of ways.

Morgan surely is an example of a critic whose work is art-like in its combination of sensitivity and sensuality. His style is elegant, inventive, and suave. His prose is often frankly beautiful. But his approach also overlaps with that of British Analytic Philosophy in its modesty and its avoidance of loose or unnecessary metaphor. The idea of the critic as artist never tempts him into obscurantism. He seems solidly a product of the British (or Anglo-American) tradition that stresses clarity and unobtrusiveness on the part of the author, rather than the continental European tradition in which the critic intervenes thickly between artwork and reader, creating a protective wall of verbiage and ideology around himself. In Morgan's work one still feels one is reading about the art and the artist, not about the critic.

Still, as a critic Morgan definitely seems to have an agenda – though it is perhaps more a social than an aesthetic one. His sympathy is always with the

subversive. He is not doctrinaire – though British neo-Marxism has no doubt left a mark on him. He is almost an anarchist in his emphasis on wit as a kind of ruling principle – a pataphysicist, reducing everything to a joke. On the other hand, this joke is serious. There is, behind it, a social and cultural agenda and a belief in the proper use of the art activity within society. At the same time, there is a deep questioning of Western society and its present moment. In such a shaky situation as the world is in today Morgan sees art's role, at least in part, as aggravating the tension and the awareness of it. 'Why,' he asks, 'assume that artists are powerless, that they played no part in building up that tension?'

> Right now the feeling that nothing is happening may be inevitable. And the sense that names and things are mismatched. Or the feeling of being trapped in a loop, stranded in the middle of something – a jump off a cliff, a song, a lifetime, a summer, a place.

For wit of course has its dark side and its critical thrust. It can be a deceptive force, as in vain mockery. Or it can be a force for what might be regarded as a kind of higher, though still materialistic, truth, as in the gestures of Diogenes.

Like the sayings of Diogenes, Morgan's essays emphasise conciseness. They can offer synoptic views within a few pages, a few paragraphs, or a few words. (We once agreed that you should be able to say *anything* in 2,000 words.) Accordingly, most of Morgan's essays gathered in this book are refreshingly brief. They leave one wanting more.

Morgan's emphasis on wit should not be misunderstood as cynicism. At the same time as they are witty, these essays are very earnest in their sense of commitment to being true to the artist. Morgan seems to reject the old Wimsatt and Beardsley idea of the intentional fallacy – that the artist's intentions are irrelevant to the reception of the artwork by the viewer, and that the critic should go his own way without consulting them. He tries, successfully, not to superimpose on the artist's work a meaning-grid of his own – which a programmatic Marxist or psychoanalytic or conservative critic often does. Rather he searches out, both through his own intelligence and through the expressions of the artist, the meaning-grid the artist intended. Often he works through interviews, directly consulting the artist's intentions, with some unobtrusive guidance from Morgan himself, and presents them directly to his readers.

So this collection of essays is not overtly polemical. It is more a matter of confidently coaxing a sense of inner meaning out of both the artist and the

oeuvre. Still, though Morgan does not try to influence or rearrange the artist's meanings according to his own preferences, he exerts considerable influence nonetheless through the specificity of his choices, who are mostly highly intelligent, articulate, hip post-conceptualist artists – Dennis Oppenheim, Glen Baxter, Richard Wentworth, Thérèse Oulton, Christian Boltanski, Fiona Rae, and so on. So the picture of the landscape of art of the eighties and early nineties that this book presents comes from a highly selective and particular point of view, at the same time that it avoids overt ideological slanting.

Despite the first essay, on Jerry Lewis, Morgan does not make much compromise with popular culture. Though many of the artists he focuses on use humour and popular reference, they are serious, so-called 'high' artists within the context of our culture. The interview with Steven Campbell, the essay on Glen Baxter, in a darker sense the interview with Boltanski, are all quite simply hilarious – in a very high IQ way. Boltanski especially leads into the dark along this path, and Morgan is delighted to escort him there.

The essay on 'British Performance', in contrast, is a serious scholarly overview of particular issues that Morgan felt, at the time of writing, had not been resolved in the discourse; as are the essays on Oppenheim, Robert Smithson, and others. What, if any, are the unifying principles behind Oppenheim's vast and varied oeuvre? What are the large outlines of the history of British performance art, and what is the prognosis for its future? At the same time that he seems to favour art that takes a deconstructive approach toward social as well as aesthetic convention, certain aspects of Morgan's writings still suggest an urge to put together a totality. This particular totality, so to speak, would be his alone, uniquely woven out of the inhabitants and associations stored in his mind. He is of course a voracious reader, and throughout this book runs a point-counterpoint of erudite references which never seem forced but are almost organically linked both with the subject and with one another. This weaving or linkage provides a picture of his mind, or at least a picture of how he presents it to us.

In a brief essay on Ansuya Blom's work ('The Secret Life of Belly and Bone'), one finds, more or less in this order, references to American jazz musicians Archie Shepp and Louis Armstrong, American poet Gertrude Stein, French thinker Julia Kristeva, American poets Delmore Schwartz and Langston Hughes, film-maker Paul Cox, French torch-singer Nina Simone, British psychoanalytic theorist D.W. Winnicott, Japanese novelist Yasunari Kawabata, philosopher Elias Canetti (author of *Crowds and Power),* American poet Sylvia Plath, French philosopher Simone Weil, Polish-English novelist Joseph

Conrad, French entomologist Eugène Marais, British biological theorist Julian Huxley, American jazz musicians Charles Mingus, Duke Ellington, Charlie Parker, and Yusef Lateef, French musical theorist Jacques Attali, British anthropologist Mary Douglas, American novelist Ralph Ellison, and German critic Janheinz Jahn. Seen from one aspect, this web or linkage of references offers an approach to the inner meaning of Blom's work; from another, it presents a picture of Morgan's mind, of the world he lives in inside himself. Indeed this entire collection shows us a mind struggling to survive in a world it somewhat lacks belief in, and reflecting its struggle in an orderly and precise reflection of that world in a mirror with a particular warp.

A brief summary cannot convey the delights of this book, which keeps the reader alternately chuckling and nodding his head solemnly as at unforeseen insights. This collection will be a pure pleasure to any practitioner or aficionado of what used to be called 'advanced' art (though the meaning of that term has certainly changed). Conservative critics such as those associated, in Britain, with *Modern Painters* or, in the United States, with *The New Criterion*, on the other hand, might hate it. For criticism too – in this way also like art – contributes to building up the tension.

Telethon

Published in Artscribe *25, October 1980*

The creeping Americanisation of the British Isles has broken into a gallop. After Kentucky Fried Chicken and *Grease*, the Muppets and the Village People, amyl nitrate and *The Little House on the Prairie*, it comes as no surprise to learn that in October Thames Television are mounting the first European telethon in aid of muscular dystrophy. The gentlemen of the press seemed neither agog nor appalled at the proposal. Maybe they haven't seen the American version...

8 a.m. September 1st 1979, WNEWTV Channel 5. 'Stanford, Waterbury, Atlantic City, Orange County, Danbury, Trenton, Asbury Park, Catskills, Bridgeport, Suffolk, Bergen-Passaic, Westchester... OUR CELEBRITY VOLUNTEERS ARE STANDING BY: MAKE YOUR PLEDGE NOW...' Above the names and telephone numbers Ed McMahon is shaking hands with union officials when a stray camera shot locates a figure huddled at the back of the stage holding his head, a cigarette dangling from the corner of his mouth. They say Jerry Lewis is 53. After 16 hours on the air he looks 103. Suddenly there's a drum-roll. In a second he's centre stage, circling the mike, punch-drunk with feigned disbelief. 'Oh wow, I don't believe it. Ed, what're you telling me?' Behind them a board clicks up $7,034,871, the band breaks into a top-speed version of *What the World Needs Now is Love*, the audience goes wild, the two men stare incredulously and, as they embrace, a close-up shows Lewis biting his lip to hold back the tears.

Tell them you watched the Jerry Lewis telethon and people ask the same question: 'Did he cry?' He always cries. After 22 hours of physical strain Lewis finishes with a song. His tuxedo is crumpled, his voice cracked, his eyes look

like huge bruises. 'When you walk through a storm / Keep your head up high...'
He sobs as he sings. Each tear means thousands more dollars for the tote board.
A second later he's gone. Credits roll silently against a photograph of an empty
studio. That very moment when we wish him back is the point where we are at
our most vulnerable – vulnerable enough to lift our phones and make our
pledge.

A clock, a board full of figures, a face contorted with pain. In one day all
three are elevated to near mythic significance. As Lewis recites numerals they
petrify. 'For four solid days my orchestra has been in rehearsal and so far they've
played twelve solid hours of music.' When cheques are presented he blows
smoke through his nostrils, winks at the camera and nods at the board. 'Heavy
numbers,' he mumbles lasciviously. As time runs short, company men with
money to present are trotted onstage with insulting rapidity. But by then the
hypnotic impact of the Lewis persona has taken effect; we only really care about
his reactions. Half a million from the 7-UP bottlers ('God bless you'), two
million from the fire-fighters ('Good bucks, good bucks'), $2,301,167 from
McDonalds ('Are you nuts? Get off the stage'), three million from the Artists and
Actors Union ('What right do you have to bring a lousy cheque like that out?
Ed, why don't we slap him right in the mouth?'). Of course, he's joking; 'More,
more,' he pleads, doing a Boris Karloff imitation. And somehow it's just not
funny. There must be a reason why millions of viewers want to watch one man
destroyed by sheer fatigue. Perhaps they are afraid of him.

Lewis's face and body dominate the show; without him it would be a day of
sprawling incoherence. A team of cheerleaders from Chicago, the midget from
Fantasy Island, a barbershop quartet singing *You Gotta Have Heart*, Burt
Reynolds reading poetry, Liza Minelli, Laverne from *Laverne and Shirley*,
Richard Burton singing *Camelot*, Paul McCartney and Wings, the star of *Love of
Life* who plays a research scientist, Sammy Davis Jr ('I have been trying to
entertain you for 50 years'), Seals and Crofts, Abbe Lane singing off-key for five
minutes, John-Boy from *The Waltons*... and cutaways to each of 213 channels
across the country, interviews with star volunteers, reports of cyclathons,
bowlathons, skatathons, danceathons, kickathons, bikathons, walkathons,
swimathons and rollathons, all in aid of 'Jerry's kids'. There is nothing tasteful
about the mixture and plenty that's distasteful about Lewis himself.

In The Comedian's Children, a short story by the science-fiction writer
Theodore Sturgeon, two scientists discover that iapetitis, an extra-terrestrial
disease which attacks only children, is bogus, the invention of Heri Gonza, the

entertainer who hosts and masterminds a telethon to raise money for its cure. Though his enemies accuse Gonza of using iapetitis 'just to keep himself front and centre', even they are forced to admit that he is a 'logician' with a superb analytical mind. Gonza is Lewis at his worst. He brainwashes his audience, uses foul tactics to override opposition, sacrifices the dignity of his sick children for the maudlin effects he can extract, and debases emotion and intellect.

11.40 a.m. Lewis is reaching his first tiredness peak. Judy Collins is ready to sing *Send in the Clowns*. He introduces her as Dorothy Collins and has to apologise afterwards. Five minutes later, with the tote board at just over eight million, he presents The Incredible Hulk. 'Ladies and gentlemen, Lou Ferigno, Mr Universe. Lou is one of the most … one of the most…' Too tired to read the cue cards, he walks straight towards them, makes a joke out of spelling each word one letter at a time, then rejoins the Hulk and starts again. But Lewis is angry at his own exhaustion. At 12.30 he explodes. Ignoring stars, cutaways and routine he addresses the camera. 'Why do I do this? I've been accused of using cripples on TV. They know what I use them for. I've been accused of egomania. I have called on every ounce of energy and every mental capacity I have. I don't care what you think. If you want to put me down, start.' For 15 minutes he harangues his audience, confronts detractors and after trouncing them thoroughly swears allegiance to the cause of muscular dystrophy until such time as a cure is found. A standing ovation follows. As an encore Lewis dances and does fake falls, goes into a wearingly up-tempo arrangement of *Can't Smile Without You* and does an elaborate, apparently improvised mime with a glass of water. And before we know it the demons of tiredness have been vanquished once more. One kind of punishment has replaced another.

Heri Gonza calculated his effects. Lewis calculates, and uses every trick in his book. Everything he knows finds its way into the telethon. The ending is copied from the blackout finish of his cabaret act, his experience as a movie director and amateur electronics freak comes in useful for controlling the cutaways, and each of the mimes and funny walks could probably be dated precisely. In the middle of an attempt to upstage Sammy Davis Jr by tap-dancing alongside him ten minutes before the end, Davis stands back, hands on hips, and takes a thoughtful look at Lewis's routine. 'Pathetic,' he says confidentially to the audience, 'Same old steps he did with Dino 20 years ago.' To a man who always thought he sang better than Dean Martin this is no joke, yet seconds after they hug and kiss in showbiz fashion. The gooey sentiment which punctuated Lewis's movies has proved indispensable to the telethon; virtuoso beggars spot

emotion in others and turn it to their own uses. A middle-aged man in a wheelchair quietly describes his depression as the disease worsened. Cute as a button, little Rocky Arresi, this year's poster child, sits in the front row with his toys and candy as Karsh of Ottawa talks about the assignment to photograph him for a day. Lewis's manipulation of all three quite transcends their own impressive but limited mode: sincerity. The alternative is terrifying; 'insincerity' is a completely inadequate description. When the tote moves too slowly he starts issuing threats: 'You know I'll do anything for my kids.' And he will. He brings out the bad cases who can hardly speak, gives unscripted pep-talks, and beseeches sponsors to allow him as much airtime as it takes to earn one dollar more than last year. After a lengthy, unscheduled sermon from Lewis during the 1978 telethon Ed McMahon, Johnny Carson's imperturbable announcer, strode on, quivering with rage. Pointing behind him, he said 'Are you aware that there's a team of gymnasts behind this curtain? They've been standing on each other's shoulders for the last 20 minutes waiting for you to announce them.' At moments like this the trickster vanishes and the tyrant comes into view. At his worst, Lewis resembles Marlowe's Tamburlaine or Herzog's Aguirre. In 1973 at the Sahara Hotel in Las Vegas he held up a dystrophic child and said 'God goofed, and it's up to us to correct His mistakes.'

Lewis trained long and hard for his role as the scourge of God. At the height of his career he surrounded himself with sycophants. He bought his own FM radio station, a restaurant on Sunset Boulevard, 14 cars and, according to Frank Tashlin, a hundred cashmere sweaters at a time. He threw socks away after wearing them once and spent $15,000 on a hearing-aid for his dog. People were expendable; his most famous practical jokes sound like exercises in humiliation. Hitting golf-balls out of a yes-man's mouth may just be forgivable. (What else are yes-men good for?) But sticking one of his secretaries to her desk with scotch tape is hardly a riot of fun. Another employee returned from a visit to the ladies' room to find that Lewis had hidden a tape-recorder there and was playing his assembled staff an amplified version of the noises she had made. Subtlety was never his strong point.

By the late sixties when Jean-Luc Godard and *Cahiers du Cinéma* were raving about him as *auteur*, his American reputation had taken a nose-dive and distributors had just lost interest. *The Day the Clown Died* was to be his comeback. Set in a concentration camp, it starred Lewis as an ex-Nazi who joked and played with condemned children to take their minds off the gas-chambers. Mercifully, it was never released.

Henri Gonza invented iapetitis. Why did Lewis pick muscular dystrophy? The story is that 30 years ago a new director arrived for his television show. His name was Bud Yorkin. Yorkin's sister had a son with muscular dystrophy. She started fundraising and Yorkin asked Lewis to help. For a 90-second plug in 1950 the Association gave him an inscribed plaque. Nothing could have pleased him more; it was just the sort of present he was in the habit of giving his staff, none of whom dared remind him that they already had a bureau full of pens with heartfelt messages. The whole telethon could have been engendered less from kindness than from vanity. They're still giving him the presents. Now he's the Chairman of the Muscular Dystrophy Association, with a research centre named after him.

But do motives matter if, after all, he is doing the right thing? Behind that wind-up toy is a proud man, too stubborn to come to terms with a world where work can be exchanged for money but money can't be translated back into physical effort, that single twitch of a diseased limb which would justify the expenditure he encourages. The arrogance which keeps him going for a day is fuelled by anger at a God who goofs, at an implacable universe where miracles can be courted but never caused. Lewis's methods show an instinctive appreciation of the advertising potential of religion with no dedication to its principles. There is no logic in his performance beyond a near-medieval belief in the subjugation of the flesh – not to preserve it from sin or by simulating punishment after death to avoid that punishment, but simply to be seen. Lewis faces an incomprehensible universe, picks one apparently tiny problem and, unable to solve it, decides to get all the energy, opportunity and brain power he needs to do so. His strategy is more pragmatic than any theologian, more American than the Buddhist monks who immolated themselves by fire in Vietnam. It is simply to display his body, scourged and bleeding, like a dime-store saint. Their cheapness is immaterial. His is of the essence. He reduces tragedy to melodrama, catharsis to mere embarrassment. And when, at the end of the show, he sings and cries, with cameras focused on each tear as it falls, he becomes a madonna stripped of her power of intercession, weeping out of sheer impotence as a taunt to an uncaring God. It is a moment so strange and hideous that it makes even the faithless feel the power of the concept of blasphemy, the stink of sin in their nostrils. Is it doubly blasphemous to suggest that Lewis is already a contemporary saint, in a church where deeds outweigh motives, where any means of getting good results is pardonable, and smugness and indifference have been ousted? If it is, I'm prepared to take the risk.

Dennis Oppenheim: Gut Reaction

Published in Artscribe *16, February 1979*

Critics of Dennis Oppenheim have one thing in common. Even the best – Jack Burnham, Kenneth Baker, Kim Levin – avoid dealing with his entire output, choosing instead to base their generalisations on one period.[1] There are two exceptions: Peter Frank's introduction to the Montreal retrospective of 1978 and Jonathan Crary's recent *Artforum* essay. Surprisingly, their overviews are completely different. Crary scans the horizon but finds the art obsessively literal-minded, an attempt to present the corporeality of thought itself, while Frank tracks his suspect like a patient detective and concludes by summarising the mythic, metaphysical aspects of Oppenheim's work.[2]

Admittedly there are problems. Oppenheim dodges between sculpture, film, video, performance, drawings, installations and prints. His art does not exhaust themes, explore materials or engage in formal experiment for its own sake. It operates on a hit-or-miss principle; while some pieces appear irredeemably shallow, others seem overcomplicated. There is change in his career, but not 'development'; at any moment he may double back to something he abandoned ten years before. Above all, there is a strangeness about the work. This man has planned to make art out of cockfighting, running through brick walls and digging his grandmother up to rearrange her bones.[3] At times his projects speak of a gauche impetuosity, at other times of a mind committed to the oblique.

Works of art talk to each other. When they are produced by the same person their dialogues unravel preoccupations particular to that person. Surely part of the critic's task is to expose patterns which contribute to one man's vision, to

reveal what Henry James called 'the figure in the carpet'. Perhaps we are too close to recognise it. Perhaps theories of imaginative integrity no longer apply.

> Each of us circles
> Around some simple but vital missing piece of information
> And, at the end, as now, finding no substitute,
> Writes his own mark grotesquely with a stick in snow,
> The signature of many connected seconds of indecision. [4]

I do not believe in the figure in the carpet nor the absent fact. Both are illusory. There is only translation, metaphor, faith in coherence, a slow dance around a vacant centre. With Oppenheim the critics have given up too soon.

Certain African tribes believe that what we call 'thought' takes place not in the head but the stomach. For us, however, the belly indicates hunger and fertility; it performs the tasks of digestion and birth. Science has taught us that the head governs the entire body. Our consequent image of the stomach is of some neglected outpost, sending messages so unsophisticated that they are a source of shame. We punish it for reminding us of our animal origins. The result is a decreased sensitivity to its subtler properties. Reaction to fear takes place there. And, as Duchamp wrote, 'We always reduce a gravity experience to an autocognizance, real or imagined, registered inside us in the region of the stomach.' [5]

Oppenheim's art circumvents rational thinking and operates according to an aesthetic of gut reaction. Consider *Attempt to Raise Hell*, an installation made in 1974. A robed, legless figure sits motionless while every hundred seconds an enormous bell hits him at eye level. Since the bell and the model's head are metal, the ensuing clang lasts for fifty of those seconds. Has there ever been a sculpture which affected the stomach so much? The very thought of it induces nausea. And when reduced to rational terms, it warns of the folly of thought, the impossibility of meditation in the face of violent damage. Bald and inscrutable, that robed figure resembles a Buddhist monk dedicated to an eternity of punishment, not only done but heard to he done. He sits in a blue spotlight and people watch until they can stand it no longer. Odd, yes. But no odder than a Hindu fakir on a bed of nails or, for that matter, hair shirts or flagellation. What links methods of subduing the flesh with this saintly mannikin is the theory that whatever damage is done to the body profits an immortal soul, which exists as a spirit, an essence, not bounded by flesh. Faith, we are told, is not intellectual, yet

neither is the ability to tolerate the meaninglessness of punishment, particularly when it hurts us more than it hurts a metal model. Increasingly in his installations of the last five years Oppenheim has resorted to repetition – of a maddening musical phrase in *Broken Record Blues* (1977), of one line of the song in *I Shot the Sheriff* (1976) and of the entire soundtrack in the pieces which incorporate sound. Not only the idea of a sculpture which 'repeats' like a record but the image of a record itself is featured: in *Early Morning Blues* (1976-7) the soundtrack is played on an aluminium disc in view of spectators; in *Untitled* (1973) a mirrored ball, spotlighted from four directions, revolves above a record player; and in a drawing of 1976, *Silver Disk Landing Field,* the shape is ploughed into the earth in a 500 foot diameter circle. In moving towards 'contemporary ritual' it is natural to try to utilise the incantatory qualities of its more ancient counterpart.[6] Yet as in *Attempt to Raise Hell* the viewer has the option of conferring meaning on the action before him or not, the indications are that in later installations a certain decay has taken place. The speaker in *Broken Record Blues* will persevere, 'knowing whatever magic there is in repetition vanished … vanished long ago.'[7] Maybe the deterioration has taken place in the sensibility of the audience, not the artist. Possibly the slow revolution of a needle in a record is a symbol of prolonged lapse, a long wait for death. In an untitled performance at The Clocktower, New York (1974) a dead dog lay across the keys of an electric organ, 'playing itself out' as the body decomposed.

Repetition, then, is a physical action with an attendant 'gut reaction'. If Oppenheim's work could he analysed in terms of such present participles the result would show that his claim to be a traditional sculptor is more persuasive than it seems. He has done the job for us in the case of one activity: falling. *Preliminary Test for Sixty-Five Foot Vertical Penetration* (1970) was a film of his practice run – sliding down a mountain on his face – for a jump into water from a peak in Idaho. On the soundtrack of *Wishing Well,* an installation in 1973, he fantasised about sinking through a wall and simultaneously through the ground. And in 1977 another, more elaborate installation focused on falling. He described it in a recent interview:

Recently I made *Dayton Falls* in Dayton, Ohio, in a room with a catwalk around it and an open area in the middle. Four steel structures were built, varying in height from five feet to twenty, and as they increased in height, their construction became more complex. They looked like electrical

towers or derricks, but also like snowflake crystals, all geometry. The soundtrack was awesome. It went on for 30 minutes, calling for people to jump off the towers. This was mixed with all sorts of verbal tracks and the sound of water falling... The sounds were recorded always acknowledging the recording equipment; as I spoke into the mike I would make tests and constantly refer to a sound man. Then we ventured into this fantasy where the sound system was falling, we couldn't keep the plugs in the walls and the mikes were falling out of our hands into this vortex... [8]

Yet the installation remained stable; whereas Acconci, a one-time novelist, moves more freely into areas where sound is unsupported by visual reference, what matters to Oppenheim is a disparity between sound and vision, desire and reality. The spectator is somehow cheated, though Oppenheim is full of good intentions.

Falling, entering, emerging or submerging are things that are constantly at the back of my mind. I've seen the body – I'm sure Chris Burden has also – as an instrument to pass through or receive or enter into material ... Essentially, falling would be like pressing a traditional tool into a soft substance. So here we are back again with the chisel and the marble. [9]

In *Dayton Falls* no falling takes place, however. In his earlier sculpture Oppenheim shifted from object-making to a situation in which he referred to objects (*Site Markers*, 1967) or looked at them (*Viewing Station for Gallery Space*, 1967). The deviation persisted; since *Dayton Falls* conjures up pictures of falling without itself moving or causing the viewer to move, Oppenheim refuses the chisel and the marble. There is a moment when the elevator stops suddenly and the stomach goes journeying on, reminding us of the limits of our sensory mechanism, the weight and volume of the body, its strange hollowness, and the fact that at certain moments it can be as totally passive as the figure in *Attempt to Raise Hell*, acted upon by a force outside itself. From a position in which he located pressures physically and geographically, Oppenheim moved to the problem of where pressures came from and what they meant. It is a question which still preoccupies him.

Tucked away in a sketchbook from 1969 is an idea he never used: 'Scatter piece: photo of stampeding cattle.'[10] While the scatter pieces of Andre or Le Va invited spectators to examine the debris left by an act of scattering,

Oppenheim's would have concentrated on that release of energy which made the cows run. When in *Maze* (1970), he stampeded cattle through bales of hay arranged in the shape of a rat maze, his own standpoint had switched from observer to instigator, rehearsing not the capture of the beasts themselves but of the wild strength they embodied. In interviews he equates art itself with spontaneous energy. 'Art is a wiry, electric force,' he has stated. [11] In harnessing it he puts himself at risk. For the performance *Extended Armor* (1970) he prevented a tarantula from moving towards his face by ripping out pieces of his hair and blowing them at the oncoming creature. The video *Rocked Circle: Fear* (1971) showed him standing inside a painted white circle for 50 minutes while rocks were thrown at him and a camera registered his changing expression. *Maze* revealed a bad conscience about the power struggle between himself and the unpredictable force which is the art; too much control turns him into a white-coated scientist who mistreats guinea-pigs. (In *Color Blind* of 1976 a quadraphonic soundtrack in a darkened room activated red, yellow, green and blue lights. Against the walls groups of outsized, foam rubber mice failed to react to either the verbal commands or the synchronised colours). Gradually it becomes evident that Oppenheim reworked the scatter piece to indicate the nature of the force which made the cattle stampede. They ran out of panic, which manifested itself as a command, experienced suddenly and spontaneously by the animals. It is no accident that many of Oppenheim's body/land pieces were presented tersely, as mere specifications, like commands. If images of contagion abound in Oppenheim – the word TYPHOID burned on the landscape in *Branded Mountain* (1969), and TRENCH FEVER, ANTHRAX and POISON spelt out similarly elsewhere – it indicates that art can spread like disease, as Artaud claimed. And if the artist's function is to propagate disease, start stampedes, then he is antisocial, even blatantly destructive. Perhaps he would also like to destroy Dayton, Ohio. Oppenheim is aware that the art exists only at the moment when the elevator stops, like a kind of conjuring trick. Yet the impulse is there and it is an impulse to control events and have power over people. Does this account for guilt feelings, as in *I Shot The Sheriff*? Or the disturbing substitution of a dead dog in the 1974 performance for a daughter *Playing Dead* in a film two years before, followed in 1976 by her 'murdering' him in *Search for Clues*? Or the idea of shooting the spectator in *Indirect Hit, Crossfire* (1973), causing a train crash in *Predictions* (1973) or announcing a conspiracy to murder other New York artists in *Lecture Piece I* (1976)? At the centre of all this carnage is the idea that the communicative

charge which the artwork conveys, like poison or a sudden blow or a bullet or a fall, is powerful enough to escape the artist's control, 'transcend the sender' and kill him or render him impotent. The man who persists in the production of art becomes a self-consuming mechanism.

Gingerbread Man (1970-1) was an installation with film of Oppenheim eating gingerbread men and slides of ten samples of faeces viewed under a microscope. The piece, an extension of *Stomach X-Ray* (1970) was also a culmination of his body/land work of the time. As Oppenheim's notes indicate, the gingerbread man was forced into an interior space where he was 'held captive'. Since the residue constituted the finished work, the process of willed creation was inseparable from a natural breakdown of matter. The fall of the smaller 'man' within the larger was not an accident but a murder: he was pushed. Traditionally sculptors breathed life into a work by building an object from nothing or by removing excess matter. Here Oppenheim robbed a sculpted figure of life, produced excess matter and instead of manipulating the object touched it simultaneously from all sides with his stomach. In his essay 'The Metaphysics of the Belly' Norman Mailer called faeces 'the material evidence of the processes of communication within us ... the expression of what we have done well and what we have done badly to that medium of food through which we passed ... the history of the life we never see within us.' [12] Oppenheim fashioned the gingerbread man. Then, since his art could have devoured him, he devoured it first, like Cronos eating his sons. It re-emerged, expressive and factual, in a parody of childbirth, an interior record he never intended. In its journey through his body the gingerbread man he composed was decomposed and recomposed. It was embraced, rejected, then displayed again with pride.

There is an extraordinary rightness about the transition from superimpositions of land and body to this image of simultaneous childbirth and cannibalism, accepted, even celebrated. Mikhail Bakhtin distinguishes between the graceful Renaissance view of the human body, separate from nature, with all its orifices closed and protrusions rounded off, and the 'grotesque' body of the Middle Ages, based completely on excrescence and openness, with surface and innards merged. He writes:

> In the endless chain of bodily life it retains the parts in which one life joins the other, in which the life of one body is born from the death of the preceding, older one ... The body can merge with various natural phenomena, with mountains, rivers, seas, islands and continents. It can fill the entire universe. [13]

This could be a description of the film *Wrist and Land* (1969) in which shots of a landscape are interspersed with others of the artist flexing his wrist, or *Identity Stretch* (1970-5), a thousand-foot long version of his and his son's fingerprints executed in tar. Is Oppenheim, like Ginsberg, asserting that 'all separate identities are bankrupt'? [14] Certainly he is examining the workings of power; consumption or imposition depend on seizure, and seizure begins with a moment of touch, when power becomes manifest and one body yields to the control of another. Touching, grasping, pressing, crushing, grinding, gripping ... all are explored by Oppenheim. In the sixties the psychology and ethics of eating were broached by more than one artist. Bruce Nauman's *From Hand to Mouth* (1967) traces the path all food must follow, while Jasper Johns's *The Critic Sees* (1961) records an equation of sight and eating so literal that in the same year he made a painting with a bite-mark. Oppenheim's images of entrapment, of the primitive hunt, are inseparable from a larger interest in the workings of oppression. [15]

Theme for a Major Hit (1974) introduced the 'surrogate' technique in which the performance is carried out by models, in this case a motorised marionette two feet high, made to resemble Oppenheim himself, dancing in a spotlight to an interminable record, 'It ain't what you make, it's what makes you do it.' Withdrawal from personal performance was accompanied by stronger autobiographical emphasis. 'Ya gotta believe in what you're throwin ... cause what you're doin is throwin yourself,' says one of the surrogates in *Table Piece* a year later. Yet death and failure crop up everywhere in the post-performance works. An Oppenheim doll lectures on his own work while slides of an empty sky appear behind him. Another is found stabbed on a floating Persian carpet in *Search for Clues* (1976) while his (real) seven-year-old daughter serenely discusses the matter on a soundtrack and a TV in the corner shows a knife thrown repeatedly into an unidentifiable mass. Blind and old, an Oppenheim doll addresses an unseen audience of one on the subject of the mass assassination of New York artists. The year is 1985. Beginning with Robert Smithson's death in 1973 a pattern of murders has indicated a carefully planned conspiracy. The purpose of the avant-garde is now 'to break the code, trace the connections, feel out the rhythms and shed light on what seemed to be an untranslatable aesthetic masterplan.'

Though many of Oppenheim's previous works could be interpreted as allegories of art and the artist, in the last four years a more direct reference to his own creativity is evident; what was implicit before is now spelled out in flares on

hillsides: *'Pretty Ideas'*, they read before they fizzle out, *'Radicality'*. Even the more abstract installations of this period – *I Shot the Sheriff*, with its curved gun and spinning star, or *Early Morning Blues*, with a kettle on a neon hotplate and a soundtrack about dying in one's sleep – confirm the obsession. Perhaps after all he was advocating an art not about the release of energy but about the dying away of that energy. The juxtaposition of novelty and repetition in Oppenheim's works, their blend of strategy and spontaneity, the option they afford the viewer of changing routine to ritual, are inseparable from a dialectic between the soul and the body, the spirit and the gut, a crucial problem for Puritan thought. Oppenheim's extraordinary sense of evil reminds us of the moral dimensions of the puritan distinction and the potency of the questions they bequeathed; to accept and welcome death is to recover the capacity to live.

To an interviewer who asked why she sang, Janis Joplin replied, 'Me, I was brought up in a white middle class family – I could have everything but you need something in your gut, man.'[16]

To sing the blues what you need in your gut is not that food which is the oppressor's right, but a feeling which comes from the hollowness of an empty stomach, a stomach which feels the threat of power and death. The rhythms of the blues are there in Oppenheim's soundtracks: 'Now you can say you're pumpin' but there's nothin comin through' (*Twin Wells* 1976-7), 'Can you travel it by midnight … Can you travel it by three … are you there in the morning … where you ought to be' (*Early Morning Blues* 1976-7). On *Broken Record Blues* and elsewhere he tries to capture the accent and phrasing of the black blues singer. He even makes an installation, *Table Piece* (1975), based on a transfer of personality from a black to a white figure, who gradually learns to speak with his voice and adopt his attitudes. Singing the blues is a 'state of mind', a ritual activity based on repetition.[17] It is a way to purge emotions by translating private sorrows into public statements. Some do it better than others; they have 'soul', a metaphor now more physical and sexual than spiritual.[18] Yet the preacher and the blues singer use the same images and devices. They speak of life at its most tempting, of the punishments that await those who grasp it fully, as animals grasp it, and of grace and redemption. Most of all, they provide antidotes, exorcise evils by enacting them.

When they succeed, they do so in spite of logic. Suddenly their clichés and stagey, sensational effects are shot through with a terrifying authority which seems to come not from outside or inside them but somehow from within the text itself. It is this authority which Oppenheim struggles for and sometimes manages to achieve.

1. Jack Burnham 'The Artist as Shaman' in *Great Western Salt Works,* New York: George Braziller 1974, pp.139-144; Kenneth Baker 'Dennis Oppenheim: An Art with Nothing to Lose' *Arts Magazine* April 1975, pp.72-74; Kim Levin 'Dennis Oppenheim: Post-Performance Works' *Arts Magazine* September 1978, pp.122-125.

2. Peter Frank/Liza Kahane 'Dennis Oppenheim: A Transitive Art' *Dennis Oppenheim: Retrospective Works 1967-1977,* Montreal: Musée d'art contemporain 1978, pp.20-31; Jonathan Crary 'Dennis Oppenheim's Delirious Operations' *Artforum* November 1978, pp.36-40.

3. Dennis Oppenheim 'Catalyst 1967-1974' in Alan Sondheim *Individuals,* New York: Dutton, pp.246-266.

4. John Ashbery 'Fantasia on the Nut Brown Maid' in *Houseboat Days,* New York: Penguin, p.85.

5. Marcel Duchamp, 'A L'Infinitif' in Sanouillet & E. Peterson eds. *The Essential Writings of Marcel Duchamp,* London: Thames & Hudson 1975, p.87.

6. A term from Burnham borrowed by Oppenheim in Lynn Hershman 'Interview with Oppenheim' *Studio International,* November 1973, p.197.

7. *Airwaves,* One Ten Records, New York 1977.

8. Stuart Morgan 'Dennis Oppenheim interviewed' *New York Arts Journal* 12, 1978, p.30.

9. ibid, p.30.

10. Sondheim, op. cit. p.251.

11. Morgan, op. cit. p.30.

12. Norman Mailer *Cannibals and Christians,* London: Sphere 1969, p.322.

13. Mikhail Bakhtin *Rabelais and His World* tr. H. Iswohky, Cambridge, Mass: M.I.T. 1968, p.318.

14. Quentin Anderson *The Imperial Self,* New York: Knopf 1975, p.225.

15. See Elias Canetti *Crowds and Power,* Harmondsworth: Penguin rev. ed. 1973, pp.237-262.

16. Ortiz Walton *Music: Black, White and Blue,* New York: William Morrow 1972, p.122.

17. W.C. Handy, quoted in William Ferris Jr. *Blues from the Delta,* London: Studio Vista, 1970, p.100.

18. Charles Keil *Urban Blues,* Chicago: University of Chicago 1966, pp.168-170.

An Art Against Itself:
Robert Smithson's Drawings

Published in Artscribe 7, *July 1977*

Four years after his death Robert Smithson is in danger of being consigned to the textbooks simply as 'the man who made *Spiral Jetty*'. The arrival in Britain of the New York Cultural Center exhibition of his drawings, first shown there in 1974, provides material for a more balanced approach. With his essays, these 154 drawings constitute the main source of information about Smithson at a time when there is no general agreement about the nature of his career.

In one of his essays Smithson quoted an entire paragraph from Kubler's *The Shape of Time*:

> Actuality is when the lighthouse is dark between flashes: it is the instant between the ticks of the watch: it is a void interval between past and future: the gap at the poles of the revolving magnetic field, infinitesimally small but ultimately real. It is the interchronic pause when nothing is happening. It is the void between events.

The difficulty of Kubler's statement lies in its definition of actuality as void. Whether this is metaphor or plain statement is unclear; the context in which such an assertion can be upheld must always remain ambiguous. Smithson, whose friend Mel Bochner made a piece called *The Properties of Between*, liked truth to emerge crabwise by means of antitheses. He must have been aware that drawing inverted Kubler's equation, seeing void as actuality. Space, which may or may not be construed as 'real', is inscribed with lines which function as edges. For the artist these lines are acts of work, meant to control and destroy a

space originally regarded as empty. A replacement of images occurs both in Smithson's drawing process and in his career in general; power over a void is reinterpreted as power over nature, which he observed with similar awe. An examination of his drawings must try to establish the meaning of this shift.

Smithson wrote of 'an art against itself ... an art which always returns to essential contradictions'. Even his choice of words betrays him; 'paradox' would involve deft manipulation of dualities, whereas 'contradiction' is an irreducible fact which the artist may labour vainly to encapsulate. 'There is no escape from the physical nor is there any escape from the mind,' he wrote, 'The two are in a constant collision course.' This pervasive hopelessness is also present in the work of Smithson's friend Eva Hesse, who died in 1970. Both were anguished personalities who fought to regain possibilities for self-expression in sculpture, at the same time casting an envious backward glance at Still, Reinhardt and Pollock. Pushing vainly towards modes of public art, both Smithson and Hesse were consoled by the desperate metaphysical clownage of Samuel Beckett, who called art 'the apotheosis of solitude'. Months before her death Hesse said 'Absurdity is the key word ... it has to do with contradictions and oppositions.'

The motif of self-defeat revealed by Smithson's working methods demonstrates one version of 'absurdity'. Only three earthworks were completed, the last by his wife and friends after his death. If most of his plans remained on the drawing-board, the reason is not hard to find. When he approached them with a project people tended to back away, not always, as is usually suggested, for reasons of cost. As part of their scheme the directors of the Los Angeles County Museum's Art and Technology programme introduced Smithson to a steel and cement company who agreed to accept him as an artist-in-residence until they realised that his proposals included a collapsed mine tunnel, a demolished building, a landslide and a display of raw materials. A polite but firm refusal followed. Canadian ecologists prevented his constructing an island off British Columbia, to be covered with a glass dome and filmed from a helicopter descending in a spiral. Another idea was an aerial museum of works placed at the edges of runways at the new Dallas-Fort Worth airport, visible only from planes. Smithson was 'artist-consultant' for the architectural firm of Tippetts, Abbett, McCarthy and Stratton, who agreed to it before – predictably enough – they lost the contract. In 1970 the New York Parks Department rejected a plan for tugs to tow floating gardens around Manhattan. For two years not a single project was realised. After such frustrations an acceptance from a company, land-owner or the general public may have seemed like attempts to

call his bluff or like an invitation to execute a work which had failed in his own terms; the essence of his best ideas may have been their near impossibility.

There is 'absurdity' too in Smithson's search for an artistic vehicle. To the casual observer his career seems to divide into three parts. He began as a Minimalist, making gallery pieces out of folded steel. Predictably, the sketches for these are intricate compass and ruler affairs. The second phase contained the non-sites, his own term to describe displays of earth, with maps or photographs of the site on the gallery wall and the earth in grids reminiscent of the 'Minimal' works. At this time the word 'dialectic' creeps into Smithson's terminology to describe his theoretical stance, a confrontation of the site's openness, plurality and indeterminancy and the non-site's closed, determinate singularity. The drawings relating to the non-sites emulate maps or make collages with geographical elements. The third, earthwork period makes freer use of various manners in both sculpture and drawing and seems to pool resources before embarking on a complete solution to the problem of object-making.

Smithson's quarrel with the accepted idea of the artwork stemmed from a feeling that Western life would only admit moveable, saleable, museum-bound objects which asked no questions about the systems of thought on which they rested. He had developed a didactic art, self-referential yet positioned in relation to outside forces. Perhaps his non-sites were compromises, equivocal, half-baked arrangements which struggled so hard to achieve the correct context for their statements that 'content' was accidentally overlooked. Like the rest of Smithson's pre-earthwork sculpture it is open to attack for being 'non-visual'. Before he could apply himself to this problem, however, a further complication arose.

Smithson's opinions on function in his work are difficult to unravel. The drawings appear to indicate that he was a frustrated architect. Spirals, labyrinths, ziggurats, stone circles and ruined fortresses all point towards buildings of a primitive, monumental type, and this particular exhibition is accompanied by a learned catalogue comparing Smithson's work with that of landscape designers and visionary architects of the past.

Unrealistic as the drawings of Boullée or Sant'Elia may have been in practical terms, they were nevertheless based on the ideal of function in a social context. Smithson approached this with difficulty, though the powerful extremes of his feeling showed signs of resolution in the seventies. The large-scale construction began around 1968. By 1972 he had adjusted his non-site theories to accommodate Frederick Law Olmsted, the architect of Central Park.

Only with the 1972 Tailings Pond project in Creede, Colorado, was a balance achieved between purely aesthetic concerns and design for other people. The plan, which was to utilise nine million tons of rock extraction of ore, was welcomed by the firm in question but was never carried out. The few completed earthworks hover uncertainly between architecture and sculpture, halfway towards design projects which would reflect his ideas about anonymity and democratic usefulness. In a limited way they succeeded; *Spiral Hill and Broken Circle* at Emmen, Holland, was so popular that contrary to Smithson's intentions the local council voted that a sum of money be set aside annually for its upkeep. Workers on the *Spiral Jetty* brought their wives and families to picnic on the shore and watch its progress. The earthworks involved each engineer and workman in the creative act. In an interview with Nancy Holt after the completion of the *Amarillo Ramp* Sid Feck, the foreman, revealed that he had secretly mixed the small surface stones so that they would be variegated and sparkling. Smithson would have been delighted.

In *Literature and Revolution* Trotsky wrote 'The wall will fall not only between art and industry but between art and nature also.' Brought up in Paterson, New Jersey, Smithson devoted some of his best essays to documenting 'vernacular' industrial design and photographing outfalls of factory waste into the Passaic river. The earthworks are meant to mediate between art and nature; Smithson's purpose was not to 'improve' sites but rather to create a unique, 'natural' configuration. He thought deeply about an art which would occupy a middle area 'between ecology and industry', doing justice to both. Yet his ideas of how art achieved meaning had always been far from public. It may be that the earthworks, changing with tides and weather, interacting with the geography of their settings, permit the individual to re-examine his experience of space and his relationship with the land in a way that could best be identified with 19th-century American landscape painting. As springboards for private meditation, they seek to produce a revolution of individual thoughts and feelings.

So the earthworks did not solve all of Smithson's problems. *Spiral Jetty*, on the contrary, seems concentrated specifically on the situation of a mind retreating from challenges. The walk from the shore to the centre over a rocky promontory takes place in hot sunlight, with the dizzying sensation of being manoeuvred on a corkscrew path and the added possibility of sunstroke. Befuddled and directionless, the participant is choreographed past stagnant canals towards a centre point which promises a revelation. Infinitely open, it should mark the culmination of a meditative journey. Instead, it offers nothing

but the feeling of physical entrapment. Encircled by past experiences, the spectator finds himself in a cul-de-sac. This, at least, is how Smithson himself explained the jetty in his writings and his film, in which he sets out for the centre at a hopeful trot, only to return glumly, his arms by his sides, unfulfilled. It is a perfect illustration of what he called an 'aesthetics of disappointment'.

The density of a sculpture such as *Spiral Jetty* proves that any neat Smithson chronology is deceptive; a cluster of visual images and themes is always present, aligned differently at each new point in his career. His most successful large-scale enterprises may be those which allow as many fragments as possible to be on view in a single work. In the *Spiral Jetty* the struggle to dominate a void and the fight for mastery of nature are both rendered as continuing battles. Whether polyvalence is achieved or thrown aside is uncertain.

Yet another aspect of the 'absurdity' of Smithson's work is revealed in the visual paradoxes with which he was preoccupied in his early geometrical pieces. In the *Spiral Jetty* film a car moves along a straight road. The camera, registering what the driver sees as forward motion, devours the horizon, bringing it nearer at every moment. Of course this regular alteration makes no difference; by definition horizons evade vision. His essay 'Incidents of Mirror-Travel in the Yucatan' began by describing the same experience with what he called the 'vanishing vanishing-point', a motif featured in a lost work with hundreds of photographs of horizons. If the vanishing-point were visible, it would be evident that it was extinguishing itself furiously, while renewing itself with corresponding ferocity. Movement towards or away from it does not alter the fact that it is there. Is it, then, the *same* point? Nothing can be proved; it is a lie, a visual convenience chosen to comfort us with the thought that everything is under control. The title of a sculpture called *Gyrostasis* speaks of a similar principle of stillness in movement, again only defensible in a theoretical area beyond normal 'vision', of still axes for rotating spheres and unmoving centres of circles. One result of such a (literally) 'pointless' investigation is to demonstrate something about the relation of fact to fiction in geometry. (In what way can spheres be said to have centres or axes?) Another is to remind the spectator suddenly that his categories do not hold, that beyond them is infinity. The critic who called Smithson's minimal sculptures 'visual nonsense' was very near the mark. The drawing for *Gyrostasis* is a 'solution' to the problems it exposes rather than a foretaste of the work; a hexagon with bisected sides will continue to compose other hexagons inside itself, but their proportions will get

smaller. Whereas the sculpture *Gyrostasis* has twelve triangular solids in decreasing proportion, combined to form an awkward spiral, resting on the largest unit as a base, the drawing for it contains an infinite number of these shapes. Mandala-like, it focuses and unfocuses the spectator's attention at once. Since the purpose of the completed work is to reveal folds in the fabric of our mental systems, the responsibility it bears is enormous. Its awkward bulk must suggest the ravages of a force eating it away rapidly. By primitive semaphore it signals to us of what is happening and we, as obedient gallery-goers, signal back that it need not worry; like the lovers on Keats's urn it will not be devoured. Unmoved by our cultured reassurances, it persists in crying mutely for help. Smithson wished the very act of placing bulky 'monuments' in a gallery space to smack of humour; the anaesthetised room protects them from the very forces he is trying to discuss. He wanted to set up a 'dialectic' within the artwork itself, and museums and photographs, both of which he regarded as 'tombs', would have had to be utilised by the artist in order to do this.

Ideas take precedence over reality in the drawings, which range from full-scale visual experiments to doodles. None has enough measurements or construction details to be regarded as a plan. In any case, Smithson's respect for process always meant that works emerged differently from their counterparts on paper. Whether project or sculpture, each 'idea' was complete in itself, though a single title could be presented in what he might have called 'allotropic forms'. *Spiral Jetty*, for example, is manifested in drawings, an earthwork, a film of its construction and an essay. It was also the basis of a proposal for a museum to display all the documentation and show the film. Allotropy also encompasses shifts from verbal to visual in his work. (Helicopters, he explained, could be expected to fly in spirals because their name is derived from Greek *helix, helikos*, a spiral.) For this and other reasons, the issue of how 'conceptual' abstraction affects an art of physical manifestation is irrelevant in Smithson's thought. Crystals, which fascinated him from boyhood, or the interest in the process of mining sulphur, which he meant to film, both involve alteration of physical state without any corresponding change in the properties of the substance. This parallels his conception of art as the record of slow obsession.

'Slowness' is demonstrated in Smithson's drawing *Glue on Glass*, one of his nearest approaches to two-dimensionality. Washes of glue serve as a visual reminder that over long periods it changes shape and overflows its frame. The 'slowness' theory may result from a combination of two early influences, Ad Reinhardt and George Kubler. Smithson's *Entropy and the New Monuments*

37

essay of 1966 contains the idea that almost tangentially over a long period a set of 'prime monuments' emerges, Lowest Common Denominators of a culture which incorporate its secrets. Searching for these would result in deliberate museum-pieces in which matter was the debris of time. Smithson set out to oppose the forces of deterioration, risking waste and loss of energy as well as seeking to modify the solipsism which Bochner discerned in minimal art.

Obsession, an over-emphasis on order, is counterbalanced in Smithson by the inclusion of degrees of disorder. In the 1970 interview Eva Hesse said, 'I was always aware that I should take order versus chaos ... and I would try to find the most absurd opposites or the most extreme opposites.' One Smithson drawing is called *A Heap of Language*. At the top of the measured graph paper is the word 'language'. Below it, stretching in progressively longer lines, are related words, as though from entries in a thesaurus. The lines are packed tightly together as if a great weight were pressing them down. That the words are handwritten emphasises the linearity and laboriousness of the process, yet the lines in which the words are arranged have no purpose beyond that of indicating that 'language' is the chief element. As we read *A Heap of Language* the meaning of the idea is clarified, despite the threat of its swift rate of expansion. A thesaurus has to be used in a way that directs its material towards definition. But the sketch refuses to be construed in this way; the words are not subservient to 'language' but exist with it in a non-hierarchical pile which challenges its claims to predominance by swamping it with sheer number. As the synonyms proliferate and their synonymity becomes vaguer, gravity does its work and information decreases. If the viewer is to regard it as capable of infinite extension, the drawing becomes a Tower of Babel in reverse, stretching further and further downwards, rehearsing words that denote and organize language, demonstrating their loss of power to define areas of sense, their deterioration into unintelligibility. The destructive force in this case is entropy, that loss of energy and information which, according to the Second Law of Thermodynamics, is constant. The purpose of Smithson's 'dialectic' was to confront such forces head on. One of the functions of drawing for him, however, was to offer a method of stating problems without the considerations that objective form entails. The *Gyrostasis* drawing dissolves his arthritic curve into a total field of potential structures, but in doing so states that the principle of its organisation is an 'ideal' system. Smithson was in furious opposition to 'closed' works of art since the tighter their form, the faster their journey into sameness or 'heat-death', the product of entropy. In a remark about Documenta V, from

which he withdrew everything but a statement called *Cultural Confinement*, he compared it with a fascist state. His own word is 'aggressive'. In the drawings named *Entropic Landscape* the description is justified; like prehistoric fortresses, these moated camps ward off intruders but are themselves desolate, subject only to time. Why then the 'ideal' system in the *Gyrostasis* drawing?

When the exhibition was shown in New York reviewers were surprised at the Surrealist turn of mind they revealed. *Movie Treatment for 'Tropical Cargo'* of 1970 contains shots of burning pineapples, lobsters swimming in a pool of milk, feathers blowing over smashed watermelons, a rattlesnake being milked and dead tarantulas buried in apple sauce. The man who could draw fish-heads sticking out of a heap of rotten bananas with a reference below it to the description of the tomb of Virgil in Bulfinch's *Mythology* was not the rationalist portrayed by critics such as Lawrence Alloway. Without doubt, this was the wild-eyed inventor whose proposals were refused, who indulged himself in picturing his worst fears without qualification or intervening 'dialectic'. Only in a drawing could he have allowed himself to fabricate a 'closed' system as in the *Gyrostasis* sketch.

Within the boundaries imposed by the drawings Smithson is a free man, able to draw a personal map of an ocean bed as if planning to walk across it, or prolong the present by gleefully stressing the molten asphalt in his *Texas Overflow*. Movement is added to hasten the growth of his mangrove swamp, drawn in three expanding stages, and subtracted to exaggerate the serenity of his barge of sulphur, viewed from behind, as it is towed triumphantly through the Panama Canal in an incomprehensible ritual display. If humour is one of the qualities most easily distinguished in the drawings, a sense of evil is another. The 'aggressive' potential of gigantic architectural structures is explored in *Sod Juggernaut* or *Pierced Spiral*, while in *Sod Spiral* or *Zig-Zag Ramps* the ambition of the structures is humourously underrated by their emptiness as gestures of power or worship.

If Smithson was temperamentally a Surrealist in the American Gothic tradition, the late essays and the *Tailing Pond* project suggest that this was giving way to a new patriotism and social purpose. His unbridled drug-taking and movie-going of 1962 to1966 are reminiscent of the original Surrealists – Breton and Jacques Vaché sometimes visited six cinemas a day – but his most characteristic trait is his worship of blind power. His works thrive on artificial disasters such as falls of earth or razed buildings. As a child he enjoyed Charles Knight's illustrations and reprinted some in an essay on the Hayden

Planetarium. One shows the artist's impression of a prehistoric event. Dinosaurs stare into space in a puzzled way while meteors whizz past, threatening to collide with the earth. Apocalyptic thought was common in the sixties, but Smithson is unusual in deploying it at every level of his work, from the tons of mud which break the roof-beam of his *Partially Buried Woodshed* to the brain's inability to cope with the unmapped reality which escapes systematisation in the non-sites. By a kind of white magic disasters can be warded off by inviting them to do their worst. The more strongly this is desired, the more effectively they are dismissed. Smithson loved his disasters but only in the drawings could he reveal the full extent of his attraction to them. As he showed by his habit of mapping imaginary countries – Cathaysia, Lemuria, Gondwanaland, Atlantis – for him drawing was not only a method of research but also a means of wish-fulfilment. Its potential lay in its power to grant him a set of perimeters within which he could lower his defences and make himself absolutely vulnerable. Desire as motive force is particularly in evidence in the most heavy-handed of the sketches. Their lack of inhibition, encouraged by years of hard drugs and the brilliant examples of surrealism in underground comics of the time, is found elsewhere only in the most vertiginous passages of his prose, private improvisations on his cluster of set themes, unfettered by reason or logic. But in the drawings it permits him, for example, to operate within the 'closed' systems he abhorred; when there was a pencil in his hand and the type of statement he made was invariably 'fictional'. While maps of real countries are subject to continual change, an outline of Atlantis will escape time by standing outside it. 'Our future,' wrote Smithson, 'tends to be prehistoric.'

One of the strangest facets of Smithson's character was his passivity. Replying to a questionnaire on the 'deepening political crisis' in America he intimated that any sort of action would be fatal, a strangely timorous reaction from a man noted for pugnacious behaviour in public. His early work was defeated almost before it began, since its purpose was to highlight flaws in perception, working on the imaginary lines that divide sight from thought, but compelled to deal in visual terms. Crevices in our thinking such as the 'vanishing vanishing-point' or the moving/non-moving axis gape to reveal an infinite universe that evades order. Later he tried to embody contradictions rather than simply exemplifying or listing them. His 'art against itself' returned to contradictions involving space, time and function. Though he defined the relative angles that film and photographs subtended to reality, he never mentioned drawing in his essays. Perhaps it was outside the limits of discussion,

an intimate medium in which to separate the strands of each contradiction, rethink its sculptural possibilities and finally envisage a complete departure from 'art'.

How, then, is it conceivable to explain the gradual metamorphosis from power over a void to power over the natural world? Ideally, in these drawings, which are a bridge from one view to the other, each line should be an act of love, calling into existence products of the artist's body, intimately connected with it yet completely apart. Yet the fate of love in America resembles the fate of art; persistent Puritanism leads to an interpretation of both as work. If, as Bataille claimed, eroticism means assenting to life to the point of death, then Smithson's art is erotic by virtue of its preoccupation with uncontrollable forces, courted and subdued in the drawings. The astonishing physical labour which would be involved in making the finished works often seems appropriate punishment for having dared to imagine them, yet the drawings escape into the realms of ideation. Octavio Paz has argued that the United States was built on the void that remained when the Indian cultures were eradicated, and that the warlike tendencies of its inhabitants are still evidenced by their wish to dominate the natural world, to treat it as an enemy.

> It's a Protestant concept of the world: the condemnation of the body is also applied to nature. If the body is natural, nature is corporeal and both are fallen states, forms of original sin ... Nature ... is a reality which man must transform and redeem through work.

Void, nature and the fall into the body are fused at the core of Smithson's creative imagination. For him the final absurdity may have been the contradiction between art as love and art as work. Forced into the compulsive activity of drawing by an array of negatives, unmanned by circumstance as well as choice, Smithson tried in his own way to make the world whole once more. Yet there was rarely the slightest fear that reality would emerge from drawing, a ritual activity with the power to conjure but not to create this wholeness. No man can have had more perverse reasons for describing the lineaments of gratified desire.

Alice Aycock: Structures, Stories and the History of Man-Powered Flight

Published in Artscribe *15, December 1978, and as part of the catalogue*
Alice Aycock: Project and Proposal, *published by Muhlenberg College
Center for the Arts, Pennsylvania, 1978*

Perhaps it was inevitable that a backlash of object-based art would follow the shift towards ideas, performance and video. Despite this reaction, the work of Alice Aycock should not be interpreted as a return to construction but rather as a prolonged experiment with an amalgam of media and styles. Increasingly, the purely three-dimensional aspects of her art have been buttressed by drawings, prose, elaborate titles and art-historical references. The object works on a multiplicity of levels – as document, souvenir, spectacle, as an abstract equivalent for remembered spatial perception or as the culmination of long research. And, it could be added, it is deliberately overworked in the process.

Two major influences, Robert Smithson and Robert Morris, offered alternative approaches to such ontological overload. Recalling Abstract Expressionist precedents, Smithson placed his sculptures under such a heavy burden of meaning that they broke under the strain, while Morris laboured for over ten years to escape the constraints of a 'style' and a single method of working. Each employed a deliberate strategy in his struggle to avoid categories. Characteristically, Alice Aycock's progress towards an authentic manner was a virtuoso achievement involving every aspect of her life and interests. Yvonne Rainer, another admired artist, said that her own film and dance contained 'a spectrum of categories'. [1] Similarly, in Aycock's art the focus is not the object as a device for formalist explorations or anti-formalist manoeuvres but a cluster of products, sometimes in different media, assembled under a single title.

Underminings, Underpinnings

From the beginning, Aycock's art has entailed meditation on time. Experimental

student pieces displayed change in 'active' or 'passive' terms. *Clay* (1971), troughs of cracking earth, or *Cloud Piece* (1971), a set of photographs of the same cloud-formation gathering and dispersing, employed sequential patterns and pseudo-scientific presentation. While such entropic processes revealed the 'benign indifference of the universe', *Sun/Glass* (1971), seven rows of five glass plates arranged at angles outdoors to reflect the sun's glare, treated spectators aggressively. [2] Active and passive modes combined in *Sand/Fans* (1971), four industrial fans equidistant from a pile of sand, blowing at the force of the prevailing wind outside. Though this prentice-work sometimes contained ingredients which would figure more strongly in her later career, not until 1972 were vision and technique aligned. Two pieces marked her maturity.

Periodically, every artist makes a work which serves as statement of intent, a point of departure or a reference for future developments. For Alice Aycock the first of these was *Project for an Elevation with Obstructed Sight-Lines*, a drawing showing an enormous mound of compacted earth angled so that as walkers neared the summit of each slope, another would come into view. For her the project resembled a manifesto, uniting assumptions which were to figure in her subsequent sculpture.

Among these was memory; the project was based on emotions experienced while crossing a barren area of Craters of the Moon National Park. Though in future the relationship between experience and sculpture would usually be less direct, spatio-temporal perceptions are re-enacted in her sculpture and sometimes recounted in accompanying stories.

Another major assumption was 'phenomenology'. After this project physical negotiation, real or implied, would always underlie her aesthetic. *Elevation* was never constructed, but in 1974 an interesting variant appeared. *Stairs (These Stairs Can Be Climbed)* emphasised participation, the single feature which most distinguished her work from minimalism, with its didactic approach to formal characteristics and its enforced division between sight and *Gestalt* perception. In this work the deliberate resemblance to stacked modules was as telling as the attempt to subvert clinical examination of parts and wholes by providing functional identity for the 'sculpture', in one sense merely an isolated architectural feature. *Stairs...* was not a self-sufficient entity but a perceptual springboard.

While *Project for an Elevation* explored sequentiality, the second key work of 1972, the *Gibney Farm Maze*, combined linearity with the experience of a received idea of wholeness. The obvious disparity between drawings of the

maze and its realised version – an impossible aerial view versus a false, ground-based impression of a single solid wall – was an ironic comment on culturally sanctioned, 'fictional' modes of three-dimensional structures. 'Plotted' by obstructions, the participant's progress across the *Elevation* has its equivalent in the decision-making process demanded by the maze, yet the overriding temporal approach resembles a palimpsest. Years later Aycock wrote that despite deterioration the maze was 'acquiring a kind of local mythical existence like its predecessors', notably the maze at Knossos.[3] In 1972 she also began to draw in isometric projection, permitting simultaneous exposure of internal and external aspects of a structure. From now on the superficies of her work would, in her phrase, refer to the 'game of history', while at more immediate visual levels memories of an individual past were evoked.[4] She has asserted the inexhaustibility of both; Baudelaire's 'J'ai plus de souvenirs que si j'avais mille ans' was her epigraph to *Project Entitled The Beginnings of a Complex* in 1974. In some more recent pieces an ironic rift separates personal from 'historical' time, and powerful emotions have given way to a wistful, toytown quality.

The artist's withdrawal from the process pieces of 1971 was paralleled later by the clean carpentry of the indoor wooden pieces, a deadpan neatness echoing the precision of working drawings, refusing access to a personality. Coolness of execution combined with capricious game-playing, a melody on the surface of the sculpture, while a magpie erudition reminded the viewer that the world was 'so full of a number of things'. In its tone of spurious objectivity Aycock's art resembled the practice of art history. After 1972 single architectural sculptures contained historical allusion and autobiography, persuading the viewer of the emotional *raisons d'être* of textbook architecture and the ritualised nature of individual experience, more fully attributable to a collective unconscious than vanity allowed him to admit.

Maze also marked the culmination of a gradual process of alignment between Aycock's scholarship and her will to make objects. In future, deliberate references would be indicated in commentaries and titles, and if, as she has said, as a building *Maze* can only be remembered by virtue of the sequence of events it entailed, access to it was controlled in a different way by her printed remarks, mingling academic footnotes with reports of visits to ancient sites and memories of emotional episodes in her life. With its sudden changes of direction, the writing conjured up the persona of a humorous, panicky woman with morbid tastes. It 'fictionalised' the art by providing a character for its creator, yet also served as an umbilical cord connecting work and creator, as impossible a dream

as the simultaneous present conveyed by the prose writing, a plane on which quotation, remembered experience, and objective fact could meet and mingle. The potential of the physical presence of the structure to 'contain' comments, plans and new reactions was a reminder of the disparity between physical and emotional experience and that portion of the mind which categorises and draws conclusions, between thinking and feeling.

The form of *Maze* was influenced by Alice Aycock's MA thesis, *An Incomplete Examination of the Highway Network User/Perceiver System* (1971), an extended consideration of how highways systems could be analysed, drawing mainly on phenomenology and information theory, but also incorporating quotations from anthropology, music criticism, the psychology of perception and the philosophy of science. The final chapter was a diagrammatic presentation of notes taken on a journey.

Though scholarly, *An Incomplete Examination...* bore traces of Aycock's later writing style; its three epigraphs were quotations from *A Portrait of the Artist as a Young Man* by James Joyce, *Norm and Pathology of I-World Relations* by Erwin W. Straus and a lesson by Mr Barnes, her brother Billy's biology teacher. Essentially a series of rejected definitions of the highway system, the thesis also surveyed disciplines which already employed definitions of multidimensional 'objects'. The highway represented 'a vast, anonymous, all-pervasive network-monument and open system which exists as an 'in-field' situation, takes place in actual experiential time and exhibits a predominantly public and democratic character, since it is relatively free and available to anyone and a great number of things.'[5] The appropriate definition was culled from Claude Lévi-Strauss, who in *The Savage Mind* referred to the 'necessary' and the 'contingent', or the 'structure' and the 'event'; the highway system was therefore 'the necessary structure and the contingent event'.[6]

She described the effect of the thesis on her work in a lecture in 1978:

A road system is ... designed ... so that when you ... act with it an event takes place and it is structured in terms of your body and your entire perceptual system, because you have to move safely on it. So they do all kinds of studies about health, about reaction time, about how tight a curve can be, how steep a grade can be ... I decided I would start building art that had that kind of quality.

I would set up a structure in order to generate an event and that would be the perceiver's interaction with it. At that time I was thinking of

how I would build a road system, and of course I couldn't build on the scale of an actual road, at least not the way I wanted to, not having the labyrinthine quality.

So I built a maze which in a certain way is a model of a road system, a scaled down model. Or it is a metaphor, let's say, in the way that for instance your circulation system might be used as a model for a road system.[7]

Considered as a sculptural statement, *An Incomplete Examination...* can be regarded as a reaction to prevailing sixties concepts. The Second Law of Thermodynamics, so frequently quoted by artists and writers, was rejected in favour of 'dynamic homoeostasis' or 'steady state', a term from systems analysis to describe the behaviour of open systems.

Closed systems go toward an equilibrium of greater simplification, increased and random disorder, and maximum decrease in energy i.e. entropy. But unlike closed systems, open systems are neither immune to nor simply acted upon by their environment. They interact with it in an input-output energy exchange which enables them to store energy – acquire negative entropy – grow, and become increasingly differentiated or complex. Growth is dependent upon the 'insufficiency' of a system; that is, the environment contains certain elements which the system needs.[8]

Later the concept of 'dynamic homoeostasis' was rejected as a mere approximation of how the whole 'complex' of a highway system functions. Yet it remains a powerful response to previous sculptural models, a logical extension of Robert Morris's 'Anti-Form' essay, published three years before *An Incomplete Examination....* One possible reason why it looms over other suggestions in the thesis is that the 'incomplete' *Examination* was 'incomplete'. *Examination* was itself intended to exist 'as an open system, characterised by insufficiency'.

Stories and Digressions

'One of my earliest memories ... is of sitting on the living room rug for hours on end, enthralled by my grandmother's stories.'[9]

Listening to stories demands what Coleridge called a 'willing suspension of disbelief', the result of a decision to allow emotions free play within perimeters

the narrator provides. The consent is a serious undertaking; dangers will have to be endured in this fictional playground. Perhaps 'art-emotions' are not those of daily life; the subtle interrelation between the two varieties of emotion and the listener's delight in his sado-masochistic bond with the storyteller provides one key to Alice Aycock's preoccupations. Oral narration preceded the novel form, which, Lukács asserted, was a commemoration of the loss of significance of the concept 'Home'. [10] Later critics have traced a progressive loss of *Geborgenheit* or 'at homeness'. [11] But could the metaphor of unhousing operate in individual terms? As an adult, Alice Aycock assumes her role as storyteller by writing. The topic of her texts is 'the romance of the past'. In a sense the past is her hero; it changes, goes on adventures, gets lost, then reappears in the present.

'Kublai Khan does not necessarily believe everything Marco Polo says when he describes the cities visited on his expeditions, but the Emperor of the Tartars does continue listening to the young Venetian...' [12] Like Granny, whose stories were all from *Gulliver's Travels*, Italo Calvino's narrator tells lies; his cities are identical. The first lesson Alice Aycock teaches us is mistrust; the viewer is invited into one of her sculptures, then his gullibility is punished by disorientation, a loss of bearings which is both dreaded and desired.

'It is a story which I have told many, many, many times and I will tell it again and again until I wear myself out and bore myself to tears with it.' [13] If the 'outside' of her creation is 'a tease, a lure, a trap', the deliberate use of cliché (or myth) is a conscious means of confirming comparisons between the artist and the obsessive bore who fascinates and repels us, whose stories are all the same. Either Marco Polo's cities are all Venice or they are all states of mind of Marco Polo.

'One day in 1968, the year I came to New York, I was about to enter a bookstore on Eighth Street when I saw a grey-haired man standing behind a table with placards. He had a large quantity of printed matter and was hawking it with the words "All my Works, all my writings, only $25, won't you give it a try?" I bought what turned out to be a thick manuscript in which the author, who lived in New Jersey, elaborated a system for decoding the bible, which proved that he, Norman Bloom, was the Messiah. So perhaps this obsession of mine is explicable.' [14] Did Norman Bloom discover he was the Messiah after inventing the decoding system? Did the system come into being to make sense of an *idée fixe* of Bloom's? Was the entire investigation a gradual realisation of divinity on Bloom's part? Invention and discovery, the *deus ex machina* and the creative workings of Bloom's unconscious are somehow deeply confused.

That way madness lies, and that way Alice Aycock situates her mental universe. She reaches for a book and shows me an illustration she has found; the position of the viewer in *Low Building with Dirt Roof*, crawling on his stomach in a roofed, body-sized enclosure, is exactly matched by that of a figure in a Bosch painting.

'The scene: Paris, Tokyo, Munich, Athens, New York, Buenos Aires, Los Angeles, Cairo, London, Baghdad, Canton, Addis Ababa, Moscow, Toronto, Marseilles, Havana, Warsaw, Johannesburg, Lisbon, Venice, Cordoba, Zanzibar, Adelaide, Reykjavik, Istanbul, Calcutta, Sarajevo.'[15] Pondering over the rickety free-form structures of Joyce, Pound and Eliot, postmodern interpreters note their preoccupation with garbage-heaps, their self-appointed role as intellectual rag-pickers creating textures of quotation and misquotation, true and false allusion, second-hand shreds and patches of history and culture.[16] One postmodern metaphor was a modernist reality. Freud believed that Joyce's writing helped ward off insanity. Eliot wrote *The Waste Land* in a Lausanne clinic, suffering from a nervous disorder. Pound was pronounced 'Criminally Insane' and interned for twelve years. Their works contain voices, droning endlessly in an improvised space/time continuum, estranged from a responsive listener. And their no man's land reappears in Aycock, whose images of uncreation vary between fertile chaos and the barren shanty-towns which surround great cities, the setting for Godard's *Les Carabiniers*.[17] The 1978 John Weber Gallery exhibition in New York included drawings for *A Shanty Town which has a Lunatic Charm that is Quite Engaging* or rather *A Shanty Town Inhabited By Two Lunatics whose Charms are Quite Engaging*; the largest of her drawings, showing a set of shanties connected by underground tunnels. Above ground only four or five streets are seen – 'there is some confusion about the number' – and a play or a movie script accompanies the plan.[18] Each shanty has its own design and inhabitants. 'The streets simply end. There are no connections.'[19] The idea was present in *Project Entitled the Beginnings of a Complex*, built in Kassel, Germany, the façades of the bogus town mimicking a solid 18th century house, restored (ironically) for the occasion.[20] Yet it was there too in the *Maze*: local inhabitants explored it, fires were laid at the centre and one wall was broken down. After a repair job the same wall was once more destroyed. Finally, the new design was left. *The Shanty Town* is a serious suggestion for an outdoor sculpture on the edges of a big city. But this time the entire work will be meant for squatters to use.

'So this was to be the story of the Middle Ages and possibly World War I and

you ask me how I got around to Egypt and the desert and I have to tell you that I simply don't know.'[21] Such digressions, like Sterne's, are often forays, leading by association to a point which is new even to the speaker, who moves through it, as through an Aycock sculpture, in a process of becoming unfamiliar to himself. The system of 'underminings and underpinnings' by which connection is made in such sallies-forth are the result of repetition, the unconscious, coincidence, cause and effect or a million other reasons, all artificial; none really defines the complexity of relations between objects and events in the world. 'Perceived things,' wrote Merleau-Ponty, 'unlike geometrical objects, are not bounded entities whose laws of construction we possess *a priori*, but ... they are open, inexhaustible systems which we recognise through a certain style of development, although we are never able, in principle, to explore them entirely, and even though they never give us more than profiles and perspectival views of themselves.'[22] The dual existence of Aycock's creations as perceived, physically involving entities and geometrical objects tests the perimeters of conventions by which objects and events are related in order to escape those conventions, to make works which both refer to and present the non-shape, non-connection, of the world. 'The problem,' she writes, 'seems to be how to connect without connecting, how to group things together in such a way that the overall shape would resemble "The other shape,/ If shape it might be called, that shape had none" referred to in *Paradise Lost*, how to group things haphazardly in much the way that competition among various interest groups produces a kind of haphazardness in the way the world looks and operates.'[23] Yet at the same time she is conscious of the proximity of randomness and proliferation to ideas of madness, the collapse of mind or form, because of excess input. If the sense of estrangement is caused by loss of direction or control, of confusion of those terms by means of which our perception is oriented, then in her work it is both craved and feared; it is at once the intention and effect of multilateral thinking.

Flying

For Alice Aycock the mingled fear and pleasure which attracts listeners to storytellers is connected with that loss of bearings she experienced in childhood in fairground machines.

> It seems to me that the disjunction, the uncertainty, the ambiguity that I
> experienced in the amusement park can be articulated. Using the
> conventional vocabulary or sign-system of architecture... as a set of

directions for a performance (as the structure for an event), it is possible to create a vocabulary of disjunction. [24]

Loss of order, organisation or logical structure is a main thematic preoccupation in Aycock, who ambitiously attempts to situate her works midway between opposites. Yet in this respect, as in others, the December 1977 Museum of Modern Art, New York construction *Project Entitled 'Studies for a Town'* distinguishes one phase of her work from another.

Tony Smith's description of a journey at night through the half-completed New Jersey Turnpike was quoted in 1965 by Michael Fried, who deplored this shift from 'objecthood' to 'theatre'. [25] Aycock's most purely sculptural proposals – *Three Concrete Chambers Entered Through an Underground Tunnel, Twenty Floors* or *Project for a Maze: Four Superimposed Cruciform Buildings* – plot the varying relations between physical, intellectual and intuitive modes of perception, generate an 'event' and isolate for examination the viewer's reactions. If this is 'theatre' it is a private theatre of the mind. Aycock's own first use of the phrase 'theatre of theatre' in 1977 corresponds to a desire for accommodation of contraries, simultaneous entry into a motion and awareness that it is produced by artificiality. [26] This manipulation of 'disjunction', a flamboyant attempt to incorporate disparities without reconciling or fusing them, typifies her art from about 1976 onwards. Participation disappears. Instead, the eye is stimulated by busy, mannerist effects. Yet references to actual motion, such as the cross-shaped 'barriers' in *Project Entitled 'Studies for a Town'*, or the ladders lying idle against walls and windows elsewhere seek at once to arouse motion and to intellectualise it in a visual counterpart of a Brechtian 'alienation effect'. [27] Underlying this, it seems, is the desire to make art which announces its historical conventions.

Conscious employment of 'disjunctive' methods coincides with a departure from simple ambiguity. *The True and the False Project entitled 'The World Is So Full Of A Number Of Things'* (1977) depended on the balance of antitheses: 'The false project after the catacombs of St Sebastian. The true project after the astronomer Lord Rosse's telescope construction "The Leviathan of Partonstown". The false project after a Piranesi engraving of the Theme of Titus. The true project after the circular building in Bosch's painting *The Temptations of St Antony*. The false project after Georgy Yakulov's 1922 stage design for *Giroflé-Girofla*.' Use of the adjectives 'true' and 'false' derives from Calvino, but also from an inability to describe her own work of that period. [28] In

pieces from 1978 onwards, concern with such thematic cross-cancellation is replaced by a more dissonant, uneven arrangement of effects. She has expressed admiration for that part of Yvonne Rainer's career when performers were disposed randomly and the viewer's eye conducted in no organised way from one to the other. While one person carried out an action which was known and practised, another would be performing at a different level of competence. 'This is something I have wanted to do in my work,' Alice Aycock has said. [29]

One reason for alighting on the Middle Ages is that the day-to-day problem-solving of the medieval man, somehow separated by an unaccountable historical deviation from Graeco-Roman thought, was concerned with inbuilt disjunctions which, to 20th-century observers, seem literal-minded, wrong-headed, needlessly complex or simply hypocritical. Instead of tending towards the attitudes of modern science, present particularly in Islamic thought, the medieval European was satisfied with a mental collage of conflicting opinions, shifting uneasily from one to another. From this apparent confusion, according to historians such as Lynn White, came the roots of the Industrial Revolution, in the form of inventions, notably the spur and the metal plough. [30]

The sculptures and drawings of 1978 allude to sophisticated thought and crude actions, mechanical innovation and violent death. A work for the University of Rhode Island was called *'The Sign on the Door Read the Sign on the Door,'* a Spectator Sport entitled *'The True Story of the Invention of the Man-Powered Lifting Devices Such as the Crank, the Treadmill and the Dredger as illustrated by the Strange Goings-On at the Grande Place de Madrid'*, and a note on the Cranbrook Academy complex *Project entitled 'On the Eve of the Industrial Revolution A City Engaged in the Production of False Miracles'* mentions the origin of fairs in funeral games and the identical siting in medieval towns of the market, the tournament ground, the playground and the gallows.

Another type of disjunction in the latest pieces results from stressing not only the ambiguous distinctions between pleasure and pain but also the extremes of metaphor which traditionally describe these emotions; 'out of the body' and 'imprisoned in the flesh' are irreconcilable disharmonies. Aycock regards flight as a fundamental urge of the Middle Ages and has linked this with the hovering effect of the perspectives in her own drawings. Yet in the works of 1978 the prevailing tone is comic. The source for the Stedelijk, Amsterdam construction *The Angels Continue Turning the Wheels of the Universe Part II in which the Angel in the Red Dress Returns to the Center on a Yellow Cloud above a Group of Swine-herds* is a postcard of a medieval painting showing a bulky angel

above a rustic group. Transcendence, that spiritual elevation of which literal flight is merely a shorthand cipher, signifies true faith as opposed to the false miracles of the market-place or the alchemists' fruitless talk of transubstantiation. In its effortless control of the six dimensions – up, down, left, right, forward and back – flight is the uncomplicated antithesis of amusement park confusion or the shanty-town space of modernism. Amid discussion of 'unhousing', disjunction, disorientation, the symbol of flight offers a sudden glimpse of a lost ideal. Though Aycock's upbringing was Catholic, it is not a religious ideal but an image of some personal 'solution' to artistic problems, a metaphor for her artistic stance.

> Medieval art is concerned primarily with religious themes and it has been described as symbolic and non-realistic. In medieval paintings the human body is often portrayed hovering above the earth, peculiarly inert, and posed underwater, or effortlessly emerging from the earth. All these situations are physically impossible, at least for earthbound creatures. And yet if one thinks of how the body feels while undergoing states of ecstasy and euphoria, religious or otherwise, or while experiencing moments of extreme fear and panic, the floating, weightless medieval figure could be seen as depicting a familiar psychological sensation, sometimes referred to as being high or spaced out. This is a state which also often occurs after a period of physical deprivation, such as fasting. Most people have had dreams of flying, especially when the dreamer is involved in a situation of danger. It is as though the body is no longer subject to the forces of gravity and can levitate, ascend or descend at will. [31]

The angel is the most grandiose and comic of Aycock's inventions, and the most 'housed and unhoused', a newly coined idea meshing completely with the web of cross-references within which she works. The unconscious, Bachelard states, was always 'housed', 'well and happily ... in the space of its happiness'. [32] Perhaps Aycock has found the one example which disproves his point.

Richard Poirier noted 'something like an obsession' in American culture with 'plans and efforts to build houses, to appropriate space to one's desires, perhaps to inaugurate therein a dynasty that shapes time to the dimensions of a personal and familial history.' [33] No better description could be imagined of the drawings which comprise *Project Entitled 'I Have Tried to Imagine the Kind of City You and I Could Live In as King and Queen'*, with its small Pennsylvania

clapboard town for the Queen to busy herself secretly, while the King looks through a rose-window at an empty space beyond. For Aycock, holding dominion over a space seems as pointless an ambition as flying like an angel, yet perhaps equally tempting. The interplay between a dogged refusal of 'contained' form, an irrational desire to overwhelm herself and viewers with information, and a counterbalancing synthetic ability, manifested in pristine drawings for apparently impossible projects which *could* be built and have been measured and scaled even on the drawing-board, re-enacts what historians have regarded as specifically American experiences of space. Temporal co-ordinates for the American immemorial past and a distant, idealised future, Adam's house in Paradise and the City on a Hill – all are reflected in Aycock's awareness of extremes of order, a primitive Adamic simplicity and a florid, apocalyptic decadence. Yet the main trajectory of her career implies the recognition that the world may not be ordered or chaotic but the product of a third possibility: merely that it is very complex. Her sustaining belief has been that 'objects' can be made to reflect this. Her method has been that of storytelling within a web of allusion which 'undermines and underpins' her intuitive ransacking of a private body of anecdotes, experiences and items of history. And her basic theme has always been the same; it is the housing of consciousness.

1. Yvonne Rainer, *Work 1961-1973,* Halifax: Nova Scotia College of Art and Design,1974, p.108.
2. Alice Aycock: unpublished notes.
3. Alice Aycock, 'Work: 1972-1974' in Alan Sondheim ed., *Individuals,* New York: Dutton 1977, p.108.
4. Stuart Morgan and Alice Aycock, 'A Certain Image of Something I Like Very Much' *Arts Magazine,* New York, vol.52, no.2, March 1978, p.119.
5. Alice Aycock, *An Incomplete Examination of the Highway Network/User/Perceiver System,* MA Thesis, Hunter College, New York May 13, 1971, p.2. Unpublished.
6. *Ibid.,* p.4.
7. Alice Aycock, transcript of lecture given at Cranbrook Academy of Art, Bloomfield Hills, Michigan, 1978. Unpublished.
8. Alice Aycock, *An Incomplete Examination,* p.11.
9. Alice Aycock, 'For Granny (1881-) Whose Lamps are Going Out: A Short Lecture on the Effects of Afterimages' *Tracks,* New York, vol.3, nos.1 & 2, p.141.
10. Walter Benjamin, *Illuminations,* London: Collins 1977, p.99.
11. George Steiner, *Extraterritorial,* London: Faber 1972, pp.3-11.
12. Italo Calvino, *Invisible Cities,* New York: Harcourt, Brace, Johanovitch 1972, p.5.
13. Alice Aycock, Cranbrook lecture 1978.
14. Alice Aycock: unpublished notes.

15. Alice Aycock: unpublished notes.

16. See Robert Martin Adams, *Bad Mouth*, Berkeley: University of California Press 1977, pp.112-138; Richard Poirier, *The Performing Self*, London: Chatto & Windus 1971, pp.45-64; Hugh Kenner, *The Pound Era*, London: Faber 1972, pp.54-75.

17. Alice Aycock, *Project Entitled 'The Beginnings of a Complex...'* New York: Lapp Princess 1977, n.p.

18. Alice Aycock: unpublished notes, John Weber Gallery exhibition, March 1978.

19. *Ibid.*

20. See Stuart Morgan, 'The Skateboard on Middle Ground', *Artscribe* no.9, 1977, pp.32-3.

21. Alice Aycock, *Project Entitled 'The Beginnings of a Complex'*, n.p.

22. Alice Aycock, *An Incomplete Examination...*, p.42.

23. Alice Aycock, *Project Entitled 'The Beginnings of a Complex...'* n.p.

24. *Ibid.*

25. Michael Fried 'Art and Objecthood' in Gregory Battcock ed., *Minimal Art*, New York: Dutton 1968, p.130.

26. Alice Aycock, *Project Entitled 'The Beginnings of a Complex...'* n.p.

27. See Stuart Morgan, 'High Anxiety' in 'The State of Idea' *Artscribe* no. 11, p.16: 'Perhaps there exists, in this painting by Velásquez, the representation, as it were, of Classical representation'.

28. Stuart Morgan and Alice Aycock 'A Certain Image of Something I Like Very Much' *Arts Magazine*, New York, vol.52, no.2, March 1978.

29. From a conversation with the author, September 1978.

30. Lynn White Jr., *Medieval Technology and Social Change*, New York: Oxford University Press 1976.

31. Alice Aycock: unpublished notes.

32. Gaston Bachelard, *The Poetics of Space*, Boston: Beacon 1969, p.6.

33. Richard Poirier, *A World Elsewhere*, London: Chatto & Windus, 1966, p.17.

Everything You Wanted To Know About William Wegman But Didn't Dare Ask

Published in the Arnolfini Review, *Bristol, May-June 1979*

No Problem

When they asked Marcel Duchamp to speak about his masterpiece *The Large Glass* he replied 'There is no problem.' And that's exactly the problem with William Wegman; there's no problem. You say 'But Duchamp was the most difficult artist of the 20th century, chock full of juicy problems.' Am I suggesting that Wegman is equally difficult? Not at all; just that there are no problems. When Wegman is working he looks like other people playing. Perhaps that is a problem. He refuses to discuss his work. That's another. One day I decided to try interviewing him. It was rude of me – doubly so because he is too polite to protest. We did it, but at the end I was more confused than ever. He stumped off to take a shower. Someone famous once said 'If you ask questions you only get answers.' It wasn't William Wegman but it could have been. I decided on the direct approach; I cornered his wife. 'How does Bill make his videos?' I asked. 'Oh, he just sits in the studio and plays with his toys.' One Wegman photograph shows him sitting on a settee reading his newspaper. On the floor at the other end of the settee sits his dog Man Ray, equally absorbed by a chewed ball of paper between his paws. Their poses are as similar as possible and the facial resemblance is striking. Bill does his reading, Ray his biting. Of course dogs don't read newspapers: they bite them to pieces. But why shouldn't Ray be as absorbed in the task before him as his master? Neither will stop until there's nothing left 'in' the paper. Perhaps Ray gets more out of his section than Bill, but the picture leaves us guessing. As in all their transactions, man is fickle, dog is stable: Bill might stop taking the *New York Times* but Ray would enjoy biting other papers just as much.

The picture is fairly representative of Wegman's interests. But what is it 'about'? That's almost impossible to say, even though the components are familiar. After all, what is drinking beer 'about'? Or taking a shower? Or walking the dog? Neither play nor work, they take place on a non-intellectual level. They could be described as habits. They happen on a plane which does not admit problems. If you go to art galleries expecting perfectly executed meditations on the anguish of the human spirit at high points of awareness, forget about William Wegman. But what the hell. Michelangelo kept a dog and read newspapers.

Body Swerve

When I spoke to Dennis Oppenheim about William Wegman he said that his greatest achievement as an artist was the acuteness of his decision to opt for humour at a certain time. Perhaps like Oppenheim's, Wegman's early career, with its periods of soft sculpture, kinetics and conceptuality, can best be interpreted as a reaction against prevailing sculptural styles. Minimalist object-makers were involved in simple geometric design, an essentially didactic approach, and the arrangement of standardised modules. Wegman rejected their pseudo-scientific point of view in favour of fun and widened his choice of available media to include photography, performance, fiction, drawing and video. While sixties Pop was concerned with public image, his world was restricted to private relationships in closed rooms, with his personal affairs – his home, his wife, his dog – yet in no sense was it autobiographical: 'Sometimes I've drawn on autobiographical material, maybe situations that I've felt trapped by, and turned them into something else, but in a very superficial way, not in an intense psychological way.' His self-effacement recalls that of Ed Ruscha, but with an injection of vaudeville. The works resemble jokes and, like good jokes, tend towards anonymity.

Like jokes, Wegman's pieces often depend on comparison or contrast. They emphasise gesture, props and rudimentary mime, establishing a social relationship with the viewer, then celebrating it by a final gift of laughter. They are as brief as possible. Most important of all, they are catalysts, permitting a release of energy. And as in jokes, the meaning somehow escapes. Instead of 'containing' their significance it hovers around in the background.

In Wegman the hovering meaning seems to indicate entrapment and release. As his tape about the Emperor and the dish explains, in the real world our willing seduction may be punished. In his private domain it is always rewarded. In its mild-mannered way, Wegman's art is informed by power struggles which

take place in daily life, our urge to be controlled and the chaos this causes. In one tape Wegman tosses a coin again and again. Each time he turns Man Ray around according to the result of the toss. Removed as he is from the hurly-burly of human life, the dog waits patiently for the whole thing to stop. Could a person do the same? Probably not, but Man Ray is exemplary in Wegman's universe.

A Star is Born

'We picked him out of a litter in Long Beach,' said Wegman years later. 'Compared to the other puppies in the litter he acted strange and distant. Later we found out why; he had swallowed a beach ball.'

Man Ray is an elegant Weimaraner with an economy of gesture perfectly suited to video. In one tape Wegman enters and stands before a curtain lecturing on stereophonic sound and indicating two unimpressive speakers. For the rest of the talk Ray registers exquisite boredom, looking up from time to time in sheer contempt and disbelief, at other moments fixing us with a long stare reminiscent of Jack Benny. Lamely Wegman finishes and leaves. It takes Ray a while to notice his absence. Then he follows him out, not before shooting a withering glance in our direction. The sheer grace of the performance is breathtaking. While Wegman's solo tapes feature his adoption of roles (teacher, salesman, bores you meet in bars), Man Ray, the natural Brechtian, undercuts him by refusing to act, indeed refusing to countenance the possibility that anyone might ever want to act. His histrionic triumphs occur despite himself. In the spelling lesson tape Wegman corrects mistakes in an exercise Ray is supposed to have written. Ray's puzzlement is genuine and touching; he even starts to whine gently and lick Wegman's face at the end of the routine. 'Well, O.K., I forgive you, but remember it next time.' This Hollywood pathos is sheer sleight-of-paw; Ray, as usual, plays himself. To describe his stance as the result of a decision-making process is misleading; dogs just don't think that way. As we see him in the tapes and photographs he seems the product of a set of negatives. His performances are based solely on the assumption that no dog could ever be less what he is *not* than Man Ray.

Noble Dog: Paint by Numbers is the title of one of Wegman's altered photographs. His respect for Man Ray is evident in his constant willingness to play stooge to his canine companion. Ray embodies an alien but innocent mode of thinking, the apotheosis of Wegman's own gawky naïveté. The dog's finest hour comes in the tape in which a male and a female voice call him from left to

right, promising a walk. His head bobs from side to side as if he is at a tennis match. Then comes a point when he gets bored or tired or decides that they are making fun of him or that it is not worth the effort; they proceed with their alternate calls while he sits bolt upright, staring gallantly ahead, looking neither to left or right and apparently snubbing them both. He has saved face. And that, in Wegman's world, means quite a lot.

I Used to be Ashamed of My Striped Face

Gaucheness is both a stylistic trait and a thematic preoccupation in Wegman's work. I have heard him tell an inquisitive admirer that when he started using video he never learned to edit. Later, not editing became a habit; entrances and exits became part of the routine, and he developed a particular talent for post-punch, throwaway lines at the ends of sequences. In reply to a reporter from Warhol's *Interview* magazine who asked him how he arrived at his dead-pan voice he said 'I never really learned to speak properly.' His gaucheness is there too in the drawings and the habit of painting on photographs. In fact, it is there somewhere in everything he does, like a signature.

The pattern that emerges is of awkwardness or inability redeemed by personal charm. Linking his separate 'jokes' is a coherent persona; as an entertainer he is no wise-cracking comedian but a droll whose personality *makes* things funny, and this tendency not to exert too much control over events, to allow them to topple gently into fun, is all the more important since Wegman so frequently brings us to what one reviewer called the 'the threshold of boredom'.

Wegman's shyness is unfeigned. Despite hints in his work that he would prefer to be less reliant on social conventions, they are the basis of his art, in the form not of behavioural nuances but of sheer survival in the company of others: when to start speaking, what to say, how to say it, when to stop. Two linked photographs demonstrate how to pronounce the word *hellow*, one syllable at a time. A drawing entitled *Trying to Start a Conversation* features two figures at a table, one sitting upright, the other with his face buried in his hands. 'I wanted to ask you something,' the one says. 'What,' replies the other, without raising his head. In many of the video routines Wegman does not face the camera directly but looks sideways towards the monitor. Combined with his monotone delivery, the effect is oddly dispassionate and numbing – 'You have your best conversations by yourself,' he has said – and the viewer is anaesthetised into a state of mind in which he can laugh at a man waiting for an

ambulance or another man with a mouth transplant or the sheer despair of the figure who sits with a permanent smile on his face, unable to switch it off.

> I had these terrible fits of rage and depression all the time. It just got worse and worse. Finally my parents had me committed. They tried all kinds of therapy. Finally they settled on shock. The doctors brought me into this room in a strait-jacket because I still had this terrible, terrible temper. I was just the meanest cuss you could imagine and when they put this cold, metal electrode, or whatever it was, to my chest I started to giggle and then when they shocked me it froze on my face into this smile and even thought I'm still incredibly depressed, everyone thinks I'm happy. I don't know what I'm going to do.

For a second Wegman's guard is down; this classic tape is frighteningly honest. 'Laugh that one off,' it seems to say, and of course we do. But it is a nervous laugh at best. In *just* evading seriousness, *just* delivering us from entrapment, he is achieving something remarkable here; he is providing a sudden glimpse of a dark world we cannot begin to fathom, outside the closed rooms where lonely men hold conversations with themselves. This is not the work of a man without problems. Yet this 'no-problemness' informs Wegman's work and is a weapon against uncontrollable forces. We must cling for dear life to what we know, he seems to be saying, and rehearse it again and again. Innocence and honesty and laughter are our stays against confusion and we need them badly.

What The Papers Say

Published in Artscribe *18, July 1979*

There's a quality of legend about freaks. Like a person in fairy tale who stops you and asks you a riddle. – *Diane Arbus* [1]

This week's *Sunday People* makes interesting reading. Sex holidays in Bangkok, the Queen's car crash, *Blind Dog's Love Trek to Home*, a pub where they play the National Anthem at closing time, and, on the front page, Ethel Chapman, a 57 year-old Birkenhead invalid with the marks of the crucifixion on her hands and feet. On Friday they bled. 'When the wounds open I can feel myself being drawn up onto the Cross. I feel the nails being driven through my hands. I see the crowds below watching.' [2] A photograph, with arrows, shows Mrs Chapman displaying her stigmata.

Thirteen pages of the *Sunday People* are devoted to sport, three each to hobbies and television, one to letters and astrology, and the rest is 'news'. Yet their news falls into such obvious patterns that the items can easily be recognised and labelled: Naughty, Sentimental, Patriotic and so on. Perhaps Mrs Chapman was so hard to label that they devoted their front page to her despite an impending election. Or perhaps she is more conventional, grouped under 'Paranormal', along with witchcraft and UFOs.

What private misery Ethel Chapman must already have experienced, like poor Gregor Samsa, whose father pelted him with apples after his sudden change into a giant beetle. In a short story by Leonard Michaels a Jewish schoolboy refuses to let his parents go ahead with plans for his bar mitzvah because of a crisis of faith:

My aunt said 'Get serious!' My uncle said 'Shut up. The crazy is talking to
me.' My aunt said 'You too must be crazy'... My cousin pulled open
his shirt. 'Look,' he cried. My aunt said 'I can't talk so I can't look.' 'Look,'
he screamed. Green, iridescent Stars of David had grown from his nipples.
My uncle collapsed on the wall-to-wall carpet. Looking, my aunt said 'I
can't talk so I refuse to look at your crazy tits.' That night my uncle sent
telegrams throughout the Western Hemisphere. He explained, with regrets,
that his son didn't believe in God, so the bar mitzvah was cancelled. Then
he pulled my cousin's five-hundred dollar racing bike into the driveway,
kicked out the spokes and left it for the neighbourhood to notice. [3]

Predictably, the news article treats Mrs Chapman as a grotesque. Sigmund
Freud might have called her an obsessional neurotic. Rupert Murdoch calls her
good business. The Michaels incident is depressingly realistic. The uncle and
aunt can 'look', register and still refuse to see. No wonder that in the picture
Ethel Chapman has a guilty expression, like a surrendering terrorist or the first
part of a BEFORE and AFTER commercial. In a week's time, she is thinking,
this space will contain a film première or a topless pin-up. She is right to look
glum. It will take less than seven days for Catholic priests to list her in their
morbid catalogues, for Harley Street to diagnose her condition as
psychosomatic measles, for historians to insist that crucifixion nails penetrated
the *wrists*, and for millions of readers to forget her completely. [4]

Five years ago Ethel Chapman could have exhibited in Vienna or Milan
with her documentation in fashionable art magazines. Remember Gina Pane,
who slashed her palms with razorblades? Or Rudolf Schwarzkogler, who
amputated his penis inch by agonising inch? [5] Neither do I. Neither do I.
Oddly, both seemed to be seeking the verisimilitude and certainly the
audience which a parallel news item would involve. Compared with
'newspaper' violence, the dramatisation of self-inflicted wounds seems a mere
gesture of frustration, testifying to art's inability to make 'public' statements.
Oscillating uncertainly between art and life, like Iggy Pop or Billy McCune,
Ethel may not be too late to embark on a new career, outdoing performers by
not performing, confusing 'live' artists by never having meant to create a work
of art at all. Romantic, didactic, somehow anonymous, a vehicle for art rather
than an instigator of it, she would be a human relic, the foretaste of a society
in which art would be replaced by moral ESP, living proof of Lenin's
statement 'Ethics is the aesthetics of the future'. As an artist, Ethel might act

more like a criminal but look less like one. And at least she would not be ashamed to flaunt her crazy palms.

Is it possible to exist, be justified by, creating curiosity, sheer human interest?
– *Genesis P-Orridge and Peter Christopherson*[6]

In a Kensington squat Dick Jewell rips a photograph out of a newspaper. In time it will be filed away. His filing system is mysterious; it proceeds on the basis of massive generalisations, while cross-references exist only in his head. In one sense, these constitute the works, products of a private editing system. In its simplest form, this consists of comparing and contrasting two images, a principle explored frequently in his prints before 1976. Among the most successful were an early 'stereoscopic' print to be looked at through a coloured plastic viewer; *Dog Jump*, a photo etching based on almost identical photographs of a man in a cloth cap and a dog hurling itself into the air, picked up under a tree in Hyde Park; *Dragon Leap*, a double photo-portrait of a friend performing a T'ai Chi exercise, then blowing cigarette smoke in the shape of a dragon; and *Island, Boat, Boat Island* of 1975, a visual narrative of a ship passing behind a rock.

More recently Jewell has presented a separate images within a single frame – a vast collage of pin-ups, each with one hand behind her head, a grid of clumsily touched up crotches from sex magazines, a pattern of impossible sporting images on the screens of a shop-window full of TV sets. *A Change of Face* (1976) features 130 faces paired to correspond to a bewildering text, written without punctuation in a style approaching news headlines: SAME PLACE DIFFERENT FACE LESS PUSSYCAT MORE TIGER LADY. Marianne Moore wrote of a landscape 'It is a privilege to see so much confusion.' In Jewell's work the confusion is human, like a good party, or a full bar on a Saturday night.

Late in 1977 Jewell printed 500 copies of a book called *Found Photos*, the product of nine years of collecting discarded photobooth portraits. Many were re-assembled from scraps lying on the ground, under or on top of the machines or in bins nearby. Nosiness is our main reason for wanting to spend time on these photographs, despite the attractions of colour faults and the occasional 'abstraction' when the machine goes wrong or someone walks out too soon. The compulsive interest of *Found Photos* is that of a remark overheard in public, but not necessarily understood. Laughter conceals a sympathy with the problem of posing, employing artifice in order to appear natural, trying to resemble one's own ideas of oneself. For us as uninvited spectators, inquisitiveness mingles with self-

preservation. Posing is telling white lies. These are the white lies which were not worth telling. Bacon's photobooth portraits stressed their quality of victimisation. Jewell's anthology of anonymous fragments emphasises another kind of entrapment, that personal attempt at truthful autobiography and the private forces of censorship which prevent it.

Printmaking today is an etiolated medium for the production of luxury objects, decorative escapes from everyday life. Jewell's use of photolithography re-establishes the traditional link between prints and news and is an implicit criticism of the escape hatches he aims to avoid. It is no accident that he is at his best when handling other people's images, anthologising, translating or editing them as he goes. In *Cosmo Babies* of 1978, terrifying fashion models from the cover of *Cosmopolitan* are interspersed with family album shots of plain babies. The effect is galvanising; that grace and self-possession cover-girls strive for, the babies manage with no difficulty. *What the Papers Say* (1977) is a printed collage of newspaper faces and brief captions, with no semblance of designer's layout, since easy ways of avoiding the truth are just what Jewell is attacking. Papers say very little, and that little in no way resembles truth. The intention is not to contradict verbal evidence with visual information; that would make satire, whereas this is simple transcription of patent absurdity. Jewell launches his attack on sloppy journalistic practice, the illustration of a text with any photograph which comes to hand, however unsuitable. It becomes a metaphor for the very activity of reporting. In a pitched battle between his private image bank and the vast official picture libraries, he wins every time.

> We have to face the fact that man's proclivity for cruelty is vested in his biological peculiarities, in common with his capacity for conceptual thought, for speech, and for creative achievement.
> – *Anthony Storr* [7]

I am sitting in my office, pretending to be a reporter, adjusting my green eyeshade, rolling my sleeves up, puffing at a fat cigar and dreaming of a scoop. The phone rings and a stranger with an American voice invites me to visit his studio. 'I've been making these things for three years and no-one has seen them…' Resisting the temptation to ask what they are or why I have to go after dark, I arrange to meet him. 'I'll be the man in the black Renault,' says the voice. 'I'll be the girl smoking two cigarettes,' I reply, regretting it at once and

making a mental note never to quote Scott Fitzgerald over the phone.

A rainy street. Two minutes later a car draws up, a door swings open and the voice acquires a beard, a leather jacket and an entire outfit of black clothes. I jump in and we drive to an old warehouse. Four flights up is a warm room lit only by a table lamp and a miniature TV. 'Wait here.' Soundlessly but colourfully, Tom and Jerry are trying to kill each other. In the darkness my foot touches a warm body. A black dog turns to face me, its teeth gleaming, its eyes catching the light.

The studio smells of ether. A single spotlight illuminates a black and white tableau. At the back is a chair, and in front of it a table-cum-cabinet with a glass top opening towards me. Mirrored inside, it contains a collection of objects which look like surgical instruments – ampoules, straps, hypodermics, needles... and, mysteriously, a set of conté crayons. On one side is a blurry photograph of a white rat. As the light catches the lid the contents are reflected. In front of the table, too near my feet for comfort, is a sloping platform bearing six stuffed rats and two black cages. A soundtrack plays amplified noises of rats screaming.

I have forgotten that rats are so big. The largest, free, looks at another who is caged so tightly that his body cannot move. In the centre a cage door swings open, pulled by a pair of rats, liberated already, while another couple, just free, sniff the air apprehensively. From their position the struggling animals are unable to see the vision of the great white rat and his instruments of pain. The two freed rats seem to sense that their deliverance is illusory; their cage door opens to reveal a more dangerous existence. Only the single caged rat remains to be freed, and the other seems to be planning this next. The irony of the viewer's position involves not only his ability to see further than the creatures themselves, but also the sum of his knowledge of rats as vermin used for scientific tests, the born losers of the animal world. Gradually he comes to sympathise with their plight. If the chair and cabinet suggest some unseen, ultimately powerful presence, they also allude to the absent taxidermist/surgeon/artist himself, intent on his obscure craft, godlike in his ability to kill, dissect and re-invest rodents with spurious life. If a show is being staged, this invisible showman may regard us as merely another aspect of his doomed creation. Or the empty chair could be for the spectator himself, supreme in his ability to 'frame' and trap reality, though the ghost of the white rat in the glass table-top may indicate that the eternity of punishment which awaits the beasts below is their fate, and that by some unwritten law rats will always be rats and always be punished.

The screams on the soundtrack are getting louder. I wonder whether the door is locked, regretting my search for novelty and that damned phone call. 'Do you

always use rats?' I ask, playing for time. 'Rats and dogs,' the man replies. 'But at the moment I'm trying to find a primate.' And he looks me up and down, stroking his beard thoughtfully.

> You could have music with infra-sound. It wouldn't necessarily have to kill the audience.
> – *William Burroughs*[8]

When COUM Transmissions mounted their show 'Prostitution' at the ICA in 1976 the *Daily Mirror* accused them of 'prostituting Britain', while the *Evening Standard* called one of the group 'a degenerate mollusc'. Questions were raised in the Houses of Parliament. One MP called COUM 'wreckers of civilisation'. Coverage in the media rivalled that of the Sex Pistols, but the similarity did not end there. Shunned by the art establishment, COUM turned increasingly to music. Their band Throbbing Gristle issued a first album *T.G.* in 1977, a second, *D.v.A.* in 1978 and a single, *United* in 1979. Their next plan is to release 25 hours of early recordings.

I had seen the band only once. INDUSTRIAL MUSIC FOR CONCRETE PEOPLE, the poster proclaimed. Outside it was just loud. Inside it sounded like air-raid sirens in an iron foundry. Onstage were two men, one with his back to the audience, showing little awareness of their existence, dwarfed by a battery of speakers. Now and then they yelled abuse at the people, who had expected entertainment not provocation, music not assault. Some were angry, others simply intrigued. And some were complaining of headaches and leaning against the walls.

A few weeks later I talked to Genesis P-Orridge, founder of COUM, Industrial Records and Throbbing Gristle. The simple questions came first. 'What does COUM stand for?'

'Nothing. Well, it does, but we never tell anybody. Never have. It's a secret. It's not just me. There's Cosey Fanni Tutti, Chris Carter and Peter 'Sleazy' Christopherson. And lots of people in and out, involved over the years, still connected or doing things independently, even people who are just close friends and have the same basic attitude to life. They're all part of it. We used to say, ultimately everybody in the world's in it. It's just that they haven't been told yet. It's a philosophy of doing rather than talking about doing. You don't say "Wouldn't it be a nice if...?" You say "Therefore I must do it".' Throbbing Gristle's the latest public manifestation of COUM Transmissions. It's disposable and kept separate. We don't write manifestos and statements and explanations; we just do it, let it

speak for itself and keep it non-threatening to the kid in the street. If we said it was art they wouldn't come along and listen. Because we say it's just music and not even necessarily music – it's just sound – they don't feel threatened or alienated or that it's contrived or élitist and we get a complete cross-section of really nice people coming along.'

He gives me a T-shirt bearing the words WE ARE COMPELLED TO PUBLICISE THAT INDUSTRIALISATION WILL TAKE PLACE: THROBBING GRISTLE. 'We don't make those,' he says. 'A boy in Birmingham does it. He sold his motorbike to get the money.' With no secretaries to type letters, no agent to arrange bookings, no big record company to edit their material, Throbbing Gristle can treat fans as human beings. 'They book theatres for us then ask us to go there and play.'

'Someone wrote to us and said that his brother had written off to, who was it, someone like the Boomtown Rats, one of those groups, and all he got back was a poxy badge or something and he said "I actually got a letter" and he was really thrilled but it was really nice that he was pleased enough to write back and say thank you. All he said in his letter was "Thank you for bothering, I realise how busy you are, you don't have to reply to this".'

Fans receive newsletters and advance notice when the band is in their area. Many have completed the questionnaire included in the *T.G.* album. 'Do you have any definite political stance? What sort of food do you eat most often? Do you have any pets? What was the last book you read? Do you practise any religion? What is your greatest ambition? Do you have any special obsession/fetish?' There are 39 questions and space to attach a photograph.

COUM is a substitute for other groups which failed Orridge. He was mistreated at school. 'Bashed me about. The whole humiliation bit.' At university he dropped out after three weeks. 'I just couldn't stand it.' Already he was planning small performances. Then the Exploding Galaxy visited the university. 'I joined them and when they came back to London I came too. The core of it was that it was very very rigidly communal. You weren't allowed to own your own clothes or have any money or eat unless you were given the food, or sleep in the same place twice on the trot. It was pretty weird. Good discipline. So I wasn't allowed to have any money. If you were hungry you had to wait until food appeared. If I wanted to go somewhere on the tube I had to say where it was and if it was for anything other than the common good I was refused. I got fed up with it in the end. I left because they stopped giving me food altogether. Because I actually once disagreed with something. The cardinal sin. I was sent to Coventry. There were good sides. We

were making rain shells which were polythene tubes, and trying to develop a three-dimensional form of writing. Most of it was talk, theoretical talk, the bane of British art. We only did about two performances while I was there. They called them kinetic operas. They were very post-hippy by then; it was 1969.'

'The idea of COUM was a total reversal of the Exploding Galaxy, then.'

'Probably. In COUM people can do what they want and revolt as much as they want. I don't even go out and see Chris and we've only been to Sleazy's house once. We meet when we do something. We meet each other every weekend to talk and write letters but it's a sort of free form; we do things by choice whenever things need to be done.'

'The stress in your statements is on acting out fantasies. How are you fulfilling yours?''

'By being me. Most of all I don't have any secrets. I'm a great believer that any form of secret can be used to attack you. The best form of defence is to have no secrets at all.'

'But COUM is a secret because you won't tell me what it means.'

'He's caught me out there. Well, it doesn't have any meaning except what it is now; it would be misleading to say what it originally stood for, which is a very hippy-type phrase. As you've challenged me I'll tell you. It stood for Cosmic Organicism of the Universal Molecular. We found it worked more accurately to let people decide for themselves. It became associated with everything done under that name. It was like Dada. Just a word.'

The music of Throbbing Gristle is directly related to the structure of COUM. 'We don't even practise. Before the last time we played live, last week, I hadn't touched my guitar for four months. I've no interest in playing the guitar. It just happens to make the sort of noise I can organise to get the effect we want.'

'What's that?'

'Pleasing ourselves. The first criterion is that we like the sound we make. And within that we've all got our own ideas of what seems melodic or rhythmic or interesting. But we try to incorporate other ideas too, like subliminal information, metabolic frequency and different control techniques used by other organisations. You can use high frequencies to get certain effects. We've done experiments on ourselves and ended up with tunnel vision, temporary blindness, loss of balance, making things move, making patterns appear in the air, feeling hungry or sick... Then with low frequencies you can make people lose control of their bodily functions, have heart attacks or epileptic fits or die. To get that really efficient you need great big concrete speakers. Ordinary ones disintegrate. Sensurround at the

cinema is playing around with low frequencies which are in fact very dangerous but it's not low enough to kill, normally. But it's like strobes; if you're particularly susceptible it could give you a heart attack or a fit.'

'And who are the "other organisations" who use these techniques?'

'The American army and police force. Most armies, I guess, police forces, scientific research labs, probably some people who are into building audio equipment as well.'

'In your case is it just experiment for its own sake?'

'A lot of it's random experiment which we've checked out on ourselves first. We use it mainly to give the kids a feeling of having experienced something quite different from a normal rock concert. We look like a rock group, more or less, but when we begin playing they notice that it doesn't sound like an ordinary group. There's at least ten minutes of confusion, of wondering whether it's going to turn into boogie. And we try to manipulate the situation so that it's like a psychic battle. We hope that by the end of the hour they will have succumbed to our approach to sound. So in a way it's parallel to a normal control technique.'

> It seems to me that the real political task in a society such as ours is to criticise the workings of institutions which appear to be both neutral and independent; to criticise and attack them in such a manner that the political violence which has always exercised itself obscurely through them will be unmasked, so that one can fight against them.
> – *Michel Foucault* [10]

The key word is control. In Dick Jewell, Denis Masi and Throbbing Gristle power is not simply a theme, but also a technique for subverting conventional methods of persuasion. In all three cases there are dangers; like Frankenstein's monster, their art may turn on its creator and savage him.

Jewell's work inclines toward mass culture; the title *Found Photos* sounds like *Live Letters*, the correspondence column in the *Daily Mirror*. His aim is the near impossible – to affect that section of the population which never looks at conventional art. But he must do so by infiltration, which itself involves an insincerity alien to Jewell's character. And – here the object lesson is Warhol – in manoeuvring himself into position to convey his message he may forget it along the way. Of the three, his is the subtlest set of tactics. While Masi and P-Orridge aim at what Woody Allen called 'ultimate heaviosity' Jewell keeps his head. He will need it. Already there are TV interviews and magazine articles, reprints of the book and

a new one on the way. He is becoming a celebrity – not a Rod Stewart or a Britt Ekland but a Dolly Parton or an Edna Everage, capable of giving way just so much to the medium, then breaking loose, surviving and turning it to his own uses. Theirs is a gift which might once have been called 'poise' or 'taste' or even 'character'. In a sense it is the art and the art is only an excuse to demonstrate it. Who could make an argument for Liberace's piano playing? It is 20th-century *maniera*, and like *maniera* either you've got it or you haven't. My money is on Dick Jewell.

Denis Masi descends into the arena to reveal the nature of human aggression. His tableaux are didactic, but are they lectures or demonstrations? The reflexive qualities of his *Encounter/counter* series suggest that he is prepared to turn his weapons on himself, to regard art as the propaganda he is attacking; the conté crayon belongs with the hypodermic syringe, since aesthetic decision-making is itself subject to the pressures he is trying to locate. 'Locate', 're-create' or just 'use'? Like Jewell and Orridge, Masi is playing with fire. Yet his willingness to incorporate sound and smell in his installations is a hint that he realises that however precise and impeccable his work, it will fail in any accurate probe. Sado-masochism occupies a cool, metaphysical realm of its own, a realm of dignity and moral pomp where no argument is possible because none is conceivable where familiar dialectics fall away. But is it real or imagined? Is it simply a set of cunning strategies and self-delusion? Is a moral system natural or artificial? The shock value of Masi's work is considerable. His work is news and his one-man show at the ICA will undoubtedly have a *succès de scandale*. It would be a pity if this obscured the serious points he is trying to make. By emphasising artifice he reminds us that the relationship of artist to material and artwork to viewer are themselves governed by role-playing and role-reversal, that the coldness surrounding any enactment of power results from emptiness and impotent play, elegant and algebraic but without issue.

Throbbing Gristle blend autobiography with moral directives, releasing recordings of telephone calls threatening to kill them, a stolen print-out from an IBM computer, a riot onstage when the audience tried to rip the plugs out of the walls and Orridge's performance after an overdose of valium. On their record covers sterile cityscapes – a Tesco supermarket, a patch of waste ground with a wall inscribed THIS SITE NOT TO BE USED – are interspersed with human images. The sleeve of the latest single juxtaposes a canister of poison gas with a boy in a shower, a tangle of naked bodies with blocks of council flats in Chiswick. Stereotyping spells death; tower blocks resemble concentration camps. Two reactions are possible. One is withdrawal, the other sexual activity, pictured here as

a celebration of COUM's 'free-form' mini-society, their Amsterdam performance: a private sex show under red lights. Though unidentifiable, all four members of Throbbing Gristle are featured on the sleeve.

'Those who speak of revolution and class struggle without referring explicitly to daily life, without understanding the subversive element in sex and the routine element in the rejection of constraints have a corpse in their mouths...' [11] Though the quotation is almost 20 years old, it seems to sum up Throbbing Gristle's approach. A major problem is the dearth of images of freedom; in common with groups like the Anti-Nazi League, Throbbing Gristle take their opponents' propaganda and turn it against them. It is a dangerous technique. Orridge has been misunderstood, well nigh broken, by the British press.

> People misunderstand, they think that if you refer to something then you're either glorifying it or agreeing with it and that's not true, you know, because if that were true then every newspaper that reported a murder would be saying 'We think that people should commit murders'. [12]

Agreed, but to suggest that the prerogative of art is simply to touch on possibilities without comment surely shows an insufficient grasp of visual rhetoric. One example will suffice. The symbol for Industrial Records turns out not to be a factory chimney but the ovens at Auschwitz, visited and photographed by P-Orridge. Even admitting that poison gas and neo-Nazism are hot news, a man who can ask angrily 'How come that reality is only the preserve of people in control of the mass media?' may well be advocating an 'objective' view which just doesn't exist. Like Jewell, who offers unguarded moments in the lives of unknown citizens and who for years has been occupied with a bulky, extremely funny 'conceptual' correspondence project, Orridge dreams of artistic free speech. (At the Hayward Annual this year he will be exhibiting six years of correspondence from three friends: Skot Armst, Monte Cazzara and Al Ackerman.) Surely he must see that no amount of manipulation of context can redeem the use of the gas-chamber logo; in purely artistic terms which he cannot escape, there are such things as a sense of diminished responsibility and a law of diminishing returns.

Yet Orridge's innocence is refreshing. Instead of debating the relevance of art, he tries to take reality by the scruff of the neck. Masi sets traps for it. Jewell sneaks up when it is least expecting him. They force us to hang around their art, to smell it and hear it. Perhaps their politics is more parry than thrust, but at times like these only a very special artist could avoid that.

I hear that Ethel Chapman is going to be a preacher. I would prefer to remember her as a newspaper headline, a mute who is her own unanswerable riddle, or just an incredulous woman afraid of misrepresentation. In my imagination she is an artist who has no public. Susan Sontag prophesied an art without pleasure, with no attempt to ingratiate itself with an audience. In an impressive chapter of *Sincerity and Authenticity* Lionel Trilling quotes her and proceeds to meditate quietly.

> This view, which takes us a little, but not wholly, aback, has had its ground prepared by two centuries of aesthetic theory and artistic practice which have been less and less willing to take account of the habitual preferences of the audience. The artist – as he comes to be called – ceases to be the craftsman or the performer, dependent on the approval of the audience. His reference is to himself only, or to some transcendent power which – or who has decreed his enterprise and alone is worthy to judge it.

These days artists must know their public; they must know what the papers say. Perhaps Trilling's artist isn't even born yet. Until he is, Ethel Chapman will have to do.

1. *Diane Arbus: An Aperture Monograph,* New York: Museum of Modern Art 1972, p.3.
2. Andrew Leatham and Sidney Foxcroft 'Are These The Wounds of Christ?' *Sunday People,* April 29 1979, p.1.
3. Leonard Michaels *I Would Have Saved Them If I Could,* New York: Bantam 1977, pp.113-4.
4. cf. Ian Wilson *The Turin Shroud,* Harmondsworth: Penguin 1979, pp.47-8.
5. Lea Vergine *Il Corpo come Linguaggio,* Milan: Giampaolo Prearo 1976, n.p. *[For the truth about Schwarzkogler's death, see 'The Mystery of St. Rudolph' in this book.]*
6. Genesis P-Orridge and Peter Christopherson 'Annihilating Reality' *Studio International* July/August 1976, p.44.
7. Anthony Storr *Human Aggression,* Harmondsworth: Penguin 1976.
8. William Burroughs and David Bowie 'Beat Godfather meets Glitter Mainman' *Rolling Stone* February 28, 1974, p.42.
9. Cosey Fanni Tutti in *Dirt* no.3, n.p.
10. Fons Elders *Reflexive Water,* London: Souvenir 1974, p.171.
11. Raoul Vaneigem 'Banalités de Base' *International Situationniste* 7, Paris 1962, quoted in Stanley Cohen and Laurie Taylor *Escape Attempts,* Harmondsworth: Pelican 1978, p.144. cf. Christopher Gray ed. *Leaving the Twentieth Century,* London: Free Fall 1974, p.32.
12. Genesis P-Orridge 'Thoughts on Charles Manson' (unpublished extract from *Dirt* no.3 interview), p.3.
13. Susan Sontag *Against Interpretation,* London: Eyre and Spottiswoode 1967, pp.302-3.
14. Lionel Trilling *Sincerity and Authenticity,* London: Oxford University Press 1974, p.97.

An interview with Boyd Webb

Published in Creative Camera, *1984*

Stuart Morgan: Nothing is very solid in any of these works.
Boyd Webb: That's why they are photographs. I like the pretense and flimsy nature of photography.
Why did you stop making sculpture and start taking photographs?
Because photography has the ability to reproduce something so clearly you are in no doubt what it is. A carpet may look like the sea, but if you look carefully it's just a carpet. There's no other way of having that degree of abstraction and reality at the same time. With sculpture you can go behind and check on the strings and nuts and bolts. A photograph brings everything into one plane and you are restricted to the view the camera has. These limitations provide a framework.
Is that good or bad?
It's fruitful for me.
How long does it take to set up a photograph?
Two days, a week, a month even to get everything properly tuned. Then the actors come, we rehearse and take photographs – we do it all again properly the next day.
Where do your actors come from?
They're acquaintances or people in the street who seem suitable – it can be a little difficult persuading them to pose but eventually most get to enjoy it.
With professionals you could get exactly what you want.
No, they are too perfect and the pictures in model catalogues are misleading. On the occasions I have used models from agencies, they bore no resemblance to their pictures and were completely unawkward. I want normal people – it also

helps if they are short.

Short?

Short people make the sets look bigger.

What kind of camera do you use?

A foreign plate camera. It's much easier to compose that way.

Even when the image is upside down?

Yes.

What about lighting?

Mainly flash, but tungsten when I want to punish the actors with 20 second exposures. I like light that is almost shadowless, light that doesn't appear to have come from anywhere, it's just there seeping from whatever is in the picture, beneath the waves, underground.

But there is no light underground.

It could be divine light, fluorescent wood lice.

Are your structures well made?

Not at all – one tap in the wrong place and they collapse – the actors get nervous.

How important to you are these structures?

Very. I used to begin by drawing and making notes. Now the physical act of sticking bits of wood together or fiddling about with pieces of wire seems to begin it all. It's all rather D.I.Y.

Is it necessary to see that piece of raw wood in *Lung*?

In a way I wanted the boat to look like a pulpit. The only way to do that was to show what supports it. Just a peek is enough. The man in the boat has a rather puritanical stance; perhaps it's his jersey… I was thinking of St Peter.

Jesus told the apostles that he would make them fishers of men. But there's a different verse in the Bible about asking for bread and being given a stone. Here a drowning man is pleading for an arm or a rope and is being offered a piano accordion instead. Isn't that a bit odd?

Not in the least. Every ship or pulpit should have one. They make terrible-sounding music and have to do with peanuts and monkeys. It seemed the perfect thing.

I suppose it would be pointless to ask if the man is going to be saved.

Of course.

In your work you have already dispensed with text and narrative. Will the titles be next to disappear?

I would hate to relinquish titles although they can be a nuisance. *Candyfloss* has had three other titles, previously it was called *Bully*.

Will you tell me the other two titles?

No.

Evidently the floss is under attack.

Candyfloss is susceptible most of all to moisture – water dissolves it instantly. This engineer's vice was the driest object I could find – having taken a bite it heads off across the rubber (itself rather parched looking).

The colour of the candyfloss is the colour of prawns.

Or lung tissue, which is also not too keen on water.

More lungs. You are obsessed with breathing. The accordion is a wind machine, candyfloss looks like lungs… In *Nemesis* an underground figure is connected to the surface by a tube and an inflatable bladder.

He's inflating it to burst the house.

These could just be formal issues of hardness and softness. But it has a stronger hold on you that that. There is a preoccupation with substance and unsubstantiality: the vice and the candyfloss. There is a need to establish total weight and there is an equal and opposite sensitivity to empty space, thin air.

For my film *Scenes and Songs* I've devised a series of short episodes accompanied by specially written songs.

Spectacular tableaux.

Precisely. In one of them there's a farmer rolling eggs gently over the edge of the world. As they fall they hit a sort of astronomical aerial, break and dribble through in slow motion. So you have the top half of the frame as a domestic farming scene and in the bottom half D.I.Y. solar flares against a backdrop of distant galaxies.

So weightlessness features in the film.

In another sequence a woman resembling Princess Michael of Kent slowly launches melons and cucumbers into space. The picture turns upside-down and they come twisting past like satellites.

At the furthest extreme from fruit in a state of weightlessness would be an elephant. Elephants recur throughout your work don't they?

And rightly so. Elephants are an ancient form of life, credited with great wisdom, and now an endangered species.

How is the carpet kept off the ground in *Icarus*?

Elephant breath.

Like a hovercraft.

Yes.

Fish occur a lot too. Why do they interest you?

Fish come from a world we can't enter or comprehend without special apparatus strapped on. They are among the most ancient and successful forms of life.

Do you think they'll outlive us?

Certainly, unless we wreck the planet first.

So you are depicting a dying breed and a shoal of survivors. As your work becomes more generalised, more representative, its overriding theme seems to be how to stay alive.

Cockroaches are extremely successful. They adapt fast. They live in television sets eating the insulation. The shop where I buy fish has weighing scales with an illuminated dial. Recently I noticed the dial seething with tiny cockroaches. It had become a cockroach incubator.

Have you made any work about cockroaches?

Not yet.

Do you think you might?

I'm waiting for the fish shop to produce enough to form a choir.

It's all getting very elemental – earth, space, human beings...

When things get worse people return to basics.

You seem to regard the life we lead as very fragile.

Things seem to become more precarious – too many people, technology causing the world to teeter.

What are you doing about all this?

Staying at home and fiddling about.

What you do is a kind of cottage industry. It's about baths and telephones, eggs and fruit and carpets – household objects rearranged.

It's about things you can do yourself.

You seem to be constructing an entire universe and dividing it into an above and below...

Places other than where we are at the moment.

Like somebody in his own private world.

I like to be able to see both sides of something at the same time. If you can't do it in real life you can do it in fantasy – be omniscient, see round corners.

If you're all-seeing, why don't you understand what your work is about?

A tricky question. I live in hope.

Boyd Webb: Tableaux

Catalogue essay published by the Robert Self Gallery, London, 1980

Tableaux marks a new stage in Boyd Webb's art of captioned photographs. Greater use is made of the single image, texts have dwindled to lapidary titles, snapshot realism has given way to shaped frames, exaggerated perspectives and high colour. Above all, the poses are denser and the humour more disturbing. Despite the abandonment of verbal narrative, his preoccupations, essentially moral, remain those of the novelist.

Webb describes the collection as 'a series of lame but colourful cartoons, combining the concerns of the Victorian genre painter and the technique of the mail-order catalogue photographer'. Whereas the advertising artist aims for instantly legible images, the Victorian painter, producing a hybrid of art and fiction, throws his audience into the middle of a plot and forces them to guess the rest from evidence at hand. Victorians rejoiced in the knowledge that time would reveal some degree of closure in their plots. Boyd Webb, as different from his ancestors as Beckett is from Dickens, plans an intricate series of lost connections. Why is the man in the pinstripe suit ignoring the woman? Is he trying to sell her a pair of shoes? Is she dead or could it be a case of 'prehensile torpor'? What about the plant she is trying to grab? Sensible people, the Victorians. They wanted to be sure that mysteries would be solved, loose ends tied up. We laugh at their silly ideas. Then Boyd Webb launches his private attack on 'sense' and in turn we are left like whiskered fuddy-duddies while he has the last laugh.

Rational thought fares badly in his work. Dignified but ineffectual, that wordsmith would fail to decode a living hieroglyph like the girl with the broken

arm. The argument about elephants should have some simple solution, but it has scarcely begun. Sometimes the forces opposing logic resemble those long words which 'explain everything' and dominate our lives. (What *is* an equator? Or for that matter what on earth is prehensile torpor?) Human nature itself is a similar giant force, hindering the scientific study of microbes and causing duels to the death over dinner tables.

The structure of each work suggests why logic fails. 'Cipher' is inconceivable without 'Decipher' and *vice versa*: critics and artists define each other. Yet the two figures are so obviously opposed. Mutually unaware, they sit in different ways, use different languages, the first social and communicative, the second introverted and private. Definition and dedefinition go hand in hand, each simultaneously justifying and negating the other. The only place for opposites to exist together is in a work of art, cradled by the artificial equilibrium it creates. Common sense tells us that permanent mid-points, like equators, are imaginary. Art has the conventions to assert otherwise. Unlike daily life, where events rush on towards a climax, art's power of reconciliation provides the invisible yoke that connects 'cipher' and 'decipher'. These photographs suggest a constant undercurrent of ritual patterns which human beings choose to ignore. Like a heraldic device, the pair of knotted worms proclaims the battle below, in which heads and tails are indistinguishable.

In these photographs truth is hard to locate. In that agonising interval when the pistol jams, why does neither aggrieved party admit the revelation that may be waiting below the tablecloth, at a point equidistant from both? (And why is that handkerchief on the tug-of-war rope shaped so oddly?) A trained eye could tell which is a worm's head and which its tail. It might even tell which worm is which. Why, then, do different opinions exist on the subject of elephants' trunks? Only the scholar with his map of Jerusalem, in a photograph which recalls a Kafka parable or Borges' account of the search of Averroes, hovers on the brink of discovery. The secret is above his head and under his very nose, not, perhaps on the document itself but in the mystical relationship between the hovering map and its celestial counterpart, between palmistry and geography, or simply in his recognition of the significance of the task which faces him, the recovery of some lapsed form of arcane knowledge. In terms of history, the importance of the 'tracing' is undoubted. Once more a process of research is the theme of the work, a metaphor for our own investigation.

Webb's manic dualism forces us to acknowledge that if comparison and contrast are basic artistic devices, they are also elements of a learning process.

The chiropodist has combined art and education. He may be unorthodox but he enjoys his work. Traditionally, he should see the world in terms of feet, but by a clever reversal it is the spectator who is forced into this position, left to guess where the chiropodist's preferences lie. If he really is a chiropodist – and there is no proof that he is – then he seems something of a sham, an amiable rogue. The strong partiality for tricksters of all sorts in Webb's earlier photographs was simple observation; cheats are universally revered as the lateral thinkers of society. The chiropodist seems in some mysterious way to be practising a new anti-science which these tableaux encourage in us. There is no shortage of logic in them but rather a surplus, applied in ways contorted to correct our vision of the world.

Thinking about these photographs, one is gradually overcome by the feeling they generate, of being introduced suddenly into the middle of a novel, of sensing some deep underpinning in this unfamiliar world, of being forced towards conclusions by pressures one barely understands, with tableaux providing brief halts in the plot.'TABLEAU: A group of persons and accessories, producing a picturesque effect. Used elliptically to express the sudden creation of a striking or dramatic situation, a "scene" which is left to the reader to imagine.' Turning from my dictionary, I see a man setting fire to my trousers.

The Burgeoning Paradigm: Glen Baxter's Drawings 1970-80

Published in Artscribe *27, February 1981*

A young man leans forward in his basket-chair, looking attentively from the other side of the Edwardian study as his friend peruses a letter. Neither seems to notice a snowdrift half filling the room, blown in through the open door. Just over the threshold is a lanky boy, too old to be wearing short trousers. A black cone, tied with string around the back of his head, conceals his nose and mouth. He waits for an answer while the recipient reads his letter aloud. 'It says we are about to become the subject of one of Baxter's ghastly drawings…'

The Importance of being Earnest

As an artist with his own 'world' Glen Baxter runs the risk of sprouting a personalised adjective. It will be a tricky business. 'Baxterish' is a type of Polish soup. The baxterian was a 17th-century Flemish instrument distantly related to the hurdy-gurdy. 'Baxteresque' a collage of 'Bakst berserk backstage', suggests tantrums behind the scenes at the Ballets Russes. It will have to be 'Baxterly' and that's that. Snoods are Baxterly. So are wimples and jodhpurs. Cowboys, Zulus, public schoolboys (and girls) and Robin Hood are also on the list, as well as people sporting false noses, false beards, false fingers and tails. Most Baxterly of all is the drawing style, filched from advertisements, the *Boys Own Paper* and children's books of the thirties.

Baxter succeeds in being Baxterly. Let's not argue about that. How his Baxterliness relates to everyday experience is more debatable. When critics agree that Baxter is eccentric they imply that his work is equally peripheral, deserving a glance, a titter and a dismissal. But eccentricity implies a dandyism from which

he is exempt. In a recent interview he was untypically outspoken on the subject of madness: 'Let me say here and now that I wish to dissociate myself from the insane ... Unlike the surrealists I am not interested in the language of the insane as a form of poetic inspiration.'[1] While insanity is often evidenced by a surplus of logical thought, the main object of Baxter's attention is common sense. Perhaps the sketches are not self-indulgent ramblings. Perhaps Glen Baxter is an artist after all, with a plan of campaign.

The difference between Baxter's collections *The Falls Tracer* (1970) and *Atlas* (1980) is easily stated; the characteristics of French Surrealist prose poetry were not abandoned but gradually changed as effects became less brittle, the humour more nearly aligned with English taste. Still using the same weapon, Baxter was moving closer to his target. It is surprising that he has not been hailed as a socialist artist; his aim is to undermine 'common sense', the unexamined philosophic doctrine of the middle class. A vicious thug forces his victim's body under water, leering horribly. 'The head librarian had a way with fine-dodgers' is a contribution to those conversations so frequent among the elderly, in which participants vie with each other to devise the severest punishments for the most innocuous crimes. 'He took her in his arms and squeezed her goatee' shows that sexism is anathema to Baxter, who can even envisage a 'long and curious' relationship between a man and a boulder. He is sympathetic to persecuted minorities – 'I'm afraid it's grim news, Sandy – The vice-consul intends to ban the wearing of wimples after 7.15 p.m.' – and in 'Uncle Frank, are you awake?' explores the problem of incest with tact and intelligence. Yet he is neither a satirist nor a social realist; his chosen task is, however obliquely, to undermine the matter-of-fact.

Duchamp's belief that the act of viewing completed an art object is especially true of these drawings. Presented with a bewildering state of affairs, the ideal spectator, as Baxter admitted, 'must reinvent meaning'.[2] Though he stresses his literary affinities with the New York School poets, his artistic parallels belong less to the sixties than the seventies. Alan Sondheim's description of text 'as archaeon, locale; a set-up for investigation, a stasis ... in which this or that remained only as relics' covers a variety of narrative or 'story' artists making video, books, songs or photo-sequences.[3] Violently compressed, Baxter's texts and illustrations also emphasize time, the time taken to absorb and resolve them. The means by which the artist structures that time and those possibilities depends totally on the conventions he chooses to manipulate. Laurie Anderson borrows from popular song, Mac Adams from the thriller; only a few of the drawings in *Atlas* and *Craneirons of Botya* (1974) are uncaptioned. So Baxter's

main rhetorical devices apply to his words, his images or both, and are imported not from fiction but from poetry. The density of his constructions has less to do with suppression of narrative than with the replacements modern poets found for a logical 'spine'.

Seven Types of Ambiguity

Litotes or understatement, a particularly English figure of speech, embraces both verbal and visual elements. A young couple walking in the woods come across a massive pencil. ('"It is certainly a writing implement of some magnitude," opined Reginald.') Seething with rage, a man smashes plates of food and kicks them around the room ('It was known that he expressed a certain abhorrence for vegetarian cuisine...') or punches a vase and destroys it completely ('Mr Bottomley held very fixed ideas on interior design'). Someone tries to tie shoelaces as thick as ship's cable ('He appeared to be experiencing some difficulty with the new type of shoelace...'). Particularly evident in *Crancirons of Botya*, litotes involves lessening, so its use is dramatized by oversized objects.

Hyperbole, the opposite of litotes, sometimes takes the form of a tall story ('Jedson was known for his withering sidelong glances'). 'In every room the ashtrays were completely filled' is similar, though of course it is just possible that a pile of cigarette ash could reach a height of six feet. In both cases the drawing shifts the text into higher gear. ' "I make a living peddling dandruff," snorted the old-timer' constitutes another type of exaggeration, more closely connected with narrative. (Compare 'There was no doubt about it – his nose had been stolen', a homage to Gogol.)

Anachronism, the confusion of different time schemes, is used more sparingly. One Cavalier addresses another. ('He spoke fervently of his vision of a chain of multi-level pancake houses in every major city in the Netherlands...') A medieval figure looks out of a castle window. ('Canst thou not see it, my liege? 'Tis but three blocks north of the delicatessen.') Robin Hood admires a modern television set, a lumberjack confronts a Roman courtier (' "*This* is what I think of your wallpaper designs," croaked Mr Latimer'), a housewife from Lima dresses as a Viking, and in a stylistic variation Baxter borrows two figures from Maurice Sendak ('Alec sensed that somehow life was passing him by') and redraws Hockney's drawing of Picasso.

Colliding and mingling with litotes is a structure which can be recognised by absence of information. Suppressed narrative may involve a secret kept from characters within the drawing. For example, one schoolboy conceals from

another a table, an Oriental jar, two pellets and a repulsive little animal. (' "What have you done with my sister?" snapped Toby.') At other times something is quite literally hidden from us. With a pained expression a prim schoolgirl rises slightly from her chair and puts one hand beneath her to remove an unseen object. ('It seemed Clarissa had located the missing Bratwurst.') Suppressed narrative forces the viewer into the future as well as thrusting him into the past. A discontented band of sailors waits on deck. Facing them is a younger man, hands on hips. Protruding from the back of his blazer is a small bushy tail. (' "I suppose you're all wondering why I gathered you here today," whispered the bosun.') In all of these drawings the absent object increases the humour.

Sometimes it seems that an image has inspired such a multiplicity of interpretation that any caption can only represent one choice among many. The picture of a smiling man lifting the receiver of a telephone is called ' "I would like to commence by eating this," chortled Nigel', while a drawing of a woman clutching a banister from beneath is accompanied by the line 'It was the third banister she had stolen that evening'. There is an air of chance here. The enjoyment lies in the apparently improvised way the titles are added, like the laugh we get from the *Punch* competitions which invite readers to supply new captions for existing cartoons.

Meaning is conferred on groups of drawings by giving them a general title: 'Fruits of the World in Danger', 'New Ways with Vegetables', 'Great Failures of our Time', 'Great Culinary Disasters of our Time', 'The Handy Guide to Amazing People' and 'The Agnes Bolt Bedside Companion'. As his erratic numbering suggests, these are never grouped sequentially, a feature which distinguishes Baxter from many 'narrative' artists. Like Bill Beckley, William Wiley or Duane Michals in his Cavafy illustrations, he sets up tensions between text and imagery only.

Out of the porthole of a Jules Verne bathysphere two men watch the churning waters. ' "But I ordered the Chicken Kiev…" blurted Cooper.' *Non sequitur*, or violent disjunction between the words and pictures, is a common device. Two cowboys are conducting a conversation on a country road, oblivious to a careless motorcyclist heading towards them. '"But surely, language is not defined for us as an arrangement fulfilling a definite purpose," stammered Jed.' The latest work pushes this division further than ever – away from humour and towards obscurity. In 'Days came and went – anxious days in which Winifred never mentioned her incredible expedition to see the general' neither Winifred nor the

general is seen. 'The driver grinned at the obvious twinkle' in which a young woman shows an old lady a cutting from an album also releases the connections between the caption and image in order, it seems, to assert the independence of titling, a feature of Victorian cartoons, in which settings, stage directions and lengthy exchanges reduced the pictorial component to the status of a mere illustration.

Despite recurrent rhetorical structures, however, it is true to say that in the drawings everything aspires to the condition of plain statement, though examples of this – 'It was an immense parcel of ears', is one – fall into none of the six categories outlined above. Not surprisingly, Baxter has compiled little books of 'strange but true' (fictional) facts – 'Rodney Smeete of Otley has been known to smother his left leg in mustard rather than speak to his older brother' – has designed a cover for an imaginary magazine called *Weird Beekeeping Tales* in which a walking hive lumbers down a crazy-paving path and one for *Amazing Tales* in which a figure in primitive diving apparatus tosses a pancake underwater. Demonstration or ritual display heightens the sheer wonder of the obvious, as in 'The twins introduced the impostor' or 'D'Arcy had taken to startling members of the lower school with his modified loafers'. The excitement of possible revelation seldom disappoints. Eavesdroppers appear in 'It was clearly the Belgian who was tampering with the pilchards', 'Robin had an idea that something was "going on" at number 26' and ' "There's only one way to eat whelks," hissed Greig'.

His seven main techniques are ways of producing desired effects – of disturbance, disjuncture, anarchy. 'Quite early on,' Baxter has said, 'my aesthetic was formed in part by a reading of Roger Shattuck's *The Banquet Years*.'[4] Among the arguments from the book which he quotes with approval is Shattuck's defence of ambiguity. Of course, he writes, for centuries clarity was one of the ultimate artistic virtues:

Yet there are subjects about which one cannot be clear without fraud. Every emotion and conviction has its reverse side, and ambiguity can stand for a profound frankness, an acknowledgement of the essential ambivalence of truth and experience, of life itself. Striving to apply a rigorous and simultaneous attention to several meanings, ambiguity aims beyond vagueness at inclusiveness for which the only other method is monumental size. In accomplishing a great economy of exposition, ambiguity parallels the process of 'dream work' as Freud called it, and of wit and humour.[5]

True Grit

An eavesdropper himself, the viewer is baffled by the style of the drawings. The impression that they might be copied from other sources, like the idea of an exhibition of books by Baxter's namesakes, supports their odd status as bogus 'found objects', dated and apparently naive, like archaeological fragments. 'I'm attracted by Jarry's theories of poetic interpretation,' Baxter has said, 'Each level of meaning is as valid as the next.' The evacuated style of the drawings suggests indefinable loss brought about by processes of translation. And the mental operations of the interpreter are a constant thematic preoccupation. Voyagers catch sight of distant objects ('They were just able to make out the lonely figure of the chiropodist'), a boy in a trenchcoat with a magnifying glass on his head hunts in vain for an object or an idea (*The Burgeoning Paradigm*) and incomprehensible machines are identified ('It was clearly a primitive device for shredding beetroot'). For Baxter sight alone provides unreliable clues for such detectives.

A hunter sits writing at a camp table as a native figure runs excitedly towards his veranda, waving a photograph. 'I'll never forget the day M'blawi stumbled on the work of the Post-Impressionists…' is not a piece of Eliotean snobbery ('Hakagawa bowing among the Titians') but a token of surprise at M'blawi's cultural sympathies. Is it the result of an accident, as with N'boto, who has a perfect street-map of Dundee tattooed on the palm of his hand? Or is he reacting to a decontextualized snippet from some alien, misunderstood world order? ('He subjected us to excruciating impersonations of Cathy McGowan…'). 'With Colonel Baxter in the foothills' from *Atlas* owes very little to Margaret Mead but a great deal to Raymond Roussel. A later cartoon 'Young Rosenberg had perfected a method of coating shoelaces with two thin layers of unsalted butter' recalls the African chief in *Impressions of Africa* who dresses in drag and sings opera for his surprised guests. Roussel's logical but arbitrary association of pairs of words, the method explained in *How I Wrote Some of My Books*, has no direct parallel in Baxter, whose approach is less systematic. Asked why he read books on geology, Baxter answered 'I don't know very much about it but it's fascinating to hear people talk about a subject in such great depth. Completely baffling to me. But it's wonderful. You don't have to know what's going on. At least I don't think you do.'

Though the truth is paraded before us constantly in Baxter, we are continually reduced to the position of the boy in the trenchcoat looking for a direction he is too close to perceive or the African chief wearing a red dress and

pretending to be an opera singer. The temptation of aestheticism is powerful; it consists of cultivating the art of getting lost. Butor wrote of 'reading' a city, Benjamin of the pleasures of getting lost in them. Similarly, Butor ordered 'novels' and Benjamin organised his book collection to simulate this experience of directionlessness, a point of utter chaos in which the mind, overwhelmed, gives up hope of applying existing systems of perception, and may naturally form some new ordering apparatus, the 'burgeoning paradigm' itself.

In terms of art, the paradigm which may or may not burgeon concerns the quality which permits an artwork to convey meaning. Two variations on Wittgenstein provide a vocabulary. ' "If a fact is to be a picture it must have something in common with what it depicts," mused Threeves' and ' "So you see, boys – What a picture must have in common with reality in order to be able to depict it – correctly or incorrectly – in the way it does, is its pictorial form," explained Tex' both involve discussion of abstract works. The picture Threeves finds unsatisfactory consists of an all-over structure of dots and lines, having something in common with his friend's pyjamas. Tex's painting contains two interlocking rectangles placed diagonally to the real frame. Pictures must depict, runs the argument. To do this they must have something in common with that which is depicted. That 'something' is pictorial form. It follows, then, that if pictorial form is an intermediary and the form imitates the shape of the frame – as it comes in 'It was Tom's first brush with modernism' – that the argument is heading towards a cul-de-sac. Everything hints at Baxter's lack of confidence in Modernist conventions as formulated by sixties Greenbergian formalism. The imposition of edges on limitless disorder or the mimicry of the edge of the frame in the internal motifs of a painting both have serious implications if viewed in terms of Baxterly 'lostness'; they are ways of telling lies.

Yet perhaps this is exaggeration. 'The two men were in agreement – It was a work of some merit', in which two rotund critics study a painting which contains one dot, finally seems less satirical than uncomprehending; accepting conventions has sharpened the men's judgement but narrowed their point of view. Like the boy in the trenchcoat they keep their eyes fixed on what they choose to see. 'Phyllis realised almost instinctively that it was just a piece of paper' shows the only possible reaction when no conventions apply. The message is no more than the illusion of having received a message, and though the act of using one's instincts to see that paper exists in another context does constitute a minor triumph, the zero degree of depiction in which 'fact' and 'picture' become fused is insignificant.

Or is it? The ideal of 'facts' and 'pictures' combining, a dream of truth, takes its strangest form in the most recent paintings. In the drawings a fondness for raw matter – cork, sago, suet, loam, hair, khaki, welded steel – leads to a kind of visual pun. Like Rossetti, who collected what he called 'stunners', words so remarkable he felt they must be included in his poems, Baxter has his favourite substances, as lovingly named as they are cavalierly drawn. Indeed, his renderings of exploding lasagne or flying kale are so free that without a text the viewer would be at a loss to identify them. Amid the products of a technique in which a horse is meant to look like a horse the stunners defy convenient visual representation. They are even interchangeable. In one a giant ball of suet looks like a boulder. In another a beard is made of cork.

Stunners also appeal on an aural level. Asked about the word 'pumice' Baxter said 'I like the sound of the word very much. I like the physicality of the word.' His latest paintings include an interior made entirely of a substance we assume to be pumice because of the title. Adopting a Duchampian premise, Baxter can assert 'It is pumice if I say it is.' It almost seems that after ten years of pondering the nature of artistic convention and sabotaging it by ambiguity, Baxter has now accepted a single, arbitrary convention in order to exchange one kind of obliquity for another. It is more probable that by situating his stunners at an interface between aural, physical and pictorial modes of existence, he is beginning another cycle of work with as yet unforeseeable consequences. In his own words, 'I like to make paintings about things that have not been too heavily painted in the past and to my knowledge there's not a school of pumice painting... I feel I can work with ease in that area.'

1. Paul Hammond 'Conversations with Baxter' *Poetry Information* 20/21, Winter 1979-80, p.82.
2. This and subsequent quotations are from a conversation with the author, 5 December 1980.
3. Alan Sondheim 'Give me an N', *American Narrative/Story Art,* Houston, Texas: Contemporary Arts Museum 1978, p.8.
4. Private correspondence with the author, 12 December 1980.
5. Roger Shattuck *The Banquet Years,* London: Faber 1959, p. 30.

Marc Camille Chaimowicz: Design for Living

Published in Past Imperfect: Marc Camille Chaimowicz 1972-82, *1983*
(Bluecoat Gallery Liverpool, John Hansard Gallery, Southampton,
Orchard Gallery, Derry)

It is both apt and misguided to attempt a restoration of works by Marc Camille
Chaimowicz. His is a poetic of loss, of ontological incompleteness accepted
without demur. Above all, in bringing his activity to a stage of even *mental*
completion commentators may be doing it a disservice by neglecting to keep
in mind its very strangeness. A better term may be 'otherness'. 'Strangeness,'
writes Geoffrey Hartman, 'involves a sense that the strange is really the
familiar, estranged; otherness (alterity) precludes any assumption about this
matter, or it demands of understanding an extraordinary, even self-absorbing
effort.' [1] Too exaggerated a claim for the artist who once welcomed viewers
into an installation by chatting to them and making them cups of tea? I think
not. Accustomed to employing a more or less disciplined mixture of empathy
and exegesis, critics have served Chaimowicz poorly. One reason may be that
his mental operations already incorporate that critical act they feel is theirs by
right; within his own thinking is subsumed a subtlety of approach to the
problem of 'self' and 'other' that remystifies their detective-work, an aesthetic
so unorthodox that their very terminology – 'art', 'artwork', 'artist' – must be
consigned to parentheses. Chaimowicz has defended his own experimental
approach: 'All one can do in 1983 is to attempt to make art rather than making
art.' And, 'Making art itself isn't that interesting.' [2] Could it be that no critical
method – only a sketch for a critical method – can cope with an aesthetic so
decidedly 'other'? At the outset no system is needed; texts contain the seeds
of their own interpretation. It is necessary only to watch, feel, notice and
unlearn.

Unlearn first the idea of 'artist'. Chaimowicz frequently portrays himself going about activities that make up his daily life. They are rituals which occupy him without preoccupying him, chores which scarcely constitute acts of work – indeed, they may serve to conceal indolence. Are we most or least ourselves when absorbed in this way? The coloured video section of *Doubts...*, photographs from the Approach Road period which crop up again and again later, the final slide of *Fade* all show Chaimowicz in a domestic environment filled with his creations. At the same time that environment serves as a source for other works. Before long we are forced to abandon not only the accepted idea of an artist but also of artworks as closed, delimited occurrences. Not only is Chaimowicz attracted to time-based activities but he also permits one stage of his career to overlap another, so much so that it may be more convenient to deal with his oeuvre as a continuing text rather than a series of separate 'pieces'.

Once recurrences are taken into account, certain types of interpretation are seen to be more relevant than others. Consider a single prop: the fox-fur. As featured in *Table Tableau* it might be read as a second skin, the strangely luxurious pelt left after a flaying which may already have taken place. (It relates to the wound on the protagonist's back – visible to us but not, perhaps, to him.) What, then, of the fox-fur in *Walking the Circle*, isolated in a spotlight? Or the one in *We Chose Our Words With Care...* thrown across the stepped structure? A *memento mori*? A hunting trophy? The skin of a dead animal? An elegant, if outdated token of womanhood, half garment, half ornament? Eroticism and death must enter any reading of the fur. Yet a major part of what it means must be that it is one of his belongings, will survive temporary arrangements and be inflected with specific emotions while retaining its status as a single item among a stock of images. His juxtaposition of specific and general is frequently unorthodox. Two realms – public and private – are brought together. The idea of the elevated existence of an 'artist' in opposition to the daily life of the 'ordinary' person is so powerfully challenged by Chaimowicz that it cannot be understood as anything but a political act. Lying on a bed or writing a letter are quotidian. So, it is suggested, is the act of creation itself. Possibly that act consists simply of regarding day-to-day existence differently.

Unlearn 'art'. Unlearn 'artwork'. Unlearn 'closure'. Unlearn 'public' and 'private'. Finally unlearn 'man'. Decoration, the use of cosmetics, most of all an insistence on abandoning machismo as a mode of artistic behaviour, have served to make his desire for universality even more evident. Chaimowicz performs striking sexual deconstructions. In *Fade*, as two figures disappear behind an

illuminated scrim which has concealed a redrawn Cocteau *Annunciation*, the alternative to human orgasm evident in the idea of heavenly impregnation is brought into conjunction with an implied earthly intercourse between two men. The effect is to lend their meeting an air of that transfiguration which is fictionalised in religion but made available to the faithless by the power of art. The possibility of a fusion of identities, however temporary, in an implied sexual union can only be translated into other images of ideal, near impossible marriage. In *Partial Eclipse* there is a sheer glut of images.

> There's such a density of information that it's impossible to grasp it … to hang on to it for any length of time. So what happens for me in that piece given that I'm curiously within and outside the work anyway is that – as with music – one tends to happily lose it and then to refind it elsewhere. [2]

The ambiguity of the number of characters involved and the prospect that the single, main figure – spoken by a woman, embodied by a man – has brought them all into being presents another association of sexual desire with artistic creation. Linkages of this kind are far more than confusions for effect. One of the things Chaimowicz has achieved in these cases, though by no means the only thing, is to align traditional male and female roles in some common middle ground. For him this has led to the abandonment of autobiography; that 'private' world he wishes to discuss has altogether different uses. His abstract design – patterns on fabric, on wallpaper, on screens, in the borders of the pages of his book *Café du Rêve* – suggest the kind of anonymity he strives for. In unlearning 'man' he has learned 'Man'.

Like Warhol, whom he respects, his is an art of context. So although a retrospective anthology of images and comment is one way of restoring Chaimowicz, it is faulty. Words are limited. Sequential, imprecise, they belie simultaneity of perception, subtlety or specificity of emotion. And photography, as Chaimowicz himself remarks in a footnote to *Café du Rêve*, is unable to record certain sensations which seem eminently photographable. Nor can feelings be captured which are apparently very precise. The danger is of restoring the picture badly – of describing a man in a room, rather than a certain man in a special room.

Je suis fait de la matière de mes rêves.
– Gaston Bachelard

A man is standing in an interior, facing a window and looking into space. His photograph intrigues me without satisfying my curiosity. The face lacks expression; if he is thinking deep thoughts there is no way of guessing what they might be. One temptation is to accept the emotional emptiness of the picture not as a property but somehow as an achieved effect, to be fooled into supposing that since his photograph is vacant he is *being* vacant. That would work better if he had adopted a recognisable pose. As it is, he has been taken unawares. Accustomed to another presence in the room he has turned his back and allowed his own thoughts free play. He could have been standing there for a few seconds or a few minutes. Even an hour. For the Romantics, windows symbolised longing, promised access to other worlds. But in this case no grandiose interpretation is necessary. This fellow does not want to be elsewhere – he *is* elsewhere. if he heard the shutter click he ignored it, lost in a world of his own.

Marc Camille Chaimowicz uses the image repeatedly. Perhaps he intends it as a signature or a self-portrait: *The Artist at Home*. Surroundings mean a lot to him.

> He had decorated it to his taste and attempted to keep it tidy, to wash the windows regularly, to water the plants, to house clean… Keeping the curtains closed it was here that he could shelter from the external world, it was here within this privacy that he gathered energy for his spirit and reacquired contact with his self.[3]

Is this what he means by making contact with the self? In reverie the mind drifts, distinctions between past, present and future are lost and an illogical part of the brain takes over, making collages of its own, dwelling on details, elaborating memories, never finishing a thought or reaching a goal. It is like consenting to be lost. 'Not to find one's way about a city is of little interest, but to lose one's way in a city, as one loses one's way in a forest, requires practice,' wrote Walter Benjamin. Reverie: willing abandonment of the mind to the unplanned. The condition is not self-sustaining. As a seagull hovering almost motionless shifts its wings infinitesimally from time to time to remain in position, the mind makes adjustments of its own to stay on automatic pilot. Why show the interior of the room at all? Because it may have promoted this state in the first place. Thought, memory, hopes, desires all change perception of time and space. The opposite is true too. We cannot guess it and he no longer cares about it, but Chaimowicz is interacting not only with his 'self' but also with his surroundings. Home, his home, designed by the artist himself, gives him that sensual well-being which

Matisse painted and Bachelard explored in his rhapsodies on the remembrance of space lost and its intuitive recapture. *Artist at Home?* I think not. The title should be *Artist at Work.*

> May not the prime motive of any work be the wish to give rise to discussion, if only between the mind and itself?
> – Valéry

Talking about his early paintings Chaimowicz described them as 'a cross between Jasper Johns and Arshile Gorky'. The sensitivity and will to privacy in Gorky are only now being explored. [4] They testify to a vulnerable, loving painter – who else but Gorky would call a picture *Hugging*? – whose works often provide stimulus to daydream and the spatio-temporal distortions it entails. Johns makes paintings that must be looked through rather than at, each taking its place in a progression of overlaps and repetitions as well as reflecting time in a more local way: the record on the surface of the canvas itself of the process of making. The relevance of both men to Chaimowicz's later thought is undoubted. No one could have summarised more crisply than Georges Poulet the dual condition of what for Chaimowicz has come to be a satisfactory 'work of art'. in his preface to Jean-Pierre Richard's *Littérature et sensation* he defines literature as 'an imaginary world' and 'a thought'. [5] Transposed, art would be an imaginary world and an act of sight, or perhaps a visual thought. For Chaimowicz, whose creation lies in critical self-examination and for whom a 'self' (or indeed a work of art) is constituted in an intersubjective relationship between inner and outer, author and viewer, the imagined environment and the conditions of perception of that 'world', no more convenient definition could be found. His preoccupation with rooms should make that plain.

His early rooms take discontinuity as a norm; he 'drifts' between separate fragments. For *Enough Tyranny* in 1972 he had wandered through the streets collecting objects he found – a beach ball, a cube of metal, a shattered mirror, a candle, a block of wood, ladies' underwear, blossom, a red hat on a stand – and allowed them to take their place alongside less seedy, luxury items: a fountain with Japanese carp, a hired television. 'I was trying to touch the threshold at which one could trust one's own subjectivity.' Also included were barbed wire, broken glass, graffiti. At these points, it could be argued that he overstepped the threshold. In essence the installation was similar to *Celebration? Realife* of the same year. While *Enough Tyranny* brought some of the ambience of street life into the gallery space,

Celebration? Realife became a refuge, a place to read, rest, socialise, restore the spirits and have fun – in short, a cross between a church and a family home. By 1974, of course, with the move to Approach Road the idea of 'home' was dominant. Yet the priority of the domestic lasted only five years.

> His search ... for a particular perfection was becoming stifling, constrictive ... a feeling deliciously close to a state of entombment ... and his foray outside of that condition held an immediacy tantamount to that of a reprieve.[6]

Metaphors of breathlessness, strangulation, of a grave or a convict's cell describe the effect of the aestheticised interior taken to excess. (Interestingly, it was Adolf Loos, later a strong influence on Chaimowicz, who regarded tombs as the point at which architecture connected perfectly with sculpture.) Ironically, the sense of threat Chaimowicz claims to have felt was due to the very success of the project – making an acceptable, potentially happy place to occupy in close proximity to his work. The single adverb 'deliciously' betrays almost breathless excitement at the prospect of self-annihilation, perhaps because of the prospect of a job well done (in his own strange terms); perhaps, in a more sinister way, from a masochistic urge to kill the ego by affirmation. From 1979 onwards he would embark on a set of tests in the form of journeys, adventures of the self.

The idea that the interior manipulated space or 'home' may become so precious that the violation of it will 'unhouse' him in an emotional sense crops up midway through the Approach Road period in *Dream: an anecdote*. The destruction of his living quarters disturbs his entire prospect of communicating with other people. In the early environments outsiders are brought into contact with the artist's self. If *Enough Tyranny* failed to make a political point it was because ideas of disorder – the visitors were permitted to alter the contents of the gallery – only impinged on Chaimowicz himself, not on the body politic. The tending of *Celebration? Realife* towards that 'housework' found so frequently in his art, confirms the direction taken by these early pieces. The initial move is to offer other people a place, then to allow that place to build gently into the presentation of an individual consciousness by a process of accretion; each component was arrived at by a meeting of self and other, a consciousness extending, delimiting and defining itself. The maintenance of the work, the slightly humorous attempt to offer the public the bare necessities for survival – tea, news, distraction, sensuous pleasure – looks forward to the later idea of the 'religion of

art'. Non-aristocratic, in touch with everyday needs and duties, the rooms put forward a democratic redefinition of 1890s Aestheticism. I exist, therefore I make art. The rooms are ivory towers brought down to earth.

Union with others, both a danger and a desirable aim in Chaimowicz, later takes the form of erotic attachment. He defines the self by specifying what it most lacks. *Table Tableau* gives voice to deprivation in terms of death. As Barthes observed, 'In any man who utters the other's absence something feminine is declared: this man who waits and who suffers from his waiting is miraculously feminised ... not feminised because he is inverted but because he is in love.'[7] In *We Chose Our Words...* the absent lover is evoked by the construction of an idealised, impossibly glamourised setting. Eroticism remembered slips into eroticism flourished as a hope for the future. Just as the title dwells tenderly on details that seem patently unrealistic, an excess of particulars in the installation itself forces the viewer into an elision. A summons in the past tense changes to an act of conjuration and the tense finally comes to rest as a conditional.

Absence is implicit in another characteristic experience – letting the mind play over the entire course of an affair. One of the four sections of *Café du Rêve* is devoted to such a reverie:

> It's in seven parts. The first is casual and carefree, as is usual. The second
> is lustful or irresponsible – besotted. The third is perhaps a condition
> nearing the sublime. The fourth is a kind of slowing down and for the first
> time an attempt at an assessment. The fifth is something close to happiness
> and totality and a sense of well-being. The sixth is decline and death. The
> seventh ... is the condition by which the others tend to be judged, and that
> is as an ideal.

In *Screens* the photographs of a couple together, seen from the vantage-point of a third person outside their happiness, could be regarded as either celebratory or vicarious, a love poem or a soliloquy on loneliness. While other kinds of mental operation focus on a particular time and space, these are essentially circular; the 'ideal' dominates over beginnings and endings, throwing a certain light over every other circumstance and condition, even 'death', by which he means the death of love. In *Partial Eclipse* for instance, a figure whose walking pattern enacts the cyclical structure of the whole may imagine the other two characters. ('I think we have one character really, and the others are fabrications.') Here Chaimowicz comes closest to creating visual corollaries for bliss. Discussing the page of *Liaison*

which corresponds to the seventh state, Chaimowicz dealt with the problem in this way:

> In terms of the words it will be the most difficult page and I'm sure I'm not the only one to face that problem ... it's the most abstract and also the most elusive ... I'd really quite like to be able to use music ... There are moments in the photographic work I've done which could quite happily be appropriated ... I'm wondering whether in terms of certain layouts, certain pages, it might not be better to use pure, simple abstract design rather than something that is too open to literal interpretation ... The most obvious way for me to describe it would be to use certain flowers or plants as effective images of harmony because I see it as a condition that is so blissful that one has explicit trust in the other. I don't know that it's therefore wise to try to be too graphic. It's logical to try and go towards botanical gardens, the exotic, the hothouse climate which produces something closer to perfection than does the polluted climate that our cities now have.

Music, flowers, abstract design, religious terminology all suggest an other-worldly harmony, cultured, artificial even, but just attainable as a release from lack of dependence.

In many ways, Chaimowicz's concept of the self seems similar to Proust's. Sartre held that consciousness was a void except insofar as it could project itself into objects in the outside world. Proust too imagined the self as an 'empty apparatus':

> Now, since the self is constantly thinking numerous things, since it is nothing more than the thoughts of these things, when by chance, instead of having them as the objects of its attention, it suddenly turns its thought upon itself, it finds only an empty apparatus, something unfamiliar, to which – in order to give it some reality – it adds the memory of a face seen in a mirror. [8]

Yet it has to be added that in writing his *Remembrance of Things Past* he succeeded in filling the void of his consciousness with a self that he could possess permanently. Soon after the passage quoted above Proust's narrator finds fault with the male sex for rushing headlong into 'action' instead of opting for the path of 'knowledge':

Just as, throughout the whole course of our life, our egoism sees before it all
the time the objects that are of interest to ourselves, but never takes in that
Ego itself which is incessantly observing them, so the desire which directs
our actions descends towards them, but does not reascend to itself, whether
because, being unduly utilitarian, it plunges into the action and disdains all
knowledge of it, or because we have been looking to the future to compensate
for the disappointments of the past, or because the inertia of our mind urges
it down the easy slope of imagination, rather than make it reascend the steep
slope of introspection. [9]

In writing he chose the latter course, built up a self by trying to be free of the
external world. His own progress through his novel is to move gradually forward
towards the future, looking behind him at every step of the way. Those *moments
bienheureux* which punctuate his life, small epiphanies by which he comprehends
time and his own mental workings, were finally of no assistance. [10] Only self-
recognition depending on acceptance of time as a shaping influence could mark
the end of his search. The *moments bienheureux* are paralleled in Chaimowicz by
attempts to double back and stop time: *Table Tableau* and *We Chose Our Words
With Care...* would be examples. But acceptance of time's regular flow has always
been problematic for him. (Perhaps that explains the small vocabulary of near-
oriental gestures in a work such as *Doubts...*) In *Partial Eclipse* the cyclical nature
of the structure maintains the daydream at the expense of flux. The high incidence
of repeated patterning in Chaimowicz's design may support the same argument.
What are the signs, then, that he may be moving towards self-recognition and of
what might that self-recognition consist?

Throughout Chaimowicz a single pattern predominates: the self requires
validation and the support that love can offer. Realising its isolation the singular
consciousness resorts to masking, fantasy or passive contemplation of the course
love must take – tactful, even reverential, yet receiving vicarious pleasure from a
togetherness that excludes outsiders and, in an even more unhealthy way,
satisfaction from the certainty that time triumphs over pleasure, that the initial
position of emptiness is realistic and defensible. At risk always is the individual
consciousness; falling in love with a couple or the idea of being included in some
way, the fantasy of being inside a closed relationship, and therefore a potentially
stifling one, without ever surrendering to it, is a temptation that can be resisted.

Yet to suggest that escape is proposed as an ideal would falsify the complexity
of Chaimowicz's position. At the same time as he recognises that the extremes of

isolation necessary for self-analysis are alien to his nature, his 'self' must be preserved from too much perfection and the consequent engulfment. The dilemma is explored in *Le Désert*, a chapter of *Café du Rêve* with a title borrowed from Albert Camus. Exotic yet arid, it is a wilderness in which the choice between boredom and temptation must be made. In contrast to *Le Parc*, in which a specific urban setting offers the protagonist consolation, the desert is less a physical space than a mental construct. To emphasise its boredom and sterility the same photograph, a found postcard of the Sahara, printed hard or soft, is used again and again, each time in the same position in the layout. Though it is associated with spiritual retirement it also provides an opportunity for what Chaimowicz calls 'wantonness'. Oscillation between the two states of mind distinguishes this chapter of the book. As if to compound the choice, two footnotes are included, one an acknowledgement to Camus, the other about Cardinal Hume, leader of the Catholic Church in England.

Hume reminds us that it is necessary to go into the desert from time to time. But as Camus shows in his essay of the same name 'The Desert' can be anywhere or nowhere. It is surprising that the essay is set in Italy, a place of natural beauty, fulfilled sensuality and a Mediterranean culture devoid of the starkness of the Algerian alternative he so respected. As night falls and he sits in the cloisters of Santissima Annunziata reading inscriptions to the dead he refuses to believe in sin and rejects eternal life in favour of greater intensity of feeling and the possibility of happiness.

The nearest approximation to a moral pattern it is possible to derive from Chaimowicz is a hedonism based on his having blurred the distinction between work and pleasure. The result is what Gide, quoted in *Le Désert*, describes as 'that leisure within which nothing can blossom – neither vice nor art.' At the climax of *his* essay Camus describes the control such a philosophy demands:

> If Rimbaud dies in Abyssinia without having written a single line, this is
> not only because he prefers adventure or has renounced literature. It is
> because that's how things are; and because when we reach a certain stage
> of awareness we finally acknowledge something which each of us,
> according to our particular vocation, seeks not to understand. This clearly
> involves undertaking the survey of a certain desert. But this strange desert
> is accessible only to those who can live there without ever slaking their
> thirst. Then, and only then, is it peopled with the living waters of
> happiness. [11]

Perhaps the recognition that Chaimowicz has been working towards lies exactly here: an acceptance of things as they are.

Wer jetzt kein Haus hat, baut sich keines mehr.
Wer jetzt allein ist, wird es lange bleiben,
wird wachen, lesen, lange Breife schreiben,
und wird in den Alleen hin und her
unruhig wandern, wenn die Blätter treiben.
– Rainer Maria Rilke [12]

Looking back at the photograph of Chaimowicz in his Approach Road interior, smoking a cigarette and looking blankly at the window it seems that he is not daydreaming at all – just thinking of nothing and existing. When asked about the plot of *Le Parc* he replied: 'For me what happens is someone understanding the value of something that is apparently hopeless … What happens is an awareness of certain underlying values which would ordinarily be seen as valueless. So for me it's a kind of optimism, a recovery over loss.'

The photograph looks more anonymous by the minute. It could be anyone at all. Just an ordinary person living through another day. Except that now there's something faintly heroic about it.

1. Geoffrey Hartman, *Criticism in the Wilderness,* New Haven: Yale University Press 1980, p.27.
2. Interview with Marc Camille Chaimowicz, 8th March 1983. Subsequent quotations are from this and other unpublished conversations.
3. Marc Camille Chaimowicz *Dream an anecdote,* London: Nigel Greenwood 1977, n.p.
4. [Editor's note: Stuart Morgan's essay 'Becoming Arshile Gorky' was published in *Artscribe* 31, October 1981]
5. Georges Poulet, Preface to Jean Pierre Richard *Littérature et sensation,* Paris: Seuil 1954, p.9.
6. Announcement for exhibition at Nigel Greenwood Gallery, 31 October- 24 November 1979.
7. Roland Barthes *A Lover's Discourse* tr. R. Howard, New York: Hill and Wang 1978, p.14.
8. Marcel Proust *A la recherche du temps perdu,* Paris: P. Clarac/A. Ferré 1954, 'La Fugitive' III, p.466.
9. Ibid. p. 465.
10. Not everyone would agree. See Roger Shattuck *Proust's Binoculars,* New York, Vintage 1967, p. 37.
11. P. Thody ed. *Albert Camus Selected Essays and Notebooks*, Harmondsworth: Penguin, 1979, p. 10.
12. Rainer Maria Rilke 'Autumn Day', Paris, 1902: 'Whoever has no house will not now build another. Whoever is alone will long remain so, will stay awake, read, write long letters, and wander restlessly to and fro along avenues as leaves blow about.'

Breaking the Contract:
a conversation with
Peter Greenaway

Published in Artforum, *November 1983*

Stuart Morgan: Is it true that the original version of your film *The Draughtsman's Contract* was over four hours long?
Peter Greenaway: Yes, a mass of stuff was cut from the present version having to do with symbolism, allegory, the relationship of people upstairs and downstairs, and the continuation of the living-statue conceit. (The statue had a wife and dog.) All the minor characters played the game of aping their masters. Maria, Mrs Herbed's servant, and Philip, Mr Neville's assistant, had sexual liaisons after dark in the garden in the same places that the drawings were made. Also, the mechanical manipulation of the drawings was shown stage by stage, as well as a scene where Porringer attacks Mr Neville in the garden, accusing him of various relations with his mistress.

So Philip knew, Maria knew…
Everybody was in on it. At one point Philip was going to be present, masked, at his master's death.

What happened after Neville died?
In the six years up to 1700 Mr Noyes married Mrs Herbert, of course, because that was preordained; the little boy died of scarlet fever; Mrs Talmann had an heir who would ultimately take over, and Mr Tallmann, being impotent, acquiesced. Philip became the new draughtsman and came back to redraw the house for van Hoyten after he had landscaped it in a Capability Brown, post-Repton manner.

So many possibilities exist.
Yes, it would be interesting to change things so that the elder not the younger

woman conceived. With his mother-in-law conceiving, Mr Talmann would not even become his illegitimate child's ward, and would lose any connection with the inheritance.

The Falls was both a summary of your work so far and a way of utilising remnants – pieces discarded from other films, fragments left unfinished, even home movies. It seems unlikely that the discarded 150 minutes of The Draughtsman's Contract will be neglected for long.

Since all my projects link together I'm very reluctant to leave things. One plan to refashion the unseen footage is a film called *The Hedgecutters*. In it Mr Porringer, the protagonist, is a 20th-century gardener to twelve country houses. He moves from estate to estate looking after pomegranates and cutting hedges. As a rainy summer wears on he is forced to take on extra help – a man called Clancy and another called Noyes. He dislikes both of them but sublimates this dislike into a time-slip, like the famous incident that transported two Victorian ladies back into the 17th century as they were walking through the grounds at Versailles. In the distance is a child on a swing, who becomes the child in *The Draughtsman's Contract*. Porringer sees a man drawing, who becomes Mr Neville. When he goes to be paid he finds the lady of the house being...

Offering Mr Neville unrestricted freedom of her most intimate hospitality?

Precisely. Ultimately Porringer is up a tall ladder, falls over and gets pushed into a pond. From time to time he visits the museum in Norwich and, in a shady corner where no one ever goes, finds twelve drawings of a country house, ascribed to somebody called Philip.

To get back to the original twelve drawings by Mr Neville...

You'll find that there were only eleven.

What happened to the twelfth?

I got bored drawing it. Actually, thirteen were planned. The thirteenth is the one he came back to do at night. Thirteen, an unlucky number, is responsible for his death. It's a baker's dozen.

The 'dozen' drawings seem an equivalent of the lists we find throughout your work; for example, the official report in your film *Windows* or the directory in *The Falls*. In the process of working through these the viewer recognises patterns and coincidences, and eventually the list is buried by surplus of interpretation. By then the systematic nature of the original structure has been lost, 'plot' has evaporated or been overwhelmed. a degree of maximum ambiguity has been reached, but something is on the point of emerging. It isn't enacted or incorporated or even described. Just

adumbrated. Maybe it's an event or an idea. Or both, since normal rules of cause and effect have been suspended.

People have certainly been upset by the lack of so-called resolution in the plot of *The Draughtsman's Contract*. They seem so accustomed to Agatha Christie. Where does the point you describe occur?

With Neville's death.

Right. One new project for TV is called *Fear of Drowning*.

So what emerges is a set of co-ordinates for a new work. Lack of closure is a means of appropriating and revising your oeuvre, permitting other structures to develop, which determine other events. From these a pattern will arise and be overwhelmed in its turn. You're attracted to closed systems with rules which alter in time. The structural principle is one of geometric progression, lists that creak under their weight of cross-references.

I'm working on a novel called *Three Artificial Histories*, a reconstruction of three centuries – one in the past, one in the present, and one in the future – very loosely based on the 14th, 20th, and 26th centuries. This provides an excuse to examine the whole problem of lists, indices, and catalogues, and thereby consider what the making of history and fiction is all about.

What is the problem?

The novel form is comparatively recent; it has only existed from (shall we say) about 1600. But authors have been making lists for very much longer. Take *The Pillow Book of Sei Shonagon* or Rabelais. Sterne and Diderot do it a lot, and then later, J-K. Huysmans in *Against Nature*. As one way of reconsidering narrative – to make a savage paraphrase of the idea that everything exists in order to be put into a book – I suggest that everything exists to be put into a list, that if you wait long enough everything will find itself in a list somewhere or other and that if you are genius enough everything will appear in every list. Examining lists means playing with the re-creation of history. History doesn't exist; it's only made by historians.

So in your film *Vertical Features Remake* the debates between the characters Castonager, Gang Lion, and the others about editing and re-editing Tulse Luper's *Vertical Features* will never be settled.

Put it this way. In *Three Artificial Histories* the second chapter is concerned with maps, as was *A Walk Through H*. Yet another plan is for a film called *The Cartographers*, about 20 different map-makers who all approach one specific bit of landscape and map it in their own fashions. Map 1 will be the merest outline indicating mountains, marsh, and a plain through which a river runs. In Map 2

other, quite idiosyncratic features like passages of deadly nightshade and areas of peacock are much more significant than towns. So each cartographer perceives the landscape in a different way according to his particular interests. You go through the preoccupations of a baker, a weaver, a pederast, a man who's never seen the sea but wants to, another who's mining diamonds, and so on. The same piece of land can be refashioned, reorganized, recoloured. Like history. *Three Artificial Histories* has an apocryphal apologia suggesting that it exists to find a use for the indices. In other words, you create indexes first, then write a novel based on them. There are lots of types: an index of place-names, of people, of birds, of ephemeral events ... Though it sounds like a device it's essential for me, because there are so many characters, so many bits of action, that I keep getting lost.

This brings up the question of mistakes, deliberate or accidental. One of the delights of your early work was the habit of linking an arbitrary visual level to a more deliberate soundtrack. Now and again an accident on one level would be explained away on the other level. In *The Falls*, for example, when a character suddenly disappears from view the commentary excuses this as a symptom of the mysterious ailment that afflicts everyone in the film. A more disturbing characteristic is your blatant use of red herrings.

For example?

All the women in *Dear Phone* were called Zelda, they were all driving their husbands mad, and thrown in for good measure was a cleaner whose favourite novel was *Tender is the Night*. None of that serves any purpose whatsoever in the film.

It serves the purpose of not serving a purpose, surely quite a valid one. Life is full of a thousand red herrings, and it takes the history of a civilisation to work out which are the red herrings and which aren't. The actual red herring conceit turns up in the scenario for another planned film called *Zed and Two Noughts* (which spells 'Zoo'). There's a little girl who is taken to the aquarium and, bluffed by adults, keeps asking the keeper where she can see a red herring. You could say that the two unexplained corpses in *The Maltese Falcon* are red herrings because nothing is really resolved at the end anyway, as in *The Draughtsman's Contract*. You could say that the ghost in *Hamlet* is a red herring, too. It depends on your viewpoint.

Come come. Your examples are too strategic. Not even the men who wrote it understood the plot of *The Maltese Falcon*. Next you'll wheel out *Last Year at Marienbad*, which Alain Resnais and Alain Robbe-Grillet disagreed about.

One wouldn't in any way suggest that this particular phenomenon makes them less interesting works of art.

The trouble is that you're suggesting that it makes them more interesting.
Indeed I am.

One possible red herring in *The Draughtsman's Contract* is van Hoyten, Keeper of Owls at the Amsterdam Zoo. In previous films he is the sworn enemy of Tulse Luper, the polymath artist, ornithologist, filmmaker, and author of *Migratory Birds of the Northern Hemisphere*. Here van Hoyten is introduced, speaks a couple of sentences in Dutch, then walks away flapping his arms as if he's trying to fly. Why is he there at all?
Playfulness. He's the new man, a shadow of Mr Talmann, one of the Northern Europeans appearing for the first time in English politics and life. He turns up all in black, looking like a Puritan.

What's happened to Tulse Luper?
He's quietly gone to sleep for a few years but will doubtless be resurrected. Cissie Colpitts, his lover/wife/mistress, is the subject of a project planned for next spring called *Drowning by Numbers*.

She split into three as a result of the Violent Unknown Event in *The Falls*, didn't she? And had difficulty getting back together.
She's also three in this movie. One woman three times.

One Cissie Colpitts married a bicycle manufacturer from Leeds, we're told in *The Falls*. Another ran an avant-garde film society with its headquarters in a disused water tower in Goole.
The third was her co-heir, who took over. In *Drowning by Numbers* the eldest woman is 64; the middle Cissie is 36; and the youngest is 19. And all three murder their husbands.

Why?
Oh, various reasons – most of them non-violent. The first finishes hers off in a bathtub in front of the kitchen fire. He's drunk and has been unfaithful. Wishing to make it look accidental she enlists the aid of a local coroner called Madget. He and his son Smut succeed in concealing the crime. Seeing Cissie Colpitts I evade detection, Cissie Colpitts II bumps her husband off in the sea. He's obese, and her excuse is that he's eaten too much. Again Madget and Smut are involved. Cissie Colpitts III, who wants to be rid of her husband of three days, lets him drift away while teaching him to swim in a local pool.

Where is it set?
On the north banks of the river Humber, not a particularly photogenic area. It's

extremely flat; the only things that stick up are church steeples, distant derricks, docks, and water towers.

Obviously it's about that conspiracy of women against men already explored in _Dear Phone_ and _The Draughtsman's Contract_. What else is it about?

Games. There are three games in the film. The first is cathartic, to help Cissie Colpitts I recover from her grief. It's an alternative form of cricket invented by Madget, using two wickets, two umpires, three balls, and a mad dog. It's called Grace. The second takes place on a wide foreshore of the tidal Humber and involves any number of people. Like lacrosse. You can play lacrosse all over the world provided you know where the goalposts are. This game, though, has a series of allegorical figures with capital letters to identify them, as in Hogarth: The Hangman, The Judge, The Ghost, The Fat Man, The Harlequin... as many as you can invent. This one is played at the wedding of Cissie Colpitts III. The last game, which concerns Noah's Ark, is again played on the beach. It happens when all the husbands have been killed and is to celebrate the conception of a child. All the animals are collected and put into arks when a storm breaks, the women go off on a boat on the river to escape it, and the last you see of them is that they're floating out to sea. Madget and Smut commit suicide because they realize that the women have gone out of their lives. There is talk of Cissie Colpitts the elder dying in a cinema in Philadelphia, haemorrhaging so the blood that wells up in her lap is the same color as the plush seats she's sitting on.

Another form of drowning.

She's watching Jean Renoir's _Boudu sauvé des eaux_, about a tramp who fell into the Seine, pretended to be drowning, and was rescued by a family without wanting to be. In the end he went back into the water.

There seems to be a connection between water and games.

Certainly there is for Cissie Colpitts. _Fear of Drowning_ is a plan for an eight-hour TV serial tracing the life of Cissie Colpitts from the womb to the age of 18, which was also the date that the Lumière brothers patented the first ciné camera; her life is also the history of the cinema. It shows that she inherited both her game-playing and her terror of drowning from her father, a man called Cribb. Every episode will contain a different game. The first, learned from a shipwrecked Italian sailor, Cribb plays on a beach to determine his daughter's future. It involves drawing squares, each of which is your destiny. You play hopscotch and throw rocks. Where they land indicates certain patterns of behaviour. Another,

the Lobster Quadrille, is an obstacle race relating to all the fears sailors have of the sea: deep chasms in the China Sea, the aurora borealis, the Sargasso Sea, the Strait of Magellan, all represented in miniaturised, allegorical form as obstacles on the beach. The games become grander, first involving a man and his child; then a man, his wife, and child; then maybe 20 people; then finally about 500 players. The last game is cataclysmic; Cribb dies just as Cissie reaches the age of 18.

But she will continue to play games until she dies.

And at the age of 36 will meet Tulse Luper, the arch game-player.

It's worth adding that drowning isn't the only violent event in your work. *Act of God*, a short TV documentary, is a series of interviews with and facts about people struck by lightning; *Windows* is an illustrated list of defenestration casualties.

Like me, Madget, the coroner in *Fear of Drowning*, is obsessed with deaths, and keeps a card index of ways of dying. We know for a fact that the composer Charles Alkan reached for the Talmud on a top shelf of his library, the entire bookcase fell on him and he was asphyxiated. The composer Jean Lully was beating time with a cane, struck his own foot, it went gangrenous, and he died. Those two real life composers have been written into an opera, *The Death of Webern*. It's about the deaths of ten composers, starting with Anton von Webern and ending with John Lennon. All of them were shot. Each time the same ten clues were present. They were all smoking, all wearing hats, all left grieving widows, all wore glasses, the deaths were all perpetrated by three bullets, their assailants all carried United States passports and so on. The idea is of a conspiracy against composers set by St. Cecilia, the patron saint of music, jealous of the success of her protégés. There's a reference to this in *The Falls*, and Geoffrey Fallthuis and Contorpia Folixchange, who appeared then, will reappear.

It's time to stop. Just for a second it's possible imagine that moment when everything appears on every list.

Losing Battles: a conversation with Richard Wentworth

From an exhibition catalogue published by the Lisson Gallery, 1984

Stuart Morgan: Why do you collect photographs of circus acts who balance spinning plates on poles?

Richard Wentworth: It's clever. Bringing something off. Keeping all your balls in the air.

Admittedly you collect art postcards too.

Picasso, Borromini, Frank Lloyd Wright, Oldenburg, Lutyens, Doisneau's portrait of Jacques Tati...

The odd thing is that alongside the Medici Library steps in Florence you stick a catalogue for building supplies from Barcelona.

They are both monumental. I find cigarette packets folded up under table legs more monumental than a Henry Moore.

But can you tell me why?

Five reasons. Firstly the scale. Secondly, the fingertip manipulation. Thirdly, modesty of both gesture and material. Fourth, its absurdity and fifth, the fact that it works.

Aren't you making an aesthetic of function?

Not at all. Poetry, not utility, is why it's there.

But if it's poetry what's that poetry about?

Making the world work. People do it all the time, with immediate, unselfconscious gestures. There is a passive way of sending messages which I find very articulate.

And how do they learn to do that?

By being in the world.

Everybody knows that artists are unworldly. You must have gone on a retraining scheme.

You could say that. In 1970 I started taking photographs. It was five or six years before I realised that most of them were about a kind of mundane improvisation – barbed wire with blue plastic around it to form a stile; people standing on two bricks to get a better view of the Silver Jubilee procession; the two halves of a step ladder lying sideways one on top of the other, to indicate that a shop was closed... Finally I had 3,000 of them. They revealed a whole language of low-level message-sending. Towels drying on a cactus in a Spanish teahouse and bath mats on well-clipped bushes outside a New York motel seemed to be the result of the same decision-making process.

Cue for elaborate semiotic analysis.

Not at all. What overcame me wasn't sensational or clever. It was a preoccupation with the nature of the ordinary, a gradual awareness of metaphor at work.

For example?

A few nights ago I visited a friend who is an artist. When I rang the bell she appeared on a gantry high above and threw something down which looked like a hand. It turned out to be a bunch of keys inside a rubber glove. But as it fell to earth it looked like a greeting or the hand of God smiting me from on high. Glove, hand, warmth, salute, entrance: a visual event with a metaphorical charge which is inevitable, dense with meaning.

What happened to your own sculpture after your encounter with this language?

For a couple of years it was devastated.

But after the turning-point in 1979 what relations did the new work have to your discoveries?

When they succeed they are complementary to that interest in unconsidered signs.

As in photographs, your chosen materials are common enough.

A lot of the things I use are only modest industrial versions of things we need to survive...

In Islington?

No, in a desert.

So what do we need?

Essentially, I suppose, tools and memories. In the middle of the last century, in the Macquarie Islands, natives were hunted and killed who were so primitive

that they had forgotten the means of preserving fire. They also had pitifully few tools, and in anthropology one of the ways you judge a civilisation is by the number of tools it possesses.

I wonder how they made themselves understood.

I wonder how we do. Think about driving – how many things and people you have to pay attention to and the whole pantomime of nods and winks you employ. Again this is a sort of sub-language, somehow connected with other types of communication. Makeshift but intelligible.

Aren't you just a closet formalist?

There are shapes and gestures which turn up throughout my work – cones, spheres, things that stand foursquare, passive placings – and most of those have been in my work for 15 or 20 years. They go on all the time. Recognising them might be like hearing rhyme or the lilt of someone's voice. Gestures crop up again and again. There's a lot of spilling and falling.

And play between big and small, heavy and light, old and new, wet and dry, dark and light... You once described your early work as 'scraps of personal experience'. After 1979 it became a study of experience as a state of betweenness, defined in concrete terms, terms suspiciously akin to those with which life presents itself. For you it exists in a position between existing codes, one of which is verbal. In your sculpture the relation of objects to material and the relation of both to language is complex. It often seems as if everything you ask us to look at depends on a pun which has somehow been lost along the way.

The first piece to contain a pillow had a tool lying across it. It's used for cutting bricks and is known in the trade as a bolster. So the work began with a pun on 'pillow' and 'bolster', triggered by a speculation on why the French should want to sleep on sausages while we do it on squashed lumps of dough. That might be a pun getting lost or gaining in resonance.

Are you suggesting that however many times we're told that names of things were bestowed arbitrarily, in reality we persist in seeing them as an essential part of those things?

Yes and no. To name an object leads to a dilemma: whether to write 'Duckdown, cotton and forged steel' or 'Pillow with bolster'. The point is I don't like puns floating on the surface in art.

Betweenness means leaving your sculpture in a state of withheld meaning. That confuses me because it becomes difficult to tell a relevant interpretation from an irrelevant one. In the work with the rock leaning on

the open brown paper bag for support I think of sugar. Sugar bags have tops that stick a long way up when opened, and the rock looks like a sugar loaf. Is that relevant?

Partially. For that piece the man who cuts bollards in Cornwall would have his interpretation, the woman who makes block-bottomed bags would come along with hers, and so on. Despite its vacuity I admire the bag. It's confident. It sits there. The stone is ponderous; it puts my back out when I lift it.

It needs the bag but the bag doesn't need anything.

Precisely.

Betweenness is not necessarily an advantage. Although you respect the improvised gesture, there is a sophisticated air about the way you build on your knowledge of it.

The sign language is a profound interest which has existed for a long time. The same could be said of the sculpture. There may be a geological fault of social necessity between them. We can't help being sophisticates. You can't strip off your upbringing. That's a sort of lie.

Perhaps this accounts for your need to locate the objects you respect in some social context. The two wrapped buckets, displayed as they were sold to you, would be one example, or the monkey wrench tied up in a bag with a picture of a wrench on it…

As sold by C.K. Tools in Pwllheli.

Here the object displayed becomes the token of social exchange.

What charmed me in the bucket shop was the decorum of the shopkeeper's approach. When he asked me if I'd like the bucket wrapped I could hardly believe my ears. It is the same, almost cherishing approach you find in European patisseries where they are prepared to box a single eclair. Do you know, the man in that bucket shop still stocks galvanised 'bungalow' baths, the long ones with the round ends, except nowadays people buy them for mixing plaster?

These things really matter to you, don't they?

Of course they matter. Try buying galvanised steel cable. Five years ago it was standard. Now all they have is the stainless kind.

Does this happen to you often?

Always. Everything is always running out on me. To go to a shop to pick up something I take to be fairly ordinary with which I nevertheless have a private relationship that's unknown to it or to anybody and to find it gone for ever…

It must be deliberate. You've developed a nose for it, a subconscious urge to encounter those things before their time runs out.

Have I?

Why else would anyone complain of things changing and still buy schoolroom globes to put in his work?

Maybe you're suggesting that I'm being romantic. That man in the bucket shop wasn't quaint; he was remarkable for his sense of values. There were things I was taught like standing up when a woman enters or leaves the room. In the new sexual democracy I'm told this is unnecessary. Do I do it or not? That man was sticking to his guns. Do you realise it will soon be impossible to buy a watch with hands on it?

Your work involves social unease, that feeling that the ground is moving beneath us. It is about exactly that move from hands to digits, measuring by kilos instead of bushels and pecks. The older scales were to do with arms and feet, how far you could walk, how much you could lift: they are 'human' measures. One theory is that every word we use was once a powerful metaphor and that poets can temporarily replace some of that lost fire as well as remind us that we are using a language.

The way I see my work is very close.

I have only one more question. Why would anyone keep eleven months' used light bulbs and suspend them in a string bag?

Why do we throw them away?

Because they aren't useful any more.

A lot of bulbs gave out and didn't get thrown away. I had a kind of curiosity about them. This is a mourning piece. When a bulb goes there is no way to tell unless you pass electricity through it. Bulbs expire in a perfect state. Breakage, shatteredness, is connected somehow. And disappearance.

I still don't understand.

Well it's about things I don't understand. I don't understand how you could be there now and then fall down dead and I'd be left looking at your body. Where would you have gone? I find that puzzling and think about it a lot.

Soup's On:
an audience with
Steven Campbell

Published in Artscribe *48, September-October 1984*

Stuart Morgan: Your paintings are populated by vacuous-looking men in twccds. Who are they?

Steven Campbell: These men are young boys growing up. They haven't learned very much. They've learned some things but not the things they should have learned.

They play games, pursue hobbies like camping and experiments. In *Wee Nook Cottage* they teach each other to dance. One thing in particular connects the paintings: the use of gesture. In one of the titles you make it clear that gesturing is the whole point – *Two men gesturing in a landscape, each with the chin of Joan Sutherland*. Why Joan Sutherland?

When you see photographs of her she looks pretty nice from the nose up but in fact every photograph is taken from a particular angle. If you see her straight on she's got the weirdest chin. It's like a growth: a huge, chunky, fat chin. So I thought if I had these two guys gesturing generally it would make a pleasant disguise.

Are you a Joan Sutherland fan?

Oh yes, because of her chin. I saw her in *Daughter of the Regiment,* where she plays the daughter, who's a young girl. The set was a mountain landscape and she came on drumming and marching up the mountain. First you only hear the drum, then gradually she appears. It was fantastic. As soon as her chin came into view the audience went wild.

Another painting with theatrical gestures is *The Humeans Debating the Wild Ferns*.

One of my totally inept successes.

Why should they debate wild ferns?

They're fighting each other. They're wild, you see. 'Can this be right?' the Humeans are saying – 'Do wild ferns fight and domestic home ferns not fight?'

Who is the woman on the wall?

It's not a woman, you swine. It's a portrait of David Hume looking down and nodding in agreement.

Why is one of the philosophers without trousers?

I had a hell of a job with the trouser legs. If you took that and X-rayed it you'd probably find a complete pair of trousers and shoes underneath there somewhere.

David Hume comes up a lot as a character in your work (as does Van Helsing from *Dracula*). Could you explain how his philosophy affects the painting?

I don't know anything about him. I know four things about Hume. Any more than that would be irrelevant. At six in the morning the Open University has debates – 'the Humeans' the woman calls them. Rosalind somebody, she's half American I think. Wears shorts.

Who are your favourite artists?

Well, Hogarth seemed too obvious even to bother with until a month or so ago I looked at him properly and thought, 'Oh God! Wonderful!' There's one of a bunch of people in a landscape setting, with a cleric holding a telescope and falling back. It's people hunting for the meaning of things. He's looking at the sky, one person's looking at the ground, another is looking at a statue and the statue is looking back at him. Pietro Longhi is also a painter I admire. There's a work in the Metropolitan with two people standing in a room and one person walking towards them. He's moving and they're still. I think his perspective must be off. Marvellous composition – lace, pink flesh, poppy-eyed women. He does the same face every time for women.

What about Scottish painting?

I usually paint things which are typically Scottish because apart from Landseer no one's really done all that. And he made such an arse of it – in a wonderful way.

In what way?

He just didn't seem to know what he was doing. He was probably very stupid.

The idea of composition matters a lot to you, doesn't it?
There's a kind of confusion in my painting but there's also some order in it and the order tends to be the composition. Somebody said that 60 per cent of the things in my pictures matter and the others don't – they're just there to fill the picture up.

Some of your student drawings show a strong interest in texture. Have you lost this now?
The paintings aren't without texture. I have every intention of building up texture. The things that are supposed to be textural look textural enough. When you're dealing with a wall, say, it's easy enough to make a wall look like a wall. But when you want a wall to look like a wall, a sky to look like a sky, and you have a landscape and figures and sculpture and plants all in the same work, that's more difficult.

Would you be happy with a very realistic style, then?
I wouldn't mind having a shot at it. It would be interesting to have a week to spend on four plants, for instance, not to make them look like pre-Raphaelite painting but like real fibre. That would be impossible, though.

Why?
I wouldn't have enough confidence to put that much time into one painting unless it was a great painting. And if it was I'd be the last to know.

This is the chance you take, surely.
I take the chance more often than most because I do one every six days.

Don't you think that's too many?
After six days they tend to look finished and I can't work on them any more. After that time another painting has crept in and I have to work on that one.

Could you describe the process of completing a work?
Well, the painting starts off as one thing and if that doesn't work I try something else until a memory of all these things is in it but none of them is particularly true except the one I've picked to title the work. The picture is a summing up of all the mistakes. It's what's left.

As a student you made collages out of photocopy paper and drawings in wax; realistic drawings of corners made from a clay model, large rubbed graphite drawings of small objects like books or bags; a phase when you made painting-sculptures rather like Stephen Buckley...
Stephen who?

Stephen Buckley.
If I knew who he was I'd admit I copied him.

Gradually the work diversified. You made furniture and sculpture and wrote, placed works in various arrangements and finally planned performances which included all of these elements. During and after the performances came a sequence of figurative paintings featuring a single person...

I called him Hunt. I was painting him and at the same time I had these forties murder magazines – I looked down and saw the headline: 'Is it Hunt or is it...?' He is athletic, wears a raincoat, walks around a lot and fails from great heights.

An all-round good egg.

But when doors were closed on him a bit of a bad one, like Patricia Highsmith's Ripley. He was a definite character, and the entire sequence was called *Hunt's Fall*. He continued when I went to New York on the Fulbright and turned into the Lost Hiker, which became the title for many of the pictures.

Let's go back and talk about some of your performances. At the time of Poise Murder you weren't painting.

Well, there were four paintings of Violette Nozière as part of the set, standing with different murder weapons.

Can you describe the performance?

Yes. In front of these paintings was a Vorticist zig-zag floor and a little bridge on which a murder took place. The men wore black trousers, black polo necks, medallions and Brylcreem. The women were in silver shirts, black tops, fishnet tights, high heels and floozied-out hair. There was a detective who crawled around on all fours and the actors adopted murderous poses to the music, which was a record by Robert Ashley. It lasted 15 minutes and we used real knives and razors.

Another of your performances was called *Opera*. How did that come about?

I'd begun making some drawings of a Greek sculpture I liked, of Ajax falling onto his sword. It looked as if he was tripping up. I made a trip sculpture with a sandal to put your foot in and a lead base and a little medallion. There's a story that he was tricked by the goddess Athena and instead of killing the enemy he has been killing sheep. When he finds out he kills himself. Instead of feeling remorse because he's killed a thousand men he is ashamed because it was a thousand sheep. Gradually this idea turned into the whole opera with the set and the actors and an audience of two who watched

through little eye things so when they caught what was going on it had a fuzzy edge. I played Ajax. Mahler was in it too – Picasso, Jarry, Apollinaire...

Did it end with Ajax's suicide?

Yes. He waves his flag, two birds slide by and he puts his foot onto the apparatus and falls onto it.

Were they real birds?

No, little ceramic things. I couldn't get any real ones. They were important. The sheep too. I called it a 'zoo opera'. It owed a lot to *Parade* and *The Blue Train*. But by this time *Einstein on the Beach* had appeared and it was from that that I got the term 'opera'.

Was there music?

No.

How long did it last?

About five minutes.

How many times was it performed?

None. I was too scared.

You were going to write a dissertation on Robert Wilson, weren't you?

I never did it. The only way to get information was to go to New York and there was no way I could afford to do that so instead I wrote about Picasso in 1920 – the classical figures and his circle at the time.

Which of the neoclassical pictures do you like the best?

There are two: *Man reading a letter* and a big dumb-eyed woman in a hat. A great mood comes off them; they're quiet, like a spell you can't break. It feels as if they're going to be there always.

There are some very static works of your own.

Van Helsing standing paralysed is one.

How did he become paralysed?

There's a snake on the ground and some fang marks on his legs. He can't move but his eyes are gleaming to show he's still alive.

If there are fang marks on his legs it might have been Dracula, who had the power to turn himself into different animals.

I think it was.

Without the title the viewer would be lost.

Maybe.

The title seems to play a big part in this one – *Hiker in a landscape turned into a marsh*. The figure looks like a giant.

No, it's just that he's seen from very near. He's really just looking down at his

own reflection in the water. There's a storm brewing but everybody thought it was some kind of bomb and liked it because of that. He gets up out of his tent one morning and what had been a beautiful dry landscape the day before has become a marsh because of the weather. He's amazed.

He's a new kind of figure.

The dead spit of me.

But you look like Van Helsing.

Only because of the beard.

Why do you give Van Helsing a goatee? He doesn't have one in the book.

He had to have some kind of authority.

Is this what gives you your authority?

It is, yes. Without the beard I'd go to pieces.

'What gives this man his authority?' I was wondering.

It's my goatee. If that came off I'd suddenly become a fitter again.

Can we sum up?

It's hard to know what to say about the paintings. Brooks Adams put it well in *Art in America* when he said they were a soup of different things. There's one idea and another and another and they all fail.

There are soups made of all the leftovers you have lying about in the kitchen but there are others which are classic recipes.

I'm talking about philosophical soup here. Campbell's soup.

Steven Campbell:
The Case of the Waggling Leg

Published in Artforum, *December 1984*

It is not always easy to identify things. This picture is full of tangible, everyday objects, each painted in its own way, not named but nicknamed. Areas are dealt with by the painter as if they existed independently of the surrounding composition. The white has been drawn so quickly through the heavy impasto below it that it looks like a sliced pizza. It ends up a little like tweed, a little like check suit, but not a lot like either. Instead it is one more item in a collection of random details that have decided to go it alone. Nor is it easy to tell what is going on. Admittedly a lot is happening. It is even happening on a kind of stage where every element is on display. The trouble is that although there are nods toward traditional methods of leading the eye around the canvas, giving enough clues to form the basis of a narrative, they remain only nods. Trying to piece together a coherent story is out of the question; whatever happens happens simultaneously all over the canvas. After looking long and hard the pieces still seem only elements of an ungraspable whole. Perhaps it is only possible to begin by picking a thing and an event together. Take that leg for instance – the one poking through the wall.

At the climax of P.G. Wodehouse's *Leave it to Psmith*, Psmith and Eve Halliday are in the living room of a cottage on the grounds of Blandings Castle, held at gunpoint by Edward Cootes, a burglar pretending to be a valet, and Aileen Peavey, a gangster's moll and poetess. Just when things are looking bad an accident occurs. At that moment 'there came from above their heads a sudden sharp crackling sound, and almost simultaneously a shower of plaster fell from the ceiling, followed by the startling appearance of a long, shapely leg,

which remained waggling in space.'[1] Attached to the leg is Freddie Threepwood, busy searching the bedroom for a diamond necklace. In a matter of seconds the tables are turned. Looking up and spotting the leg, Cootes fires in alarm but succeeds only in bringing down a quantity of plaster. The leg is withdrawn, Psmith jumps to his feet, grabs a chair, hits Cootes over the head with it, then relieves him of the pistol. For the moment, at least, disaster is averted.

Steven Campbell read all of P.G. Wodehouse. Then he half forgot it. So, in *'Twas Once an Architect's Office in Wee Nook* (1984), we find something like Freddie Threepwood's leg protruding through the wall. It has entangled itself in a fifties bookshelf, sending one seated man tumbling backwards while another, apparently stuck inside a table, clutches his hair in alarm. The maquette of a building is flung aside, the ceiling bursts apart to reveal part of a stained-glass dome, and, while a piece of archaic chemical apparatus rattles into activity, the floor collapses to reveal the ghost of the Scottish philosopher David Hume, who – like Van Helsing, the pious Dutch philosopher responsible for Dracula's death in Bram Stoker's novel – has become one of a set of figures occurring regularly in the paintings.

Wodehouse once claimed that he wrote novels with a 'cast' of characters in mind, thinking perhaps of the repertory companies of his youth. In his preface to *Summer Lightning* he defended himself from charges of repetition by openly admitting their truth. 'A certain critic – for such men, I regret to say, do exist – made a nasty remark about my last novel that it contained all the old characters under different names ... He will not be able to make a similar charge against *Summer Lightning*. With my superior intelligence I have outgeneralled the man this time by putting in all the old Wodehouse characters under the same names. Pretty silly it will make him feel, I rather fancy.'[2] Like Wodehouse, Campbell insists on varying a basic pattern. His actors, all male, hike, camp, play tennis, hold debates, cook soup, hunt, and conduct scientific experiments. Unfitted for what they do, with bloated anatomies and a passion for tweeds, they are doomed to failure despite their good intentions. They collide with signposts or each other; wake up to find that overnight the landscape has turned into a bog; confuse maps with reality and try to climb them. Accidents are an inevitability. After all, they do provide a structure for the paintings.

Precariousness has a long history in Campbell's work. *Man Amazed at the Height He Is Up* (1983) shows a hiker on a ledge, with fir trees behind him and a precipice in front, terrified that he might fall but exhilarated by the danger;

Happy Camper (1983), with a bulky figure plummeting head first off a cliff, is an updated version of *Hunt's Fall* (1982), the title painting of a long series featuring a man called Hunt. An early performance, *Opera* (1981), based on the story of Ajax, was to culminate with the hero stepping onto a tripping device centre-stage and falling sideways to be impaled on his own sword. The performance never took place before an audience, though Campbell prepared props, which doubled as art objects in their own right. That Ajax was to have been played by Campbell himself, though, reveals a few of his major assumptions: that the artist is a hero, a fool, above all an overreacher. Ideally, then, his art will aspire to a condition of hyperbole in which heroism, folly, and ambition are raised to the highest degree.

Time passing and time ceasing, movement and stillness, preoccupy Campbell. The inspiration for *Opera* was an illustration for a Greek statuette of Ajax falling to his death.[3] Because falling, like flying, was problematic for Greek sculptors, the figure seems to hover clumsily, apparently reaching out as if a friend were there to rescue him. Similarly in an interview Campbell discussed William Hogarth's *Lord Hervey and his Friends* (1738), in which a clergyman standing on a chair to look at a church steeple through a telescope topples backwards into a pond.[4] Another obsession has been with gesture; in all his work figures posture and signal without any meaning emerging, theatricality without expression. One early performance, *Poised Murder* (1982), consisted of a series of *tableaux vivants* that began with the stylised violence of Apache dancing and ended with suggestions of actual assault. The setting consisted of paintings of newspaper photographs of Violette Nozière, the famous murderer.

Campbell's use of Romantic irony is characteristic; it is a way of darting to and fro between the terms of art and life in order to make serious statements comically while modifying the pretension of his stance. In the Greek bronze and the Hogarth painting the statement is clear enough; for Campbell it is that falling and remaining in place, acting and suffering, are identical in a work of art. As John Berger has noted, when movement is represented by stillness 'the ensuing images are still static whilst referring to the dynamic world beyond their edges, and this poses the problem of what is the meaning of that strange contrast between static and dynamic. Strange because it is both so flagrant and so taken for granted.'[5]

From claiming that Campbell permits his viewer to stop taking it for granted, if only for a moment, it is a short step to seeing him as a doctrinaire deconstructionist in search of the aporetic in painting. The truth is more

interesting than that. His thematic preoccupations and his practice are intimately connected. His figures pass time; so does he. They bumble; he bumbles. It is his ineptitude that brings him to the point of insight. Perspective is not remade in a picture such as *Through the Ceiling, Through the Floor etc.* (1984), a 'sequel' to the waggling leg, in which the character's left and right legs have somehow been reversed and turned inside out and the floor slopes into the distance at the bottom of the canvas. On the contrary, Campbell was trying his best to achieve a traditional perspective, making mistakes and leaving them. The same happens in *Wee Nook Cottage* (1983), another waggling leg picture, in which the locale is (confusingly) specified.[6] By fixing his mind on the desiderata of his ideal painting, he is almost bound to fall short. Since his method is to complete a painting in six days, with no preliminary drawing, he must rely on known factors, before forcing himself to improvise. This ends in *buffo* painting, in which the object is to emerge triumphant over the forces of disorder.

So great is the emphasis on the battle between order and disorder that an unusual generic claim can be made for Campbell's work. Gradually it has shifted from fun to comedy, from comedy to farce, and from farce to the fringes of nonsense, a peculiarly British form. Only by categorising it as nonsense, perhaps, can the work be approached at all. In the works of Edward Lear or, in particular, Lewis Carroll, a delimited world is proposed, which operates like a game with rigid laws which cannot be questioned within the game itself. To accept these rules is to gain freedom. Played by treating the familiar things of the world as counters, the game is emotionless and irreconcilable. (People too are treated as inanimate objects.) The poles between which nonsense functions are those of singularity, the additive tendency, and an all-engulfing sameness of the kind which triumphs at the end of Alexander Pope's *Dunciad*. Its aim may be to preserve a model of a universe that is never more than the sum of its parts.

It must be significant that so many writers of nonsense – Lear, Carroll, Hilaire Belloc, G.K. Chesterton, T.H. White – felt the need to illustrate their work, and that an untutored style was almost always felt to be most suitable. (Why, when he was a highly sophisticated academic painter, did Lear make drawings with little regard for perspective, with characters who clap their hands behind their backs in a manner that has been described as medieval?) Elizabeth Sewell, who held that nonsense resulted from the dialectic between different parts of the psyche, suggested that because the effect of these pictures is to inhibit half of the mind though apparently provided to nourish the imagination, they in fact extinguish it by means of detail and precision.[7] A parallel argument

would be that 'imagination' is so subordinated to 'fancy' in Campbell that it is only perceptible in the spirited rendering of the marks, admissions of the contingent nature of signs.

The unseating of imagination in his work is linked to the banishment of 'expressionism', still the accepted Modernist stance in his native Scotland. Abstract Expressionists painted the myth of the point of emotional origin. Campbell and other post-conceptual painters may be painting the aesthetic moment itself, a moment in which stillness and movement are confused, blocky poses become natural and eloquent, distinctions between levels of reality are broken down as art is pushed to its limits, and the artist's selfhood is put in danger of total eradication as space is folded, concertina-like, and time collapses altogether. While a Wodehouse denouement is prepared with Aristotelian precision and progressive haste, Campbell's exists unmotivated, beyond past and future, as a sudden 'presence'. The energy released in the recent paintings – in one a man breaks Van Helsing's neck in order to obtain the charge for a galvanic battery – is pure power. It serves to dramatise the suspension of cause and effect generated by a moment that is totally unforeseen and unforeseeable. 'Were a man such as Adam created in the full vigour of understanding, without experience,' wrote David Hume, thinking of his favourite game of billiards, 'he would never be able to infer motion in the second ball from the motion and impulse of the first.'[8] Little wonder that Hume is summoned from the grave by the turn of events above his head.

Campbell has proceeded by considering painting synchronically, as an ideal he must strive to emulate. His process of 'making mistakes' is a critique of his own version of painting, concentrating on points he considers illogical. The resulting works are the doubles of painting, a 'signing' which takes place at an ironic distance from the traditions on which he depends. By putting himself in the position of an Old Master, he is free to isolate painting like a new chemical element and strive to regain its lost innocence. There are other issues – like its relation to the outside world. Perhaps the leg can be read as the intrusion of a chaotic force into a sacrosanct realm. Perhaps it is the ultimate power which will subsume all detail in the architect's office at Wee Nook, the created and the planned, the quick and the dead. Or perhaps it can act without effect. 'God,' wrote St Thomas Aquinas, 'is pure act without any potentiality': a miraculous fulfilment of Hume's little myth.[9] Begin anywhere; there's no knowing where details will lead. Could the waggling leg really be the hand of God? Or is it just Freddie Threepwood upstairs being silly?

1. P.G. Wodehouse *Leave it to Psmith,* New York: Doran 1924, p.325. One problem is that every Wodehouse 'reference', in Campbell's work may turn out to be conflated or misremembered. Cf. the episode when Chimp Twist breaks down Hash Todhunter's door at Mon Repos, Burberry Road: 'Arriving on the threshold he raised his boot and drove it like a battering-ram. The doors of suburban villas are not constructed to stand treatment … And Chimp, though a small man, had a large foot.' (*Sam in the Suburbs,* New York: Doran 1925, p.326; English ed. *Sam the Sudden* London: Methuen 1925, pp.232-33.) Titles for two later paintings seem to be remembered from the same novel. *Through the Ceiling, Through the Floor etc.* may refer to Sam's breaking down the wall between San Rafael and Mon Repos at the end of the book, a deliberate 'accident' which makes him rich (op. cit., p.343). Another title, *'God's in His Heaven, All's Well with the World'* (1984) is a misquotation of 'Pippa's Song' by Robert Browning ('God's in His Heaven/All's right with the world'), which Sam recites to his friend Hash when life is trouble-free (op.cit., p.251).

2. P.G. Wodehouse *Summer Lightning,* Leipzig: Tauchnitz 1931, p.31.

3. Gisela Richter *The Sculpture and Sculptors of the Greeks,* New Haven: Yale 1970, figs 133-34.

4. Stuart Morgan 'Soup's On: An Audience with Steven Campbell' *Artscribe* 48, September-October 1984, p.31, and this volume.

5. John Berger *And Our Faces, My Heart, Brief as Photos,* New York: Pantheon 1984, p.26.

6. After accepting an invitation to Blandings Castle from Lord Emsworth, who assumes that he is a Canadian poet, Psmith insists on moving into an unoccupied gamekeeper's cottage in the west wood, some distance away (4-5, R-S on Ionicus' map 'Blandings Castle, Shropshire, in frontispiece to P.G. Wodehouse *Sunset at Blandings* ed. R. Usborne, New York: Simon & Schuster, 1977). "'What a horrible looking place,' [Eve] exclaimed. 'Whatever did you want it for?" "Purely as a nook," said Psmith, taking out his key "You know how a man of sensibility and refinement needs a nook."'(*Leave it to Psmith,* New York: Doran 1924, p.295.) The name Wee Nook occurs in *Joy in the Morning,* when Jeeves arranges that Lord Worplesdon, the second husband of Bertie's aunt Agatha, lends them a 'small but compact residence' in the grounds of his home in Steeple Bumpleigh. It is named Wee Nooke. Bertie calls it "'a decentish little shack … A bit Ye Olde, but otherwise all right.'" (*Joy in the Morning* New York: Doubleday, 1946, p.68.) Immediately after his arrival, however, Lord Worplesdon's young son Edwin, a Boy Scout and 'as pestilential a stripling as ever wore khaki shorts', performs his daily act of kindness by cleaning the chimney. Having put gunpowder up to clear the soot, he sets the whole cottage alight, then throws paraffin on the flames instead of water. Wee Nooke lasts for only one chapter.

7. Elizabeth Sewell *The Field of Nonsense* London: Chatto and Windus 1952, pp. 111-12.

8. David Hume *A Treatise on Human Nature: Book One* ed. G. B.C. McNabb, London: Fontana 1962, p.342. Campbell, who claims to know almost nothing about Hume, acquired this knowledge from BBC Open University programmes on philosophy. (See D. Cockburn/G. Bourne *Hume: Reason and Experience* Milton Keynes: Open University Press, pp.44-62, in which the question of the billiard balls is debated at length.)

9. St. Thomas Aquinas *Summa Theologica* Westminster: Christian Classics 1948, vol. 1, Article 3, pt 1, p.16. Sewell strongly argues the case for a parallelism between nonsense and Scholastic thought.

The Death and Rebirth of British Performance

Text of a lecture, first published in
'Cinq and d'art-performance à Lyon' in 1984

One root of the word criticism is the Greek *crinein*: to sort grain, to separate the wheat from the chaff. Hence the implication of distinction, the activity of valuing one thing more than another. But there is another, quite different root. The word 'criticism' relates to the word 'crisis'. Perhaps it flourishes at moments of crisis.

Performance in Britain does not seem to me to be flourishing. Indeed, it has reached a critical point in both senses of the word. Whether the crisis has occurred as a result of outside, political pressures or some inner failure solely to do with the life of the form itself does concern me but it is not my primary concern. The two are always related, of course, but that relation changes as time goes on.

Go to London and try to find the work of an entire generation of seventies performance artists: Brisley, Chaimowicz, Gilbert & George, Bruce McLean. You will be surprised. Chaimowicz is at work on a book. Bruce McLean shows paintings but seldom performs. Brisley writes poetry and makes sculptures. Gilbert & George never perform now. Is performance dying as an activity in and for itself? In a recent *Artforum* (April 1983), John Howell complained that despite the strong influence of performance on artists like Schnabel, Haring, Cindy Sherman, Robert Longo, Jack Goldstein and others, it is receiving little or no support in New York at present, that there has been a failure of nerve. He blames the financial situation, pointing out that performance is the most extravagantly wasteful of the arts and the least easy to reconcile to the gallery system. In Britain matters are worse. We have never had our Laurie Anderson

or our Robert Wilson. British performance has remained, as it has always been, solitary and noticeably poverty-stricken.

Yet to blame financial factors alone for the decline in performance activity would be unfair. It could be argued that a more open situation now exists, that our idea of what constitutes an artist is different: he or she now moves at will between painting, sculpture, music, literature, and so on. It is a point like that reached at the end of the sixties with the radical rethinking of the art object that took place then. There is a fundamental difference, however. The enormous critical swerve at the end of the seventies in favour of painting (defensible in terms of feeling, less defensible in terms of logical critical argumentation) has resulted in the attempt to re-establish an artistic persona more familiar from the Renaissance to the Enlightenment: of the artist as a man of power, a figure in the world again, producing masterpieces naturally, quickly wherever he goes. (I say 'he' advisedly; the ideal of the artist as a virile male is crucial, with all the notions of charisma and riches, star-systems and glamour that this implies. Women and women's art have little place here.) Unfortunate though this is in so many ways, it could be that it has ushered in a period where differentiation and hierarchies are suspended. A small sketch and a grand mural, a plan and its fulfilment, can be viewed with equal respect. Combination forms are particularly prevalent. For years now there has been no terminology for one kind of work: installation, slide/tape, performance and video . . . Abraham Moles' term 'inter-media' is the best definition I know of this area, which is one that should remain undefined.

Performance is not dying, then. Far from it; it has become increasingly respectable, entrenched, institutionalised. Already it suffers from a burden of history. It has textbooks, magazines, reviews. In Britain it is taught in colleges and polytechnics, with results little short of disastrous. So far this increased respectability has been inhibiting; performance as an illegitimate, underground activity is now unthinkable. Yet starting from scratch is out of the question. Though most performance fails to sustain analysis of the type familiar from other branches of criticism (music, architecture, film, literature), criticism of performance demands a range of skills as yet unobtainable. Imagine a writer who reacts equally sensitively to (say) Stuart Sherman, Pina Bausch and Laurie Anderson.

Is performance in a bad way, dying in agony, ready for shooting, like an old horse? Has it taken its place among a range of choices available to artists? Perhaps it was a mirage, and no such thing as performance ever existed. There is one weakness in the usual definition of performance as a combination art,

which may even be present in Moles' term 'inter-media'. That is that in its urge to emphasise the mixture of forms, the cacophonic effect, it denies the possibility that there is such a thing as 'pure' performance. And just as there must be room for 'pure' painting or 'pure' sculpture in our new non-hierarchical future – with no suggestion that as media these are inherently better than others – there must be room for 'pure' performance. But what *is* pure performance? Does such a thing exist? If it does, is it capable of expressing great truths about life and death? Is it capable of extreme formal beauty and of meditative speculation? An art not yet fully in existence may not be defined in terms of the past, but if it is to be *necessary* it will have to have the potential of achieving a Bach fugue, Piero della Francesca's *Flagellation of Christ*, or the final acts of Shakespeare's *Antony and Cleopatra*. Can we put our hands on our hearts and say that we have ever experienced this density of meditation, this richness of sensual effect, this level of pertinence not to the local incidents of human life but to the urges and failings that beset mankind? I have not. This is the real crisis of performance, for me at least.

Could it be that a form is defined by its conventions? And that its conventions consist essentially of what that form cannot do? An aesthetics of performance has been held back by emphasis on Dada and Surrealist precedents. That is not the only way forward. Let me return to Stuart Brisley, who has been making a set of works called *The Georgiana Collection* for a few years now. His present installation, on view in London at this moment, is *Georgiana Collection No. 6*, consisting of a cage mounted on work benches. Hanging by strings of different lengths from the top of the cage are gloves filled with plaster. All of these are from a British Rail Lost Property Office at Baker Street Station. Each has a label indicating that it is part of the Georgiana Collection – and a number. The title of the piece is *F 66,666*. Two labels on the wall declare 'This is the record of failure without parallel, without reason'. I counted over 60 gloves – there may have been 66. Each one denotes 66,666 unemployed people in Britain at present. Brisley has used cages in his work before. Replacing a caged person with a set of caged gloves, waiting to be claimed by their owners, unreachable through a wire mesh, is significant in terms of Brisley's own career. A figure struggling for life, tortured and expressionistic, could be construed as heroic. The gloves – 'a record of failure without parallel, without reason' – offer less logic. They are detached: hands that can't grip at life. And they go into a mock-museum collection as a kind of pointless archive. Brisley has written:

The specific absence or presence of employment is not the context for the sculpture; rather it is concerned to act as a conduit for current reactions to the idea of work. The image of negativity presented by contemporary notions of redundancy neither confronts immediate individual problem nor questions abstract systems of order. Operating at a level beneath capacity results in a quantity of effort that is not directed toward a qualitative end. Condition becomes determined by market forces; material is displaced to the residual; the sense of isolation, the awareness of inaction, further marginalises areas of potential. Controlled urgency is replaced by the reality of the statistic: the lord of misrule governs.

The tone of Brisley's statement tells us a lot about the mood of Britain at present. It is one of recession, making do, of the small-time entrepreneur and the jack-of-all-trades, of recycling and of enforced conformity.

The first obvious signs of a reaction to this in performance art were in 1979, with a worked called *Passage* by Kerry Trengove, where he spent eight days at the Acme Gallery in London tunnelling to the outside and talking to spectators. In another piece called *Solo*, again at the Acme Gallery in 1979, he spent two weeks training unfriendly dogs. In that year Denis Masi showed his installations at the Institute of Contemporary Arts in London. *Rattus Investigatus* is characteristic: a tableau of stuffed rats caged, with spotlights, a table containing instruments of torture, a soundtrack of rats screaming and a smell of rats' faeces. Like Brisley and Trengove, Masi moves between sculpture and performance: later he made a performance in which he bit the head off an eel. In 1980, Helen Chadwick made a performance and a set of photographs called *Trains of Thought*, in which she examined the body language and reactions of commuters on the underground. This was followed by *Model Institutions* in 1981, an installation with sound, made to look like the booths that applicants for social security – money for the unemployed – have to sit in, in order to be interviewed, with a different speaker describing his or her experience in each one. In 1979, Roberta Graham made a tape/slide performance about the Kray Twins, two murderers from the East End of London, petty gangsters. And, in the same year, Ian Bourn showed a videotape he had made called *Lenny's Documentary*. It is not a performance: it is scripted and *acted* by Bourn himself. Bourn at this time was a poet who had been making structuralist films at the Royal College of Art: film about film. His frustration with the means at his disposal led to this tape. Lenny is a lower-class boy who lives in a London suburb. We see him coming

back from the pub and talking about his life, making his documentary about the world around him. The rift between the closed formalist work Bourn had been doing before this and the statement he wanted to make about England resulted in *Lenny's Documentary,* one of the most interesting works of the late seventies.

The similarities of all the works mentioned will be evident: a preoccupation with exerting power, with the connections between the behavioural theories of B.F. Skinner and right-wing groups, with a sociological approach to everyday life. To return to the idea of formalist performance, there is a need not only to satisfy the artistic requirements I outlined but also the socio-political conditions which brought about the work I've just mentioned. The prescription for a 'pure' art form of great formal precision, as removed from the day-to-day world as a Monet waterlily painting or a Jackson Pollock abstraction may seem impossible. Certainly it is unfashionable. But if crisis in performance is the result of either inner or outer pressures, then the life of the form or the political situation will demand a new formalism, to answer the needs of the moment. A performance which would parallel early modern abstraction in art? I would like to think about this for a time.

When Anthony Howell published his book *Elements of Performance* in 1977 he was explaining the exercises that he had used for three years with his group, The Theatre of Mistakes. In the group each member was both master and servant: each could initiate actions which the others were bound to follow. Performances based on elementary exercises operated according to agreed rules. But these worked themselves out in an increasingly complex fashion. One main preoccupation became that of ordering other members to copy one's own actions, for example. Gradually actions became longer – so long that the next person was unable to repeat them – and mistakes were made. If a mistake *was* made a signal was given that the offending performer (or someone else) would have to correct it as a punishment. A disparity grew up between the activity presented and the method of presentation which seemed to deform and distort it. In *The Waterfall* water was transferred from a bucket on the ground to another at the top of a set of tables and chairs by means of cups. The piece was essentially an additive counting game and cues were given by a chant which the whole group did together. The number of performers was additive too: it increased by one every day, over a period of 48 days.

Howell's method, which has been called 'structuralist theatre', began with an assumption of equality – equal rights for each member, a non-hierarchical relationship between units of the performance, the concept of a theatre which

would be visible from all four sides. Howell himself has spoken of the influence of Chekhov and also of the relationship of parts in field paintings such as Jackson Pollock's. It would be more useful (perhaps) to think of his starting with a minimalist grid (with Pollock the other great post-war non-hierarchical invention) and stretching and distorting its structures. By the time of *Going,* in which the performers employ a set of gestures of leaving as well as a kind of dialogue each addresses to each other, he had exhausted the rules he had set out in *Elements of Performance.* He still used tables and chairs, suitcases and buckets, and looked deliberately to art for other examples of their use. Earlier he had made a long improvised piece called *Homage to Pietro Longhi,* a painter who had utilised a wide variety of the same gesture in painting not from life but from Venetian theatrical performance, from the comedies of Goldoni. Now (in 1979) he wrote a companion piece, *Homage to Morandi,* a 'still life' with three figures. In this piece, which has four acts, six scenes in each act, a process of subtraction takes place. In Act 1 there are four chairs, three cases and two wardrobes; in Act 2 there are two chairs, one wardrobe and no suitcases. In Act 3 there are two chairs, one wardrobe and no suitcases; in Act 4 there is one suitcase, no chairs and no wardrobe. Suggested but not shown is another act with no furniture at all. As furniture disappears, the actors take the place of each item. Although there are no 'characters' as such, one figure is the chairs, another (the tallest) is the wardrobe and so on. The words they speak evoke a seedy, lower-class life.

Orpheus and Hermes, which had a structure modelled on Greek tragedy and used a set of doors which opened in two directions at once, was Howell's last work for The Theatre of Mistakes as a group. After it he went back to writing poetry. But two new works resulted from his solitary studio practice, works of what he calls 'functional choreography'. In *Going* a whole series of events came into being when a table was turned 90 degrees. The two solo pieces called Table *Move* take this 90° shift as the main problem to be undertaken. Number one, written second, is the more comic and this work was performed at a comic pace reminiscent of the slapstick in *Homage to Pietro Longhi.* The performance takes place in a square which contains the following props: a wardrobe, two suitcases, a carpet, a chair, a spare jacket (always kept in the wardrobe) and a spare pair of shoes. There are eight scenes, so the entire set of props is moved twice around the square. But as well as the eight 90° moves, another objective becomes clear. After a certain point these moves *must* take place without the performer being seen. And the point at which the figure begins to hide is the hinge or *Wendepunkt* of the action.

So the 'plot' is as follows. In Act 1 he changes his shoes, changes his coat, packs up the carpet and the spare shoes and jacket, then moves all the props through 90°. In Acts 2 and 3 he does the same. But now the set of fundamental expectations has been established, like a time-step in tap-dancing. In Act 4 he changes one shoe, changes his coat, hides behind the table and moves everything through 90°. In Act 5, he changes his one pair of black and white shoes for the opposite pair of black and white shoes, hides behind the table and moves through 90°. In Act 6 he is almost totally hidden. But (he points out) he is not totally hidden to the audience – but to an imaginary audience hidden backstage. For Acts 7 and 8 he is totally hidden to the audience, as usual moving the furniture through 90°. At one point a shoe is thrown out, as a red herring, a way of creating a diversion to prevent the audience from wondering about his motives. The change of shoes to a black and white pair he regards as a subplot.

The entire action is an extension of the way the actors become the furniture in *Homage to Morandi*. Not every one of the actions contributes to the main functions of moving through 90° and hiding. The shoe subplot does not, for example. As the performance continues, we take delight in watching a man solving physical problems in the most acrobatic and elegant way. The same is true of *Table Move II*, which begins in total darkness and is totally different in both pace and tone. The square 'stage' is still there. One by one each of the props is presented: two chairs, a table, a wardrobe, two books inside the wardrobe, two buckets also inside the wardrobe (one of them empty, the other full of water) and two gas lamps. Each time a prop is brought out the whole set moves through 90°. One of the assumptions is that the wardrobe never moves. As in *Table Move I*, there is an added condition. After a certain time, the aim is to move the furniture through 90° but without touching the floor. The onset of this second condition is marked by the wardrobe falling – suddenly and noisily. It is then that the figure jumps onto a chair in surprise, and never touches the floor again. The hinge of the action is the point at which after every object has been set out, the figure begins putting them away again. At this point, when the audience can imagine what is about to happen, the action must become more unexpected, more dense and more various. The piece gets higher and higher. The wardrobe falls. Most unexpected of all is the sheer virtuosity of Howell's progress diagonally from one side of the square to another, over a table and a bucket in order to pick up the book without touching the floor. Everything finally returns to its original position except that it has been subjected to a 90° move and is flat on the floor. It seems to the viewer that he is seeing it from above.

Language has disappeared from Howell's range of elements now that he works alone. His movements are more balletic – he trained with the Royal Ballet school. And perhaps the systematised mime he performs is nearer than ever to being a demonstration of a process of thinking. Only logic can free the figure from a situation which is illogical because it is arbitrary. In an interview with me three years ago at the time of *Homage to Morandi* he said 'I think we (the Theatre of Mistakes) use logic to defeat ourselves'. Finally the number of intersecting systems governing the decisions of his company became so complex, so removed from the outsider's understanding, that they produced events which were almost arbitrary. Howell admits the influence of Raymond Roussel, whose method of writing was a machine to replace imagination. The distance from content in Howell is similar. In an interview he compared writing to performing: 'You'd think you'd get more distance sitting at a desk, on one's own. But I think actually one doesn't because one's closer to oneself in that situation.'

Just as he is not 'close to' himself in performance, the audience is not making contact with an individual personality directly, nor with a persona. Nor is he employing a Brechtian alienation effect. So unfamiliar is the concentration on sheer structure that it is well over half way through each piece that the configuration of the set elements assumes any emotional potency at all. In the second *Table Move* there is one moment where at last the chair is at the table, the lamp is on it, the book lies in the light of the lamp, the coat is over the chair. It looks like home. A second later he has picked up the table and ruined the image. Howell is conscious of the associational qualities his gestures take on – the diagonal trek (he admits) resembles a kind of Noh theatre version of fording a stream by means of stepping stones, for instance. Yet the image was not deliberate; it was found, not made, as the piece made itself. Similarly the gradual ascent to higher places and the bucket of water give a strange narrative air to the gestures, as if this is a time of emergency such as a flood.

The *Table Moves* evoke emotion although they do not convey it in the usual expressionistic way. 'Chamber' works in more ways than one, they are a deliberate attempt to create a performance version of Cubism, with objects resolved in front of us, even showing their tops and bottoms. Just as the earlier Theatre of Mistakes pieces were the result of concentration on one element from the exercises, the *Table Moves* follow naturally one from another by means of removals. Howell points out that if in *Table Move I* he takes away himself by concealing his person, in *Table Move II* he takes away the floor. There is a

toughness about the necessity of adapting that they display; if something is taken from you, you solve your problems without that thing. The elegance of the solution, the sheer panache of Howell's execution, comes to resemble triumph over adversity. Perhaps after all we are watching not an acrobatic feat like a Chinese juggler but some sketch for a contemporary *King Lear*. If tragedy is admitted – or floats in from nowhere, as ideas and content and emotion do in the *Table Moves* – then so is spirituality. The image of the figure making his way perilously across the edge of the fallen wardrobe to make a tableau at its base, above the floor but not looking down, arms outstretched in an embracing posture, is the end of a journey, a sign of received grace. The audience is made vividly aware that something of great importance has taken place.

The question, then, is elementary. Is there a way out of the performance crisis? If so, perhaps the activity that restates the potential of the medium and distils its best may be too 'abstract' to deal with matters of relevance. With Anthony Howell this is not the case: the politics does indeed lie in the structure. The *Table Moves* are capable of making a social statement without confronting social realities, without directing or re-expressing them. In addition, they determine a future for avant-garde performance by ignoring outdated problems of 'mixed-media' or some 'underground' political sexual/social statement inherent in the use of performance itself as a medium. As long as even one person can make works as vivid, ambitious and elegant there is a way out of the crisis.

An interview with Joseph Beuys

Published in Parkett 7, 1985. *The interview was recorded in London shortly after the Miners' Strike of 1984-5, at the time of the exhibition 'Plight' at the Anthony d'Offay Gallery*

Stuart Morgan: Is it true that your *Ulysses* books contained drawings related to the present felt-lined room?
Joseph Beuys: Yes, I began using felt towards the end of the fifties, beginning of the sixties. That was for small objects. Bigger ones did not appear until 1962-4. The concept of felt sculpture on a wall, on its own in a gallery, dated from 1968-9 and there are drawings of a room exactly like this one in the *Ulysses* notes – a room related to felt and feltiness, but with a proportion of four.

Why did you choose *Ulysses* as a point of departure?
There was no choice. Once I received the commission from James Joyce to prolong his novel to six volumes I simply did it.

The title of the new work is *Plight*. Is it your plight?
No. 'Plight' is an idea with two poles – one positive, the other negative. On the one hand a difficult situation, a dilemma. On the other trust, a bond.

Between... ?
Between human beings; between human beings and nature, human beings and animals, plants, earth.

So far I see only felt-lined walls, a piano, and on it a blackboard and a thermometer. What else will be in the gallery?
Nothing else. So from this point of view you could say it is a concert-hall, although there is no possibility of sound penetrating it.

A hall for silent music?
No, a music hall which is silent. But it is not silent because nobody is playing there; it is like that because of this cultural aspect which is an expression of

being silent. It is isolated, insulated. There *is* no sound less than sound. And when there is no outer sound, nothing physically to be heard, then the inner sound of the soul – let's say the *imagination* of the music – appears as an even stronger suggestion. So *Plight* works by a very strong contradiction.

The less there is around us, the more we fall back on our imagination.

Yes, you could say that. But also the less the din of exterior noise, the greater the possibility of a healthy imagination. I am reflecting on human innerness, the development of human potential. Outside the situation there is no more sound. It is at zero, which marks the threshold of the conventional understanding of sound or music or sculpture and tends towards an anthropological understanding of art.

'Anthropological'?

The development of art, as everybody instinctively knows, is one of the most important things in the world because it reflects the fact that secret things are condensed, especially in human beings. So the movement of art inwards is a kind of approach to this threshold. No longer are all the rules given by outside authorities as was the case in Egyptian culture, Roman culture or the Renaissance. Nowadays it has to come from the people, principally. Hence the most interesting common factor of Modernism: the elimination of any tradition in favour of individual concepts. So, for this reason, there is no connected style as there was in Baroque or Gothic, which were collectively indoctrinated. Now every human being develops his or her own culture. That's visible in Modernism, and most of the radical carriers of the idea of the Modern are trying hard to eliminate tradition. So there is a lot of destructiveness in Modern art, but it is destructiveness as a positive activity – to destroy the tradition in order to approach concepts which lead to freedom. This is the reason for Expressionist distortion and equally for the concepts of Mondrian, which offer a very radical elimination of tradition in painting. This implies that a time will come when people will have to create the world anew, a transformation of the social order. Art based on such transformation is an interesting historical development. When there was spiritual leadership as in the eras of Egypt, Greece, even partly in Rome, everything served the idea of religion and the spirit. In Roman culture everything was directed by law. Nowadays our culture, seen radically, can only be described as economic. Changing the law or economic conditions according to old socialist concepts is not possible any more. The only tool is revolutionary power based on mankind's creativity, self-determination, self-government and self-administration. This means that through the idea of art, democracy and

freedom and brotherhood could one day become a reality. But – and this is the result of my experiments – this is only possible by the methodology of art. So you have to widen and revise your traditional understanding of art to an understanding of a relationship to mankind's labour.

What is the role of the artist in the social model you've outlined?

Because he is already using this kind of method to work with the idea of creativity, the artist has only to come to a consciousness about these things. I try to bring a kind of clarity to this consciousness. Not every artist is convinced of my ideas. Most of them stay in their conditioned understanding of painting and sculpture. They look for effects and see if they succeed or not. This is interesting, naturally, but it is not the meaning of art. For me art means a radical change in the social order.

Marcel Proust had a cork room. He shut himself off from society. How does your felt room relate to that?

One association of my room in *Plight* is of isolation. The other is the warmth of the material. Surely this shutting off from society is an anti-communication element; it has a negative, even hopeless feeling as in some Samuel Beckett pieces. The other quality of the felt is to protect people from bad outside influences. So it is also a positive insulator. You can make a suit or a tent out of it, like the Mongol tribes. It protects them against cold, storms and the outside world because it contains a lot of warmth. It is organic. This positive side – protecting people from danger – is the other extreme of the meaning of this piece. So the idea of a concert hall without sound looks completely negative at first, but it is meant to stress a threshold where everything moves to a critical point. Everything beyond that point is transformed, transubstantiated, and surely the general meaning of art is the complete, radical change of human beings, beginning with their knowledge of themselves. During the last 300 years they have followed radical, rationalistic, intellectual, materialist ideas of life and nature. This one-sided view of intelligence is a great danger – at least, I see it that way. Intelligence is a fine thing and also, perhaps, the ability to employ mathematical concepts. So I am not against the fruits of the materialistic period. I even admire the results of materialism. You could say that the atom bomb is a masterpiece of technology; potential for analysing physical laws, invention in physics and chemistry and so on. So you could say that the materialistic period has been very necessary for the transformation of mankind. But that kind of knowledge overrates rationalistic judgement. Every part of nature, and therefore human beings – will die if this one-sidedness stays for too long. So art brings in

some other understanding of what creativity really means: not intelligence, simply, and finding an answer to what something means. Art is approached by all the senses – and human beings have a lot of senses. Visual art touches the senses. Balance, hearing temperature (I find temperature the most important element of sculpture)... Those things are interesting because they are translatable into the human psyche. Instead of something you are confronted with, outside, all the senses combine to make the human being and the sculptural work one thing. Otherwise 'understanding' means only a logical explanation which would be better written down. If the meaning of art is that there is anything to understand by some intellectual method, it would be better to write it down immediately; there would be no reason to work with felt or bones or clay or whatever to make forms. So this identification of the perceiver and the maker has to become a kind of unification. Immediately an identification with the senses is possible. Gradually people will learn that creativity is not just a leisure-time problem but a stratum of their own being. They will also learn that there are different strata; thinking is a structured thing with intelligence on the lowest level, and on the highest level intuition, inspiration and imagination. So a lot of possibilities exist for the development of man's thought and thinking power. It is very useful to learn this because the future of the world is the work of human beings. There is no longer a God to do these things, a creator who cares for the forests or for the ecological problems. The future of the world has to be the work of human beings. So they have to approach the quality of a god. They have to move in this direction. The spiritualisation of the human being is a working problem which extends the whole network of society. The miners' problem is principally related to this; it is not a social problem which can be solved with the ideologies of the last century. It can be solved with the idea of self-determination, self-government, the idea of creativity and the discovery of new workplaces because there *are* no more available workplaces. Soon the so-called traditional workplaces will have almost completely disappeared and to struggle for more of them in an old-fashioned way is struggling for an impossibility.

So what is the immediate answer for the miners?

The immediate answer is for them to stay together. The problem with the Labour Party and the Unions can only be solved by avoiding a clash of opinions. It is important that differences exist. These can be discussed all the time – there can be a permanent conference. But in order to talk about social problems first requires solidarity.

You have talked about animals and politics, in the *Hirschdenkmal*, for instance. How does this relate to unions and solidarity?

The *Hirschdenkmal* was an idea of the workplace where the idea of the worker was widened to include the stag, an animal which is also a soul, not so very different from a human being because of its strong feeling of power and suffering. The stag is connected to the social problem of workplaces. I called this *A Meeting for the Animals*, to go into factories and take part in the labour that has to be done. This kind of development of understanding of work and labour means that animals have to have their own democratic laws. But at present they are being killed. They die earlier than humans. It seems true that animals have more tender biological defences against pollution than human beings. So this has a lot to do with evolution. They have a lot to do with humans. Animals must get democratic rights, must be implanted with 'human rights'.

Could we talk about the *artist's* workplace?

Team work was always the characteristic of the Renaissance – Raphael is a good example. A lot of his work was done by others. I think he had about 300 people involved, always working. He was a very clever businessman.

Do you approve?

It depends. Working with other people is very positive. It depends on the meaning and the result. Making art alone very seldom occurs in antiquity. Modern artists develop a studio. But not everything can be done by a single person. Supervision is necessary. So for *Plight* the felt 'half-column' units were made specially by a factory in Bavaria – they left their other jobs and finished these for me in two weeks – but the decisions about them were all taken by me. The thickness, the shape, the height, the tension of the rotundities, the proportion of seven, the softness or hardness of the material, the colour, the stitching... say, about 40 different parameters. This leads to a kind of co-operation. I have found that Andy Warhol's ideas are close to mine – the relationship of art to the workplace.

In your work an ideal of co-operation depends on individual decisions, it seems. Similarly, *Plight* is a place where people go to be alone. After the experience of innerness they return to society.

Yes, they leave as changed people.

Edward Allington:
Getting It Wrong

Published in Edward Allington: New Sculpture, *Riverside Studios 1985*

A perfectly respectable box changes its mind halfway and dwindles to the floor in a leafy serpentine. A leaning form like a plasterer's hawk which has sprouted breasts supports, or is supported by, an outsize wooden scroll. A room with drawings covering the outside walls becomes a peepshow offering glimpses of a drawn environment and objects within, with the same configuration repeated on ceiling, floor and walls. This is an art of redundance and manic doodling, varying between inertia and excitability; of embellishments deprived of an edifice to embellish; of shadows, mirrors and unexpected encounters in empty rooms. Unlikely combinations of elements and styles erupt as decadent classicism becomes Surrealist neo-Baroque. This is hardly 'expensive executive jewellery', a recent charge levelled at new British sculpture. [1] Rather, it is an art of the improbable, of disjuncture, of ornament as excrescence, of elegance become bulk, of matter as time; it is an art of the white elephant.

These shapes are not the product of whim; they are the result of common sense. Allington is no *faux naif*. Nor is he untrained. He simply thinks about things he cannot understand and evolves his own answers to them. At any given time his work embodies the latest stage of his deliberations. In his conversation one phrase crops up repeatedly to describe what he does: he says he is 'getting it wrong'. Then he corrects himself. 'Getting it wrong *my* way.'

Allington has always been preoccupied by the shifting status of the world. *Trompe l'oeil* exercises such as *The Golden Pavilion: As Seen From The Front* (1984) proceed from moments of actual uncertainty. He relates a childhood experience of crawling up a gulley in Cumberland out of a valley covered with

orange bracken, when, because of the shape of the hill and the angle of the sun, he moved and the bracken turned blue. Drawing and sculpture together offer the possibility of stage-managing such incidents, of simultaneously registering and eradicating discontinuity – in sculptural terms, of making the greatest possible disparity between angles of vision. Both in terms of vision and belief, the reaction is one of fluctuation. Describing a panorama he saw at the age of nine in Innsbruck, a combination of a 360° painted canvas depicting a battle scene from the Napoleonic wars and real earth and scattered objects, he says simply that 'as a child my eyes and mind ... alternately accepted this extension of the illusion and then rejected it.'[2] But to extend an illusion is also to destroy it. If both visual situations are viable where does the truth lie? Perhaps it exists between the polarities and can be shown only by a cipher of absence. *The Hall of the Mirrors' Scream* (1985) employs the mirror and the window, the two main metaphors for representation in Western culture. There is no true way of picturing a mirror. Nor is there a way of perceiving reality in a mirror, which inverts any image before conveying it to the observer. Once more truth escapes. Just as ornamental fragments exist in the absence of the building on which they depend, the goal of Allington's work seems to have no physical existence; it is the grin without the Cheshire cat. Even in less deliberate operations, Allington remains aware of what Joyce called 'the ineluctable modality of the visible'. In his drawings objects cast shadows so odd – either perverting the objects we assume have cast them or appearing out of perspective – that a dialectic is established between the 'real' and its double which calls both into question. Invariably the figure-ground dichotomy is emphasised; Allington's paper is never blank or new but consists of a collage of old, found documents with a history of their own, bearing information which demands to be read in a different way from the drawing.

If Allington brings his viewers to a boundary between defined modes of vision, he does something similar when coping with another aspect of the status of objects: their nature as genuine or spurious. This year he has been making bronzes of his wooden sculptures, calling them 'false' versions. Yet falsity seems inbuilt into his way of approaching things in general. In a characteristically dogged attempt to find a sculptural vocabulary that would be complete, personal and 'true' he spent a year making *Ideal Standard Forms* (1980), a set of floorbound plaster shapes. The apparent discrepancy between the adjectives 'ideal' and 'standard', the celestial and the workaday, is typical; these imagined forms would be divested of their ideal nature as soon as they were made. The

very gesture of manufacture, of forcing imagination into real terms or adding one more dimension to the drawings, indicates the unsatisfactoriness of *either* dimension; the work, essentially, exists nowhere. In more down-to-earth terms, of course, Allington explains that in making his version of Platonic forms he was failing in his own way.

Another approach would be that the genuine is the original and the spurious a copy. Allington changed his views on this after a journey to Greece. Always enthusiastic about Greek culture, he visited masterpieces of Greek architecture only to find them overrun by tourists, multiplied and distorted by souvenirs and postcards. His conclusion, that there *was* no original, was reflected in a jotting of 1983. He wrote that the Argo, the ship that bore the Argonauts on their voyages, was subject to one ordinance: that if any part rotted it had to be remade.

> Thus the Argo became immortal in the manner of that well-known saying: 'This is my grandfather's axe, my father fitted it with a new shaft and I have fitted it with a new head.' Consequently I have no doubt that the Argo still exists today, perhaps transformed over the centuries by the minutiae of human error into a restaurant or a souvenir shop of the same name gaudily bedecked with plastic ornament... [3]

As a ceramicist, the choice to mould rather than throw pots had vast cultural ramifications; historically, moulding was connected with mass-production and consequent devaluation of the 'original'. Reacting against the Greenbergian distinction between art and kitsch, he opted for a longer view – a *regressus in infinitum* of man-made vessels with no first or last. When, as a student, he devised his *Venus de Milo Fireplace* (1974) or his *Vase* (1974) bearing transfers of the Temple of Athena Nike at the Acropolis, he was attempting something akin to the remaking of the Argo – reconstruction, which (in a statement on his own work) he carefully distinguished from 'reproduction':

> Take something like period films where the costumes have been doctored, tuned up to fit a contemporary idea of history. With Fellini's *Satyricon* for instance the costumes have no relationship to any historical model ...
> Then take the costumes in *Spartacus*, also wrong, but Fellini's [film] rings truer because it's so off-key. It's like the difference between reconstruction and reproduction. In reproduction you aim at this thing which is totally effect; with reconstruction you are aiming at the idea underneath

something, not just the appearance. The important thing is this sense of wrongness. [4]

His recent plan to remake the *Ideal Standard Forms* may be partly reconstruction, partly reproduction. Now, while he is still intent on making a vocabulary for himself, as *Room As A Box* (1985) demonstrates, his reconstituted forms in *Ideal Standard Forms: Ornamental Version* (1985) are pretentious, kitsch, overloaded. Is he updating his *own* 'originals' and starting all over again? Will his versions of the ideal standard forms become increasingly decadent and overgrown as the years go on? That the two systems are in opposition seems evident from the sculpture *We Are Time* (1985), in which one older and one newer form are spliced together.

We Are Time consists of an elongated satellite evidently in movement, propped up by a fixed bulbous leg, made more monumental by its leafy markings. The result is an irreconcilable combination, the kind of visual nonsense which invites us to interpret *Kisk* (1985) or *Odalisque* (1985) in the same light. ('Kisk' might be a mishearing or a Northern dialect variant of the word 'kist', meaning a chest, particularly for money, or a coffin.) In the manner of Allington's previous spirals from *The Fruit of Oblivion* (1982) onwards, the startlingly lively leg could be ascending or descending, a branch or a root. Coffins disintegrate, fertilising the ground from which they came. So this wedding of the raw and the cooked could be moving either forward or backward in time. Yet there is a third overlay; *Kisk*, like *We Are Time*, seems intent on becoming a piece of furniture, in this case a grand piano, resting on its pedals as if they were front legs. *Odalisque*, as its title suggests, has figurative overtones; it lolls heavily, flaunting its sexuality. The significant co-ordinate is undoubtedly design; Allington's ideal would be to restore the idea of instilling meaning into decoration, even if shock tactics were needed to do so. Baroque provides a model for this, and increasingly Baroque is the period 'reconstructed' in Allington's work. Again a remaking of one sculpture led the way; the first version of *From Forgotten Seas*, dated 1981, was completely white. By 1982 the three plaster shells had been scraped and painted white and gold, in homage to the Baroque 'misunderstanding' of the Greeks. In the new work, *Kisk* is particularly Bernini-esque, a reminder of Daphne's metamorphosis into a laurel tree. That physicality, or more properly sexuality, which is so powerful an undercurrent in Baroque, has been touched on more than once in Allington's previous sculpture. The story which accompanies *The Groan as a Wound Weeps*

(1984), for example – a shower of plastic tomatoes tumbling out of or ascending into a blue shell – is about German Baroque woodcarving, where sheer voluptuousness, either pain or pleasure, meet and mingle in the carved drops of blood of a crucifixion, are changed into decorative form. Above all, perhaps, the theatricality of Baroque is attractive to Allington, who quotes with relish Borges' introduction to *A Universal History of Infamy*:

> I would say that the final stage of all styles is Baroque, when that style only too obviously exhibits or overdoes its own tricks. The Baroque is intellectual, and Bernard Shaw has stated that all intellectual labour is essentially humorous. [5]

The polarisation of bulk and trickery in Allington's latest work produces some of his grandest paradoxes. The conception of time as undifferentiated flow, without past or future – the logical extension of the refusal to acknowledge a beginning – is now confronted by its opposite: style as an act of forcibly halting time in order to make it congeal elegantly. Again Allington cites a literary precedent – Yukio Mishima's explanation in the postscript to the printed version of his play *Madame de Sade* that the rococo glamour of the actresses' costumes would be adequate compensation for the lack of onstage activity. Concomitant paradoxes, more explicit than in the cornucopias of 1982-4 with their posed flux, have similar resonance. Overtones of glut (both dream and nightmare in capitalism), of sexual abandonment, religious idolatry, are still present. Yet the mood has changed. The more empty, brittle and aristocratic it becomes, the more sinister the opposition of bulk and trickery. Allington has spoken with approval of the Dionysiac urge:

> Reading about it or gazing at dislocated fragments in museums we can catch a glimpse of another way of living which was orgiastic and physical, even almost bestial. What we need now is a new understanding of what was lost then. [6]

According to René Girard the Dionysiac elimination of distinctions rapidly degenerates into a particularly virulent form of violent non-differentiation, as man and woman, man and beast, man and god are confused in religious rites. [7] The possibility of total breakdown of accepted barriers makes Allington's strategy all the more pointed. Suddenly the act of repeatedly situating his works

on boundaries between modes of vision, definitions of status and accepted functions of the object seems dangerous in the extreme – a way of courting and holding at bay forces he can barely gauge. The thinking behind the works is still steady, even plodding. Yet this slow plod has taken him further and further into enemy territory – forbidden zones of godlessness, statelessness and taboo. His work shows that in any age the most subversive act is to think for yourself.

1. Art & Language, 'Julian Opie's Sculpture', in *Julian Opie,* London: Lisson Gallery, 1985, p.10.
2. Jacqueline Ford, *In Pursuit of Savage Luxury,* Nottingham: Midland Group 1984, p.27.
3. Ibid. pp.28-9.
4. S. Nairne and B. Ferguson, eds. *Space Invaders,* Regina, Saskatchewan: Mackenzie Art Gallery, 1985, p.11, 14.
5. Jorge Luis Borges, *A Universal History of Infamy,* Harmondsworth: Penguin, 1981, p.11.
6. Jacqueline Ford, op. cit., p. 27.
7. René Girard, *Violence and the Sacred,* tr. P. Gregory, Baltimore and London: Johns Hopkins 1977, p.127.

Eric Bainbridge:
Dumb Insolence

Published for an exhibition at the Air Gallery, London 1985

An Eric Bainbridge sculpture is an exercise in taxonomy, a lesson in camouflage, the rehearsal of a formal repertoire; above all, it is an act of defiance carried out with unexpected weapons. 'All the good things I've done have been made despite my intelligence,' says Bainbridge. Certainly his career so far cannot be plotted as a succession of neat formal tricks. On the contrary, it constitutes a series of impasses; at each stage the problem of how to continue has been compounded rather than solved. His work is not anti-intellectual. For him stupidity is not a message but a point of view – a way of scoring points against 'civilised' values.

Inexpressiveness appeared in an early work called *Putting on a Brave Face* (1981), which comprised two boxes, both of one-inch thick plywood with another box on the inside, so heavy it took four people to lift each one. The first was tightly packed with padded rectangular units. Just below a glass top was a neon hieroglyph in the shape of a curve which partly resembled the simplified form of a head but which, considered abstractly, hovered between male and female identities. Wedged midway inside the second box was a five-foot square photograph of a man whose expression was part grimace, part smile. The ambiguity of the situation and the noncommittal, tragicomic reaction to it made a closed circuit. Dramatised by restricted visibility, contrasts of scale, brilliance and, most of all, by the faulty placement of the single object in one box and the fixity of the blocks in the other, the 'brave face' itself was a legitimate response to an enigma.

The problematic engagement of the self with a world which might be out of reach of the senses subsequently gave rise to three large paintings on paper:

Man in the Night, Man with Oxygen on His Back Against a Dark Landscape and *Idiot Against a Dark Landscape* (1981). Loosely rendered in dull colours varied with pinks, yellows and limes, they showed cross-sectioned profile heads with 'vision' beaming from the eye and brightly outlined, unspecified organs located outside as well as inside the skull. Expanding on the crisis of perception — paradoxically internalising it and rendering it theatrical at the same time — the three figures showed a precarious hold on perception, even on life itself. An entire phase of the sculpture resulted from these works: two-dimensional, wall-mounted wooden cut-outs leaning on sticks which protruded from their eyes; faces made from hand-sized lumps of ordinary clay, with features formed by poking fingers quickly into them; a large box of these heads; and most significantly, large, upturned heads, again of solid clay, their necks thin and elongated like handles with which they could be wielded.

In combining two approaches – the head as heavy object, a solid lump of matter, or as a vessel so fragile that not even its vital components would be retained, these tangible caricatures suggested permanent disjunction. To focus on the rift between perception of matter as either dead or alive, between gross flesh and insubstantial spirit, between feeling and non-feeling – Nietzsche said 'Things are the boundaries of people' – permits an examination of these margins. At the same time Bainbridge was aware that they could only be summoned, not displayed; *Wound* (1982), a limbless torso with a deep incision, employed bulk to frame an absence.

After being portrayed within the work itself, the response to an existential crisis had been explored in terms of contradictions which characterised existence itself: the relation between disunited elements in our own make-up – physical, emotional and intellectual. A play of opposites also marked the new approach begun in 1983, an approach he continues to adopt. Objects built up singly out of chicken-wire, supporting layers of hessian scrim and industrial plaster, are covered in cheap fur fabric, then assembled into complexes. Though the modelling is rough and the application of the fur makeshift, these tensions are partly assuaged by a full-scale structural principle which has come to govern his formal choices. The determining factor is a doltish classification system which disrupts deep-seated beliefs and challenges our culture, itself a sorting system. For the tone of mute opposition is heightened, not dispelled, in these nonsense anthologies.

From harping on unendurable tensions Bainbridge turns to constructing them for himself. High meets low, ideal and abnormal rub shoulders, above all

143

humour and fear are brought together. That which should be kept apart is condemned to coexist, forming a hybrid with no generic description. So in *Monument* (1985) a hair slide, a music-centre, an exhaust pipe, a ship and a child's soft-drink container are thrown together — in other words a vessel/tower which contains air and repels water; a plastic, air-repelling container of liquid which is sucked; a tube for the passage of gases, complete with two nipples and a phallus; a slide/sword of no value nor of any heraldic significance, all resting on a nondescript box of value and technical sophistication. Sucking, blowing, penetration, withdrawal, luxuries and rubbish. Interfering with this cross-referencing are three opposing tendencies: metamorphosis, camouflage and a kind of poetic licence. Walking around the sculptures it is possible to recognise shapes from some angles but not from others, with the result that they loom in and out of recognition independently, establishing a permanent state of dissonance within the work itself. Weight and scale are subject to adjustment. Most obvious of all, the bogus animal pelts throw misleading shadows over the masses, denying and complicating their true shapes. The 'fun fun' serves to advertise the insistently 'animal' associations of the forms while joking about the taming of these instincts. The joke is the permanent, triumphant emergence of the infantile.

Two pressures counter each other in these works. One is the sheer vitality and invention, encompassing a wide range of reference. *The Dilemma of Jimmy the Nail* (1984) parodies the predicament of earlier heroes, with their brave faces and idiot grins. Combining visual cues – the zigzag cipher which denotes infinite extension in technical drawing, the face of the actor Jimmy Nail, who plays lugubrious North Country blockheads – with verbal ones, like the fact that his local football team were called 'The Steelmen', Bainbridge creates a mascot whose jauntiness belies his state of imprisonment. (*The Ascension of Jimmy the Nail* (1985) affirms his status as a captive whose only hope is divine intervention.) Similarly, *Pelouche* (1984), a deadpan rearrangement of the features of a human face, parodies modernism in the same spirit Tony Hancock did in his film *The Rebel*. It was designed as a belated footnote to that film – the prop that was never included, the sculpture that such an artist, with his total faith in his own ability to make masterpieces, should have made. If Bainbridge's energy seems to reach out into the world, drawing it into the purlieu of his art, he is equally responsible for an opposite pressure. Severed connections – chopped heads, liberated lungs, kidneys on the run – become muffled and dry. Their furry wrappings protect them from each other. By stages the imagery has

been removed from its origins. Despite the fact that the title refers to reggae, for example, the swan in *Dark Style Swan* (1985) was modelled on a soap dish from an Oxfam shop. By the time of *Disguise Style Swan* (1985) its neck has grown into an ornamental bracket from a kitsch candleholder. Perhaps it was inevitable that Bainbridge would embark on a series called *Abstract Sculpture*; his complaint about the defunct British formalism he was taught at the Royal College of Art was its irresponsible approach to the images it removed from the world. His eventual attitude, however, seems equidistant from Caro and Cragg, nearer in aim to the recent Cragg, with his attempted relocation of early modern concerns.

His suggestion, supported by the oversize scale and the furry texture, is that the entire activity is a form of play – not without its more sinister undertones, as Categories disintegrate, male and female merge and separate, bottles grow faces, nails sprout wings, dinosaurs develop skyscrapers instead of warts. All this occurs in an area of easy transference where limits between the natural and the civilised are abolished and permanent discontinuity is the norm. Behind grotesque is myth. Behind myth lies the id, which follows what Freud called 'the inexorable law of ambivalence'. Operating on boundaries between classifications, which are the rules we live by, Bainbridge proffers a vision of the possibilities of an unfallen world, a way of understanding our fallen nature. The oppositional stance of work like his is obvious. The only way to reach it is by rejecting norms and laws, by embracing stupidity and proclaiming that embrace. We need art as dumb and insolent as this.

Colin McCahon:
The Leap of Faith

Published in Artforum, *October 1986*

Earlier this year, a visitor to the National Art Gallery of New Zealand in Wellington would have seen Colin McCahon's *Practical Religion: the Resurrection of Lazarus showing Mount Martha* (1970) hanging in the entrance hall. Because McCahon's paintings remain in museums or private collections in New Zealand; because almost all the published criticism of his work has emerged from within his own country; even, perhaps, because he has rarely ventured beyond his native land, the canon of 'world art' never includes him, and his greatness is acknowledged only there. But if even a reputation supported by the power of the local institutions has barely extended outside two islands in the Pacific, how can other New Zealand artists (including Maori artists) ever enter an international arena? The New Zealanders could be wrong, of course, or biased, or provincial in their estimate of their own art. What if they are correct?

The impact of *Practical Religion* is disorienting. Painted in black, white, and grey, it resembles a huge home-made billboard with elements of text and landscape. One of a series of paintings containing advice on the everyday aspects of Christianity, on 'practical religion', this visual litany is a meditation on the raising of Lazarus from the dead as described in the New English Bible, which is also the source of the painting's subtitle, *Victory Over Death*. As the eye is drawn to one local incident after another in the work, from a shift of scale to the impetus of a brushstroke, the relation between those incidents becomes harder to grasp: the reading of the painting unfolds gradually, with many repetitions and new beginnings, each modifying the narrative that is being visually dramatised for the reader. McCahon's rickety calligraphy is used to

stress assertion or ambiguity or suspense, to support or reverse interpretations as they emerge.

As in many of McCahon's works on biblical themes from the forties onwards, when he began to use his immediate locale and even his neighbours as subjects (in *Marge as the Virgin Mary at Maitai Valley*, painted in 1946, for example), his version of the miracle is set in New Zealand: Lazarus' sister Martha doubles as Mount Martha, in North Otago, the area where he began painting his brooding, unpeopled landscapes. The Bible provided a reservoir of understood knowledge that could be applied to the individual – in this case, a New Zealander. Localising the setting of New Testament events was a way of bridging a divide between collective feeling and individual experience. Despite his biblical subject matter, however, it would be wrong to regard McCahon as a religious painter or even a religious man. When he focused on the Lazarus story, or on the remarks of spectators witnessing the Crucifixion ('Will Elias come to save him?'), he allowed room for scepticism. As in his *Necessary Protection* series of the seventies, about the preservation of wildlife and a view from the cliff tops over the sea, he was choosing a problem generally couched within fixed parameters, but he then resolved it poetically, by means of ambiguity, extending the range of possible meanings so far that a proposition and its opposite could coexist. So *Six Days in Nelson and Canterbury* (1959), the record of a journey, divided into six separate frames, refers to the Creation but approaches heresy by suggesting that the walker himself is responsible for it. The freedom with which McCahon dealt with accepted religious ideas is paralleled by his unusual ability to relate to different cultures – Japanese, Maori, Renaissance, and Modernist art – and to operate at a point where they intersect.

McCahon's 'writing' has sometimes pre-empted any other action in his work. Virtuoso draftsmanship is among his strong points; as a child he was supposedly able to draw different pictures simultaneously with his right hand and his left. At art school he produced 'hundreds of posters' and it is hardly surprising that the virtues of the classic poster inform some of his paintings – *The Virgin and Child Compared* (1948), is only one example. Speech bubbles, a device borrowed from the design of the Rinso soap-powder box, began appearing in his paintings around 1947, issuing from the mouth of the prophet Ezekiel or of Mary, the mother of Christ. As calligraphic experiment continued, McCahon's paintings became vivid records of the act of inscription. His way of loading a brush with white paint as a writer dips a pen in ink, then writes until it is exhausted, parallels breath in song or lineation in poetry, while his dispersal

of parts of a text, with overlaps and differing emphases, gives an abstract impression of how narrative, like music, draws to a rhetorical climax. His transcription of texts is partly performative: McCahon 'delivers' his lines like an actor. And, like an actor, he speaks other people's words. His quotations may be in English or Maori, from the Bible or from poetry.

For the artist to act out his borrowed words by painting them, as a priest gives a sermon, is also an aid to understanding his thought. Below his version of a particular text the reader glimpses other, equally rich possibilities. The self-referentiality that the text acquires, as if it is reading itself as we watch, recalls experiences of music, or the ritual repetitions of oral cultures like that of the Maori, who recite their genealogies as a record of history and as an act of self-definition. In Western culture, only the telling of beads would offer equivalent meditative possibilities. McCahon has copied Maori genealogies in multi-panelled paintings, and has also employed the motif of a semicircle of airborne dots, like the map of a trajectory that has become both a rosary and a Polynesian lei.

During the seventies the meanings of McCahon's paintings became increasingly rich as he employed his vocabulary of signs in an ever more bewildering variety of contexts. *Mondrian's Chrysanthemum of 1908 (View from the Top of a Cliff series)* (1971) recalls an image from the work of a favourite painter and allows it to hover on the horizon, turning it into a setting sun or an atomic explosion. In *Tui Carr Celebrates Muriwai Beach: Moby Dick seen off Muriwai Beach* (1972) the tau cross, a familiar cipher, doubles as McCahon's young grandson, throwing his arms upward in sheer joy as the offshore island of Oaia turns into the Great White Whale. Similarly, the letter I, which appeared in *I Am* (1954) as the very name of God, gradually develops the associations of a passage of light from Heaven to Earth, a path for grace to descend. A negative space like an I, defined by two dark verticals, adjacent but divided. reappears in paintings of twin black cliffs – Motutara Island, with its resident gannet population, and Otakimiro Rock, a parallel cliff of equal height. Yet it is impossible not to look at this pictorial breach without recalling a long-running theoretical concern of McCahon's: the invention of a 'way through' the surface flatness of the canvas, which he felt had been approximated by Georges Braque and perfected by Piet Mondrian – a way of connecting with real space, the space beyond and outside the canvas.

So, as series overlap, extend, or interrupt others, McCahon's long-term preoccupations are orchestrated and rearranged and the ciphers he continues to

use are reduced to essentials while acquiring an ever heavier significance. The name of God in the Old Testament, handed to Moses to use as explanation, was 'I Am That I Am'. The term 'I', which defines a single person – a term perfectly stated in pictorial terms by the addition of two abutting black verticals to an empty field – McCahon achieved in art only through relinquishing artifice by means of artifice; in moral terms, the equivalent would be one's willingness to define oneself with reference to God. Within a single configuration McCahon brings together religious and artistic themes. Like Barnett Newman, a painter with whom he is sometimes compared, he pictures the act of artistic creation as a Promethean endeavour, and seems to regard the duty of the artist as a kind of liberation – the stripping away of inessentials and the unmaking of one's own skills. A 1974 painting in the *Jump* series dedicated to the Japanese artist Tomioka Tessai, whose work he saw on his only visit to the United States, uses a dotted line to trace the leap between the twin pillars of rock, a leap as impossible as it is unavoidable. Though the result may be extinction as easily as redemption, the jump is a risk that everyone must take. In McCahon's own terms, it involves art or faith or both. It is one's duty, simply, part of the definition of the 'I'. It is a jump he knows.

By the seventies McCahon's painting and his process of thought were indistinguishable: his signs and calligraphy were capable of sustaining debates on both politics and religion, debates carried on as the testimony of a representative man having to make a moral code from scratch. He had turned into a consummate actor; as his work moved through him he altered its course. While making the Lazarus painting, he said, he was racked with 'joy and pain'. Then he added, 'To be honest, it was a bit like drawing a Mickey Mouse cartoon.' A Walt Disney crucifixion scene would involve a near-impossible collision of tones which McCahon regularly attempted in his painting. Irony is simultaneously invited and dispelled. His historical stance was equally risky. Gradually he moved toward a final position: a summation of Modernism, an extension of it, and a meditation on it, in a sign system as polyvalent as it is ontologically rich, with the simplest mark intended to be read in as many different 'languages' as possible and the meanings in each language not only differentiated but set against each other. The main achievement is to resolve the problem of the alienation of the artist by making the vocabulary flexible enough to include issues that can be regarded as matters at once of individual duty, shared responsibility, and universal concern. From the plight of small birds on a single cliff top he explains humanity's relationship to nature, for example.

Bridging cultures, mixing dissimilar patterns, he makes an art that is properly post-Modern in the least obtrusive way.

McCahon's is a career with no famous teachers, no direct contact with Modernism except distantly and late – a friend of a friend who studied at Hans Hofmann's school in Munich, a chance meeting in Melbourne with an old lady who had attended the banquet for the Douanier Rousseau in 1908 in Paris. Forget distance and lateness. McCahon, who today no longer paints, was eager to engage not only with Cubism and de Stijl but also with Giovanni Bellini and Maori carving, with Petrus van der Velden and Tessai. The dates of his paintings may sometimes seem to put him behind the times; sometimes they put him ahead of them. His *Object and Image (notice board)* (1954), a painting of the dictionary definitions of the terms 'object' and 'image', has been dismissed as a piece of graphic design. And so it might be if McCahon had not proceeded, in the seventies to make his own version of what the rest of the world recognizes as postconceptual painting.

Sooner or later the games will be played out. A critical élite will decide to expand the limits of the canon to include McCahon, perhaps as an oddball, perhaps as a unique variant on more familiar figures. Let us hope it never happens. He neither needs nor deserves condescension.

Terra Incognita:
an interview with Simon Lewty

Published in Artscribe *56, February-March 1986*

I know you keep dream diaries.

Yes, I write my dreams down as soon as I can. If I wake up in the night there's a strong resistance which often takes the form of a feeling that this particular dream is too obvious to bother to record. These are probably the very ones you need to take note of because if you can draw or annotate them somehow, then come back to them, you can't remember a thing. It's as if they happened to someone else.

What form do your notes take?

Well, noting the dream is done mainly in writing but there are also little scribbles in which I try, if I'm working on dream imagery, not to alter or improve but just to get it done. The result is a kind of tangle, but also the diagram of an experience. It doesn't look much like a drawing. Parts might be written. I find that I have to leave that and return to it later because of a temptation to elaborate too consciously: by projecting something onto it you censor it. The drawing may come next day or not for some time after. In it I try to be as faithful as possible to the feel of the dream and everything about it – the sound and smell as well as the visual part – and to include equivalents for those.

What relation does the finished drawing have to what you saw in your dream?

Not all of it is dream material; dream is one ingredient in the total mix. Above all, I'm concerned with superimposition. The idea of layering and palimpsest as a metaphor for imagination. The earth itself consists of strata. People who pass through the landscape leave traces.

So you want to show time in a concrete way.

The passage of different kinds of time: time as history (outer time) combined with time as myth (inner time).

Memory is also a kind of overlay. Memories of childhood figure largely in your work.

The actual situations in the pictures may be where the childhood memories come in. Not really understanding what was done to you; going to hospital where everyone is kind but you don't know what is happening; going to school for the first time ... The experience of life as a map you don't have a key to. Later when you are in disturbing situations you become a child again. People don't get much better at coping.

Overlay also plays a part in your technique.

Yes. The final version of the drawing, made by squaring it up and transferring it to the larger sheets, is done on tissue with black acrylic. That is the most calculated part. Then I prepare a sheet of paper the same size. But thicker. It's been written on, scribbled on, stained and rubbed. Most of the writing goes on at that stage. The texts are sometimes prepared; sometimes improvised. The same is true of the strings of impossible words.

What purpose do they serve?

Very often they occur to me just before I drop off to sleep or when I'm in a daydream. Then they seem curiously real – more real than a thought but not as real as an object. All words are metaphors but also objects in their own right. A neologism is a word which betrays its function of communicating.

When you make the word are you thinking of an object?

No, just sounds. And association must play a part because one word triggers off others. When you read them they have a kind of incantatory quality.

As well as the strings of nonsense words there are prose passages. How do they relate to the images?

Obliquely. Sometimes they do refer but not always. Sometimes two narratives could be going on simultaneously. What I don't want is the feeling that the text is just illustration. I enjoy the feeling that the words and images might interpenetrate spontaneously, almost by accident. When you bring disparate realities together the mind is bound to try to make sense out of them. The act of combining them is already halfway towards interpretation.

Finally the two sheets of paper are stuck together.

Then what is underneath shows through, or partly so. There are places where solid acrylic might cut into a word.

How do you feel when a drawing is finished?

Strangely unpossessive.

Your drawing style veers between gigantism and miniaturism.

Often in the same picture. It disrupts habitual local length. I like that sort of picture you can get your nose up to, then step back, then move forward again. Text does funny things too. It flattens space – the Cubists knew that – and disrupts the experience of looking.

Another basic feature of the style is the constant use of dots.

The technique of building form through using dots of different densities was carried over from earlier, smaller works in pen and ink. It suspends figures between physical and mental existence.

The edges of your figures emphasise volume while in the centre there is almost too much empty space.

It's like being in a dream; your limbs look heavy but feel light. I like the feeling of form without tactile sensation or illusion of volume.

The freedom allowed these figures is reminiscent of the independence of the elements in (say) a Miró. What relation do you have to Surrealism?

Well, I wouldn't want just to evoke a psychic realm. That's where a lot of second-rank Surrealists floundered; they destroyed themselves because they were not in control of their images. l would not want to become a kind of magician. I would like to root things in a context which could be historical or even geological. This is where the landscape interacts with the organisms that inhabit it and it grounds these things – literally brings them down to earth.

There are two anachronistic habits. One is a deliberately reversed projection.

In Byzantine mosaics the perspective is often not just wrong: it's opposite to what it should be, as if you're in the picture looking out. I do it quite a lot. It still reads as perspective yet it contradicts illusion.

The second is an almost medieval use of compartmentalisation.

It's an alternative to perspective – a space you read from one section to another.

But there is no correct way of moving between sections.

Exactly.

One feature of both word and image is the constant return to given locations.

I have certain themes, and all of them associated with places you could go to and experience but which wouldn't mean anything to anyone but me. As soon as I begin drawing or writing I'm in one of these inner worlds. They also tend to focus on a theme which can be displaced, shifted sideways.

So each of these situations carries certain emotions.

And has certain effects on its inhabitants. For instance, the idea of the field is like

a place where a lot of things meet, past and present, a place with a fluid boundary which things pass through without stopping.

And the room?

Rooms in my work are all associated with early childhood memories of particular places in the house, which seems an endless space for a child. Going in the attic is like a safari to the ends of the earth. The room protects but can also threaten. It's a refuge, a container, yet so often in dreams that sense of enclosure becomes oppressive. It's the antithesis to the field.

The yard lies somewhere between the two.

It's an enclosure out of doors. It isn't nature: it's man-made. Yet it's not contained within the house. I'm interested in marginal areas, not quite city or country. Allotments are an example: places where all the rejects from people's lives – doors, bathtubs salvaged from demolition sites are recycled in a shabby way.

Your barns seem to be made of solid brick. They are a complete mystery. The viewer has no idea of what is going on inside.

Maybe nothing. Or they might be full of sheep, or straw. Except for a door and a vent-hole they are totally enclosed.

Is that comforting or not?

I think it is.

How many recurring locations are there?

Field, yard, room, barn, hedge, gate, city street at night, fence as enclosure, water, in the form of a stream flowing from a well into a tunnel…

When these shorthand descriptions of places are located on a single plane the result looks like a map or an old document.

In maps made before the scientific age they included all sorts of things. What they didn't know they invented. So they were as much inner as outer maps. They knew that Jerusalem wasn't literally at the centre of the world but in another sense it was. They had no idea of creating an imaginative construct of what they knew about the physical world.

Because a map was more like an encyclopaedia, distance would have been a hazy notion.

Space would have been measured in time – the distance it took to cross it. So a young man's distance would have been different from that of a child or an old woman.

In your work this is interiorised.

Movement is movement through yourself – travel as metaphor for life.

But the idea of cartography also involves abstracting from lived experience.

Well, a map is diagrammatic but it also functions as a surrogate for experience, in the way a score relates to a musical performance. The map of a place you know well is almost like a key which lets you back into remembered experience. If it's a map of *terra incognita* it's also a key; certain places can only be visited through maps and possibly my landscapes are among them. It's not just about a place and associations with that place; it's in as many dimensions of experience as I can encompass. Map as key implies that art involves coming to terms with experience, putting together apparently unrelated things in the only way I can: by including as many dimensions of experience as I can encompass. Sometimes I bring in uncharacteristic things. One picture has a television set in it, which is very far from the timeless quality of a lot of the rest of my work. My problem has always been that I want to get everything in. My work is a way of composing experience, of recreating through imagination a lot of mental matter from many different sources and levels. In his preface to *The Anathémata* David Jones says there must be no loppings-off, no tidyings-up.

Could a comparison be made between the structural disturbances in *The Anathémata* and the spaces between the elements in your own work?

What gives Jones's poem its unity is his religious commitment. His theme is the Mass. I have no such theme. I am dealing with the residue, polarising it around myself because of inability to polarise it around a tradition. I'm not a Catholic or a Buddhist or whatever. Something between an individual and a collective idea. So there are iron filings but the magnetic centre is gone. The difficulty is one of communication and interpretation, because one's own experience is private to a degree and although it links up with other people's shared experience there's no single thing, outside the individual, which we can plug into like a religious symbol. My pictures are like icons without a prototype.

So are you reaching out to an idea of art which would function as a means to contemplation?

The attitude to my own work which I find most satisfying is that one. There's a story about a Chinese artist who painted a large picture of the emperor. It was a landscape but it had a door in it and everybody wondered why he had painted the door. When they asked he said 'That's easily explained,' and he went up to the picture, opened the door, walked through it and was never seen again. I like that idea of being able to live in a picture. When I'm making one of mine I am in it, absolutely involved in the actual processes that take place. I am seeing my own imaginative workings mirrored back to me at every stage.

Under the Sign of Saturn

Introduction to the catalogue of an exhibition selected by
Stuart Morgan for the Nigel Greenwood Gallery, 1987

'*The manuscript should be with us on Monday,*' says the voice on the telephone.

'*No sweat,*' the writer replies: '*It's going well.*'

This is a long way from the truth. It is already Sunday morning and so far he has not written a single word. That lie came glibly off the tongue because at this stage he needs to feel that it might be true. After putting the phone down and circling the room, picking up objects – a bad daily newspaper, a postcard, a book – he returns to his desk even more disconsolate than ever, and remains staring at the sheet of paper in front of him. No prison could be more confined than his, no mind more mobile yet unproductive, no body more sluggish, no labour so apparently humdrum. He sits for a while, waiting for invisible cogs to engage. Then he returns to his circumambulations.

The book catches his eye. This time he picks it up and begins reading. The blank page, it says, 'is a place where the ambiguities of the world have been exorcised. It assumes the withdrawal and the distance of a subject in relation to an area of activities. It is made available for a partial but regulatable operation.' That word catches his eye. Regulatable, indeed. 'A separation divides the traditional cosmos, in which the subject remained possessed by the body of the world. An autonomous surface is put before the eye of the subject who thus accords himself the field for an operation of his own. This is the Cartesian move that initiates, along with a place of writing, the mastery (and isolation) of a *subject* confronted by an *object*. In front of a blank page, every child is already in the position of the industrialist, the urban planner or

the Cartesian philosopher – of having to manage a space that is his own and distinct from all the others in which he can exercise his own will.'[1]

As he puts down the book and picks up the postcard he notices a chubby child in the background of the picture, busy scribbling, oblivious to the winged woman who scans the horizon balefully in the foreground. Surrounded by tools which lie unused, she ignores her starving dog and her half-empty hourglass. There is work to be done, there are journeys to be made, flights to be taken. But not today. Today she has abandoned her equations, left her writing undone and sits gazing into thin air. She has a bad case of something or other. The writer is wondering what when he spots a bat flying past in the distance with the name of the disease in its mouth. 'Melencolia', it says, and in Albrecht Dürer's day everyone knew what that meant.

Distracted, disorientated, the melancholic proves faithless to other people, and therefore solitary. Frustration over this self-inflicted loneliness can lead to suicide. But, like work, suicide can be postponed in favour of contemplating misfortune, an abstraction which becomes 'massive, almost thinglike'. The phrase was coined by Walter Benjamin, himself a melancholic, or so his contemporary admirer Susan Sontag has maintained.[2] The pleasures of hashish and getting lost, arranging and rearranging his book collection, occupied part of Benjamin's time. The part he devoted to his writing was never as large as he would have liked; his magnum opus on the arcades of 19th-century Paris was never completed. Refused a university post, bullied constantly by Bertolt Brecht, he tormented himself with the prospect of literary analysis which would be cabbalistic in its multi-layered approach, and dreamed of a book of collaged quotations from other writers, organised so cunningly that they would spring upon the reader, he said, as brigands attack travellers in a forest. If these were cures for terminal boredom, they all failed. Confronted by Dürer's etching, Benjamin might have been drawn to that giant stone shape on the left, 'like something completely indigestible', as Heinrich Wölfflin described it.[3] And with his taste for emblem and allegory Benjamin might have seen it as the ultimate writer's block. Could the way to shift it be to solve the riddle of its strange proportions? Saturn, the ruler of artists and depressives, is the planet of measurement, after all.

As he picks up the newspaper the writer reflects on its lack of proportion; the world has more to offer than sex in Streatham, royal babies or lying politicians. If only art could take a journalistic role – not one of reporting facts but of testifying to how if feels to be alive, here, now. What is needed, the writer

believes, is an art which encompasses the everyday, which allows for sublimity without refusing to acknowledge the difficulty of the meditative exercises which made that emotion possible; an art which is commensurate with our knowledge, despite the problem that this knowledge may no longer seem translatable into imagery; an art with emblematic or iconic density which will exist both in and out of the world in a subtle, unfixed relation to insides and outsides, to thinking about experience and the simultaneous embrace of that experience; an art in search of a new measure and a new phenomenological ratio. But how can he write that down, he asks himself, returning to his desk and gazing into space, his head on his clenched fist and his elbow on his knee.

1. Michel de Certeau *The Practice of Everyday Life,* tr. S.F. Randall, Berkeley 1984, p.134.
2. Susan Sontag 'Under the sign of Saturn' in *Under the Sign of Saturn,* London 1983, pp.109-134.
3. H. Wölfflin *Die Kunst Albrecht Dürers*, Munich 1984, p.208.

Louise Bourgeois: Nature Study

First published by the Arts Council of Great Britain in 1985 for the exhibition 'Louise Bourgeois and Alice Aycock' at the Serpentine Gallery, London. Subsequently republished together with the essay 'Lair' in Louise Bourgeois, Taft Museum, Cincinnati 1987

'I think that to be a sculptor is to have things to say,' Louise Bourgeois told one interviewer. 'I wouldn't say ideas because that's intellectual. But there is something you want to say and nobody is going to keep you from saying it.'[1] No one ever kept her from her art. They simply ignored it. With the exception of Joan Miró, the Surrealists paid no attention.[2] Predictably, the Abstract Expressionists were not interested. Bourgeois kept on working. 'A woman has no place as an artist' she said, 'unless she proves over and over again that she won't be eliminated.'[3] Persistence, determination… the third principle was repetition. 'If we are very compulsive, all we have at our disposal is to repeat, and that expresses the validity of what we have to say.'[4] Her 'say', her repeated proof that she would not be eliminated, was her art itself, a body of work – never has the metaphor been so applicable – which confirmed, time after time, that it was her: her circumstances, her emotions, her flesh, her sexuality.

Recognition came at last, with a retrospective exhibition in 1982 at the Museum of Modern Art, New York. Although she is now a famous artist, her output is relatively little-known. Critics have been slow to discuss it in depth; perhaps her directness, the sheer intensity of emotional effect, causes trepidation. Perhaps the apparent simplicity of her statements is a way of diverting attention from the difficulties of her art. Or perhaps both the size and the nature of her output is disconcerting. For an artist with no fixed style or material or medium only one rule seems to apply. That is, that there are no rules – no rules, at least, which cannot be broken. But perhaps the very idea of breaking them provides the clue.

From the age of twelve, Louise Bourgeois was employed by her parents, tapestry restorers from the Aubusson region of France, drawing outlines on canvas to guide workers with their repairs. Usually, she recalls, she drew limbs. One problem was that 'the new colours – natural ones, earth and plant derivatives ... would never fade and mark themselves as different.' [5] Irrelevant? Perhaps not. When she grew up she would not only make her art but also invent her own model of what art could be. Dislocation is crucial to that model, together with ideas of breaking, departure from, incongruity, even counterfeiting. The common characteristic is a single unit which has two parts, or two components read as one, an apparently innocuous state with serious ramifications.

Unwary visitors to Bourgeois's solo exhibition in 1984 at the Robert Miller Gallery, New York, entered a small room only to be confronted by a bronze monster. *Nature Study* seems anything but natural. Firstly, it is a fragment. Light slithers over the flanks of the headless creature, revealing a double set of paws but no forelegs. Secondly, the animal proves to be a little more human than we might wish. Could this be what makes us shudder? Or is it the three tiers of female breasts combined with sexual organs which are indisputably male?

Duchamp's remark that the spectator completes the work of art has never been truer than in the case of Bourgeois' sculptures. Each one offers an individual drama. By 1949 she had abandoned bases in an attempt to destroy the museum paradigm. Instead, she explained, her works would 'construct and inhabit their own social space,' jolting the viewer out of a passive state. [6] In this case, then, the base as part of the work itself and the references to antiquity can be read ironically. The jolt is accentuated by the spotlights, the appearance of antiquity and the height of the pedestal, which raises the genitalia to eye-level. Shock is part of the effect. Yet unlike hieratic beasts who exist merely to show defiance, this one is poised to defend itself as much as its invisible charge. Instead of the expected fleece is hairless, sensitised skin. (Is it afraid because it is trying so hard to be frightening?)

Bathed in light, its sleek, shaved musculature makes it only too evident that no points of transition exist between itself and the environment. Deprived of orifices, the creature is all skin, that membrane which separates us from that which is other, foreign. It therefore becomes such a model of self-inhibition, so deprived of exchange with the outer world, that it is bursting for transaction. Erect, weighty with milk, it is prepared for the world

to come to it, on condition that there is no absorption, no excretion, no perception, no conscious emission of signals. It forces us to be its slave, yet it does so without malice. The conditions by which *it* is governed are the moral dimensions of one entire view of the body: the myth that we have insides to serve as receptacles for holding breath, suppressing passion, summoning subjectivity. If the result is swollen, it is because in order to establish a 'skin', a truly protective barrier, there must be an inside expanding to make it. Skin begins where the expansion stops. The creature is striving for mastery. Why then is it hairless, flayed, weak? One reading of the Fall (Genesis III) is that Adam and Eve are expelled from a condition of harmony between their bodies and external nature into an awareness of their body surfaces, consciousness of nakedness, guilt about eating, painful childbirth, a wrenching from the earth out of which they are made and to which they will be returned. Doomed to consciousness of their orifices, they will be compelled to control focal points of transition. [7] Defined as a Western human being, this monument, this paragon of self-control which Bourgeois has set up, may fall from grace at any moment. It quivers in fear or anticipation of the descent into the orificial.

Bourgeois's relation to her work is direct and unforced. 'I feel that l have been shredded,' she tells a reporter. An enterprising researcher would have gone immediately to look at her *Shredder*, a bulky wooden torture instrument to roll over bodies and mangle them neatly. In *Nature Study* the ability to objectify forces that threaten or condition her is aligned with surrogate self-portraiture. It should come as no surprise that in a quite different context Bourgeois once said 'We are all vulnerable in some way, and we are all male-female'. Another dislocation enters the repertoire, with all its attendant confusions. [8]

'Gamblers and womanisers, that's how they were,' says Bourgeois of the men in her family. [9] Her father combined the two in a liaison with an English woman named Sadie, an affair complicated by his wife's willingness to employ Sadie to tutor their three children. What might have seemed a good idea – at least she knew where he was – had embarrassing consequences for children faced with the prospect of having to construct their own model of family life by splicing together two incompatible relationships. Young Louise never reconciled the unusual ménage with her own need for security, her need to be told the truth, most of all her perception of precise distances between people. She did not know where she stood. (When she made her

vertical personae later, she stressed that they could be grouped in different ways 'although ultimately each can and does stand alone.'[10]) Foreground and background merged. What should have remained secret was common knowledge: it was 'open' but not discussed – certainly not with the children, who were the most affected by the consequences. That the extra-marital had not remained extra-mural left a lasting impression. For little Louise the next ten years was a period of divided loyalties, of fantasies of the murder of both her father and Sadie. The violence of her reactions has never diminished: as late as 1974 she built an environment called *The Destruction of the Father*, subtitled *The Evening Meal*, a cave-like space where pendulous shapes dangled over a floor strewn with what appeared to be bones. It is clear that for her the situation has taken on mythic dimensions. 'Aggression,' she has said, 'is very easy to recall.'[11]

Despite traditional caveats against the 'intentionalist fallacy', the temptation to employ Bourgeois's own comments about her work in any discussion of that work is overwhelming. (D.H. Lawrence put it best: 'Never trust the teller. Trust the tale.') Somehow her details, even of life, seem to unlock the art, not diminish it. The way Bourgeois has talked about her pieces has always broken 'unbreakable' laws about the supposed non-referentiality of abstract sculpture. In historical terms her position could be represented as a kind of holding action. William Rubin has argued that her stress on intimacy involved a refusal to alter the morphology of sculpture in response to Abstract Expressionism. In other words, landed with an outworn vocabulary Bourgeois responded to the need to replace it by simply looking at it differently instead of changing it physically. Embracing Rubin's historicising point of view leads to a conclusion he may never accept. Since women were excluded from Abstract Expressionist circles, it never occurred to anyone that their relation to the grandiose tragic content of the period might be different from that of their male counterparts, though based equally firmly on the ideas of the time. Rubin's motive is to categorise Bourgeois as an artist trapped between different phases of history and devise a neat formal solution to her problems.[12] Feminists would scoff at this. For them Bourgeois was undoubtedly responding to the same stimuli as Pollock, Newman, Still and the men, but she was responding as a woman, and as a woman of outstanding visual intelligence. That she came armed with her own content has repercussions not only for a period of art history but for art in general and women in general. If a tension exists, then, between her talk about the art and the art itself, the reason can be sought in Bourgeois's 'entrance' as

an artist – the moment she aligned herself with a given tradition but tried to disturb it in a fundamental way. [13] An 'either/or' interpretation has come to apply to artists of the period. For example Rothko's move from evident mythic content to full 'abstraction' has to be construed as either an incorporation of earlier subject matter or a departure from it. Bourgeois's talk is symptomatic of her equivalent position: to insist on a local habitation and a name for each of her works, before turning them loose. Does she operate in some split language, then? Addressing himself to the Gospel according to St Mark, the critic Frank Kermode suggested a dual identity for the text – a 'carnal' or literal reading and a 'spiritual' or latent one. 'Carnal readings are much the same,' he argued, 'Spiritual readings are all different.' [14] Bourgeois may respond to similar treatment. Hers is also a text which jumbles proclamation and concealment.

The more one considers her practice, the odder it becomes. Take the habit of remaking a sculpture in a different medium, then shifting it to yet another, at the same time an outrage to beliefs in truth-to-materials and an attack on doctrines of 'originality'. Or the need to express equilibrium in decoration, with what Gombrich called its 'oscillating interplay between representation, fiction and pure form'. [15] She confesses that her working is 'eccentric', off-centre. 'Perversion', Leviticus would call it. 'Swerving aside', Freud would have said. The Hebrews had a word for it: *tebhel*, a mixing. Crossing barriers, the loss of strict limits, is as familiar in Bourgeois' work as her own signature. *Genre, genera*, genitalia…each is undefined, redefined. She performs her act of adultery/ adulteration – of corruption, debasement, counterfeiting or (as the Oxford English Dictionary would have it) 'base admixture'. Improper conjunctions, unconscious though they may be, demonstrate an inbuilt need for transgression. Bent on impurity, at war with definitions, Bourgeois tries to alter the fact that framing and genre, defined sexuality, and most of all value judgements are one and the same, both repressed and repressive, above all inherently, traditionally, male. For her the most 'natural' reaction is to make (let us say) a classic sculpture which is also a travesty of one, in the form of a non-existent breed with a sex which is both sexes at once. Natural? One can almost see her shrug her shoulders. Of course. But this is no mere polemic. It is part of her – 'a Louise Bourgeois'. For this woman every nature study is a *human* nature study.

1. Lynn F. Miller & S. Swenson *Lives and Works: Talks with Women Artists,* Metuchen, N.J. and London: Scarecrow Press 1981, p.6.
2. See Robert Storr 'Louise Bourgeois: Gender and Possession' *Art in America* April 1983,

p.134.

3. Cindy Nemser *Art Talk,* New York: Scribner 1975, p.9.

4. Lucy Lippard 'Louise Bourgeois. From the Inside Out' *Artforum,* March 1975, p.28.

5. Robert Pincus-Witten *Bourgeois Truth,* New York: Robert Miller Gallery 1982.

6. Susi Bloch 'An Interview with Louise Bourgeois' *Art Journal,* Summer 1976, p.372.

7. Jean Starobinski 'The Inside and the Outside' *Hudson Review,* Spring 1975, pp. 333-347.

8. Lucy Lippard op. cit., p.31.

9. R. Pincus-Witten op. cit., n.p.

10. Deborah Wye *Louise Bourgeois,* New York: Museum of Modern Art 1982, p.55.

11. Deborah Wye op. cit., p.100.

12. William Rubin 'Some Reflections Prompted by the Recent Work of Louise Bourgeois' *Art International,* April 1969, 17-20.

13. George Kubler *The Shape of Time,* New Haven: Yale 1962, p.6.

14. Frank Kermode *The Genesis of Secrecy,* Cambridge, Massachusetts: Harvard 1979, p.9.

15. E.H. Gombrich *The Sense of Order,* Oxford: Phaidon 1979, p.162.

Taking Cover:
an interview with
Louise Bourgeois

Published in Artscribe *67, January February 1988*

Stuart Morgan: What's this piece called?

Louise Bourgeois: It embarrasses me to say I don't know what it's called. As time goes on it means different things to me, so I don't have a title. This is not my job. As far as I'm concerned it should have four or five titles. My subjects recur. They might look different but the subjects themselves are the same. This one might be called Number 17. I've done about that number of these. *Triangle 17.* It is a triangle because there are three points.

And what does the triangle mean?

Triangle means trouble. Triangle means a conflict in the relationship between three people.

It looks like a single form.

Three people or three different sides of the same person.

Does a triangle represent a love relationship?

Love? I didn't say love. A triangle means a tense relationship between people. Most of the time it is quite hostile.

Are we dealing with passion? Or revenge?

Resentment, yes. Revenge? It is very unwise to be vengeful. Disagreement, I would say. Instability. But this hand, which appears several times, is a pacifying hand which says 'Now, cool it. It's not so bad. Things will be alright.'

If a three-way relationship which is so tangled and fraught can reach a point of equilibrium is that good or bad?

It is very good and it is very rare.

The work is about the alleviation of tension, then.

Well, there are three spirals here, and the spiral is a symbol of tension. The centripetal spiral becomes wider and wider and nothing happens. This is a centrifugal spiral, which moves towards one point. This is to say that you crank it, and if you crank it too much, it cracks.

In this case energy is turned in on itself. Is it emotional energy?

No. Plain energy. The energy you have at 11 o'clock in the morning after a very sweet, sugared cup of coffee. You might call it strength. What you do with it is something else.

Is the work autobiographical?

The pacifying hand could be considered a self-portrait. Rightly or wrongly, I fancy myself as reasonable. In this other triangle, my hand is a child's. It is inquisitive, almost grasping, very young. It wants a lot and wants it instantly. Children are unreasonable, unwise, and undisciplined. Their wishes are conflicting, exaggerated. They have no doubt. This is the hand of a little god.

Are children foolish?

They know no strategy.

You lay great emphasis on techniques for survival.

I'm interested in all that but I'm an ignoramus about it. I have no doubt that you understand strategy yourself.

This is turning into a private conversation.

I don't mind. Whether something is private or public makes no difference to me. I wish I could make my private *more* public and by doing so lose it.

Aren't you afraid of exposing yourself by doing that?

Yes. For instance, when we started talking today I felt that I couldn't go on because my clothes were going to fall off. I said to myself, 'Louise, your clothes are *not* going to fall off,' and I controlled it.

Let's get back to strategy.

This show is about the inability to use strategy. When I fail to trap whoever I want, what else can I do but run for cover?

Taking cover is an acknowledgement that *you* are trapped.

Yes. Absolutely. You have it. I am trapped. How do you expect me to trap anybody when *I* am trapped? So it is a movement from the active to a regression into passivity, into means you can afford. I don't want to be bookish but I'm going to be. I am interested in the phenomenon of inspiration: why today I cannot do a single thing and the next day everything happens and I can make myself understood. In the 18th century when they were very pragmatic and very scientific and very American, they had it pinned down. Inspiration, they said,

was this or the other thing. Ernst Kris has written, and I discovered it at the end of his book, that inspiration is the regression of the active into the passive. 'I have to hide, otherwise I will be trapped.' So in admitting that we have no power, we become more than ourselves; we think in ways that the mind has no normal access to.

So what you are saying is that the mind is not finite.

No, no. The self is always turning round.

But if we admit that we are finite, even for a moment, we receive energy from somewhere else. Where does it come from?

It comes from our love of the self. That is to say, instead of despairing and breaking, you say, 'Well, I cannot have this,' and you have to be satisfied with less. This is an admission of fear and maybe of hostility too. Inspiration comes from retreat.

Well, how do you feel about religious people who...

I am not dealing with nuts now. I am being absolutely rational, Right?

The metaphor of retreat is central to your work. One of your favourite titles is 'Lair'.

I know how to make lairs. I can make them subterranean, I can make them...

How do you define 'lair'?

It is a place to go, a place you need to go, a place of transitory protection. The latest is called *Articulated Lair* because it has no fixed form; it is completely flexible, with 47 uprights, each of which has three hinges.

And they fit together to make a circle.

If the circle was not completed, the parts would all fall down, like dominoes. And you can add or subtract.

There are two doors, one in front and another at the back, to one side.

One is an entrance, and the other is an exit, in order to escape if cornered.

For *you* to escape.

Right. For people without strategy. All they can muster is a lair.

Is escape a strategy?

It is a strategy alright, but a miserable one. It doesn't deserve the *title* of strategy, that's for sure. For me, strategy is always a move, not towards the self but towards someone else.

So you sit on your stool in the middle of your articulated lair.

And I enjoy it. It is a beautiful place.

And it's your nest, like an animal's.

Right. If this one is destroyed, I can make another.

So it's about lying low.

And watching. You watch to see whoever is coming and you have an attack of anxiety whenever a person is coming. But you recover and escape. It is a very considered way of living.

'Articulated' means the lair is made in sections.

You can add or subtract. That's what 'articulated' means. So articulation is the symbol of a relationship that can change or improve.

Another new work is shaped like a house, cut away to reveal every floor. But it also looks like a kind of shop-window display showing white plaster moulds with clustered forms that resemble fingers or cacti.

It's about the pleasure you get from being with and talking to and fooling around with people you understand. The people I understand are artists. I cannot understand critics. I bear with them. I cannot say we are pals. But artists are all basically the same. When there are no tensions or rivalry then we really have a good time because there is room for everybody. In this piece the elements are happy to nestle together and act together because they want the same thing, they suffer from the same elements.

It looks like a greenhouse, with things growing.

But as you see, some *don't* grow. Some stay tiny and others develop. But they definitely like each other. In civil rights marches in the sixties there were thousands of people who didn't know each other. They communicated because they wanted the same thing. And you had the feeling that every one who came in was welcome. It is actually the definition of America. I don't want to be moral now, but this is the feeling I have as a foreigner here. If you make the effort you won't be pushed out.

Presumably the dangling leg relates to a difficulty in articulation.

It is about the control of pain. When I was about 18 or 19, I got a job as a guide at the Louvre in Paris. Believe it or not I talked to Americans, and sometimes people from Australia. The Australians would say 'Gorgeous! Gorgeous!' I'd never heard that word before. Anyway, this was my job. I worked from nine to five. Now, the French are very strong on lunch. I was allowed to go to the basement and have lunch with the staff. This is like a story I am telling. So I go downstairs and find a hell of people with amputated limbs, people who had been wounded in the war. If you are wounded in the war in France you are entitled to an official position. I'm talking seriously now. And I walk in and look and a leg is cut off or an arm is gone and they are all in that basement eating their lunch. And I had such revulsion. I had to do something about this unfortunate

occurrence with legs. This is trouble with articulation, right? If you take a little key you can unscrew this bronze leg and change the direction of the light. It is definitely not a catastrophe. definitely. And that is it. When I say articulation I mean hardware. With the *Articulated Lair* my pride and glory is that the hinges are foolproof. There are three of them on each upright and nothing can go wrong. Each piece must be lifted out. It is simple and very secure.

The *She-Wolf* seems to be about a relationship.

The She-Wolf is simply my mother – not the way she was but the way I perceived her until recently. There is an enormous creature with no head. the head has disappeared and the throat has been slit. So you can see the poor thing has gone through quite a lot. But she is still standing because she is eternal. There is something under her left paw, a little figure nestling there. And as you move up close, you see that the little figure is pleased as Punch, because she is protected. The murderous figure who is treating her that way has no motive except to be loved. The kid is myself. It is a self-portrait.

That figure has appeared before in your work.

Yes, it is the shape of the *Fallen Woman*, which is also a kind of self portrait. All these subjects appear on many occasions. Now, *The She-Wolf* is a very tender piece. The fact that you have tried or even almost succeeded in killing your parents doesn't mean that they don't like you. You can count on them.

When you talk of killing the parents you are talking literally or metaphorically?

I never talk literally. Never, never, never. You do not get anywhere by being literal, except to be puny. You have to use analogy and interpretation and leaps of all kinds.

How strange that you think this, then go away and work with hard materials.

Oh, but the resistance of the material is part of the process. If there was no resistance I could not express myself. I can express myself only in a desperate fighting position.

Fighting against the marble.

Fighting anything you can. If you look at the finish of the material in *The She-Wolf* you can see that it has been hacked away with a pointed chisel. This is a unique finish for me and it is very carefully done as you can see from the light. It allows for extremes of tenderness and aggression.

Why is her surface different from that of the child?

Because she can take it. Such is the resistance of the mother figure. This is the

definition of a parent. You have to be a saint to be a parent.

Would you call *The She-Wolf* a drama?

In a way it is dramatic; it is universal, but the figure is personal.

Don't you feel that in working this way you are making a monument?

But my parents *are* monuments. This is not too big. It could be much bigger.

Once again this is an articulation, two things moving in rhythm. Do we conclude that the only strategy is to make life tolerable by trying for equilibrium like this?

You know I have no recipe for anything.

Then we can't end the interview.

We can end by saying that sculpture is an exorcism and when you are really depressed and have no way out except suicide that sculpture will get you out of it and get you back to a kind of harmony. That is the purpose of it.

Simon Linke: Twilight Zone

Published in Artscribe *63, Summer 1987*

Locked for the night, the brightly lit gallery looks perfect: clinical, resolved, tragic. Inside, the paintings adopt a position so weak that they leave no option but to tolerate them, their structures too banal to satisfy, their size unrelated to anything at all. How distant they seem even from the advertisements which provide their subject. Incident abounds: the tangles and serpentines of impasto between each letter of 'Lucas Samaras' or the looping brushstrokes between each of his names; the paint flicked into a peak like shaving-foam between the N and the W of 'Robin Winters', the staccato flurries over the 'Alice' in 'Alice Aycock' or the wavy motion over the 'Ross' in 'Ross Bleckner'. All this is decoration and bluster. That paint began thick. It goes where it is pushed, but where it is pushed seems somehow arbitrary. Perhaps the act of copying makes art into a chore, and painting a canvas becomes like painting a window-frame. Forgetting they are on top of buildings, steeplejacks step off into space. Does an equally dangerous Forgers' Syndrome exist – growing bored, doodling and giving the game away? Instinctively, one searches for errors and finds a few: accents misplaced in 'Miro' and 'Tapies', artists' names misspelled, like 'Simon Edmunson' for 'Simon Edmundson' or 'Susan Fuller' for 'Susan Hiller'. Bloomers, no doubt. But whose? The artist's? The magazine's? It scarcely matters; the question of simulation has been broached. Curtail traditional assumptions – originality, intention, expression – and what is left, exactly? A knowingly debilitated art, bound to fail? Or a stratagem by which issues of power are engaged?

Reflect on the sorry dislocation of constituents. Brushy painting and pigment the consistency of icing sugar recalls the critique Wayne Thiebaud mounted of a second rate Abstract Expressionism which took Greenberg's culinary metaphors too literally. Updated, the style becomes both parody and disclaimer. Neo-Expressionism flaunting its hefty brushwork espoused the causes of the Right, however much it protested otherwise. This style neither sanctions nor condemns the activity to which it is geared: the production of paintings for sale. It simply exists as proof of acceptance of that production. These are paintings about the art-business from inside that business, to be bought and sold by insiders. Is this the end of the line? Or could it be the ultimate in gallery shows? 'I only want to buy one if my name is on it,' coos one young gallery-owner an hour before the opening. 'Is that narcissistic?' she adds, looking me straight in the eye. Perhaps. But it is also the perfect response to these overly self-reflexive devices. 'Self-reflexive…' The term makes them sound musclebound, armed to the teeth. Nothing could be further from the truth; having backed down from any position of resistance, they have capitulated with market forces by appealing to those for whom buying art offers a means of enhancing their social and financial standing. Superficial almost by definition, the paintings also parade their status as token of exchange. For all that, as paintings, they may be about an ideal.

Artforum's advertisement section permits a glimpse of the cogs of a vast machine by which art is publicised, bought and sold. But it is more than possible that this machine may already be outdated, intriguing more for its prestige than for its usefulness, pitiable in its assumption that interpretation is anything more than the jargon-ridden pastime of the young and financially secure, pursued as a means of gaining academic promotion. Bent on staving off cynicism by persisting in their attempt to equate artistic with economic 'value' museums, galleries, most of all magazines are fighting a losing battle. Value is now the province of corporate consultations, private dealers, powerful collectors. If that is the case, these are quotations of a symbol, not a reality. Combining the veneer of the recent past with assumptions centuries old, they resemble fake antiques which may seem either more plausible or more outlandish as time goes by. What is a contemporary antique? The product of misdirected craftsmanship in an age where the significance of that craftsmanship has declined. And rightly, inevitably declined. Out of context and time, it is the test-tube baby of contemporary culture, conceived in a vacuum as an art commodity. As such, it is appropriately impersonal. In the 19th century it was

customary for silversmiths to sign the grandest pieces 'Benvenuto Cellini', not to fool anyone but to indicate genre, the knowing virtuoso fake which was neither fooling anyone nor trying to. Perhaps there is something Victorian about these paintings, in their conception of history as an accretion of detail seen from a provincial, protected position and their consideration of history in the abstract as an invocation of its power to continue as a force. Who could be blamed for feeling nostalgia for the old-fashioned marketplace on the eve of its demise?

Yet such a reading may avoid the obvious. These are 'end of painting paintings', fighting their own shadowy battles within a patch of no-man's land which was never much more than a thin strip. Disenchanted by the idealism of their conceptual predecessors, with their dream of hand-to-hand combat, painters of end-of-painting paintings accept the emptiness of the vehicle they have inherited and use it to battle with phantoms, playing into the hands of the enemy. On that narrowing patch of ground good guys and bad guys begin to look alike. What is fought and what is fought for move into alignment. 'When the dream is at its most exalted, the commodity is closest to hand,' wrote Adorno of Wagner's operas. When the idea of art as commodity is pilloried, will the dream be interrupted? But will the idea of art as commodity only be pilloried by raising the stakes and making token art which is even more of a commodity? Stranded midway between objects and idea, these paintings exude a slight nostalgia for 'art'. But it is only slight. Their business lies elsewhere. Their abdication of power was in a good cause. Clinical, yes. Resolved, certainly. But not tragic. Realistic, rather, in its estimate of what is to be done.

Andy and Andy, the Warhol Twins: a Theme and Variations

Published in Parkett *12, 1987*

'I always wished I had died and I still wish that,' wrote Andy Warhol in his book *America*, before listing his gunshot wounds with grim relish. The comment recalls the first sentence of an earlier memoir, *POPism*: 'If I'd gone ahead and died, I'd probably be a cult figure today.' A strong enough desire for fame must culminate in a death wish; only after some major change of state is it possible for one human being to entertain fantasies about another and indulge them to the full. Warhol, the man who never cares about misrepresentation by newspapers, may have welcomed one event the press could not distort. But it is more probable that he regarded it as the ultimate Warhol artwork.

Reduced to a state of passivity, he would suffer alteration, not of person but of image. But if that was his fantasy, the reality proved quite different.

He had joked about it; one of his movies bore the title *Is There Sex After Death?* He had watched it vicariously while making the *Suicide* paintings. He had studied near misses; his first movie in Technicolor had been an interview with a man who had slashed his wrists over twenty times. He had pondered its punishment potential in the *Electric Chair* studies. He had anticipated its aftermath in pictures of atomic explosions and car crashes. He had registered the formalities of mourning in his portraits of Jackie Kennedy at her husband's funeral. Staring death in the face may have made it seem full of promise, but by the time he regained consciousness it had lost its charm. 'I feel myself becoming a god,' said George Washington on his deathbed. Cheated of such intimations, deprived of the most timely of endings, Warhol felt humiliated. At the point when he had reduced himself to the status of a mere logo, exchanging existence for fiction, flesh for idea, daily life had intervened, with all its mess and

174

meaninglessness. Could the mistake be rectified? Perhaps there was a way around it after all. It was risky, but it might just work.

Before June 4, 1968 Andy Warhol had developed into a proto-conceptual artist comparable to Yves Klein or Piero Manzoni. Before that date his career had been gathering a momentum of its own, as if all he had to do was tend it and comply with its demands. The snowball effect was most easily seen in the progress of the Brillo box sculptures, from hand-painting to screen-printing on wooden solids, then on cardboard boxes, which soon became the same cardboard the Brillo company used. A lawsuit was only avoided when Brillo executives were persuaded that this was art, not business. It never occurred to them that some less obvious plot was afoot. As well as parodying realism, Warhol's process also seemed to parody industrial working conditions. Production took place at a 'factory' which was called the Factory but looked more like a club. At least, it did in those days, when newspaper pictures showed starlets rubbing shoulders with drag queens, and hustlers cavorting with debutantes in an environment where age, class and sexual preference were elided in yet another parody: of American democracy itself. None of this was untrue, exactly. From the start Warhol's movies had shifted from criticism of an old, mendacious system to a new, alternatively structured America: an invented society where communality triumphed over individual demands, where deviations were tolerated, crime was punished by the people themselves and relationships were founded on pleasure. Was this fiction or documentary? Much of Warhol's activity before 1968 consisted of publicising the private, attempting to extend the Factory situation beyond its obvious uses.

Yet emphasis on the workplace as a pivot of political change, that single feature of Warhol's practice which Joseph Beuys defended with such eloquence, never became an obvious issue. The Factory was simply a factory, where goods were produced by paid workers, one of two such places, with separate staff, the other being a studio for Warhol's commercial work. Everyone helped. Starlets rarely stayed long after they were asked to sweep the floor. The solution to the problem of two studios lay in addressing contradictions inherent in Warhol's original incarnation as an illustrator. Could the mystique of manual dexterity and the production of individual drawings be reconciled with the realities of reproduction to which they were inevitably subjected? The Factory offered a single, perfect, oblique solution; surrounding himself with people caused a blurring of the source of Warhol's ideas. In gossip about him – invariably more relevant than criticism of his work – the same remark crops up repeatedly. Warhol stole, the interviewees insist. Despite their accusations a single fact remains: that his prevailing interest

through the Factory period, from 1962 through 1968, was to question the very nature and existence of artistic ideas. As he stole, from Rauschenberg and Johns as 'Matson Jones,' from Nathan Gluck or Billy Linich he gradually departed from ideas of original creation, indeed, from the idea of a person altogether. From being both his own boss and workforce, he promoted himself until he became Chairman of the Board, then the name of the firm itself, a position of power equated somehow in his mind with democratisation. After his death, Auden described Freud as being no longer a man but 'a whole climate of opinion'. Something similar could have been claimed for Warhol in the first five months of 1968. Four days later the climate changed.

When he returned to work after the accident nothing was the same. His previous strategy had been one of increasing concealment. For example, he had boasted that his novel *A* was the first never to have been seen by its author; instead, Ondine, given instructions to record a day's conversations, passed the tapes to a typist whose transcription went straight to the printers, then to Billie Linich who checked that all the errors had been included. In contrast, *From A to B*, written after the accident, was supposedly autobiographical, written in the first person apparently in response to a demand for 'true confessions'. And if Warhol had suddenly turned into a celebrity, his art had grown to resemble a celebrity's pastime. He offered to make portraits of rich people's dogs. He started drawing again, an activity which had played no part in his work since 1962, before the advent of screen-printing on canvas. His work took on a clandestine air; the idea of 'piss paintings' made by visitors to the Factory on canvases left on the floor and subsequently lost, was repeated now, with Warhol privately urinating on canvases prepared with copper pigment. And though his art still meshed with his social life – 'screen tests' of visitors were discontinued in favour of double portraits based on photographs – the mixture of high and low which characterised his pre-shooting milieu was replaced by a new snobbishness, recorded with endless snapshots of the rich and famous partying at expensive nightclubs. Under Warhol's imprimatur but Paul Morrissey's direction, the movies deteriorated into formularised sex comedies, vehicles for a new Warhol entourage intent on the commercialisation of the underground. Despite Holly Woodlawn's superb improvisation in *Trash* or Candy Darling's in *Women in Revolt*, Warhol aficionados will scour the later movies in vain for some equivalent to the bite and daring of the Pope Ondine sequence in *Chelsea Girls*, Ingrid Superstar reciting recipes to the bashful *Bike Boy*, the long pan from beach to balcony in *My Hustler* or the reel from *Couch* which shows a single standing figure facing the camera on one side of the frame while further back a

figure seated on the ubiquitous couch slowly makes love to another draped across his lap. Not all of Warhol's work after 1968 showed a depreciation in quality. The most intelligent of all his studies of replication must be the *Mao* series, for instance, featuring the politician whose attempt to halt the proliferation of images of himself might well be regarded as the publicity coup of the century. And the hammer and sickle paintings designed to hang in the Documenta building at the point where visitors passed from Eastern to Western bloc art and back equalled the *Most Wanted Men* series in impact and complexity. Yet such isolated points of consolidation do not form a coherent pattern. The only real consolidation is of a position which dictates that replica replaces original.

'I have come to debase the coinage,' announced one ancient philosopher. His aphorism summarises the approach which has led Warhol increasingly towards slickness, ease and mere entertainment. By now, it seems, his success is commensurate with his ability to employ art as advertising for a product indistinguishable from his own celebrity. Yet as time passes, the basis for value judgements, even within Warhol's own body of work, tends to become blurred. What if the object of analysis in Warhol's case is neither the work nor the life but the very economy of a career, its rhythms of productivity, its internal coherence, its features as an entire, incomplete artifice? In this case assertions of connoisseurship will not help. Only grand attempts to find images for a long, self-referential construct will suffice.

Warhol's career has represented a prolonged involvement with ideas of fame, image and stardom. As a star now, Warhol exists on a higher plane than his script. Though it provides a vehicle for him, casting still prevails; there are lines he could not possibly speak and remain in character. Like star 'biographies' released to the press in the great days of Hollywood, Warhol's 'life' engages with reality only at selected points. And, like those star biographies, it draws on what the fans want to be told, drawing on shreds of fairy tale that they only half recognise. Remember the plot of *The Man in the Iron Mask*, where one of a pair of identical twins becomes king and keeps the other in a dungeon, wearing an iron mask, until one day the prisoner escapes, orders the guards to arrest his brother as an impostor and takes his place? Or *Kagemusha*, in which a poor peasant who looks like the king takes the king's place after his death, in an attempt to keep the knowledge secret from enemies who may use it as a chance to overthrow the country? Or *Cobra Woman*, in which Maria Montez played two queens, a good one and a bad one, and wrestled with herself at the climax? Apart from Thomas Pynchon, who employed a stand-up comedian to give speeches for him before he changed his identity and was lost

to the world for ever, Andy Warhol is the only figure in American post-war culture to have toyed consistently with ideas of cloning. He used Alan Midgette to double for him and, if gossip is true, for years now has paid two or three lookalikes to attend parties and openings in his stead. The idea of changing appearance has formed a constant undertone in Warhol's art. (*Before and After*, taken from an advertisement for cosmetic surgery, the references to make-up in *From A to B* and an early Pittsburgh painting, one title of which was *Boy Picking His Nose*, all relate to a single long-standing worry.) But what if it is possible to substitute one life for another? Given a second chance he did not want, Warhol must have had to consider how his future would be. 'There should be supermarkets that sell things and supermarkets that buy things back,' he has said. The deliberate doubleness of his career could well represent a grand gesture of addition and subtraction, asserting a dying myth of the Modernist avant-garde before erasing it by colluding with business. Yet the possibility of redemption, the second chance, may have suggested other patterns.

A life deliberately structured as paradox harks back to a long tradition of Western male homosexual culture. Leo Castelli was affronted by Warhol's exaggerated effeminacy when they first met. The film-maker Emile de Antonio lectured Warhol about it. 'You play up the swish – it's like an armour to you,' he warned. As redefined for her generation by Susan Sontag during the sixties, 'camp', possibly from the Italian *campeggiare*, to protrude like panels which form part of a stage set, was a mode of ironic behaviour by which scores were settled, inequalities resolved, by which the good end happily, the bad unhappily. ('That,' as one of Wilde's characters observed, 'is what fiction means.') A decade later, Sontag criticised a homosexual facility for sustaining fictions so well that they seem to feed into reality. 'Fascinating Fascism', her study of gay sado-masochistic role-playing, may indeed represent a return to her earlier theme. A mode of theatricality with the potential for rasing set belief-systems to the ground must of necessity be anti-historical and destructive of the social order, anarchic precisely because of the equation it makes between rulebreaking and mental play. Despite its rejection by Sontag, the final word of whose essay is 'death', the *laissez-faire* which camp seems to promote is not only connected with its unanswerably social aspect, but also flourishes in proportion to the loss of freedom that sponsored it. Only recognition of that fixed ratio could provide a tool for monitoring Warhol's recent progress. The complexities of tone which can enable him to rise from bottom to top of American society, the familiar fairy tale, then pose as crackerbarrel philosopher publishing his views on poverty and homelessness alongside pictures of Diana Vreeland, Ronald Reagan or Truman Capote deserve careful study. The confusion

might be that the apotheosis of the underdog, as contemplated by Jean Genet in *Our Lady of the Flowers*, works best as pantomime, so awesome is its level of make-believe. Open your mouth, as Warhol noted in *From A to B*, and aura disappears. It is a sour, repressive summing-up but an inescapable one. Unless, of course, Warhol knows best.

After His resurrection Christ took things easy, showing His wounds to unbelievers like Thomas, meeting friends, relinquishing the political aspect of His task for one which was mainly pastoral. He delegated authority as much as possible and made sure that things would run smoothly without Him when the day of His assumption came. Charles Lisanby, Warhol's greatest friend from his days as an illustrator, remembered his striving for fame, his need to be noticed, but most of all a single remark he made one day. 'I want to be Matisse,' he said, and in the record of the interview, made with Paul Smith in 1978, Lisanby insists that he is not misinterpreted. 'That's exactly what he said ... and that's really what he meant ... Really, that must be clearly understood.' What Warhol meant was not that he wanted to make art like Matisse but that he wanted the standing as a cultural figure which Matisse had earned. No one can deny that he has succeeded. But as a good Catholic, shocked into faith by the sudden proximity of death, could it have occurred to him on June 4, 1968 that his more proper duty was the imitation of Christ, not man? Already something in him, that perverse, reverse face of camp, would have made him aware that if he succeeded he would run the risk of becoming an Antichrist, the ultimate debaser of coinage, the final blasphemy. Flaunting his presence as the figure who has called value into question more fully than any even than Picabia, Dali or de Chirico, Warhol has spent years of his life ingratiating himself with an international public incapable of appreciating his satirical stance. By now it has become clear that perhaps no one fully appreciates that stance, since whereas in the past satire relied on a set moral yardstick, 20th-century satire can operate according to a shifting standard, a quality which Warhol has exploited to the full.

There are other possibilities, of course. Perhaps the Warhol we have been seeing and hearing since 1968 is a permanent stand-in, while the real Warhol, having had his nose-job, is living elsewhere, plotting and making telephone calls. Or being held captive; or in fact dead. Perhaps the famous full-page shot of the sewn stomach after surgery is the most we shall ever see of a figure who has practised anonymity more successfully than any other artist in our post-lapsarian culture. Bleed, we say. He refuses. And already by the time the photographer did his work, we were too late to test the warmth, the reality, of a body which has always seemed sepulchral, a little less than real.

Double Vision:
an interview with
Thérèse Oulton

Published in Artscribe *69, May 1988*

Stuart Morgan: *'Lacrimae'*, the title of your latest collection of paintings, is printed with quotation-marks.

Thérèse Oulton: Because it is a quotation. It's the title of a piece of music by John Dowland. My paintings were meant to parallel that music.

How, exactly?

Elizabethan music fascinates me because effects that were later pushed to Romantic extremes occur there within a narrowed range. *'Lachrimae'* consists of about 16 variations on a single song, repeated with small shifts. Compression makes it more potent and claustrophobic.

Dowland seems to have been depressive, doesn't he? *Lachrimae* means 'tears' and another of his songs is called *Semper Dowland, semper dolens*.

It's melancholia rather than depression, both an affectation and genuine feeling. Though it is believable as melancholia it does not engage the hearer in that.

The pace of the music is unusual.

Only if you expect development from propositions to conclusions. Dowland does not pivot on expectation. He uses deliberately paced repetition which is not mechanistic; it seems open to alterations of circumstances and changes within its own laws. Listening to it, one has no need for climax and resolution. It is as if the listener were suspended in a state of permanent improvisation.

Could that parallel your own improvisation?

Because mine occurs within a defined, artificial structure, it is not improvisation proper; as with Elizabethan music, it is determined before setting off. So there is no question of changing tactics completely. My paintings set up conditions by

which a development can be followed. Everything about them points to their status as made things which belong firmly in art.

Weaving is a metaphor you have used for your own work.

It's still there – the title *Pearl One* refers to knitting instructions, for instance – but it's been changed into something resembling needlepoint, where the paint-mark is equivalent to a stitch. There is no underpainting or overpainting. Each mark is a deliberate move towards building up some bigger structure.

Your detractors write this off as virtuosity, and in one way they have a point.

Virtuosity seen as meaningless only applies within a post-Romantic framework. Before that, it was not necessarily a term of abuse. Nor did it have associations of self-aggrandisement. It is a word burdened with arguments about self-expression.

You oppose self-expression?

It's hard to say that. A picture that is not you and does not directly translate any of your feelings or moods or who you are is still irrefutably yours and no other person's, not in a cause-and-effect way but in some more elusive and profound sense.

Tell me how you make a painting.

The approach is classical. A tinted ground sets a middle way by which extremes can be gauged, high points to low. It can be cold or warm, depending on the colour idea that they're begun with. (Before setting out I have a tonal range in mind.) A strict palette is adhered to throughout; paint is mixed before starting the day's work so nothing interrupts a process which is very concentrated and close-focused. During the day I rarely step back from the canvas so decision-making depends on very small shifts from one point to another. In recent pictures, it was even more deliberately shown that there was a method of construction, not overall composition but spreading across by attending to minutiae, letting the whole take care of itself.

How is paint applied?

With very soft brushes. No hand or fingerwork any more. That stopped four years ago.

And there are different colours on your brush.

With the right balance between viscosity and stickiness you can load the same brush with an entire tonal range from highlight to shadow, to allow for chiaroscuro techniques.

Chiaroscuro without an object to describe.

If you relinquish the option of describing objects and spaces you are left free for

separate painterly elements to act according to their own particularity.

Yet there are conscious metaphors, like your references to phosphorescent rocks in underground caverns. Why, when you offer me free painting, do you leave yourself this fall-back position?

Because to be free you have to recognise that this is freedom by stating everything that has gone before.

Does 'free' imply lack of conclusion?

Your eyes dart over the surface. They can't rest. That can be an experience in its own right.

Stepping back from paintings in your 'Fool's Gold' exhibition, already seeing one kind of space, with towering landscapes, it was possible to lose that entirely and see only a shimmering surface like a butterfly's wing. Yet it was impossible to hold on to either type of vision for long. Despite the presence of the paint, the idea of returning to illusion again and again still underlies your paintings, as recent titles show: *Counterfoil, Descant, Doubleback*. It is as if you are telling the spectator that it is impossible to cope with either materiality or immateriality in their own terms.

Separating those realms is an idea that has taken hold. But the prospect of their being divided might be unreal. At the time of 'Fool's Gold' I was thinking of alchemists. Though we are told that transcendence was their goal, they were obsessed with material process in its own right. Their instructions are so elaborately ritualised that they seem anything but goal-orientated. For them transcendence was wrapped up in transformation of actual stuff, including ideas. They were interested in unfolding for its own sake.

As you describe your work, it sounds simple and open. I sit here asking myself why the effect should be like someone whispering secrets. Perhaps you are a secretive person.

Why do you say that?

Wasn't there a time when you decided to live in a triangle between Prague, Vienna and Budapest?

Yes. Prague attracts me, its intellectual atmosphere in particular. It's like Europe in a time capsule. The old part of the city evokes very strong emotions.

This is secrecy, surely: a thirties capital outside a European context, an old city within a newer one, Kafka using one language inside another.

The doubletalk certainly appeals, the idea of using a language which is not the one you're born with, that Beckett and Nabokov translated themselves, even translated translations of their own work, interests me as a strategy. The heavier

the structure of givens you have to deal with, the more intricate your means must be; although it uses the same language and the same words, doubletalk can actually eat away pre-ordained meanings and the things one is supposed to believe in. Deviousness also appeals to me; it has real power to damage, and attacks foundations, however slowly.

By 'doubletalk' you mean one language inside another, an interior language. So you are not exactly secretive.

Say I'm a very interior person, working to obtain a private sphere for my painting.

Why make one context within another?

If meanings are being appropriated in the outside world there is a need for a private sphere to undo that, to make one's own sense of something because the meanings provided don't make any sense.

So if I asked whether it was possible to make paintings now you would reply that it is, but only in private.

Absolutely. But you can only gain that privacy by addressing the issue of the outside world and its given meanings. Since there's no true boundary between the two, the private world has to be created deliberately.

Given that, you're providing within painting a model for the mind to dwell on, to work itself loose from its moorings, a model for a freedom which shows what has been abandoned to arrive at that point. Given your academic training, you have inched further and further towards heresy.

Prague was a centre for heretics, of course. For alchemists.

Under the Emperor Rudolf.

The Emperor collected them together to do their experiments so there were times when heresy became orthodoxy. But it was also a hotbed of intrigue.

I know the court was a centre for Mannerist art and Jewish mysticism as well as Catholicism and alchemy. But what about the intrigue?

No one was sure who wrote it but a manifesto was published which was written in mystical terms, but used those terms deliberately to create a situation where everything was unstable, although it has also been suggested that it was strategy to propose a utopian state. The Rosicrucian manifesto provoked hysteria in places like Paris and London, where they thought the end of the world had come because old values were being overturned.

Who wrote it?

There are stories that the Emperor's Chancellor, who was not high-born, had 'socialist' ideas and that it was he who advised Ferdinand –

– who married James I's daughter –
– to claim the throne of Bohemia, knowing it would result in disaster. He might have intended to turn available powers against each other.

When you made a series of paintings called *Letters to Rose*, you were punning on Rosicrucianism, weren't you?
Yes, but also on 'rosy coloured spectacles' that prevent people seeing the truth.

More and more we seem to be talking about an act which unsettles. Would the Rosicrucian manifesto be a good example of an attempt to cause permanent unsettlement?
No, because there was an element of cynicism there. The Gnostic Gospels might provide a better example. But long-term desires might not have been what these documents purported at all, simply a throwing-off of reason, a deliberate alternative to a situation where everything is wrapped in meaning immediately. It is analogous to mysticism. The most painful aspect of mystic experience is that you supposedly move outside language to an experience which eventually has to be communicated when it re-surfaces in the world, so that it is swallowed up by the known as it tries to express the unknown. Maybe mysticism provides a babble which sidesteps the problem of how to come back into language.

Why would you want to address paintings to someone who had a vision defect?
The spectacles are the way one wants to see the world, a desire for the world to be different, a recognition of striving for things you are not going to see.

You're saying things can't be changed.
Not changed. You have to present an image of how you want that change, then strive towards that image even though it is a vision with no final point, for in order for change to occur there has to be constant rethinking, not a fixed utopia.

So if you were to succeed in making your double language in painting it would immediately exist in a context where it would have to be remade to preserve its power of critique or interiority. Is this how you see your own career moving?
Yes, but often I have a sense that the painting does that for me and I am left scurrying along behind.

Thérèse Oulton: Sub Rosa

Published by Galerie Krinzinger, Vienna, 1988

Clinging with difficulty to what seems to be a slippery canvas is paint which has been subjected to a variety of small moves. Its direction is unpredictable. So is the colour; any single stroke has others threaded into it, so that it seems to be changing even at the moment of vision. Space buckles and advances without warning. The relation between individual strokes and the structures they seem to suggest proves uneasy; grand designs arise only to disintegrate again. And the very nature of these structures remains in doubt; the virtuosity of the performance lies in a persistent refusal to lapse into illusionism. Thérèse Oulton's first proposition seems obvious: for her, painting involves a series of refusals.

Her second proposition is equally important: style is a machine for procrastinating. Improvisation can be used to preserve the freedom of painting, like a child inventing endless excuses not to have to go to bed. Oulton speaks knowingly of Bach's *Art of the Fugue* experiments, in which the sense of a 'home' key has been lost but where that loss leads to a less tethered existence, a perpetual hovering without resolution. Her own style travels far from 'home'. Most successful when least constrained, it yearns to be free of its enabling support, an effect heightened in the latest paintings by the presence of areas quite devoid of impasto – ratifying, not repudiating, her former metaphor of painting as woven fabric.

The confidence with which a term like 'style' can be used implies aestheticism – 'pure' virtuoso painting for its own sake. No description of Thérèse Oulton's strategy could be more inaccurate. Her training was from

abstract painters. Instead of rejecting their attitude out of hand, she extended it. Most importantly, she examined her premises. Like that of other British post-conceptual painters, her *modus operandi* is the result of a revised view of painting following a widespread loss of faith in its powers. Artists such as Christopher LeBrun or Steven Campbell began by isolating painting's components and assumptions, then subjecting them to scrutiny before reassembling them – not necessarily in the same order or with the same significance. Artaud wrote of 'Theatre and its Double'. This reconstituted art of the eighties was the 'double' of painting. When, in Thérèse Oulton's work, a constituent of classic art such as chiaroscuro exists without reference to the object which might have occasioned it, its use cannot but evoke the shadow of classic painting which it has forsaken.

Yet the result is not nostalgia for the possibility of renewed faith in outdated means. Still less is it a meditation on the decline of the West. It is a re-engagement with painting divested of sentimentality, spurious authority, bogus authenticity and hocus-pocus. Oulton's project is at once an exercise in distantiation, with all the associations of starting from scratch which that entails, and the construction of a model for a subversive art. Hence the title *Letters to Rose*, a reference to the lost history of women through the ages, to the sense of intimate community and the thought of setting things to rights. The determination to step aside from arguments and *remain* aside, to renew oneself automatically, to make paintings which hang suspended between negative paradoxes ('neither this nor that'), to envisage immanence and potentiality, suggests the cluster of problems which is both her subject and her situation, as a woman and an artist: the need to formulate a rejection of what is known, as a leap of faith which in itself might be the stimulus for creating a new language. One aspect of this might be the deliverance of the body. ('Rose', as Marcel Duchamp knew, is an anagram of Eros). Another might be the reappraisal of pleasure, drawn from play within the perimeters of the act of painting itself. A third might be the rethinking of labour, of a work of art regarded as a work of work, and related to this the renunciation of the simplistic aesthetic belief in 'expressionism', regarding the artwork instead as an artefact.

Hints of a new order are everywhere in Oulton's work. References to alchemy are frequent, as is the visual pun which connects rock or mud with gold, or just the flash of gold in sunlight: if not the real, then at least the visually perceptible riches hidden at the centre of the earth. Yet these are also the poles of alchemical lore, which depends on a process of transformation. *Rose Cross*

refers back to Oulton's fictional correspondent but also to Rosicrucianism, another alternative faith (or invented alternative to faith) which hoped for a bright future when the dead wood of Christ's cross would flower. But what if the metaphor of regeneration was unfounded in both cases? Could it be that each was an elaborate method of encouraging people to re-assess their position, to see the world as it is and not as they would want it to be? In other words, to abandon the 'rose-tinted spectacles' of religion?

Thérèse Oulton's letters to Rose recommend just that. The main mark of her work, seen at its most expert in a series such as the *Dissonance Quartet*, is an ability to frustrate any reading of her painting, to force viewers to ransack their visual repertoire and to employ various, often mutually exclusive, types of interpretation simultaneously on one picture. So *Dissonance Quartet 2* could be read as a tidal wave overwhelming a city, or as an 'abstraction'. The painting is therefore able to combine, if not to heal, contradictions by situating itself between them and summoning both at once. It is an ideal state of affairs, which Oulton with her unusual ability to rehearse her philosophical dilemmas in her art, has tried to utilise. Many of her paintings have evoked subterranean images, for example, because according to the separation orthodox religion made between matter and spirit, a division it had a vested interest in preserving, the earth exists in opposition to the world above, a world on which it is proper to fix one's attention – to the detriment, it might be argued, of one's well-being here below. In the bowels of the earth the densest forms of material, such as fossils, flout the matter versus spirit debate by containing their own light and even emitting it in their own unpleasant way, which Oulton recalls in *Cast*. Her recent desire to show the outsides and insides of things at the same time, with skin and ribs in full view as if the object had been flayed or disembowelled, constitutes another impossibility which can be demonstrated in painting but nowhere else. It is in keeping with her technique of perpetual elaboration that each new advance resembles a variant of the first: that dual visual reading which characterises her work, and from which the entire career, a career of remarkable poetic consistency, begins. Duplicity also underlies the *Letters to Rose*. They may be about heresy, they may be about the strength required to divest oneself of outworn beliefs before the advent of a new order, but primarily they are about looking, painting and thinking, and more particularly the connection between the three – a connection which impels Thérèse Oulton herself. And finally, the letters do turn out to be subversive, precisely because they are available for everyone to see. They are subversive as only an open secret can be.

Pepe Espaliú: Cat's Cradle

From a catalogue published by Galería La Máquina
Española, Madrid, 1988

An early self-portrait showed Pepe Espaliú's profile twice, once on each of a pair of hands which formed an intricate, if puzzling, gesture. Lurid, gothic even, the painting included two of Espaliú's longstanding artistic preoccupations: sign-systems and children's games. On television when he was a boy, he recalls, a series about conjuring would always begin with two hands which spelled out the title on the empty screen. The manipulation of negative space has always held a particular fascination for him, as if making art consisted of controlling the play of shadows or performing a conjuring trick. But while projectionists and prestidigitators know which tricks they are performing or which reels they plan to show next, Espaliú decided to resist logic, taking tailors' patterns and following lines at random until a composition emerged, as if he never knew which forms would be urged into existence. That, at least, is the impression he wanted to give; as a late Modernist, Espaliú keeps his own personality at arm's length in order to make general propositions for a meta-art of his own invention. Only by the sequence of his moves is it possible to define his position or plot his trajectory.

Viewers expecting personal statements may be daunted by the amount of game-playing which Espaliú practices, or the level of secrecy that he maintains. Deception is paraded almost for its own sake. It seems that childish undercurrents connect his imagery: an impressionable love of uniforms and galloping hooves which reaches bathetic fulfilment in a photograph Espaliú has included in catalogues, of himself as a soldier on horseback; an only semi-parodic feeling for those images of maternity which played such a part in education in sixties Spain. More recently, there is fascination with hollow leather shapes, sculptures 'you can

188

lie down beside', as he has willingly admitted. Wish-fulfilment, a search for role-models, a strong taste for the ideal and a certain sexual confusion – preoccupations of a young boy – are countered by adult techniques of repression: coding, mannerism, a need to invent puzzles. As the fetishistic aspect of his sculpture has developed, his painting has assumed and adopted another stance, neither in opposition to it nor as a subtext, but as a running, albeit distant, commentary. Yet simple definitions such as 'painting' or 'sculpture' are no longer of use; Espaliú prefers a territory he regards as out-of-bounds. This fascination with taboo and an equal and opposite desire for censorship are both reflected in his work; while exploring his unconscious, he ponders the social consequences of the infantile and the perverse. And gradually his habits of mind and the entire economy of his production have grown together. Most recently, four 'paintings' dedicated to the French writer Jean Genet were followed by leather 'sculptures' designed by Espaliú, but sewn for him by craftsmen in Seville. Then these in turn were followed by masks based on African counterparts. Though no deliberate dialogue determines his thinking, Espaliú's procedure reveals a pattern based on a strong element of daring and an equally strong urge for safety. And while his working method encourages dialogue between the separate and permanently divided parts of the self, it also prolongs the battle by making both sides more permanently entrenched.

Espaliú's fascination with Genet can be traced back to his years in Paris, when he sat day after day in a car opposite Genet's hotel, simply in the hope of seeing him. With Genet, as with Kafka, the life and the work are inseparable; just as every word Kafka wrote is read as 'literature' so the mere fact of Genet's existence seems always to have outrun appreciation of his plays and novels. *Saint Genet*, Sartre titled his vast book about him, borrowing his subject's habit of exchanging high and low. (By his own account, Genet had lived as a criminal and been jailed repeatedly). Espaliú's abstract, four-part meditation on his hero takes its lead from Sartre, who saw him as the ultimate existentialist. As the sequence progresses, an element resembling a physical organ – a heart or liver, perhaps – is eaten away and a climax is reached as the organ, now vividly black, is disconnected altogether, and distanced even more by a frame in the form of a brick pattern. The more diseased and captive it becomes, the more power it seems to gain.

Lying flat on low bases, the leather sculptures lead an existence close to that of objects in the world. They gather dust, they give in under pressure, they can be polished or carried about. One resembles a jug, another a corset, and all of them are abstract and hollow. (In most cases, an interior is felt, not seen.) And as usual

with Espaliú's works – the Genet series being a notable exception – the set they form lacks any internal sequence or even a fixed number of elements; they come to an end only when the artist's attention turns elsewhere or when a single idea is exhausted.

In contrast, the masks are fragile, boxed like museum specimens. (Espaliú has mentioned the British Museum's collection of masks from Zaire and the Ivory Coast, and their deathly sense of being behind glass, in exactly the way corpses are displayed in Spanish morgues.) While the making of the leather sculptures is meticulous and workmanlike, the very imperfections of these masks serve to generate unease in the viewer. Objects of power, they have been assembled from simple materials in a way that blends clumsiness with precision. Assembled out of pieces of gauze and the foam from shoulder-pads of dresses, they are things that needed to be made. And the seriousness of their purpose is never called in question by the amateurishness of their technique; on the contrary, this expresses implied danger even more fully. There is even a sense of macabre comedy; one mask is made on top of a pattern of dots and arrows, which, if joined up, would make a figure, as if a page from a child's puzzle-book had a mask to conceal it.

What connects the parts of Espaliú's work? What path is he following? Perhaps all art is only serious play, after all, and Espaliú wants his viewers to be reminded of that. Two techniques that most recall play give us our main clues: repetition and change. Games can be played endlessly. They are always different, while obeying the same rules. Espaliú uses his art as a search for identity, a search which will also alter his identity. But as important as this quest is his constant search for the rules of the game itself, and beyond those for the meaning of play.

Take his odd technique of hammering nails into paintings, then threading cord around them to make patterns, sometimes very simple ones, the kind children make with cat's cradles, a pursuit which depends on complex finger-movements. In cat's cradle the number of possible variations is enormous. In painting the same is true of sign-systems. Yet Espaliú's superimposition of one over the other suggests that the moves are more restricted than they seem, that again Espaliú the artist is about to be reminded of his limitations, and that these in turn will form the basis of his art. Cat's cradle, where it is necessary to return to the simplest moves again before embarking on more complex ones, is a perfect analogy for Espaliú's method.

As in the cupped hands of the self-portrait, in cat's cradle the medium to be modelled is vacancy itself, as if the sole purpose were to describe imaginary objects in space: a gesture of desire. The masks are vacant, after all, and the leather

containers empty. How negative Espaliú's estimate of the artist's purpose seems: a person who has to start again from scratch after each separate foray, with nothing in his hands, then like a cheap conjuror, to play tricks on his gullible audience. There is nothing grand about this, no deeper spiritual meaning: only bodies and what they can do.

For Espaliú the importance of Jean Genet lies precisely in his celebration of the free as soon as it is forced to submit to discipline. (In *Our Lady of the Flowers* Genet presented masturbation as the basic gesture of the artist, the act which brings forth the entire action of the novel and so, metaphorically, releases the prisoner from captivity, an idea echoed in his film *Chant d'amour*, in which warders envy the limitations placed on convicts, and the consequent heightening of their forbidden pleasures.) He himself makes sculptures out of skin, polished to make a shiny carapace. Like human skin, the material will age, become brittle and finally disintegrate. The more fragile the work, the more heroic the gesture of grasping thin air, of stating a lack. Yet what more poignant reminder can there be of other skin, of another body? When the same man makes masks, we may suppose that for him deficiency is nameless, homeless by definition, that any implied carnival atmosphere can give way to the fact that freedom is nothing at all. We may interpret the masks as an interminable statement of the multiplication of identities, the infinite manipulations of the cat's cradle. Yet they speak the desire for an end to all this. Like breasts, like genitalia, like faces blurred when seen at close range, they are objects of compromise or transition, reminders – so psychoanalysts argue – of a time of complete union with the mother, before separation anxieties set in, and when sexual identities were undifferentiated. They signal a need to end the constantly dichotomous thinking and working practice Espaliú employs. They are the ultimate objects of desire, because while indicating a need, they go part of the way towards fulfilling it. Alone with his body and his fetish objects, the imprisoned narrator of *Our Lady of the Flowers* becomes godlike in his freedom, like the demiurge in Egyptian myth who created the world by masturbation. Compared with our fetishes, every other object in the world fails us.

The only answer is to go back and back, rebuilding the cat's cradle. Yet his repetitions may not be as arid as he supposes. The play with the string has turned into a ritual activity which has gradually gathered expressive force and ever wider meaning. And, like any continued statement of need, it has become a prayer or invocation. Espaliú will continue to pray. As he recognises only too well, a prayer may exist not to be answered but also as a poem in its own right.

Robert Mapplethorpe: Chiaroscuro

Published by Mai 36 Galerie, Lucerne, 1988

A white man makes black and white pictures: pictures of black things and white things, black people and white. He is from Manhattan, where perfection is bought and sold. And as a professional photographer, he is expected to narrow the gap between ideal and reality, to sell 'image' rather than truth, to deal in dreams of wealth, fame and, above all, power. Yet Robert Mapplethorpe the artist blurs the distinction between commissioned work and projects done by choice. His portraits of the rich and privileged are not of people but of collective social fantasies; so vast is the distance between how they look and how they are expected to look that it is hard to say just what information the photograph itself conveys. This is Mapplethorpe's audience, included in the spectacle as special guests, like the viewers who were allowed to sit on the stage during a Shakespeare play. They are important, no doubt. (Even the children Mapplethorpe portrays are their children.) Yet the apparent snobbery is challenged in various ways. Mapplethorpe is homosexual, for example, and sexual preferences have nothing to do with social boundaries. Alongside millionaires, he includes portraits of casual pick-ups, anonymous intruders elevated to superstar status.

This is only one of a string of deliberate reversals in Mapplethorpe's work. Others suggest psychological reasons for the principles of reciprocity which govern the interrelations he stage-manages. Fetishized in the pictures, nude black males have been posed with the traditional attributes of slaves, for example, while other tableaux depict master-servant relationships in which blacks dominate subservient white counterparts. In a country where slavery

lingers in the psyche, this could pass for unconscious penance or as the deliberate proposal of a single metaphor for social relations. The sado-masochistic acts which form another area of Mapplethorpe's subject-matter emphasize the solitary aspect of such enacted dominance or submission. Alongside regulation life studies, they act like an infection. After seeing them what are we to make of a black model displaying his buttocks to the camera?

Not only his studio practice but his entire production process begs questions of freedom, then. Mapplethorpe copes with this by demonstrating his own captive state. His studio has become a world, his art an edited version of that world. The mode is neoclassical, the genres fixed and timeless: the portrait, the nude, the still-life. What prevents this from becoming reactionary in terms of the politics of artistic form is not his style, a kind of late seventies New York *Neue Sachlichkeit* also practised by Laurie Anderson in *United States* or Robert Longo in *Men in the Cities*, but a mesh of relationships which the viewer may discern between separate units of meaning. The camera is a natural democrat. Granting equal status to each photograph, Mapplethorpe equates anonymity with stardom, the waxen feel of lilies with the bloom of a taut muscle. And, inevitably, black and white merge. Gradually, the rebellion the photographs proclaim begins to seem more complex.

As Mapplethorpe's furniture and sculpture confirm, his output as an artist, selected in part from professional assignments, marks an interface between public and private life. If his clients are pictured, so is he, in clothes ranging from evening dress to black leather, in attitudes of polite composure or total unreadiness. If narcissism has a place here, as in his early boxes, so does simple documentation: we watch as he grows older, less decisive, more obviously *between* expressions. Unlike his models, who remain so superbly oblivious to a world outside their immediate existence that no problems touch them, he is subject to time though not to fixed identity, as he adopts one pose after another, from society host to terrorist, complete with machine gun. Finally this game-playing constitutes a running manifesto. He stands inside and outside his own work because its meanings are brought into being with less and less input by him, in a process of comparison and contradiction between givens, fixed counters of meaning which correspond to unexamined moral and aesthetic stereotypes of middle-class, white, Anglo-Saxon Protestant society in the United States. Examined, enacted, they not only fail to add up to a single world view but clash disturbingly. Nature is set against culture: flowers are permitted only when they are cut and dying, the self-conscious celebrities lack even an iota

of the intelligence of an anonymous black face, deep in thought. Gradually, Mapplethorpe's studio comes to resemble a laboratory in which chemicals combine or clash and he watches disinterestedly, his hands stuck deeply in the pockets of his white coat. These days his experiments seem to perform themselves. This procedure, not any separate artwork it throws up, is Mapplethorpe's great invention. Formalist critics who regard his homage to classic photography as proof that he is no more than a throwback to a time of individual masterpieces disregard his art training during the seventies, when Conceptualism was taken for granted. Nowadays his closed circuit of equalized images seems to have an existence of its own. Fashion photographs in colour for Italian Vogue have parodied Mapplethorpe givens as if they were clichés, products to be bought and sold in the same way as the products they frame. So a black nude kneels with a woman's shoe on his back, while a flower 'poses' wearing a gold necklace.

Free or unfree? Black or white? In time, Mapplethorpe's private universe, a schematic remaking of the one we know, serves to demonstrate the poverty of our terminology, the paucity of the guidelines by which we deal with the world outside. Yet it not only provides no answers; it depends on never staying put or suggesting answers. As a sexual option, sadomasochism depends on a unusually high increment of game-playing between partners as well as a fine perception of where boundaries must be set. Yet without the teasing suggestion that these boundaries are movable any such relationship will remain static, theatrical to no purpose. Some parallel principle must be called upon to explain Mapplethorpe's art, creative to the degree that it is anarchistic, an art which may, finally, risk decadence in the sense that it deliberately reaches no conclusion but remains a kind of elaborate tampering, with the capacity for entertaining any value system worn away. In an essay on Cavafy, the poet Joseph Brodsky wrote that since the homosexual's notion of life 'might, in the end, have more facets than that of his heterosexual counterpart,' the concomitant sense of sin might be more complex. His suggestion may not solve all the problems Mapplethorpe sets, but for the moment it will suffice.

Little Christians:
a conversation with
Christian Boltanski

Published in Artscribe *72, November-December 1988*

Stuart Morgan: Your studio is full of old biscuit tins, cut-up newspaper and piles of second-hand clothing.
Christian Boltanski: I do not know what to do with the clothes yet.
Why did you choose clothes to work with?
They are like pieces of dead people.
And the biscuit tins?
I am an artist from the second half of the 20th century. I am influenced by Minimalism.
That can't be the only reason.
Well, of course, there are things inside. If you have a box, there must always be something inside.
But the viewer won't know what it is.
No.
What was inside the biscuit tins in *Détective* which you showed at the Stedelijk Museum in Amsterdam last year?
There were photographs of faces on the wall, with lamps shining down. And the work was called *Détective* after a French magazine of the same name. Half of the people were criminals and the other half were victims, but now I can't remember which are which. The faces are re-photographed from articles I cut out. The boxes contain the articles themselves, folded together so that if you open the box you see an article without knowing who it refers to.
***El Caso*, which you made for the Centro Reina Sofia in Madrid this year, also had tins and photographs.**

I had come across *El Caso*, a Spanish newspaper devoted to crimes of violence – the kind of sensational paper which shows full-length pictures of bleeding, mutilated corpses, lying exactly as the police found them – then I cut up copies from a single year and put the faces on the wall, framed with lights. Inside the boxes are photographs of the same people dead.

In that room you had wooden shelves reaching up to the ceiling, with lengths of folded cloth on each shelf.

The building was originally a hospital and this room was very close to where they kept the bed-linen. The whole installation was made with Spain in mind, a kind of Catholic joke about *vanitas*, an old theme in religious painting. This room was about the destruction of the body. Then there was a darkened room with candles and tiny figures which seemed to move in the candlelight, and the other darkened room with the domed ceiling, the single light and the revolving figure made of wire and feathers, which seemed to fly round and round above your head. We could say that the angel was Paradise, a soul, and that the candles were Purgatory... What interested me most was the transformation from a live body to a thing, an ugly thing wrapped in a winding-sheet: to have a normal face but to know the destiny of the people in the box, people who seemed beautiful but whom we know to be disgusting objects. A large part of my work is about the difference between subject and object, the stupid banality of a situation where a person who is so many things one minute is just an obscenity the next. And if I use photography, it is because photography makes people into objects.

This sounds close to the idea of relics.

All works of art are relics. A long time ago, in 1972, I organised a public auction of all the important objects and souvenirs I had at home. Some of them were very important to me. I had a friend who was an auctioneer. 'Try to sell them,' I told him.

Why on earth did you do that?

To show that what is important to you in life means nothing when you are dead. He would say 'How much am I offered for this love letter?' But nobody wanted to buy.

Did you really want them to be sold?

Yes.

But you wouldn't ever see them again.

That's right.

Didn't you care?

No.

Why?

Because I am an artist and artists are not human any more. They just make art.

Surely what is happening is that you are dividing yourself in two somehow, as you did when you played at being a ventriloquist.

At the time I played with my little dummy, I felt that the more you worked, the more you disappeared. Working as being nothing is a very Christian idea. I feel that the artist is someone who stands and holds a mirror that anyone can look into and recognise him- or herself. But the person holding the mirror is not reflected, so he is nothing at all. When you remember comedians you don't think of them for themselves; you simply remember that their stories reminded you of something. My idea was to be some kind of nothing; not me anymore.

What did you call your puppet?

He was called Little Christian.

So he was you too.

I have often used my name when it was not me.

But you have said in other interviews that he was very close to you.

Well, it is very complicated – the resemblance is probably too close for me to admit. I made a book with ten photographs of a child with captions that read 'Christian at 8' or 'Christian at 10' and so on.

But the last of those *was* you.

Well, it says 'Christian at 20' but in fact I was 28, so that was not the truth.

So when you make the art you stand aside from yourself in order to talk about yourself.

At another stage I wrote letters to people. One of the last was the hand-written letter of a man who is really out of his mind and about to kill himself. When I wrote this letter I was very, very depressed. I sent it to 20 people and I'm sure that if I hadn't been an artist I would have sent it to only one person.

But in fact you received three answers.

The fact is I felt that because I had sent this to 20 people it could not possibly be a mad letter. It was art and I was safe.

The most obsessive of your works must have been the 3,000 balls of clay you exhibited in 1969. Were you making a statement about madness when you did that?

It's difficult to say. At that time I was a very strange person. Quite crazy.

I can't print that.

No, really. It's true. Now I'm normal. I was very fortunate, because at this time if I hadn't been an artist and I had made all these little balls just for myself I would

have needed to go to hospital. Luckily I was an artist, so I made a show of them. I spent all day making these little things. It is very lucky that I was not the son of a farmer, but lived in the city where people would understand that this could be art. When I was doing it I knew and didn't know at the same time. To know it was art saved me. It was not a madman making something; it was a man making something about a madman.

The difficulty is that you play the madman you are talking about. But the idea of play leads to all sorts of problems in your work. In 1969 at the start of your career you deliberately set out to look for reminders of your childhood in the book called _Research and Presentation of Everything that Remains of my Childhood, 1944-1950_. But because you find almost nothing, you tell lies about your early life. And lies and play and art become tangled in your mind. That is true and it is not true. I wanted to forget my own childhood and to create a collective childhood. I have never said anything honest about my own childhood.

You have claimed that you no longer remember anything about your childhood because you have told so many lies about it. Is that true? No. I was lying. But there were all sorts of things about my own childhood that I suppressed in my work because they were too special. For example, in my first works I never mentioned that I was from a Jewish family. I described it as a normal French family. And for many years my father was afraid of being alone. Although it was a large house we all slept in the same room: my two brothers, my sister, my parents and the dog. None of this occurs in my work. I talk about my childhood as a very normal thing because I wanted to make something everyone could remember. I work with the idea of collective memory. The idea is that a piece of art is always made by the person looking at that art. I send a stimulus so that each person sees something different. If we look at a photograph of a boy on a beach, for example, you and I see something different; while I see a beach in France, you see a beach in England. I try to send an open message so that everyone can reconstruct a private story. Because of that I say that the artist is someone who disappears. The idea of being everybody is too Christian for me now: to disappear because we want to be everybody. But everybody sees what he or she wants to see. That's why I use biscuit boxes, for instance. They are biscuit boxes but they are also urns for the ashes of the dead and they are the places a child puts treasure. In the same way the white clothes in _El Caso_ may be hospital linen or clean washing in a mother's cupboard. It is better not to be too directed. Everybody works with collective memory because it is the only way for people to

understand anything. When he was asked what the landscape looked like, the first man on the moon said it looked like a baseball field. It was impossible to describe it as something that no one had seen before. When you are very young you have a lot of images but after that you never see reality; you only perceive reality with the image you have.

This sounds a little like the idea of 'models' you once presented at the Sonnabend Gallery.

I thought it would be a good idea to make my own family album, which would look like anybody's. So with Annette Messager I began to work on this idea of model images. When the show opened everybody hated them and no one would buy them because they were the same kind of photographs they could have themselves. My sister is in them and my nephew. Each time you make a photo you have a model in your head and you try not to look at reality but to take the photo you knew before. For me it was a kind of catalogue of all the photographs people can make.

How many models are there?

Not so many. Perhaps a hundred. Most of them come from the Impressionist artists, I think: the smiling baby, the picnic on the grass, the beautiful woman... There were two nude women in the show at Sonnabend, 'artistic nudes'. At the same time Annette and I made a piece in Venice for which she had done a lot of nice little drawings and I took photos of her just like the ones people take when they are on their honeymoon. After all, you have to bring *something* back from your honeymoon! At this period I wanted to destroy what people were thinking about me. I was seen as a very sad, emotional artist, so I set out to change all that. Coloured photographs of smiling people on beaches can hardly be sad. At least, people feel that they are not about death, although death occurs every time you take any photograph.

Do you see yourself as sentimental?

Certainly. I got into trouble recently for calling myself the Claude Lelouch of contemporary art.

But what if the opposite is true, and you are mocking what people cherish, hating children, scoffing at our traditions of death and mourning?

There is certainly a sadistic side to my work. I am fascinated by dead people. My studio is full of photographs of them, like objects. In concentration camps they always spoke not about people but about the weight of their bodies.

Your approach strikes me as similar to that of a 19th century novelist.

I'm a little like Proust: a man from an intellectual Jewish family, with an approach

based a little on Central Europe but much more on France. And, in my case, more and more to do with Catholicism.

Give me an example.

C.E.S. des Lentillères in 1973, the piece with the faces of all the pupils at the school in Dijon, was really a Catholic work. They all look the same but actually they are different. In the Catholic church there is a festival called *Toussaint*, 'All Saints'. All the children of Dijon *are* saints, all there on the wall with light on them.

How do you think you arrived at something so disengaged only a few years after making three thousand balls of earth?

After that mad, expressionist phase I started to put all my objects into glass cases, cold and quiet. It was similar when I made all those little puppets and very large photographs, like normal paintings. I seem to need this distance.

In life, something cold and quiet is often dead.

There's probably some psychoanalytic problem here. A vitrine is just like a tomb, and my deep frames are just like tombs too. Because the sides of my frames are so deep, photographs disappear but the frames will last forever, as it is in graves when the body has disappeared but the wood is still strong.

By making dead things are you trying to remind yourself that you are still alive?

It is hard to say. Nothing is ever that obvious. Artists have very few subjects: they always speak about the same things. I am working with the idea of fragility and disappearance. So if my work is about childhood, for example, it is not because I am interested in childhood, it is because that is the first part of us that is dead. We are dead children. We have the bodies of children inside us. If I have been interested in children it is because they are always dead, and we are dead.

You have persisted in calling yourself a painter, but will you ever return to painting?

Probably not, because I am unable to touch things directly.

Why?

Because I am afraid that if I do that people will see what's inside me.

So after that early tactile stage you shut up the objects you made so that no one could see them, as in the piece where small handmade sculptures are supposed to suggest to the viewer what your mood was on the successive days when you made them. But you put them all into biscuit tins. The conclusion must be that you're an expressionist who hates himself for it.

I can never speak directly. Perhaps that explains why I often decide to hide

things. That's also why I lie and admit I am a liar. When I say something then contradict myself it means that if people want to catch me then I can escape.

Why do you make art?

To give people stimulus to recognise their own problems. Artists can help people to do that. And help themselves too, perhaps. A long time ago an old curator came to my home when I was making a little paper plane and he told me 'Before you throw those you must put them in your mouth. Then they'll fly better.' It's true. I did that too when I was a child. But it was beautiful the way this old man remembered what he had done 40 years ago. I am sure that when I made pieces like *The Album of Family D.* or *The Mickey Club* I was thinking of the war and the concentration camps, though at the time it was impossible for me to admit that to myself. *The Clothes of François C.* is particularly close to the concentration camp museums and I'm sure it was about that, although when I made it it was impossible for me to focus my mind on the subject. The more you work, the more you think about yourself and the less afraid you become.

Tell Me Everything:
an interview with Richard Prince

Published in Artscribe *73, January/February 1989*

Stuart Morgan: How did you begin painting jokes?
Richard Prince: Well, the jokes came out of doing the cartoons, the cartoons came from looking at pictures of cartoons and that in turn resulted from considering various ways that advertising used illustration instead of photography. Before looking at advertisements I was looking at film stills. It's the way most artists move; looking at this, they notice that. What I was calling 'jokes' were in fact cartoons, so dropping illustration and working simply with text seemed logical. They began as something abstract. Gradually they became tragic in a quite unexpected way. The jokes came out of my writing too. Jokes are not like other kinds of sentences, especially the endings.
At the end something is tied up, but just as this happens everything bursts apart. In front of large audiences the effect of laughter sounds like waves breaking – exhilarating and terrifying at once, like a rough sea. You took a cartoon to pieces in 1986.
I spent a summer copying Whitney Darrow as a way to keep drawing. The one I broke up – two men drinking at a bar and the one saying 'I'm missing and presumed dead' – is a Stan Hunt. That group of images, that gang, is academic but easy to understand if you yourself do the re-photographing. It's like being a movie director; you move around the image, shooting any part of it or all of it. It was the only gang I've ever done that with.
Why that cartoon?
It's a joke on myself, on appropriation, on authorship. I'm missing and because of the death of the author I'm presumed dead. It's funny to me

because I don't sit around thinking about such things.

Jokes don't have real authors, of course.

Even cartoons don't have real authors. As far as I can tell, a lot of them are drawn first, then the punchline is added by someone else. Similarly, using cartoons was a way for me to hand over what I was doing to someone else. With the jokes I use I'll see them repeated in other magazines or books. For example, 'I went to a psychiatrist. He said "Tell me everything." I did and now he's doing my act.'

That particular joke was then superimposed over sets of pictures which involved a couple and someone walking in on them and catching them out. Why did you do that?

Cartoons have recurring patterns, like a person entering a room and discovering a husband or wife with a third person. (The other situation is desert islands.) A husband finding his wife in another man's arms has nothing intrinsically funny about it. And it's international; you don't need language. So I just took the captions of these cartoons and superimposed jokes. Since the caption is no help, it is about how to focus on a situation, and on the fact that at any one time I'm using about eleven jokes in rotation. In a year or so they'll change.

Like a stand-up comedian.

I used to work for the stage crew in a New York nightclub and when the comedians came off-stage they were the most depressed, unfunny, demanding, mean-spirited people on earth. The transformation by which they become funny is unthinkable.

It's probably sheer terror.

Having a show as an artist is just as terrifying. One day I read my own guest-book. On one page someone had written 'I love you Richard'. On the same page it said 'I wish Richard Prince was dead'. That's showtime. That's why I made *The Entertainers*, so that people could go and have a good time and see themselves reflected in the glass and read these funny misspelled first names.

What kind of entertainers are they?

People assume they're porn stars but in fact it's like the movie *The Sweet Smell of Success*: about getting a break somehow, going onstage and doing a ten-minute spot or a bit part in movies or stripping. They always carry their publicity pictures with them and every time you meet them they have a new legitimate name, for which they keep altering the spelling. Leora, Plastique, Nikkki, Fayy, Tamara… They're just working to pay the rent, as I did at Time-Life, tearing up magazines.

Unusually for you, they are human scale.

They lean back against the wall in a pose good-looking people adopt in bars, not having to work hard to attract, waiting for other people to come to them. There is something sexual in the leaning, something instinctive and weighty, and the viewer's own feet and body are reflected in the glass.

Making relationships plays a large part in your work. But calling gangs *Girl- or Boyfriends* seems a little cruel or sad somehow.

Either that or it's accurate. Those *Girlfriends* are actual girlfriends of boys who sent their pictures to the magazine. It's a strange lifestyle. The *Boyfriends* don't work that way. That's about some kind of struggle with myself, the idea of not censoring what I'm attracted to, the possibilities of relationships that exist between men and men, men and women, women and women. Calling those sad would be more about you, which is what the work should be about.

What I'm saying is that surely a man from a porn film is intending to be a perfect one-night stand, not a long-term relationship.

Maybe that's why it's been such a struggle and I ended up using a cartoon and calling it *Cowboy*. I haven't titled a piece *Boyfriend* yet.

Have you learned anything from making them?

There was nothing to learn. It's been there from the start. I resent not being included in any closed group. Some of the best art I've ever seen is obviously homoerotic and there has to be that possibility in my work. I think I let it in.

How do you see your relationship with your audience?

I derive a certain pleasure from reminding them that things exist despite the fact that they might want to deny them. Sometimes it works, sometimes it doesn't. Sometimes I'm aware I'm not being offensive or inoffensive enough.

Bare-breasted women with torn stockings on motorcycles, quoted by a man, is something a lot of people would like to exclude from their life-experience.

Live Free and Die could be labelled repressive but these women are living on their own terms. I don't look at them as signs. These things exist. They are pictures of what I was drawn to, instead of the advertisements. I wasn't drawn to those in the same way. Recently I made a poster for a show in Germany and chose an image of women holding shotguns. Then I asked myself why and tried to be hard on myself. I thought, well, I'd like to go to bed with these women and have them kill me.

Would you? Really?

Well, what do I know? Yes, I wouldn't mind it. But this, of course, is an answer from a person looking at an image. If these people were alive, would I feel the same? Images are not going to come true, and they aren't really going to kill you,

and a relationship with an image differs totally from a relationship with something that moves and breathes. Since (say) 1949 there has been a whole generation of artists who have grown up with the idea that they can actually have a relationship with an image as if it had an ego or were alive. There has to be a good reason for making it into an ad and publishing it in magazines. And I wouldn't mind somebody saying 'This is beautiful'. Who said a naked girl on a motorcycle wasn't beautiful?

Are you saying there's nothing special about the images you choose?

To me it seems that way, but there is. What happens when I look at them is that it's about my life, the lives of my friends, the lives of people I don't know and the lives of dead people. Tolstoy could have been talking about art when he said a good revolution is one that makes people feel good. But still in a way it is not special. When someone told stories around a fire in the deep past, that wasn't special. In this generation a few people have been thinking about the idea of authorship, and obviously it has been on my mind that the artist is not as special as he or she was made out to be because of Modernism. When I went to look at my jokes hanging in a gallery I saw people laugh out loud. They weren't thinking about colour or form or content. For a second that was all there was there.

Once more, what are the jokes about? Taboo, abandonment, terror...

Personal problems, good problems, not liking yourself, liking yourself as much as you can... I had no idea what the psychiatrist joke meant. Someone had to explain it to me. Then I didn't know where I located myself. Was I the patient or the psychiatrist? Whose act was I doing and who was doing mine? I ended up putting that joke on the Spectracolor board in Times Square. It was the first thing that came up on January 1st, 1988. The title was *Tell Me Everything*.

Timing like that has become more important recently.

Now I've even begun signing and dating jokes to the second. I've never signed anything on the front because I felt it would interrupt the look of the work. But it shows how long it takes to write them. The comedian's timing, that wave breaking... But it's also about a critical position towards the function of the artist and a relationship to an audience. In the eighties the romance of signing has returned – I've seen artists who sign pieces several times, as if they are halfway through or at the end of a working day. Other people love this: it's something of the artist, like a diary. But doing it to the second is like saying 'Stop. Enough, already.' In terms of my own work, it was a way of ending a practice and beginning something from zero. I'm not associated with the hand;

I'd been re-photographing images for ten years. Beginning the jokes was like starting over. I didn't know what I was doing. At the time sculptors were casting sculptures in bronze, making huge paintings, talking about prices and clothes and cars and spending vast amounts of money. So I wrote jokes on little pieces of paper and sold them for $10 each. I had a hard time selling them. One dealer bought two and asked for a 10% discount. So I decided that every six months I'd double the price. All this was possible because no one was looking at my work. That's a fairly good position sometimes. You can get away with a lot of things.

What was the reaction to the jokes?

The same as the reaction to the re-photographed stuff ten years before. Complete disbelief.

A change of style can take place for different reasons. In your book _Why I Go to the Movies Alone_ you wrote of one of the characters: 'His own desires had very little to do with what came from himself because what he put out, at least in part, had already been out. His way to make it new was to make it again and making it again was enough for him and certainly, personally speaking, almost him.' Is the running fantasy in your work about being someone else, or less than an individual?

Just the opposite. 'Personally speaking' is what's strange about that sentence. I was trying to be very precise with that little curve because I knew it was so unexpected. People writing about appropriation at the time were not being honest. They were making a life situation into an art situation. My position was a personal one like everybody else's. So at the time I was trying to move away and say that maybe the reason I used other people's pictures was that I didn't like my own. Maybe it was that simple: I was saying to certain critics, 'Look, I appreciate your attention but you're all wrong.' When you do that, you run the risk of damaging your own career. You know, biting the hand that feeds you.

You've said 'In the future no one will be famous.'

There was a time when the famous were revered. Now fame is associated with clowns and fools. Gifted people will choose to step out of the public eye because it might be more of an advantage – or more manipulative – to know when to step in and step out again. More people will want that advantage.

Is that what you want?

To have no one looking at your work is healthy because it provides the possibility of certain freedoms. Like the jokes or the Brooke Shields episode. In 1983, I opened a gallery called _Spiritual America_ and had a person front it for

me. There were cards and openings but it was all simply to show a single picture in a private situation, a room with one work on the wall that would survive from month to month so I could see it the way I wanted to see it. I have never allowed the picture to be reproduced.

But why *that* image?

It represented the most expensive photograph in the entire world because of the lawsuits surrounding it, one where the camera took over and did things there was no control over... When Brooke Shields was ten years old, she was included in a portfolio by a guy who was taking images of children dressed up as adults, to publish in a brochure promoting his business. It was all innocent enough at the time. But one of the children grew up to be American royalty. So there was a big lawsuit to protect her girl-next-door image. A photograph had become evidence, which is what the history of photography has built into it as opposed to painting. Late one night under conditions of great secrecy I got the picture but could only keep it for about eight hours, in order to rephotograph it. When I saw it, I thought of an image I had just come across, an Alfred Stieglitz photograph of a gelded horse, which he called *Spiritual America*. What I saw was a woman who was still a child, with a body that was gelded and oiled. It had really got out of hand. The mother didn't know it. The child didn't either. Nobody knew. It had become a living thing that needed its own space. I owned an 8x10 and sent out a card: *Brooke Shields by Gary Gross by Richard Prince*. What I was hoping I said was accurate. Very soon lawyers came in limousines with the owner, a woman who had the rights to the photograph – how they knew about it was a mystery – but when she walked into this cement storefront on Rivington, off the Bowery, it was cleaned out, the photograph was in a gold frame with one of those blue, 19th century lamps above it, and she was one of the only people who really enjoyed it. She really understood it and went on not to prosecute. Her lawyer dropped his case. Then another lawyer appeared, representing the photographer, and he went after us. But they went after the owner of the gallery, and thought it was the woman who fronted it for me. After a couple of months they got tangled up, wasted a lot of their money and didn't know who to go after in the end.

A Summer Place

Catalogue essay for an exhibition of the same name held at the Salama-Caro Gallery, London, 1990, of works by Simon Periton, Mike E. Sale and Paul Stone.

There is a moment in Yogi Bear cartoons when he moves so fast that he fails to realise that he has been running along a cliff. With his feet rotating like propellers, he shoots forward, off into mid-air. The second he looks down and spots the ground below, he plummets like a sack of cement. Call it bad luck. Call it just deserts. The time that falling bodies take to land could also be called 'relief'. But what is the name of the state before that, that brief but spectacular bout of high- speed pedalling? For those of a moral turn of mind it is pride that cometh before a fall. Or could it simply be the condition that prevails when the beginning is forgotten but the end is not yet in sight? Situated somewhere between depression and panic, inertia is caused by doubt about why you ever started running at all. Intermediate by definition, it belongs to mid-career, mid-life, even mid-year. Its proper season is summer. [1]

'Summertime', the song runs, *'and the living is easy'*. Not in 1990. Not in Britain. But though the unrest is almost tangible, as always in the middle of a British summer nothing seems to be going on.

At a moment when she has turned into a creature of myth and legend – a recent inquiry revealed that she has had more popular songs named after her than any figure in history, three ahead of Adolf Hitler – Margaret Thatcher has decided to ignore the protest of 200,000 marchers who recently descended on Trafalgar Square as a demonstration against poll tax. [2] She has also decided to do nothing about the ozone layer. But it's summer, after all, two months of something deader than a British Sunday. Nothing will happen; the city is becalmed. Easy living, indeed. The real summer song would go round in circles,

like that irritating one I used to hear as a child; once you began humming it you couldn't stop. With every repetition, you became a little more vexed; what had begun as a glorified advertising jingle was turning into one of the circles of Dante's Hell.

In the first week of June I hear it drifting through the wall. My next-door neighbour is a musician and he is playing it on a keyboard. 'Jon,' I say when I see him next, 'I remember that new song you're doing. What on earth is it called?' He hums for a second. 'That one? *A Summer Place.*'

Released in 1959, *A Summer Place* was as raunchy as censors would allow, a cross between two genres, the beach-party movie and the *Peyton Place* bedswop bonanza. It starred Troy Donahue and Sandra Dee, and in true Hollywood style, a theme song was commissioned with the same title as the film but with no perceptible relevance beyond that. Over 30 years later, the tune feels and sounds like summer, a period of inaction verging on paralysis, when the only issue is that no issues seem to apply and the only problem is that though all the ingredients of change are present, nothing happens. But what does that mean, 'nothing happens'? What *is* an event, after all? Alteration can result from storming barricades. But it can also follow a process of erosion from within, making structures increasingly unstable until they collapse altogether.

Recent scientific developments have been notable for a sense of collapsing categories as well as for a specific refusal of accepted ways of working. In 1986 a BBC radio talk with physicist David Bohm came badly unstuck because of his complete denial of principles that seemed second nature to his interviewer: that science is based on observation and experiment.[3] 'I mean, why do you want to explain experiments?' snapped Bohm. 'Do you enjoy doing it or what?' Then, after dismissing observations as 'a secondary affair', he attacked his interviewer once more: 'What is it about making observations? I mean, that's an idea that started a few hundred years ago. People hold onto it because they have been taught it by their teachers.' Moving in for the kill, his interlocutor forced Bohm to repeat that because no experiment had been conducted or even formulated to test his theories, the topic of their debate was not science at all but 'philosophical standpoints'. At this Bohm exploded. 'I'm trying to say that if everybody took that attitude, saying we will not listen to anything anybody has to say before performing an experiment, then nobody can ever propose anything fundamentally new.' Meant as an interview, one of a series on the relevance to quantum theory of the Aspect experiments reported in 1982, the occasion had turned into a pitched battle because of Bohm's defence of speculative thinking

as distinct from the testing of ideas one at a time. His reference point, he has often admitted, is early Greek thought; he has argued for an 'intuitive' understanding of scientific principles and he once said 'Physics is a form of insight and as such is a form of art.'[4]

All this could be dismissed as eccentric except for other factors. For some time commentators have been arguing that an entire alteration in scientific thinking has been under way, a change as far-reaching as the adoption of a mechanistic model of the universe by Galileo or Newton or the alternative model offered by quantum theory early this century. The change involves what things are made of and how they are organised. Correction: how they organise *themselves*, for it has also seemed that we are on the verge of discovering new principles of organisation in nature, principles that do not necessarily contradict existing ones, whether mechanistic or quantum. At this point physics verges on metaphysics, just as quantum theory threatened to topple into mysticism in its most characteristic explanations. The possibility in view is nothing less than a theory of the arrangement of everything. This has sometimes meant returning to simple observation – of movement in clouds or liquids, for example. It has also involved setting aside certain apparent inevitabilities of scientific thought, terms like 'experiment' or 'law'. Another idea that has needed to be jettisoned is the truism that science and religion never mix. Science combining strands of Eastern and Western thought, discussed in popular studies such as Fritjov Capra's *The Tao of Physics* or Gary Zukav's *The Dancing Wu-Li Masters* may be what the future has in store. Talk of Butterfly Effect ('sensitive dependence on initial conditions'), the idea that even the flap of a butterfly's wings can alter the weather, opens the way to an image of the world as a network of relations, and equally to mysticism and religion.

That it can also capture the popular imagination was demonstrated by the influence of chaos theory. Published in Britain in 1988 and in paperback the same year, James Gleick's book *Chaos: Making a New Science* had little perceptible effect on the art world. The only British critic to publicise chaos theory was the late Peter Fuller, with his Ruskinian passion for finding 'sermons in stones'. But for fashion the time was right. The legendary 1988 Summer of Love marked both the zenith and the eclipse of Acid House, not only a style of music but an entire subculture, stamped out by the police and the gutter press.[5] By April 1990 when *i-D* magazine produced its chaos issue, chaos imagery derived from the fractals of Benoit Mandelbrot was turning up in advertising, fashion and video. Indeed, the Mandelbrot Set was 'threatening to replace the

peace symbol as the sign of the times', one caption read. [6] Somehow the ecological, quasi-mystical aspects of mobile paisley patterns had collided with the woolly politics of Coca-Cola or Benetton advertising, Live Aid and 'world' music to reach an audience that cut through social categories from hippie to yuppie. Acid House drew on naive sixties optimism, the yuppie fascination with technology and the sarcasm of punk. Peace-oriented, it was the harbinger of the nineties mentality.

'Towards the end of the last decade, the chill wind of unenlightened individualism that had blown through the previous ten preceding ten years started to slow to an insipid breeze. People felt that the nineties would be a different kind of era. Words like concern and care replaced enterprise and initiative as the universal clichés used to endow products and ideas with a positive aura ... On the underground, in the clubs ... something was happening and had been for years. "Peace" and "love" had become the watchwords.' [7]

And, surprisingly, it did last longer than three summers even without the illegal warehouse parties, chemicals and hallucinogens. [8] The effects of acid are still evoked by computer graphics, forms in continual flux, extended equilibrium, infinite summer limbo. Acid House suggests that if one collapse of categories is overdue it might be between lifestyle and art statements. A news item in a recent issue of *Art Monthly* reported on a conference in France, held in the dullest of places, where drably dressed people sat around doing nothing whatsoever for weeks on end. [9] The subject of the conference was *banality*.

That all this may not have been the entire truth was deducible from a single shred of evidence: the author was Ralph Rumney, erstwhile member of the Psychogeographical Committee, the London branch of the Situationist International. Perhaps the mere existence of the article was simply one more example of the growing interest in Situationist theory which has been evident in recent years. In 1989 in Paris and London, then in 1990 in Boston, exhibitions and books were devoted to the Situationists, though the entire notion of a Situationist exhibition is problematic; in 1962 the group abandoned art for politics. [10] What happened after that was sketchy and perhaps aborted, ending with Guy Debord, the self-styled leader, in hiding for ever, 'in fear of his life', as one of the French curators of the exhibition put it. [11] Nevertheless, the Situationists' aim remained identical in both periods: 'the critique of everyday life' (the title of the book by Henri Lefèbvre) or 'the revolution of everyday life', the title of Raoul Vaneigem's book. This may be the goal of both art and politics. (Pinot-Gallizio, who had become the political representative of a group of

gypsies, went on to make models for a post-revolutionary nomadic city where play, not work, was the object. 'ABOLITION DU TRAVAIL ALIÉNÉ', he scrawled on a canvas in 1963.) Situationists recognised the way that governments use the threat of unemployment to subdue the populace. For their part, they kept the most vivid human activity of all, the disturbance of the status quo, as their ultimate outrage: an autobiography with not a single word written by the author and each page designed differently (*Mémoires*) and a film with no images (*Hurlements en faveur de Sade*) were among Debord's works. But how else did the Situationists spend their time? They had an office with no telephone. And, presumably from and to that office, they walked around Paris, walks that eventually turned into maps of a city made by cutting it into sections and relating them differently, according to states of mind. *Guide Psychogéographique de Paris,* one work by Debord is called, with the subtitle *'Discours sur les passions de l'amour'*. Boredom, Situationists maintained, was unproductive. Yet their boredom had its seductive appeal. Attempts have been made to connect the original Situationists with British Punk. These days their problem would be to remain untainted by a culture they regard as irredeemably compromised. (The term 'counterculture' no longer applies, one British critic joked. Only if the counter is in a shop.) [12]

From the time that Jean Baudrillard's first book *The Society of Consumption* (1967) was published to a point 20 years later when Peter Halley could mention Debord in the same breath as Barthes as an influence on his own thinking, a chance remained that artists would take Situationist thinking to heart. [13] In the course of that 20 years, it seems, the likelihood of their doing so became more remote. The passion for conceptualism and other transitory art forms was followed by an equal and opposite 'rematerialisation', an insistence on objecthood and permanence. Gradually the political aspects were drained away from conceptual art in all its guises, and equilibrium was restored to the art market, which is to say the 'market' in general. What happened between 1968 and 1990 is a confused, ferociously debated story which has never been properly told. Some facts: new art even in New York, now the last bastion of conservatism, fighting for its life as the period goes on, has preserved the memory of the non-existent object, and recent American art has continued to play with the idea of the vanishing object, treating it (correctly) with more liberal doses of irony as the years pass. Major conceptual artists might well have capitulated on their former positions. With Reagan, Thatcher and the rest the right wing became firmly entrenched, with everything that that implies. And,

between the time of the Arab Oil Crisis and the recent New York Stock Market Crash an unholy alliance had been forged between art and money, with prices spiralling to unforeseen heights. To those who lived through the late sixties – a period which seems to produce a strain of factual amnesia in its former participants, who are unable to discuss it without donning rosy-coloured spectacles – the story of WHAT CONCEPTUALISM DID NEXT consists of a roster of sell-outs. The single factor that makes their testimony more or less valid or, conversely, invalidates recent art, politics, and art politics, is summed up by the prefix 'neo-'. Neo-conceptualism is not conceptualism, neo-conservatism is not conservatism. That goes without saying. But it is the ratio of difference that is the crux of every argument. What if *echt* Conceptualism never ended and, having slated their demands for dematerialisation, artists then proceeded to state them more specifically, to explore (as any utopian Modernist would and did explore) the ramifications of an objectless future world? And what if that exploration involved making objects and including them in the exploration? Are we so naive and literal-minded that we suppose that what you show is what you want? What if the real achievement of 'conceptualism' (which was a misnomer in the first place) was a more subtle engagement with ontology in general? What would then emerge is the advanced stage as it exists now.

'The Marble Period', Germano Celant has titled this era, in which a second-generation conceptual discourse about objects is conducted in visual, not refusal of visual, form. [14] He also calls it Unexpressionism or Conceptual Baroque, indicating its 'critique and parody, a displacement and a construction/deconstruction of economy and information, consumption and the languages of the public and mass media.' Walt Whitman once dismissed his *Song of Myself* as 'only a language experiment'. Baroque Conceptualism may amount to something similar. Celant is describing a state of affairs – an international state of affairs, to be precise – in which art straddles more than one world (the gallery and the mass media), more than one tone of voice (seriousness and parody), in which it employs objects while striving to undermine them at the same time. The way that a work of art exists in such a period constitutes an enormous part of what it says. A glib remark perhaps, that perpetuates outdated dichotomies like form and content. But the history of neo-conceptualism is the history of the gallery, the history of the vitrine; it is an account of separation between two contexts: gallery and street. And why? 'To be able to perceive the realities of the New York streets and live within the confines of the "art world" demands a personality too schizophrenic for survival', wrote Kathy Acker in 1990. [15] And

the tension is that great. Why assume that the artists are powerless, that they have played no part in building up that tension? If we live in a post-modern phase, and post-modernism is not simply a period which follows modernism, as Lyotard began by arguing, but as he went on to suggest, a recurring moment when the modern needs reinventing; if the difference between the art world of the sixties and that of the eighties is the difference between fiction and parody; and if Baroque Conceptualism represents a moment before categories implode in art as they have in science, would it be too much to expect 'the sublimation of a revolutionary project into the social system it once refused', the revival of (at least neo-) Situationist tactics? [16]

Models for art are changing fast. If appropriation embodied a disillusion with media, it reacted to this by employing those same media. So a closed circle was created, a circle, it could be argued, which can only be broken by direct experience, human engagement and honest response to matters of life and death. The AIDS epidemic sets much recent art in context and has everything to do with the way art is changing. (This would not need to be said in New York. In Britain, there are extremely powerful people, at the cutting edge of the art world, who think not. Names will be supplied on request.) 'We used to say: "how can we live like this?",' writes the narrator of a Gary Indiana novel. 'And now the question really is "how can we die like this?"' [20] It could be that neo-conceptualism has become increasingly redundant as the years have elapsed, and that making art for billboards in Times Square has not been the way to reach the majority of the populace. It could be that fascination with the media has outweighed revulsion in the work of artists such as Cindy Sherman or Richard Prince. A new model for artistic practice would include working half-in, half-out of media and differing social contexts, engaging with their resources in order to use them and alter them at the same time – a revival of the original plan of some of the artists I have mentioned – and a new relation between what is public and what is private, a more direct link between separated areas of our lives. When the period of hovering is over and changes come in art, they will come fast. [18] *We must be prepared.*

We are living, so they tell us, in a system-break. As the year 2000 approaches, a decade of 'end of the century stocktaking' lies ahead: a period not only of revision and correction but of new ways of thinking. [19] The seventies was about post-modernism, and the eighties about internationalism, Thomas McEvilley announced at a conference in Britain this year. The nineties, he added, will be about *globalism.* Already sketches for a new world-view are being drawn up.

'It combines Eastern thought with relativity physics with Sufic and Franciscan and Zen mysticism with pagan animism with astronomy with biology with Hellenic polytheism with tribal ritual with Jungian and Freudian and Gestalt psychology with ecology with the arts with African aesthetics with Jefferson with Marx with... Well, the point is that one of the historical projects in force now is a planetary movement to form a new faith...'[20]

Experts have compared the contemporary situation to that of the first century A.D. Comparing it to the decline of the Middle Ages might be nearer the mark: a time of pandemic depression and plague, and also of visionary experiences. There is very little to hold on to. The idea that we are part of what we observe, that the universe is a play of forces, indeed perhaps a finite amount of force, that everything affects everything else, however difficult it is to perceive, that life expectancy is dangerously short... and that for the whole of our lifetimes the same ideas will recur, as they are sifted through and their alignments alter in that sifting, as what is useful remains and what is not is abandoned, in the search for an appropriate mind-set. Right now the feeling that nothing is happening may be inevitable. And the sense that names and things are mismatched. Or the feeling of being trapped in a loop, stranded in the middle of something – a jump off a cliff, a song, a lifetime, a summer, a place. We may yearn for change. And for ways to show how that yearning feels. But we must go on living through it. Things could be worse. After all it *is* SUMMER.

1. See the present author's *Under the Sign of Saturn,* London: Nigel Greenwood, 1987, and *Panic*, Rotterdam: t'Venster, 1987.
2. Robert Chalmers, 'A Song for Margaret', *Sunday Correspondent*, 6 May 1990, pp.29-30.
3. P.C.W. Davies & J.R. Brown, ed., *The Ghost in the Atom*, Cambridge 1986, pp. 118-134.
4. David Bohm, *Unfolding Meaning*, London, 1987, p.31; P. Buckley & F.D. Feat, ed., *A Question of Physics*, London, 1979, p.129.
5. Antonio Melechi & Steve Redhead. 'The Fall of the Acid Reign', *New Statesman & Society*, 23-30 December 1988.
6. Jim McClellan, 'Chaos Culture – The New Order?' *I-D* no. 79, April 1990, p.43.
7. Sean O'Hagan, 'Flying Club Class to Inner Space', *Sunday Correspondent*, 22 April 1990, p.38.
8. Ralph Rumney, 'The Importance of Being Banal', *Art Monthly*, September 1989, p.2.
9. I. Blazwick ed., *An Endless Adventure ... An Endless Passion ... An Endless Banquet: A Situationist Scrapbook*, London, ICA/Verso 1989; and Greil Marcus, *Lipstick Traces: A Secret History of the Twentieth Century*, London: Secker, 1989. See also the present author's 'Niños Perdidos/Lost Children', *Arena* (Madrid) no. 5, December 1989, pp.62-69.

10. Anonymous quotation in Christopher Philips 'Homage to a Phantom Avant-Garde: The Situationist International', *Art in America*, October 1989, p.189.

11. Steve Redhead, *The End of the Century Party: Youth and Pop towards 2000*, Manchester, 1990, p.90.

12. Peter Halley 'Notes on Abstraction' *Arts* no. 61., Summer. 1989, p.39.

13. Germano Celant, *Unexpressionism*, New York, 1988, p.20.

14. Kathy Acker, 'In the Underworld', *New Statesman & Society*, 15 June 1990, p.42.

15. Jean-François Lyotard, *La condition post-moderne*, Paris, 1979. 'Reply to the Question: What is Post-Modernism?', *ZX* , Sydney, 1984, pp.10-18.

16. Edward Ball 'The Beautiful Language of Our Century: From the Situationists to the Simulationists'. *Arts*, January 1989, pp.23-27, and 65.

17. Gary Indiana, *Horse Crazy*, London, 1989, p. 88.

18. Ronald Jones, 'Hover Culture: The View from Alexandria'. *Artscribe* 60, Summer 1988, pp. 46-51.

19. Jean Baudrillard, 'Hunting Nazis', *New Statesman & Society*,19 February 1988, p. 16.

20. Michael Ventura, *Shadow Dancing in the U.S.A.*, Los Angeles, 1985, p.224.

Ansuya Blom:
The Secret Life of Belly and Bone

Catalogue essay published by the Stedelijk Museum, Amsterdam, 1990

'The body is a model which can stand for any bounded system. Its boundaries can represent any boundaries which are threatened or precarious.'
– Mary Douglas

One small, early painting by Ansuya Blom consists of a white ground inscribed in black and red. While the long, red striations resemble an electric charge – flickering around the centre, even over the edges of the stretcher – the black strokes form a complex figure, fixed at the top, dwindling to a set of verticals below which converge as if gripped and wrenched. The sense of crisis is heightened by paint-handling which lacks anything fluid or felicitous. The result carries suggestions of violence – bars ripped apart, teeth bared in a snarl – while its title, *Attica Blues* recalls the riots at Attica State Prison, where guards 'virtually assassinated' Sam Melville, leader of a prisoners' revolt and the only white man to take part.[1] In 1972 Archie Shepp wrote a suite with the same title, a collection of avant-garde jazz pieces each in a different style, punctuated by 'invocations' on the rights of man. Shepp's intricate orchestrations and hybrid rhythms may seem light years away from the hollers of early blues. But since the term never lent itself to convenient explanation – 'Lady, if you have to ask what it is, you'll never know,' Louis Armstrong told a woman who asked for a definition – Shepp leaves his listeners to interpret his use of the term 'blues' for themselves. Recalling Mondrian, who used the term 'boogie-woogie' to describe a visual equivalent

of running bass in his later, New York paintings, Blom reaches for a convenient inter-art analogy. Yet hers is not based on any formal correspondence. Instead, it denotes a mood and, indeed, an entire genre.

By the end of the seventies, the time of the *Kwanza* series, Blom had grown dissatisfied with the conventions that governed Dutch abstraction. Gradually she began to break free. Partly in response to developments in European painting, more particularly to feelings of herself as an outsider, she abandoned ideals of 'progress', that avant-garde byword that had served women badly for a century, and of 'purity' of media. Turning her attention to film, collage and sculpture and using titles which also referred to music and literature, she began giving way to her compulsions. An early example, the book *War Songs*, provides hints of the shape her career was taking. Beginning with the picture of a lifesize Mayan clay sculpture with a mouth that opens onto a vast hollow darkness inside, she printed key images – an Indian tribe photographed on the eve of battle; a photograph of a white guard glancing in fascination at his bare-chested, muscular, unrepentant black prisoner – together with texts, sometimes handwritten by the artist, alongside or superimposed on the photographs. The principle is not montage but palimpsest: instead of experiencing jarring contrasts between fragments, as so many Modernist texts demand, the reader is free to make connections or appreciate tensions between images, voices and images which blur in the mind. Time no longer flows from point to point. From this time on, Blom's working process involved doubling back constantly, allowing her preoccupations free play. Then they are repeated, altered and related. So the Mayan statue proclaiming war crops up later in a drawing, with greater emphasis on the face and mouth, for example. There are Modernist precedents for this approach, but troublesome, discordant ones. 'No matter how many times you tell the same story if there is anything alive in the telling the emphasis is different,' wrote Gertrude Stein in her *Lectures in America* of 1934. It is interesting to compare Blom's response to the call for a post-conceptual painting. Before long, Kiefer, Baselitz, Penck, Immendorff and others abandoned their urge for deconstruction of traditional painterly rhetoric in favour of signature style, grandiose scale, over-production and the market demand for old-fashioned masterpieces. While their break from the past and subsequent reconciliation with it have their place in recent art history, Blom's intimacy, limited output, abandonment of logic and scorn for neat development point in another direction entirely. Rejecting myths of

Expressionist markmaking as a token of speed and emotional authenticity, using allusive titles that combine to form an image-bank or commonplace-book, she even hints at relinquishment of ownership of the means she employs. Julia Kristeva stressed intuition and the idea of eternity as aspects of 'woman's time', a perception different from men's and potentially destructive of it.

Above all, Blom's habits of retracing her steps but overlaying previous moves with current ones corresponds to Kristeva's definition. [2] It is not a question of repetition; the issue is how thoughts shift and realign as time passes, art's power to change meaning while apparently staying the same, 'The real blues is played and sung the way you feel,' said one country blues singer. 'And no man or woman feels the same every day.' [3] Perhaps blues is inexhaustible because it addresses important issues – work, money, pleasure, sex and freedom. And, like 'woman's time' as Kristeva regards it, it speaks of and from the body.

In a poem called 'The Heavy Bear Who Goes With Me' one of Blom's favourite poets, Delmore Schwartz, described his own body, 'that inescapable animal'. Having a body and what this means, the consequences of what Schwartz called 'the secret life of belly and bone', offers one approach to Blom's art. Like a statement of intent, the chicken bones which appear in her first film *Lady Lazarus* (1984) recur in her second, *Borderline* (1985), dancing like marionettes in front of an abstract painting. Two photographs from the book *War Songs* (1984) also show chicken bones, in one case strewn across the floor, in the other attached to one of Blom's own paintings. Opposite two-line fragments from a Langston Hughes poem, they recall the desolation of a post-apocalyptic landscape ('Until time is lost/And there is no air') as well as their use as drumsticks ('Death is a drum'). Another important motif occurs in the film *Ysabel's Table Dance* (1987), the drawing *Minor Intrusions* (1988) and the collages *Man of Flowers* (1988), named after a film by Paul Cox, and *The Other Woman* (1987), after a song by Nina Simone. The idea of wearing vital organs – brain, heart, liver and kidneys – above, not below, the skin provides a theatrical demonstration of a main theme in Blom's art: human outsides and insides and their relationship, or differently stated, the line between Self and Other and its constant renegotiation. 'I used to wonder/About there and there' – wrote Langston Hughes in 'Borderline', the poem which Blom quotes in her film of the same name, 'I think the difference/is nowhere.'

Blom echoes the line in *Ysabel's Table Dance*. 'So here I am,' says the narrator, whom we take to be Ysabel herself, 'So there you are.' She seems to want to make certain that there are two people. Yet she seems unconvinced.

The climax of the film occurs when characters begin to blur. A lonely woman in a closed room is holding her annual celebration in honour of an absent friend whom she, infatuated, has tried to become. As their identities merge, time stops in a never-never land of her own creation. There is a sinister, saccharine tone about the preparations that take place. Her unpartnered flamenco, eyes closed, bags of offal tied around her head and body, represents an attempt to pretend that nothing separates them. The film ends at the height of her magnificent delusion, at the very moment when, for an onlooker, the scenario she has fabricated for herself becomes implausible.

At this point it becomes obvious that Ysabel has invented a ritual, which it is tempting to compare with the final scenes of *Amazing Grace*, when the girl, seeing that her life lies beyond her bedroom, takes her possessions and sets fire to them. In each case the heroine chooses to escape the situation in which she is trapped. But while both are lonely and spend their time with playmates, more imagined than real, one inches toward deliberate loss of selfhood, while the other decides to put away childish things and face the world outside. How difficult it is to distinguish private ritual from a lapse into insanity, and how easy to see that the plots each invents for herself involve reassessing the body. Whether it can be reduced to infatuation or mystical experience, Ysabel's emotional state eradicates distinctions between self and other, while the young protagonist of *Amazing Grace*, having realised the choices that will face her and having gauged her position in the universe, has no further need for 'transitional objects'. According to D.W. Winnicott's definition, these are 'objects that are not part of the infant's body yet are not fully recognised as belonging to external reality'. [4] Later theorists have extended the term to denote objects chosen to occupy our 'transitional space', a safe area around the body, which is both 'me' and 'not-me'.

Blom's sensitivity to this area is continued in more recent work such as her series *The House of Sleeping Beauties* (1989). The abandonment of the dolls' house in *Amazing Grace* followed an instruction from a disembodied voice. Its command 'The Queen must die' is followed to the letter. After hacking her doll to pieces with one of the knives, displayed earlier like an endless row of teeth, the limbs come to rest in rooms too small to contain them. *The House of Sleeping Beauties* takes this grotesque wrongness a stage

further. The title is that of a short novel by Yasunari Kawabata, in which, against his better judgement, the main character Eguchi takes a friend's advice and visits a brothel with only one bedroom. Here men warned not to interfere with them can spend the night with young village girls, drugged for the occasion. Despite the danger and the threat of humiliation if his secret were discovered, Eguchi continues his visits. The novel consists of his thoughts and feelings as he lies awake with one girl at a time. A precarious balance governs the rules of the house: though girls know what is expected, they never meet clients, who have promised not to take advantage of them, though whether this is polite hypocrisy or not remains a mystery to Eguchi. In the House emotional and mental permissions are reshuffled. And in her series Blom's use of toys, the ultimate transitional objects, is revised to include men's use of women. (Or near-women; Eguchi has a daughter older than the village girls.) The result is a disturbing game in which the child-like elements of sexual desire are acknowledged, with the release of unsocietised violence that children's play involves. To summarise, three basic plots are examined; the first a marriage of self and other, or a greater absorption in self, with transitional objects used to support that sense of selfhood while, visually at least, incorporating parts of another person; the second an act of willing renunciation based on an acceptance of a new relation to the 'outside' world and determined by the place of the individual body in that world; the third a temporary release from time, the lapse into a state like reliving one's life before sudden death. (Appropriately, Blom recycles her own previous imagery in order to underscore a view of time ratified by the procedure of her own career.) All three involve freedom achieved through pain, physical or emotional, and could therefore qualify as rites of passage, in which the initiate moves through symbolic death to a new life or rebirth. This alone should stimulate critics to search for a master plot.

It would be easy to mount an exhibition of Ansuya Blom's work, in which the route taken by spectators would parallel a journey through the body. From the image of the open-mouthed Mayan statue visitors would proceed to the drawing *Borderline* (1984), a hearth or threshold formation perceptible in *Vreemdland* (1985), and on to works with patterns of teeth, such as *Untitled* (1983) in oil, *Minor Intrusions II* (1988) or even the bedframe of *Hush Now* (1988) with its decorative arching pattern. The digestive tract appears frequently, often doubling as the tunnel of a termitary. When collaged organs appear in the tunnels, as they do in *Home of the White Ant* (1987/88),

for example, anatomical rightness seems to have been flouted. Yet the journey the visitor is taking, of course, is the same as that which food takes through the body, and since carnivores eat vital organs, this should come as no surprise. A title such as *We All Live Here* (1988) leaves no doubt that humans are animals too. And there are enough darkened, closed rooms in Blom's work to hint at the end of the digestive process, an act which takes place in secret with a hint of shame. Elias Canetti's book *Crowds and Power* includes lengthy disquisitions on the significance of eating. Eating, he argues, is the literal incorporation of prey; a ruler's ultimate aim is to suck the substance out of his subjects and then dispose of them like excrement. Archaic man felt that his weakness was smallness of number. As a beast of prey he never wanted to be solitary. 'In the enormously long period of time in which he lived in small groups he, as it were, incorporated into himself, by transformations, all the animals he knew. It was through the development of transformation that he really became man; it was his specific gift and pleasure.'[5] And since transformation and increase are connected, ancestors good at dancing (say) the kangaroo for their tribal rites were revered and initiated, because their existence, as men and kangaroo equally, ensured good hunting and the increase in the numbers of men compared to that of kangaroos. In myth and legend, transformation became a form of flight, of not being eaten, and heroes could become one thing after another. Sometimes, however, even a hero feels trapped and will not eat because he feels that he is being eaten and does not wish to be reminded of this: since 'everything he has attempted has been in vain, he is resigned to his fate and sees himself first as prey, then as food, and finally as carrion or excrement.'[6] This state of mind is the one later known as melancholia.

Yet melancholia, we know, was also felt to be fruitful for artists. Influenced by Sylvia Plath and also, perhaps, Frida Kahlo, both of whom took the modernist metaphor of 'decreation' (as Simone Weil called it) or 'the destructive element' (as Joseph Conrad described it) and both exaggerated and dramatised it, taking it over into their own lives as a form of 20th century melancholy, perhaps genuine, perhaps feigned, but certainly a spur to creativity. Yet here the parallels cease. While both Plath and Kahlo adopted the stance of avant-garde artists, to the extent of overdramatising their own positions, Blom has always allowed the work itself to generate thoughts about how the problem of Self and Other could be solved, if 'Self' continues to be conceived simply as the marginalised, revolutionary individual of Modernist

culture and 'Other' as an uncaring bourgeois multitude. Her art contains hints of an aesthetic which will move beyond this position.

Termites first appeared in Blom's drawings in 1984. Shown in cross-section, as it is in *Amazing Grace* the termitary resembles a factory. Yet a large body of theory, extrapolating from ancient political comparisons between body and state compares ant colonies with the gastrovascular system, for example, or the hormonal organism or germ cells. Such descriptions can be traced back to Eugène Marais's *The Soul of the White Ant* (1911) in which he proposed that instead of a separate psyche ants possess a 'group soul' like the organs of a human body, and compared the way ants co-operate with the creation, of the siphonophora, a 'fish' formed when different fish swim close together, each relinquishing all physical attributes but one, in order to become the new fish's eye or stomach or mouth. How they decide to do this, or how ants communicate, was a problem not even Marais could solve. As Julian Huxley wrote 30 years later, 'There is no real sense in which ants have leaders.'[7] It is a problem which has occupied Blom for over a decade. If ants can manage without being told what to do, can humans survive without leadership? References to such alternatives exist where least expected. In one sequence of *Amazing Grace*, for example, water flows with almost imperceptible slowness to the accompaniment of a gamelan orchestra.

Gamelan ensembles are directed by a single musician, a drummer who determines tempi and gives cues. Apart from that, no orders are given. Gamelan music is polyphonic, with about twenty parts, and no two performances are ever the same. Above all, there are no soloists.[8] (Indeed, good manners compels an orchestra member to change instrument at least once during the evening.) Gamelan is a social event conducted purely for the sake of the players, it seems, as a way of teaching restraint and refinement and as one step towards achieving *klas*, a state beyond emotion. Western commentators agree on one point, that 'Javanese music is what it is, can only be what it is, because Javanese society is what it is.'[9] No Western equivalent to such peaceful co-operation seems possible, though one unsuccessful attempt never seems far from Blom's mind. Titles are one way for the artist to contextualise her work and without question more titles refer to the music of Charles Mingus than to any other source. *Half Mast Inhibition*, *Far Wells Mill Valley*, *Minor Intrusions*, *Ysabel's Table Dance* and others were all Mingus pieces. Critics are still far from reaching a consensus on Mingus. This is hardly surprising. Drawn back repeatedly to the music of

contemporaries he revered, notably Duke Ellington and Charlie Parker, he strove for two ideals: firstly, a polyphonic music with complex structures and secondly improvisation, which he pushed to its extremes. (He is reported to have given Yusef Lateef a picture of a coffin, telling him to improvise on it.) Mingus is probably misrepresented by records, on which he can be heard shouting cues to his musicians. He demanded a fresh response to every occasion, and would sometimes leave the stage to break the tape recorders of audience members. He never stopped tinkering with his compositions, changing their titles as current events changed. So *Fables of Faubus*, named after Governor Orville Faubus, a racist politician, was changed to *Fables of Nixon*, when Richard Nixon, not yet president, altered his stance on black rights. How far from the Javanese gamelan orchestra it all seems. Yet, in its essentials, perhaps, their ideal is the same: the meshing of social and artistic conventions and the fusion of audience and players in an ensemble which changes constantly, like a living organism. Jacques Attali's ideal of 'composition', analysed at length in the last chapter of his prophetic book *Noise* (1977) was anticipated by Mingus, whose advantage, like Shepp's, was an ability to draw on blues, a tradition in which musicians and listeners were seldom distinct categories.

Blom's experiments have been as complex as they are wide-ranging. Exploring situations which range from considering co-operation in insect society to home-made initiation rituals, she has turned her art into a sensitive register of forces acting on the self. And in her work self is seen in terms of body, remembering Mary Douglas's statement that the body can stand for 'any bounded system'. [10] If Douglas is correct, then Blom's work constitutes a thoroughgoing political statement, though never an explicit one.

She makes it in a surprising way. Beginning with the pose of underdog – Mingus called his autobiography *Beneath the Underdog* – the blues singer, a figure with no very high ideal of him- or herself, it seems, tries to reintegrate. That, at least, is how it appears, and what convention demands. It could be that, as the novelist Ralph Ellison suggested, blues offers 'no scapegoat but the self', that melancholy self seen as existing only to be devoured. [11] Yet by some miracle the fictional and the real coalesce, and by a form of catharsis the process of coming to grips with trouble unites performer and audience, whose troubles are the same. Robbed of the power of transformation, unable to flee the aggressor, the performer has brought about its rediscovery and has set the cycle in motion again.

In terms of Blom's master plot, the digestive process is functioning normally and the hunted has become the hunter in an unceasing cycle not of aggression but of aggression expended. Blues, insisted the German critic Janheinz Jahn, was not about happy or sad moods but preservation of autonomy and consolidation of power, and he suggested the introduction of the term *magara* which in less than a sentence summarises the theme of Blom's art: 'the life force which one possesses, which one wants to increase, and which can be diminished by the influence of others.'[12]

1. According to Lawrence Lader, *Power on the Left*, New York 1979, p.277. Cf. John Cohen 'It is not hard to believe that Sam was executed' in Samuel Melville *Letters from Attica*, New York, 1972, p.74.

2. See T. Moi ed., *The Kristeva Reader,* New York, 1986, pp.187-213. The essay, 'Woman's Time' was published in French in 1979.

3. Big Bill Broonzy, quoted in Harry Oster, *Living Country Blues*, Detroit, 1969, p.20.

4. D.W. Winnicott, 'Transitional Objects and Transitional Phenomena' in *Playing and Reality*, New York, 1971, pp.1-25. See also Morris Berman, *Coming to Our Senses*, New York, 1989, pp.19-103.

5. Elias Canetti, *Crowds and Power* (tr. Carol. Stewart), Harmondsworth, 1984, p.126.

6. ibid., p.401.

7. Julian Huxley, *Ants*, London,1930, p.167.

8. Cf. Leroi Jones, *Blues People*, New York, 1963, p.66: 'The whole concept of the solo ... was relatively unknown in west African music.' 'How deeply Mingus's music is centred in the traditional blues' (Wilfred Mellers, *Music in a New Found Land*, London, 1964, p.349) is a common critical reaction to Mingus's music.

9. Mantle Hood, *The Evolution of the Javanese Gamelan* vol 1, New York 1980, p.14. Cf. Jennifer Lindsay, *Javanese Gamelan*, Singapore, 1979, p.39: the 'structuring of layers of sound ... reflects the ordered structuring of Javanese society'.

10. Mary Douglas, *Purity and Danger*, London and New York, 1984, p.115.

11. Richard Wright, *Shadow and Act*, New York, 1973, p.94.

12. J. Jahn, *A History of Neo-African Literature*, New York, 1968, p.172.

Thomas Grünfeld: Dead On Arrival

Introduction to Thomas Grünfeld: Misfits I-VII,
published by Karsten Schubert Ltd, 1990

The Gentlemen's Clubs of London are easiliy recognised: White's by its billiard tables, the St. James's by its acres of deep-buttoned sofas and the M.C.C. by a piece of history which would look strange anywhere else: a bird stuffed and mounted on a cricket ball. 'This sparrow was killed at Lord's by a ball bowled by Jenghir Khan (Cambridge University) to T.N. Pearce (M.C.C.) on July 3rd 1936,' the label reads. After titling works after other clubs, in 1988 Thomas Grünfeld used a photograph of this unusual monument to make a sculpture consisting of a vitrine in which three cricket balls were placed on felt and each had a stuffed sparrow on top. [1] The occasional nature of the work proved deceptive; in fact, it incorporated the main features of Grünfeld's sculpture so far. His research has involved skilled artisanship and a context that varies between public and private. (Hence the attraction to clubs.) It blurs the distinction between art and design. Most importantly, it depends on a precise perception of contemporary taste with all its subtlety of allusion. Take the felt, for instance, a nod in the direction of Joseph Beuys, who based his artistic mythology on ideas of density and insulation, but also emphasised his own felt clothing. Felt was important to him, Beuys maintained, because of the Tartars, who saved his life after discovering him injured in the snow after a plane crash. In his turn, Reinhard Mucha uses felt as a poor but seductive material, harking back to the postwar poverty of the German nation. A satirist might note that in his later years Beuys would wear his felt boots and hat with expensive silk shirts or that Mucha is too young to have been scarred by austerity. But Grünfeld is a

satirist; used by tailors to make the collars of men's coats, he noted, felt can be 'made of rabbit hair... actually quite an expensive material.'[2] High-class tailoring is one sphere in which art and workmanship are confused. Others are taxidermy and making sporting equipment by hand. But doing something once, as the M.C.C. Club have, and doing it three times, as Grünfeld prefers, means something quite different. In art, the number three signals the onset not only of pattern but also of production; it demonstrates that something is capable of being multiplied. Intent on unsettling the context of the art object, Grünfeld turns a monument into a souvenir.

Locating his works between art and non-art contexts – mounting them, on at least one occasion, alongside items from his own home – Grünfeld aligned them with his own talent for social observation. Those spiky green plants which Cologne residents put on window-sills did not escape his attention, nor the use of frosted glass in office furniture to indicate exclusion, nor the fact that no civilised interior is complete without 'primitive' wooden bric-a-brac, genuine or not. He became a student of *Gemütlichkeit*, that sense of well-being which emanates from and is promoted by bourgeois furnishing. Indeed, he thought hard about what 'furniture' could be. Use plays no part in defining it, his work suggests. Celebration of status certainly does, however, whether that status is real or supposed. Furniture tells us less about the circumstances of the owner than about a stereotyped lifestyle to which he or she aspires. But quite often the pieces are relegated to the level of neutral lumber, there for no apparent reason. Devoid of deep meaning, furniture in public spaces seems to be the brainchild of interior designers so intent on inflecting the entire area at their disposal that they invent new, impractical items to be looked at, not used. Hence Grünfeld's preoccupation with pointless drapes, with single-buttoned *pouffes* which seem to exist only for show because they are impossible to sit on without falling sideways onto the floor; in short, with that point where exhibition and use intersect. 'Use a Rembrandt as an ironing-board,' wrote Marcel Duchamp as the instruction for one of his 'assisted readymades'. Grünfeld returns to such exercises confident in the knowledge that for a large percentage of the population a household object is more cherished than a work of art, and that the fate of what Duchamp might have seen, naively, as some pure aesthetic engagement has been the production and consumption of kitsch. From stating the terms of a more popular ideal of art – a blue-faced Tretchikoff woman rather than the Mona Lisa – Grünfeld turned his attention to making trophies. For this is

what they are; their cost, spurious historical value and the degree of artistic pretension that attaches to them matter less than their existence as booty, tangible by-products of a successful lifestyle. Hunting (that traditional aristocratic privilege), object fetishism (the pursuit of the middle-classes) and leisure (the workers' ideal) assume tangible existence in taxidermy and sporting paraphernalia, furniture and souvenirs respectively. Ignoring class divisions, Grünfeld has covered all three with his objects: useless, empty, allusive, undefined. That they *are* objects is fundamental to his thinking. The conceptual 'anti-aesthetic' of the late sixties, with its dominant metaphor of opposition, resulted in performance, earthworks, words typed on sheets of paper. Paraded as 'anti-art', these were only too capable of being absorbed by the system. That very absorption may have sealed the fate of the avant-garde, the way of thinking that Harold Rosenberg described as 'the tradition of the new'. Nowadays only stealthy readjustment of prevailing values seems possible. Rejecting notions of revolution, classic modernism and its tenets, has also meant ignoring myths of self-referentiality; for Grünfeld meaning is pre-eminently social, and his art aims to examine how such meaning is generated.

Why taxidermy? The idea of illegitimacy, of something that does not belong jammed into a place it has no right to enter, is a source of repulsion, the state which, Freud explained, was inevitable at moments when the unconscious penetrates the conscious mind. [3] Perhaps confusion of categories is the ultimate heresy: inside and out, fur and feathers, edible and inedible, tame and wild. Inextricably jumbled, they become a way of positing what freedom might be; an absence of those antitheses by which language ensnares the brain. One opposition in particular governs our perception of what a person is: the preference for 'depth' over 'breadth' as human virtues, with the accompanying ideal of knowing people better by penetrating their outer shell, in order to mine treasures which multiply as the mining process continues. What if people are solid all the way through, or below the outer casing only stuffing can be found? (A religious variation is the sense that the body is worthless and that only the spirit matters.) Why do we stuff animals but not human beings? Why do we eat animals but not human beings? At the core of Western culture is a dualism we cannot bear to examine, a set of oppositions we live by but which are painful to consider for more than a moment.

Perhaps they can be shown, however. Grünfeld has always been interested

in the issue of display, to the point of making a work consisting of a frame containing three differently sized fake wood pieces, illuminated by lamps around the frame, one shining on each. The preoccupation continues, but the object of attention is now a pseudo-scientific collection assembled in order to illustrate some form of backbreeding. From 'display' to 'monster' is a shorter step than it seems. As Michel Foucault once pointed out, the words lead back to the Latin *monstrare*, to put on show – not, it might be added, for reasons of debate but as a form of spectacle. If freaks are despised and venerated in equal measure, one reason could be their power to defy analysis. They are guaranteed to block any ongoing discussion, whether of genetic engineering or developments in art. The suggestion is that art and science equally – for the overtones are those of a museum – have lost touch with genuine, difficult issues, which can be seen, but not solved.

Neither historically accurate nor a restoration of anything that ever existed, Grünfeld's new trophies are assembled by combining parts from different animals, made to look as plausible as possible – as plausible, at least, as a narwhal, a stick-insect or a platypus. Numbered, not titled, the *misfits* look lost and vulnerable in their cabinets of German oak – 'lost' because the cases are obviously too big, 'vulnerable' because of the neon lights and glass on three sides. Their sole function is to be displayed like specimens, and their disturbing air of self-consciousness may derive from this fact. Admittedly, they differ. While parts of a rabbit and a pheasant and the teeth of a fox give III a classical air, VI and V seem humorous and visually appealing, for example. In his *Croquis Parisiens* of 1880, J-K. Huysmans, a favourite author of Grünfeld, described a bar with vitrines full of clumsily stuffed animals, many with fixed, idiotic stares because their orange and black eyes are exactly the same, swans with beaks made from yellow wood, with unevenly filled necks and stuffing protruding from their bellies or an old toothless crocodile patched with shoe leather. Huysmans' descriptions rely on two familiar reactions: recognising human characteristics in the animals and a sense that though amateur taxidermy has resurrected them artificially their second life is all the more vivid because of clumsy workmanship. Grünfeld's misfits related to the Southern German *Wolpertinger* tradition, tall tales about improbable beasts lurking unsuspected in the wild. Neither drawings and descriptions of these animals nor concocted specimens serve to increase their credibility. Instead, they further the mythology surrounding them, a phenomenon which even moves into print with popular books such

as Alphons Schweigert's *Und es gibt sie doch!* or Heim and Reiser's *Mit dem Wolpertinger leben.*

In biological terms, it seems, the specimens in the cases are the born losers of the animal world, one-offs doomed to failure like the experiments of Wells's Doctor Moreau or the monster of Frankenstein. From the viewer's point of view, their survival seems in doubt precisely because their mixed parentage gives them no advantage whatsoever. The way we perceive them is by a process of spoiling a single, dominant beast and relegating variations to a subordinate status. In other words, the way we view them is biased in favour of what we already know, and what we know about breeding. Only the strong survive, and they are uppermost in our minds even in the apparently unbiased act of vision. Despite this, it is human nature to invent monsters: the grotesque offers a permanent means of testing and confirming our own limits. What the Gorgon has in common with E.T. is that both remind us of what being human means. Famous monsters of history are ways of posing and partially solving problems of beauty, evil, power and seduction. But only the famous ones; monsters too have a success ratio.

> We are as ignorant of the meaning of dragons as we are of the meaning of the universe, but there is something in the dragon's image that appeals to the human imagination, and so we find the dragon in quite distinct places and times. It is, so to speak, a necessary monster, not an ephemeral or accidental one, such as the three-headed chimera or the catoblepas. [4]

Jorge Luis Borges argued that monsters should be subject to the same tests as other imaginative constructs. In his terms, Grünfeld's *Misfits* would be the result of tampering rather than full-scale anatomical overhaul. Just as 'necessary' monsters are survivors of the imagination, their ephemeral counterparts pay tribute to the species which perished so that history could be written. Their very existence seems a tribute to our own justice and mercy. Or perhaps not. The M.C.C.'s sparrow might give the impression that it has been stuffed and mounted out of good manners to the bird, but the whole exercise was really about the game of cricket. Like the interminable lists of batsmen and bowlers quoted by experts, it becomes history, a continuation of tradition. But forget cricket. The context of these *Misfits* is double, like every context in Grünfeld's work. These are trophies for the home but also items

which gallery-goers examine. And the gallery could as easily be in a museum as in a place where contemporary art is sold.

In recent years the two have merged; the very idea of a *Kunsthalle* is to take art straight from the studio and install it in what was traditionally a context which only time could ensure. Bypassing vicissitudes of taste or critical outlook, sanctified instead by immediate decision-making, art has become instant history while what was once thought of as the gradual progress of culture has dwindled to mere fashion. Exhibiting developed from a willingness on the part of the nobility to open their homes to the public. At the time museums seemed a good idea. 20th-century commentators have not always been so sure.

> The German term museal (museum-like) has unpleasant overtones. It describes objects to which the viewer no longer has a vital relationship and which are in the process of dying. They owe their preservation more to historical respect than the needs of the present. Museum and mausoleum are connected by more than phonetic association. Museums are the family sepulchres of works of art.
> – *Theodor Adorno*

In 1980 Douglas Crimp used these words to open an attack on museums in an essay called 'On the Museum's Ruins'. [5] As Adorno saw it, and Crimp agreed, the museum murders objects by robbing them of their vitality. Nine years later, in an essay called 'The Museum Without Walls Reconsidered', Crimp moved a stage further. In the case of a *contemporary* art museum, he argued, objects would be killed without ever being allowed a chance to live. Nowadays, he adds, because objects are intended *for the museum*, to be interpreted within its discursive practice, 'they are already dead when they're made'. [6] In Grünfeld's thinking, opposition to art as a train of thought within fixed perimeters is possible only by subversive activity within those perimeters, not by gestures from outside. Yet this means an acknowledgement that the myth of the avant-garde must be prolonged artificially in order to demonstrate that it no longer has force or significance. Perhaps only a manoeuvre as paradoxical as *Misfits* can do justice to the illogical situation of contemporary art.

1. A. Lejeune and M. Lewis *The Gentlemen's Clubs of London,* London 1979, p.186.
2. Quoted in Cornelia Lauf 'Thomas Locher, Thomas Grünfeld' *Artscribe* 71, September-

October 1988, p.87.

3. Sigmund Freud 'A Note on the Unconscious in Psychoanalysis' in J. Strachey ed. *The Standard Edition of the Complete Psychoanalytic Works of Sigmund Freud,* London 1958, vol. 12, p.264.

4. J.L. Borges *The Book of Imaginary Beings,* Harmondsworth 1974, p.14.

5. Douglas Crimp 'On the Museum's Ruins' in Hal Foster ed. *The Anti-Aesthetic,* Port Townsend 1983, p.43.

6. Douglas Crimp 'The Museum Without Walls Reconsidered' in R. de Leeuw & E. Beer ed. *L 'exposition imaginaire,* s'Gravenhage 1989, p.272.

Homage to the Half-Truth

*Text of a lecture given at the Van Abbemuseum, Eindhoven, 1991,
at the symposium 'Writing About Art'*

Criticism provides a permanent record of a train of thought or a theoretical position or an encounter with the unfamiliar. Although its task is usually held to be judgmental this is only finally the case. More immediately, it offers interpretation. Above all, its function is didactic. Perhaps the only real way to learn is to listen or watch as another person solves a problem, the aim being to sample models of thinking rather than to learn methods. Instead of being judged by their capacity for deduction, though, critics should be respected for their capacity for intuition, sympathy and imagination. To gain full impact, after all, criticism has to display qualities of creative thinking. And no definition of criticism should omit this element of artistic inspiration.

Horace said that poetry was both beautiful and useful. In order to persuade, criticism also needs to be both. That criticism refers to another art does not prevent its existing as an artform in its own right. (We don't despise ballet because it needs music.) Its nearest neighbour may be translation – the act of shifting an experience from one language to another – since finally, perhaps, the experience of perceiving art can never be explained, but only evoked or paralleled. So art and criticism should be regarded as rivals, not allies, since under the guise of critics lurk potential usurpers. This is inevitable; critics operate as double agents, at an interface between artist and audience, seeming to speak for both sides while making both equally mistrustful. But suspicion is in order. Whose side are critics on, after all? There is only one possible answer. The critic is on the critic's side, for criticism means reserving the right to take any side at all.

The prerogative, even the duty, of critics is to change tactic or allegiance or orientation and it is not necessary for the reader to identify a continuing argument nor a particular line of enquiry in their work. That criticism is so frequently reduced to this is partly due to exigencies of journalism, where opinion is put in capsule form. So leaps of mind are necessary for what is the essential gesture of criticism, of a mental and emotional leap, an act of recognition. Chief among myths that underlie the critic's task might be that of Cupid and Psyche, in which total identification brings about the ultimate rift between lovers. But perhaps the basis of that story is not identification at all, but recognition akin to that which a critic feels: some sudden awareness of a pattern which was previously only intuited, a flash of similarity between what is inside and what is out, between self and other, or of mental and physical distances brought about by the experience of loving, or at least of attraction. If so, then critics can never be more than faithless lovers, wooing whatever attracts them, risking the inevitable which is that in explaining it they might succeed in explaining it away.

I know nothing in art criticism that equals the impact created by William Empson's analysis of a single Shakespeare sonnet in his first book *Seven Types of Ambiguity*, where he returns to the same poem time after time, producing interpretation after interpretation like a conjuror pulling rabbits out of a hat. This unrelenting display was based on the assumption that, at least as Empson saw it, greatness can be equated with multivalence, so the more things a poem means, the greater that poem is. When, after the book was published, it was pointed out to Empson that he had misquoted the sonnet and as a result had been discovering meanings for which Shakespeare had not been responsible, he included a footnote in the next edition of his book to point this out but he made no attempt to change the text. The entire exercise had been rhetorical after all. (How is it possible to convey inexhaustibility?) In the same way, all criticism must be rhetorical, because thinking is not writing; it must be reflexive, for as one writes one reads oneself writing. Above all, it must be dramatic, for the written self differs from the actual self. So criticism is indirect and conventionalised.

Description in criticism, for example, is not mere description; it does not serve to demonstrate that the critic has been looking carefully but instead provides the elements of the artwork which he or she considers relevant. So by a process of omission, it contains the seeds of the conclusion, like a detective story. The first-person singular in criticism, the word 'I', refers to a body of

published work. In short, critical writing is never naive; it is a literary construct, taking its place among many literary constructs signed with the same signature, a way of distinguishing these fragments from others and encouraging readers to use them to find a single 'voice', a single method of thinking to compare with their own, to be used in formulating their own position. Oddly, then, criticism is a combination of the very personal and the strangely impersonal. No middle ground exists because that middle ground will be occupied by the reader's own conclusions. And the perfect form for the act of criticism is the essay.

'Essay' means 'attempt', a sallying forth. It is a distinctly modern form which shows one person trying to sort things out in public. This is what Hamlet does; as he stands before us, we listen as he tries to solve a problem. And as he comes to a conclusion we listen and consider his process of arriving at it. And Hamlet is usually shown before us holding a book, which is traditionally the *Essais* of Montaigne. And it is what critics do to this day in an *essai* or verbal sallying forth. The range of available methods of doing so still alarms some readers. Having written an essay to be included in the catalogue of an exhibition touring the United States, I was startled to receive a copy of the complete publication, in which my contribution was prefaced by an introduction by a museum curator warning readers that what they were about to read was so unconventional that it resembled poetry more than criticism.

I fear academicism in criticism because it might dilute the strength of the writing. The prospect is horrifying. In New York at present there are radio channels where you can hear contemporary jazz played by orchestras made up of instrumentalists who all have PhDs in Jazz Studies. They are told to be completely abstract. (They must never grunt as they play; expressionism is out.) Perfect synchrony is achieved because every note is written down and if there are singers, they are made to sing laundry lists so that the music will not be allowed to mean anything outside itself. Criticism is free, it must change, it is amateur (meaning not unprofessional but the work of someone who enjoys what he or she is doing), it should be representative and personal and happen on an interface between viewer and world, artist and public, but equally importantly, between one part of a person and another, and between seeing and writing. In other words, it suffers a kind of sea-change in the process of being written. It become an object of writing, occupying an area of its own which is fictional. But perhaps that word and the bearing it has on criticism should be explained.

As a boy, I was particularly fond of the work of a golf columnist called Henry Longhurst. He was my idol and I would steal the sports sections of the papers

to enjoy what he wrote. 'It was twilight on the eleventh green when the champion took up his club for what might be the last time. If he lost this match his career was finished. And if this shot failed, the match was over. Birds were singing, and in the distance a church bell could be heard tolling faintly. Could they be tolling for him?' I was on the edge of my seat; surely no writing in the world could equal this. What a game golf must be, I thought. Some years later I changed my mind. One night I was talking to a man in a pub. He asked me what I did and I told him. Then I asked what his job was. He was a golfer, he said. Here was my chance. 'I don't suppose you read Henry Longhurst,' I asked. He seemed surprised. 'Longhurst?' he said, 'Why on earth do you like him?' And I told him about the sunsets and the church bells and the night drawing in. To my surprise, he laughed and laughed. 'You've never been to a golf tournament, have you?' he replied. Shaking my head, I asked how he knew. 'For years, Longhurst has been an alcoholic,' he explained. 'He stands in the bar and drinks all day and pays young boys to run out onto the green then run back and tell him what's going on so he can write it down.'

Artists should fight critics and they do. The most difficult artist I have ever worked with – and the most challenging – is undoubtedly Louise Bourgeois, who is French but never goes to France, and is American but speaks a combination language of her own devising, and who, they tell me, has co-operated on the writing of her biography. I doubt this. Firstly, in the nicest possible way, she tells lies. Secondly, she works hard to alter her biography as time goes on. Perhaps we all do. But Louise Bourgeois on Louise Bourgeois is something very special. (She often talks about herself less as a person than as an animal, fighting for survival, at war with countries, sexes and definitions.) One spiral form recurs in her work. Finding that her parents were tapestry-restorers, one writer concluded that it was a form derived from a repeated gesture: wringing the tapestries after washing them in the river Bièvre. Her own explanation of the movement was totally different and unexpected. The movement was her, wringing her father's neck, she explained.

For Louise, partly because of her generation, sculpture has the kind of presence it has in a tribal culture; it is totemic. When I made an exhibition of her sculpture, I asked for one work in particular: a pointed, pierced, forked shape like a person with no arms. 'I would like that figure,' I told her.

'No, no. You can't have it. That one is made of wood. You can have the bronze version.'

'But I don't want the bronze version.'

'The bronze is better than the wooden one.'

'But Louise, I don't want the bronze. And I know you have the wooden one.' Finally, after long silences and shrugs and a great deal of walking up and down, the truth came out. 'It has been broken,' she admitted.

'No problem,' I replied. 'It can be fixed.'

'You don't understand. It has been broken many times.'

'So there was an accident?'

Another vivid silence. 'No.'

She was never going to tell me. Since the work is a portrait of her son, my suspicion is that when he was a child, she kept it lying around the house and if he was naughty, instead of losing her temper and hitting him, she reached for the sculpture and broke it over the boiler or a table. When she had stopped being angry, she would fix it again. So it was the surrogate for a person but with the spirit of that person. Try saying that in criticism.

Periodisation in Louise's work is equally confusing. She studied in academies in Paris in the thirties. Now, not surprisingly, one of her systems of organisation is based on casting, in all its stages and with all the physical conditions that implies. And though she never seems to drop a theme or motif completely, despite the fact that it might lie fallow for decades, how then do you classify a new addition to the canon of her work? She is battling against biography, against objects, against periodisation, against fixed theories of sexuality... and she is intent on keeping secrets for ever. One set of works baffled me completely. They feature a strange, double form she called *Trani Episode*: either a fat phallus or a breast with a nipple at each end, one lying crosswise over the other. Imagine three versions of that: the first in clay, so it is hollow and removing the top reveals a hollow box below; the second in bronze, the top now sealed to the bottom; and the third carved from granite. Time and again I asked her what it meant. Time and again she refused to answer.

One day, I changed the question. 'Louise, what is a trani?'

'It is not a what; it is a where.'

'So it's a place. A place where something happened. The Trani episode. What kind of episode was it?'

'A very happy episode.' Another long silence.

'You're not going to tell me, are you?'

'No.'

'You'll never tell anyone.'

'How do you know?'

'Because you make it hollow, like a box to keep a souvenir, to open and shut as you wish. Then you keep that hollow place and the memory inside but you seal it so that it can't be reached. Then finally you close it up altogether, so only you know.' No answer.

Was I really expecting one? Hers is the work of a complex, perverse mind, cross-questioning itself constantly, striving to operate on an interface between what thoughts are and what objects might be. And of course the problem with criticism is that it works only with thoughts, not with objects. How good it would be to find an artist who was a real critic, who made objects that answered other artists' objects. The act of criticism itself is deeply flawed unless we suppose we are all Walter Pater and that everything we do is poetry. Which is what the American curator supposed I was writing. This was kind but untrue. What I make is not poetry at all. Neither, on the other hand, is it fact. So what am I doing? What can I say? I want to be Henry Longhurst.

Body

Essay published in the catalogue of the Niek Kemps retrospective, Van Abbemuseum, Eindhoven, 1992

Poetry, wrote Jean Genet, is *'la rupture (ou plutôt la rencontre au point de la rupture) du visible et de l'invisible'* (the break [or rather the meeting at the breaking point] between the visible and the invisible).[1] So in physical terms, skin equals poetry; it is how we achieve visibility and a reason why the body is regarded as beautiful. For us, beauty, as we ourselves confess, is only skin-deep. Yet saying so does not account for the centrality of the human body in Western aesthetics, rather than (say) abstract design. 'The woman *is* beauty, of course,' Molly Bloom tells herself as she regards her own nakedness in Joyce's *Ulysses*. And for once she is right.

To ask why would involve analysing thousands of years of cultural history. One argument concerning the more recent past would be that as the time went by, sight vanquished touch.

> The loss of touch as a conceptual component of vision meant the unloosening of the eye from the network of referentiality incarnated in tactility and its subjective relation to perceived space. The autonomisation of sight … was a historical condition for the rebuilding of an observer fitted for the task of spectacular consumption.[2]

The truth of this can be easily established. Now photographs, not paintings, are vehicles for eroticism, for example. This may not hold for other cultures, however, where relations between sight and tactility differ. Confronted by works of traditional Japanese eroticism, most Westerners see a body 'like a

sack of potatoes with knobs on it, rather slimy in texture', to quote one eminent observer, and are baffled and dismayed at the thought that such an invention could have been designed to arouse.[3] Bombarded as they are by Western culture, the young Japanese, keener to look like Madonna or Michael Jackson than like their own parents, might even agree. A prime example of the 'unloosening of the eye' from its tradition of tactility must be virtual reality, three dimensional *trompe l'oeil* in which touch is expected but never happens. Here the participant's relation to perceived space is subjective yet the same as anyone else's when confronted by the same stimuli. Brainwashing, the scandal of the fifties, has now become a popular toy. That is one approach. The other would be to welcome any innovation which might alter the traditional Western patterns of perception.

Not noted for their spatial innovation, the Surrealists dealt nevertheless with 'tactility and its subjective relation to real space', with the emphasis on the word 'subjective'. Bound, chained, masked and sightless, Boiffard's figures become both subject and object of their own fetishes, for example. Asked to make a radio drama when he was suffering from cancer of the bowel, Artaud screamed with pain. Masson's orgiastic stabbing scenes were dismissed as abstraction run riot until evidence came to light of a Surrealist group (including Masson) dedicated to enjoying group sex with dead women, and successful in their attempts. These examples all suggest that traditional theories of beauty demanded a serenity and distance that broke down when the mind was disturbed. The coolness aestheticians took for granted was either a sham or assumed such a lofty viewpoint that it was good for nothing, except perhaps parody. Life was not like that. Outsides and insides were more jumbled than philosophers had led us to believe.

The Scots poet Robert Burns wrote 'Would that God the gift would gi' us/ To see ourselves as others see us.' To be given this might immediately resolve one major problem. Because we perceive ourselves only in terms of a combination of ourselves only in part, and never as a physical entirety, as others do, our insecurities focus on the ramifications of this simple fact. In adolescence, for example, when the body is subject to alarming physical changes, confronting others can be a source of extreme embarrassment. At times like this, we are overtaken by a sense of complete powerlessness; temporarily lacking any sense of wholeness, we have surrendered power to others and feel (or choose to feel) that we depend on them. The fact is that though we may achieve some measure of physical equilibrium as we grow

older, our sense of dependency is perceived first and perceived accurately at this stage: as a subtler repetition of the trauma of being born. Being born means exile, a severing of the tie which marks the end of the most intimate relationship we will ever enjoy. In store is dependency, a lifetime of being seen by others while remaining partially sighted oneself. Mikhail Bakhtin wrote: 'Only the inner body (the body experienced as heavy) is *given* to a human being himself: the other's outer body is not given but *set as a task:* I must actively produce it.'[4] And later, in his study of Rabelais, he proposed a medieval and a Renaissance view of the body: the medieval centred on orifices (hence 'Rabelaisian') and its Renaissance counterpart on sheerness and integrity.

Bakhtin's book had to justify the study of Rabelais himself of course, an author for whom sex, excretion, vomiting and eating are of major importance. To do so, he invented an entire mode, the carnivalesque, which seems to incorporate and reject Renaissance values even before they are established, since it consists of symbolically overturning all fixed value systems for the duration of the carnival. Such a way of thinking escapes the field of scholarship or medieval studies; it is about reconciling ourselves to a body which seems both 'open' and 'closed'.

For a surgeon, the body must seem both open and closed at the same time. Indeed, for such a man the body must be what jungle warfare is to a field marshal. Despite sophisticated machinery, the traditional conventions still apply. And though they might not look quite the same, *ad hoc* solutions of the type used in battles or emergencies – splints, slings, bandages and other simple devices – continue to be employed. Immobile, the patient turns into an object, seeking the simplest kind of reassurance from doctors, nurses and, in particular, surgeons. The more bestial the signs of good health these people exude, the more faith in them their patients seem to have. For undergoing an operation means being the not quite willing victim of intricate internal rape carried out by masked men who have drugged you and cut their way in. In the far future, things may be different. (One bad Hollywood film I scarcely remember featured a submarine which was miniaturised and swallowed and which then journeyed for an hour or more through the œsophagus of Raquel Welch.) Surgery without surgery may be the future of medicine, like the cuts that medicine men profess to make, splitting apart for a second only to knit together without a wound. But then, the entire abandonment of the body deserves serious thought. If the money spent on

travel to outer space were allotted to travel into inner space then scientific advances would really be made.

The feeling of the integrity of our bodies seems so crucial to us that it must not be violated, however, even in death. How potent the modern myth of *The Invisible Man* remains, and how full the British Museum mummy collection is, day in, day out. Bandaged figures which are neither wounded nor dead form the basis of childhood fantasies we may never manage to outgrow. How odd a twist this is to the legend of Gyges and the ring which made him invisible whenever he wished. (What is the name of the Invisible Man? Does it matter who these wrapped Egyptians are?) We want to be like that: not only to eavesdrop on what happens when our back is turned or to hear the remarks people are not prepared to make to our face, but to know we are winners in a power struggle we are forced to endure but in which we never asked to be included in the first place. Yet the apprehension which accompanies the fantasy of the bandaged body was clarified most fully by Joseph Heller, whose novel *Catch-22* included an unrecognisable character in bed, so heavily bandaged as to be unrecognisable, with tubes at both ends, one leading out, the other in.

For there is no way out. Thrown into being, we become only too aware that existence involves flesh. Indeed, so preoccupied have we become with the fact of our own physicality that it has been increasingly hard to believe in the non-corporeal. Despite this, a sense of loss prevails, the feeling that the sensuality of previous centuries has become an impossibility for us. T.S. Eliot wrote of a 'dissociation of sensibility', believing that in the 17th century a thought indulged for its own sake had the same validity as smelling a flower, in other words that an entire gamut of thought and feeling available at that time had perished for us. The idea is attractive if only because it allows culture a specific function, as if the purpose of intellect in modern life is to eradicate the body. Yet this is theorising, merely: the description of a loss and a vague recipe for putting things right. That art is the answer seems the most potent and accurate of these. In the words of John Crowe Ransom, poetry restores the world's body. The fact is that only occasionally does it it give us the feeling of grasping the problem, as when Yukio Mishima describes how he wants to trace the muscles of his beloved with the blade of a sword, drawing and watching them bleed at once; when Artaud describes ideal acting in terms of plague symptoms; when Sternberg reduces the face and body of Dietrich to a cinema screen within another cinema screen, a site

simply for the play of light and shadow, or when Lang dwells unashamedly on the face of Kriemhild in his film of the Nibelungenlied. Prepared to edge towards nonsense by satisfying a sensual need, art can demonstrate where our failures lie, and may even provide antidotes.

Since perception of a human figure is also perception of one person by another, we credit that other with attributes of our own; we use them, to satisfy our needs. So they become an extension of us. In an erotic encounter with them, the same may be true, despite the obvious physical differences. Yet in this case, delicate human negotiations can be shot through with desire and fantasy (which is surely a function of deep memory). Can we know the beloved in the way a surgeon knows a patient? Can we ever see any other human being in an objective light? Gradually the edges of the body assume a tragic nobility, like a permanent seal celebrating our own independence when what we want most is to be Siamese twin. (Plato called it 'the desire and pursuit of the whole'.) The body is all we really possess. Whether that is what we wanted is another matter.

1. Jean Genet, *Oeuvres complètes*, part II, Paris 1951, p.19.
2. Jonathan Crary, *Techniques of the Observer*, Cambridge, Massachusetts 1990, p.19.
3. William Empson, 'The Nude', in William Empson *Argufying*, ed. J. Haffenden, London 1988, p.587.
4. Mikhail Bakhtin, 'Author and Hero in Aesthetic Activity' (1920-1923) in H.Holquist and V. Leapunov ed. *Art and Answerability: Early Philosophical Essays*, Texas 1990, p.52.

Fiona Rae: Playing for Time

Catalogue essay published by Waddington Galleries, 1991

Jugglers are proud of their deliberate mistakes, those moments when they pretend that everything has gone wrong and that running alterations have to be made to put them right again. Meanwhile, their audience is intent on two things at once. The structure the act can have been expected to take has been established. Now, the greater the delay before that structure is resumed, the more exquisite the audience's pleasure will be. Meanwhile, the performer maintains the pretence of digression – not a complete pretence and not a complete digression – until the last, when everything comes out right, as in any comic plot. This is an art of virtuosity for its own sake, of bluff and double bluff – how improvised *is* improvisation? – but most of all, of barely controlled embarrassment. That flirtation with failure, that longed for moment when it is impossible to foresee a happy outcome, the willingness to tolerate that moment and even relish it, all say a lot about our capacity for self-torture, our need to make ourselves suffer by putting things off. Artistic structures of this kind depend on a sort of masochism. We could be talking about jazz solos or Shakespearean clowns. The principle remains the same: of virtuoso procrastination.

In Fiona Rae's *Untitled (purple and yellow I)* an airborne coffin, an atomic cloud, a plane crash, two ink-blots, a beached whale and a tree with a breaking branch meet and mingle. That is one way of describing it. It does not account for the ownerless breasts, the Hebrew letter, the cock's comb and the badly frayed item of male underwear on a flying visit from some parallel universe. But once more something is wrong. Glib journalese will do no more than provide

nicknames for component parts of a work that is studiously non-representational, in which forms are never allowed to exist as more than paint-marks, each with its own associations. For they have not appeared out of thin air. The painting adapts part of Georg Baselitz's *The Tree* (1966), superimposes a Gerhard Richter skid over the trunk and below it adds a pair of black hands from Max Ernst's *Loplop Introduces* (1932), while the purple square – Rae has talked about choosing colours of seventies airport lounges – recalls the small, square tableaux with which Winsor McKay concluded his *Little Nemo* comic strips. Beneath each of these heterogeneous borrowings lies a logic of its own: a logic which could be read as a statement of intent.

The only way painters can depict breakage is by a kind of graphic shorthand. Rae heightens the effect of unreality this creates by situating the cracking branch beyond the edge of her painting. Another impossibility on canvas is to portray an accident; every move is rendered deliberate, illustrational, simply by the artist's decision to preserve it. Both the Richteresque stroke and the Ernst 'blots' parody the use of the consciously slipshod by doubling as realism and suddenly starting and stopping. But why? Conventions in art develop from deficiencies in the medium, it could be argued. Rae finds loopholes in painting and subjects them to playful interrogation. And, of course, the greatest convention of all is the status of a painting itself, and its potential for suspending disbelief within a fixed area of stretched canvas. Doubling as mannered geometry, Rae's homage to Winsor McKay deals with this problem while providing an apologia for her own aesthetic. In the final 'frame' of McKay's geometrically organised strips the same thing always happens. Nemo, the boy who in dreams can move anywhere and see anything, is roused every morning by parents whose role is to bring him down to earth. Rae's predilection for the Nemo strips could be explained by their no-nonsense approach, paralleled in her own case by her insistence on the here-and-now, the fact that painting remains painting no matter how hallucinatory or compulsive its effect. And reality remains reality. Her work has nothing of the solipsism of David Salle, the major influence on artists of her generation, nor does it share the feeling that his paintings exude: of an emptiness at the heart of things. Despite an obvious attraction to all the mental truancies involved in 'reading' painting, Rae returns her viewers to solid ground.

Can abstract painting continue? Rae's contribution to the debate is less eccentric than it seems. Constructed by some principle of hectic serendipity, her paintings pose as sad, silly confections: nervy, unfocused, wavering between

quiet dawdles and bouts of hectic proliferation. Each one has its own private awkwardnesses, its signs of compositional problems solved at the last minute, with a limp cascade of flowers or a bout of arty, left-handed charcoal drawing. Like a dancer who begins with the wrong foot, Rae is bound to find herself in trouble sooner or later, but the thrill of the panic this generates, the feeling of suddenly moving into overdrive, means a sudden rush to the head as problems are located and solved without premeditation. The hint of cultural leavening, even of stocktaking, is there in its galumphing way, without any of the squeaky-clean sophomore mentality of post-modernist art theory. Faced with the problem of how to go on, Rae simply ploughs ahead. Treat this as pig dumbness if you will. The choice is yours. But don't forget that the elaborately witty play on problems of intention and accident; the doleful suggestion of letting things go to rack and ruin before trying to pull them into some shape; the perpetual straw-clutching, are all part of the act. If Rae can just bring it off and keep bringing it off, the problems may right themselves. Playing for time means *making* time, after all.

Damien Hirst: The Butterfly Effect

Written for 'In and Out of Love', the Damien Hirst exhibition at
Woodstock Street, organised by Tamara Dial, 1991; unpublished

It began with the man next door. During a two-year interval between school and art college, Damien Hirst struck up a nodding acquaintanceship with an elderly man called Mr Barnes, who could be seen wandering about the neighbourhood during the daytime and returning home every evening with objects he had collected. Then one day there was no sign of him. Time passed, but when he still failed to appear, Hirst and his friends climbed over the fence to see what had happened. They never managed to find out. Barnes himself had gone for good, but he had left an astonishing legacy: rooms packed from floor to ceiling with objects he had amassed, at some points leaving only narrow pathways through which to move. His outings had served as preliminaries to a baffling taxonomic process which should be guessed at rather than analysed, the extent of its self-reference never fully perceptible. Parts of his master-work seemed to relate to other parts not only spatially but also temporally, to be negotiated in present time like a work of architecture, a condensation of the past. The age and state of the materials; the control of the passage of a real inhabitant and (possibly imaginary) visitors; a technique for remembering where things were; the idea of a work of art as the work of a lifetime – there was no doubt that Barnes's building was meant to be regarded as a kind of monument. As such it had not one but an overlay of histories: the record of its conception, construction, use, symbolic significance, state of existence (complete or partial), not least its reception and access, restricted in this case to Barnes himself and a few uninvited guests who witnessed it before its destruction.

Art survives through its effect on others. Struggling to assimilate what he had seen, Hirst began making collages and reading about Kurt Schwitters' *Merzbau* project. Joseph Cornell became an influence, as for a time he placed objects against theatrical settings or arranged them in sand in the corners of rooms. But if Barnes's flat proved to be a short-term blessing, it also became a long-term stumbling block. Everything Barnes had touched, it seems, had been drawn into a sphere where proliferation and classification were strangely allied. Other people saw the result of losing a battle, as objects – tended, packed, sorted and placed – had gradually overwhelmed the maker, as though time and space were running out. The collages Hirst made from materials he discovered in the flat could be interpreted as responses to Barnes's sense of time as well as to mental and emotional liberation, achieved in the face of engulfment. Sometimes this kind of freedom is achieved. At other times it seems to lapse. One squarish structure, for example, reveals something akin to a distant landscape, framed and framed again by wooden struts. Others consist of pieces of rusted metal, soiled rag or painted wood that has seen better days, all released from their temporal co-ordinates to become elements of a more refined, formal pastime like a game (as the use of playing cards suggests) or some kind of exchange (as the fragments of handwritten letters might lead one to suspect), only to lapse into their true identity as ageing constituents of an entirety which tries but fails to ward off the effects of age. For the main assumption that underlies Hirst's collages is that though ordering practised for its own sake can be tantamount to procrastination, time will assert itself at last. Compared with painting, collage is particularly prone to wear, of course; its elements have already led other lives, and time will claim them sooner rather than later. As if to emphasise this, another collage repeats the motif of distant mountains, but now they have turned into a mirror on which a watch-face is attached. The same work contains a well-worn shell, a puckered rubber bell, and – as if mocking the face which will form the final, round element of the composition – the words 'I Love You' are written by hand on the mirror.

Neither his reading nor a preliminary year of art training equipped Hirst to appreciate Barnes's achievement to the full. First he had to adjust to the aesthetic his art teachers were intent on instilling: a doctrine of Romantic subjectivism. Hirst responded to this way of thinking, so much so that he embraced some of its aspects once and for all. For him, colour remained an intuitive concern, for example. Nevertheless, two permanent corrections to hyper-subjectivity followed in quick succession. The first was evident in multi-

coloured arrangements which seemed to have sprouted like fungus from walls and rafters, each separate unit a different colour. Whereas the collages had utilised found materials, thanks to their gloss paint these constructions looked shiny and new. Observers might have supposed that the spot paintings that succeeded them perpetuated that very habit Hirst had been struggling to avoid: the choice of colour according to emotional and aesthetic decisions. In fact, though they represented a complete capitulation to it, that surrender was modified by other factors. Equally sized spots of colour were arranged in grid formation that parodied a household paint chart. And the colours were chosen intuitively – or, rather, by a process of decision-making based on aesthetic and non-rational demands. One thousand colours had been mixed beforehand in a pseudo-systematic way: one hundred reds, one hundred blues, and so on. Having made one spot painting consisting of one hundred and fifty spots in ten vertical, fifteen horizontal rows, Hirst removed half of each spot on one side of the first, then did the same on a different side of the second painting, giving the impression that the pattern was somehow being rotated.

These initial spot paintings matter less than the decision Hirst went on to make, however: that these would be the first in an 'endless' series. Sizes and variations might change, the spots might be made on paper, on the wall or on canvas. Above all, they would serve as a permanent undertone in his work. One problem they broach is that of identity. Hirst decided to call a pair of spot paintings by names of people whose Christian names and surnames were identical – John John, for example, or David David – and to have identical twins stand in front of them like a visual palindrome, so that as the two components of their names melted into one, so also did the features of two people who resemble each other or two paintings with the same construction. Identity led to two other concerns: time and language, more specifically repetition and definition, in the form of titling. A zero degree of all three, time standing still, or simply being 'marked' – separate identity asserted but not perceived, language refusing to vary – generates paradoxes which were discernible at the very outset of the entire series, paradoxes which in turn foreshadowed that interest in pattern recognition which constituted the unstated theme of Hirst's third mixed exhibition: 'Gambler'. The very title of which broached the idea of play between randomness and coincidence which underlies any game of chance. Operating within defined limits of structure and colour, the 'endless' series of spot paintings, better described as a series which ends only with Hirst's own death, offers physical variations on a conceptual theme, one argument would run:

foreplay without resolution, line after line of suspension points building up expectations which remain unfulfilled. Another view would be that since the colours are already chosen, the series must be regarded as a single painting, the sum of every possible combination of spots. A third view would be that the cumulative effect of the spot series would resemble a self-portrait, to be assembled by means of a computer readout or even a viewer's impression of Hirst's most frequent choices of colour and positioning; all the more persuasive an option in view of the obsessive nature of the entire enterprise and its inbuilt resistance to ratiocination. A fourth would elaborate on Hirst's own tendency to see them as monochromes. Yet establishing visual unification of the different hues is far from easy. Goethe once wrote that nature 'oscillates within her prescribed limits'. Yet, he added, 'Thus arise all the varieties and conditions of the phenomena which are presented to us in space and time.'

In Hirst's work every oscillation has a name, however, and at this time an apparently arbitrary system of titling came into operation, when Hirst first came across a catalogue from a drug firm – Sigma Chemical Company's *Biochemicals for Research and Diagnostic Reagents* – and decided to call his own works after the products listed, working alphabetically through the book, using every name in order. An arbitrary enough decision, on the face of it. In retrospect, however, it came to seem less arbitrary; things establish relationships with their names, as people do. In this period, collages, spot paintings and cabinets were being made at the same time. Crossovers between the series were obviously no accident. In 1988, the two spot paintings included in 'Freeze', the first of the mixed exhibitions that Hirst organised, were named after drugs. The cabinets, of which Hirst made twelve, had titles borrowed from all the songs on one Sex Pistols album, shortened to suit his needs. So 'God Save the Queen' became *God*, 'Anarchy in the U.K.' turned into *Anarchy*, and so on: a way of finding a methodical underpinning for what would otherwise have passed for Romantic or Expressionist titles. Because the twelve constituted a set and the titles on the album had been exhausted, when two more cabinets were constructed for 'Gambler', he chose the names *Heckler* and *Cosh*, after the name of a firm which manufactures machine guns, a piece of information that by no means invalidates more imaginative interpretations, like that of one over-zealous reviewer who argued that both titles referred to methods of violent attack, verbal and physical respectively. The changing fortunes of visually stable art objects is one component of their meaning. Refusal to envisage major formal alteration in the case of the spots and the cabinets is offset by play with titles, constant grouping

and regrouping. Tension between artworks and titles, the use of human or inanimate metaphors to encompass them, whether they can be defined by their constituent parts or whether they are greater than the sum of their ingredients in chemical terms, whether they are mixtures or compounds – how they interrelate. All these things matters to Hirst, for whom the constant visual fluctuation in his spot paintings is accompanied by constant fluctuation in meaning. What is it? How does it endure? How can it be described? For Hirst, these questions are related, and their interrelations, considered as a changing mental construct apart from the objects themselves, make up a model of human life.

With his contribution to 'Gambler', Hirst made exactly that. A glass chamber was divided in half. In one part pupae hatched, flies emerged and escaped through a hole to the other half, where an Insect-O-Cutor was dangling. Tiny bodies crackled as they hit the blue fluorescent tubes. And there was one other component: a cow's head, lying on the floor, placed there to be eaten and to rot. The work was called *One Hundred Years*. Another, just the same except that it lacked a head, was called *One Thousand Years*. As with the spot paintings and the drug cabinets, a rectangular structure contains a collection of similar elements, yet this time they are mobile, and, for a while, alive. Their passage from cradle to grave, generation to destruction, is so short in human terms that calling it *One Hundred Years* demands an altogether different view of time. And making a century equal a thousand years is of a piece with the comic redundancy of the entire project. For the third time in as many years, Hirst introduces a new sequence with 'twin' works, bringing a potential series to a premature standstill. The idea of disintegration entered his work when a new series of drug cabinets was made, containing old, half-used packages of chemicals arranged on open shelves. The phrase 'Modern Medicine', the title of the second of Hirst's group exhibitions, offered one potential interpretation of the work: as a pessimistic rejoinder to Joseph Beuys's image of the artist as shaman or 'medicine man', healing rifts – between man and animal, for example – that opened aeons ago. Rotting bottles and packets on shelves featured in 'Gambler', the sinister title suggesting a blurring of the distinction between 'good' and 'bad' medicine, chemicals used to harm or heal. And as this visual unfocus extends from equalised circles of colour to rows of labelled packages or a blur of flying black dots, life and death are visible at once and what was an 'oscillation', the eye's inability to settle, has assumed an unexpectedly literal form. But how is it possible to interpret this pervasive visual tic?

When Hirst began making his 'spot paintings', directly after the medicine cabinets, tablets protruded halfway out of the canvas in vaguely minimalist style, as if the visual reverberation had lapsed somehow and was about to disappear altogether, below the surface. Like the child's game of *fort/da*, which Freud analysed, this 'Now you see it, now you don't' preoccupation could stem from a need for reassurance: the exhilaration of seeming deserted, followed by the reassurance of finding one is not alone. Could this be the significance of the ubiquitous 'oscillating effect' in Hirst's work: art as a purely visual equivalent of the reassurance a loving human relationship is assumed to bring? The title of the piece that follows offers confirmation of what might seem an eccentric reading: *In and Out of Love*, exactly the effect of that fluctuation between the appearance and disappearance of the object of affection, brought about by the child (in this case the artist himself), and repeated throughout his career. Consider the flap of a butterfly's wings: a momentary reduction to near-invisibility followed by a re-emergence of that double pattern, like a pair of eyes or open arms, or simply a symmetrical, twinned form, redundant but reassuring, of the kind that Hirst is accustomed to make at the outset of a new, and necessarily unfamiliar, series – in other words, at times when he needs reassurance.

After the fly pieces, Hirst devised an installation shown in the very centre of London. Walking into a space in Woodstock Street, visitors entered an extremely humid space in which butterflies would hatch and fly around, alighting on paintings or hiding inside bowls with hectically coloured, hand painted interiors. Instead of being killed, as in the fly works, the insects flapped away and settled elsewhere, like mobile camouflage, while the insipid title created a mood in total opposition to the hard-hearted spectacles that immediately preceded the butterfly period. Hirst's fly diptych recalled the usual fate of art: the glass cases which protected, preserved and conferred value on them became sepulchres. In contrast, the butterfly installation offered a visual miracle: creatures which might have been taken for dead suddenly stirred, fluttered, sailed through the air and, as they alighted, changed the existing pattern on whatever surface they chose. Slowly but surely, the lesson of Mr Barnes had been absorbed, and with it something of the purity and playfulness of what is wrongly termed 'naive' art. For gradually Hirst had become a naive conceptualist, working in a stubbornly personal fashion on lines laid down by Stanley Brouwn or On Kawara (as titles like *One Hundred Years* reveal). The mapping and spatialisation of time continues in his work, and the eccentricities

that accompany it. Identity, duration and language persist as themes, interlocking now one way, now another, as Hirst weaves the kind of patterns with his present that historians do with the past. The potential scope is unlimited. What did Goethe write, almost disbelievingly? 'All the varieties and conditions of the phenomena ... presented to us in space and time.' And all this from the sense that everything oscillated within mysterious, but established limits. How nearly his findings in his experiments with colour approximated the findings of chaos theorists of recent years. How very strange the patterns of nature's 'oscillation' would turn out to be. 'Does the Flap of a Butterfly's Wings in Brazil Set Off a Tornado in Texas?', asked Edward Lorenz in a conference paper in 1979. From strangeness comes pattern: acceptable, even familiar, only to be broken or refined as research continues. Nothing to do with Hirst and *his* scientific researches? It would take a brave person to argue that. Hirst too has his vision of oscillation. With his endless series, he has decided never to abandon his own, private Butterfly Effect.

Rachel Whiteread: Inside Out

Published as the introduction to Rachel Whiteread *published by*
Van Abbemuseum, Eindhoven, 1992

In 1989, Rachel Whiteread was invited to show at the Barbara Carlile Gallery, a space in a busy urban street where her work was visible to passers-by. After careful thought, she purchased three pieces of wartime furniture – a dressing-table, a wardrobe and a bed – filled each one with wet plaster, waited until it set, then knocked the wood off and exhibited the hardened innards. Her subsequent career has consisted of meditations on this single procedure. Years later, it continues to resist analysis. Why fill concealed spaces, then put them on display? Why (in this case) destroy the moulds? Why the urge to turn emptiness into matter, private space into public? Admittedly, at the Carlile Gallery, exhibiting and exhibitionism were forced into alignment because of the shape and condition of the building. But Whiteread's apparent overreaction might have had other causes. In retrospect, they seem easier to locate. One could be confused with puritanism: a refusal to do anything but adopt one tactic and show the result. Call it 'truth' and you approach the second cause: a wish to display evidence of the past of each sculpture, a foray into cultural archaeology, a history of the humble, the familiar, the overlooked... in short, the private life of the British lower classes in the period during and just after the Second World War. At this stage, the process of retrieval seemed more logical than the result: evidence in its most brutish manifestation. A Freudian reading, in which archaeological and psychoanalytic metaphors were elided, might conclude that Whiteread's plaster blocks corresponded to 'blocks' in the collective consciousness, and that, knowingly or not, Whiteread had sublimated her own resentment, possibly a reaction to the fact of being born too late, of suffering the

consequences of a history in which she played no part. Whatever, having stumbled across a ritual gesture which served purposes she had only just begun to acknowledge, she did what was necessary; she repeated the gesture.

In 1990 she exhibited the cast of a complete room. The result was like a banana skin, architecture flayed, then put on display. *Ghost*, its title, accounts for its eerie whiteness and its strange plane of existence: as a flimsy surrogate for something more robust. (The Anglo-Saxon root of the word, 'gast', means spirit or breath). If, as Henri Bergson wrote, pure perception is to memory as matter is to spirit, then Whiteread's approach to sculpture – diverting attention from the concrete aspect to another space for which it serves as drawing, albeit a full-scale, solid, three-dimensional drawing – is situated on a cusp between the two. Bergson stressed the role of the body in the process of remembering, as a 'place of passage', 'a hyphen, a connecting link between the things that act upon me and the things upon which I act.'[1] This, indeed, is how it feels to walk around *Ghost*, nudged into extrapolation yet pulled back time and again to detail, like a detective working on a case. How much the case consists of the characteristics of casting, however, and how much the clues given by specifics of the work was not yet evident. One thing was certain: the potential monumentality of the resulting sculpture.

A monument is what a civilisation erects to honour what it considers most valuable. Yet only the most foolhardy commentator would deny the element of barely suppressed violence in the Carlile exhibition, the proximity of poverty in *Ghost* or the hint throughout Whiteread's work that she is giving back to her viewers exactly what confronts them. As a kind of realist, she catches the spirit of an historical phase, beginning with Punk and ending with passivity. Despite this, her work is not directly concerned with poverty, violence or public events. Instead, it patrols the boundary between 'me' and 'not me', between accurate perception of space and misunderstanding of it, interiority and exteriority.

As experiments with casting continued, certain starting-points predominated; the gate-leg table, the single, sprung mattress, the enamel bath, the china sink – all the kind of bare necessities available from any second-hand furniture shop – were re-examined, as well as the activities that accompanied them, activities involving minimal self-consciousness. To be nudged into considering them means reconsidering 'lost' time, automotor activity, routine and learned responses. The time taken to 'solve' a Whiteread sculpture is prolonged by pleasure and the appeal of a visual wild goose chase. Tables look like fortifications, rendering themselves unusable by fending off the approach of

legs and knees. Closed, and securely so, they seem to indicate a refusal of physical extension – that step towards someone, that extended hand, that pull of the chair toward the shared meal – which are marks of community. Baths resemble nothing so much as mummy-cases without the decoration and minus the mummy. Babies' beds are given such shapes. In the West, however, only hammocks curve like this to cradle adult sleepers. Here, as elsewhere, womb and tomb move too close for comfort. The glass plates on top of *Valley*, for example, suggest incapacitation or drowning. (English viewers would recall the death of Lizzie Siddall, the Pre-Raphaelite model who died after posing as Ophelia in a bath of cold water.) And though *Ether* is a bath without a lid, the deep plug-hole and the title suggest breathing, loss of consciousness and death. The shape of a bath parallels that of a coffin, after all. And, of course, a bed. And it was to mattresses and beds that Whiteread turned after this, reversing her inside-out method of working, perhaps to underscore the point. Now mattresses seemed to have sprouted nipples instead of springs or seemed capable of rocking like a ship or straining in agony, like a woman giving birth. And lozenges in seductive colours seemed attractive until the truth dawned: they were mortuary slabs.

The fundamental gesture of Whiteread's work reverses one major convention of Western sculpture: the desire to see it live. That courtship of death which has exerted such pressure from the first had to do with reversals. In Whiteread's work, insides became outsides. Consequently, the assumption that meaning inheres in the artwork itself signals the beginning of that strange relationship between 'empty' and 'full' which characterises the moulding process. Like a conjuror, eager to demonstrate that there is nothing up her sleeve, Whiteread begins with an object, puts its through the usual processes, and varies them so as to end with a puzzle, not to do with genuine or bogus but with body, mind and object. If the Carlile exhibition encouraged an awareness of current problems, *Ghost* presented a perceptual puzzle. Where was the viewer? Making the private public had been one characteristic ploy of women's politics throughout the eighties. Posing questions about perception may involve a parallel paradigm shift. If, as Francisco Varela has suggested, cognition consists of embodied action, 'knowledge is concrete, not abstract' and the concrete can exist only in the present, then shock tactics are needed to force viewers not to consider process but the result of process in the here and now. [2]

1. Henri Bergson *Matter and Memory* tr. N. M. Paul & W.S. Palmer, New York 1991, p.171.
2. Francisco Varela, *Incorporations.*ed. S.J. Crary & S. Kwinter, New York 1992, p.321.

Grenville Davey:
The Story of the Eye

Catalogue essay published by Kunsthalle Bern, 1992

Grenville Davey's first exhibition at the Lisson Gallery included a work that resembled a manhole cover. Cast in steel, with a central area protruding above a rim circled with tightened bolts, it seemed to summarise his concerns. Industrial materials and techniques had been used to conceal any evidence of the artist's intervention. The placement, flat on the floor; the exaggerated size; the idea of its being a lid or a canopy all heightened the suggestion of intricate play, shifting attention from the work itself to a dark, vacant space below, as if the sculpture were situated above a subterranean escape route. Davey had borrowed the idea, he said, from a Bugs Bunny cartoon in which Bugs looked at his rabbit-hole, a black outline, then picked it up, tucked it under his arm and walked away with it. [1] The game of hide-and-seek, what could and could not be seen and what should be assumed by looking at what the artist was prepared to offer, had already become a feature of Davey's work. Earlier, he had experimented with drawing in space; thin, metal rings described huge, absent forms, and a single sheet of vinyl, pierced with holes and folded into a conical shape, stood unaided. The traditional conjuror's assertion 'Nothing up my sleeve!' had never been more apt; Davey seemed determined to survive by sleight-of-hand. Later, he added a sense of deliberate wrongness – wrongness of scale, of finish, of material, of usage – in an obvious attempt to remove any hint of realism or the Duchampian readymade. For references to everyday life would have been misleading. Far from being appropriated from the culture, these works were self-regarding, dysfunctional and, at the same time, self-defining. Drawing on 'the paraphernalia of communicating systems and spaces – mirrors, hatches,

manhole covers and airlocks', they paraded their desired status as solidified marks of mediation (like doors) or punctuation (like commas), proposing other links between eye and brain, 'pure' cognition and the ratiocination which is its inevitable accompaniment, abstract form and its mundane connotations. [2] Two shapes like wing mirrors, completely covered by a layer of monochrome paint, protruded from the wall, angled (it seemed) to provide helpful reflections but in fact redundant, like a version of those curved mirrors with which drivers negotiate difficult bends. *Grey Seal*, a domed floor work with a tubular element around the edge, curling like a tongue across the top, confirmed the motif of resistance which characterised the work of this period, while proposing the art as a perceptual halfway-house. Regarded in this light, the incidental, admittedly deceptive flashes of 'content' in this, Davey's first public exhibition served as a key to the context of the work, a device – to borrow Davey's own imagery – which would unlock meaning. The work informed us that 'unlocking' never took place. Yet at the same time, the conjuror's boasts of flagrant deception were completely justified.

The outstanding feature of this work was its air of theatricality. The German writer Peter Handke once suggested that since in a play an actor is a person pretending to be someone else, in the same situation a chair onstage must be a chair pretending to be another chair. Suspended between use and uselessness, artworks and industrial artefacts, Davey's hybrids recalled New Generation abstraction, with its coloured surfaces and elegant blandness. This was art with a split personality, its layer of paint deceiving the eye into supposing it lighter, in both weight and tone, than might have been supposed. Bulk suspended; the materiality of girders; tanks and weaponry cosmeticised: the tensions Davey established at this time led to an interrogation of what an 'art object' could be. Not a tool; tools, as Heidegger pointed out, are 'used up' while art preserves its potential for meaning. Not handmade; today that suggests that its value lies solely in its craft. Not unique, for each of his sculptures is generic; entire families spring from a single formal invention. Not inviting interaction, though the alterations of size and colour, the placement and the air of dumbness constantly throw the viewer back to his or her own body. And not neutral; T.S. Eliot wrote of flowers that 'have the air of flowers that are looked at'.

Davey's works always had that air of self-consciousness; firstly, their titles have combined with their visual appearance to form a subtle, poetic whole and secondly, from the beginning they have spoken of the process of their own interpretation, as at this point the metaphors of duplicity and the punning verbal

aspect did. While *Cover*, the title of the round, steel piece with bolts, served as both noun and verb, *Seal* had the associations of an autograph, readable and identifiable. Both resisted the viewer's gaze, as the mirror shapes without mirrors did. In the same room, at a slight distance from the wall, a white metal annulus was framed by a trapezoid of the same galvanised steel found everywhere in British cities. That the flatness of the round, white shape made it look different when viewed from different angles seemed to suggest a joke about painting. Yet the protected white circle, part of the visual language bequeathed to formalist sculpture by David Smith, prompted another interpretation entirely.

Gradually, the circle was to dominate Davey's work, and he would play any number of variations on the sense of completeness that it offered. Unity became a nagging concern. In *By Air* (1989), two elements that lay apart, one on the floor, one leaning against a wall, were to be fitted together visually by the onlooker, while *Pair* hung side by side, proposing a more difficult unity and, also in the same year, *Blesa*, a combination of rim and cover in painted steel, began a new stage of the enquiry. Glancing from work to work, the viewer would sense some deeper pattern. For example, wouldn't the two parts of *Pair* combine to form *Butt*, an apparently closed unit with a heavy lip? Family resemblances between an artist's works are to be expected. Yet the number of variations Davey can play on a relatively small set of formal concerns is so extraordinary that each reappearance of a device confirms its initial rightness without reducing the potential number of variations of chosen elements. The idea of a sheer, stretched surface with space beneath it, in *Butt* or *Drum* or *Rack* or *Deputy to Another* or *Type* extends the concerns of *Red Giant* while offering other directions for viewing the leaning rimmed disc which had become the basis of *fa* (1989), *Interalia* (1991) and *Thin Air* (1991). Circularity symbolises completeness but also limitation, for what is a circle but a perfectly bounded plane? In Davey's work it gathers associations of resonance, display, tautness, equilibrium or instability, fitting (as stackable units fit) or not fitting and, instead of resilience – what could be more resilient than a drum? – potential damage. For gradually the circular motif takes on a delicacy, and an equal potential for grotesque, that seems more Japanese than British. And the works with this motif come to possess all the mesmeric power of eyes themselves, as well as all their conditions. In *Over* (1989) the 'closed lids' of the earliest works started to wink. On occasion they even, nightmarishly, began to unravel, as in *Pole* (1989). To look at a discrete, self-sufficient object is one thing. To engage with something that resembles an eye and, by association, another human being watching you

watching is another matter entirely. The transitive aspect of Davey's thinking has been mentioned before. (Even forced to choose a note, he chose *fa*, perhaps for its pun on distance, but equally because of its potential for lapsing into a third or a fifth.) Art that takes the form of the apparatus by which it is apprehended seems caught between two places and two opposed points of view, destined to hang in the air between them. The personification of the art 'object', the enforced acknowledgement that a mind and a personality, not a set of formal propositions, is at stake in the communication that art succeeds in making, may be one result of the contact that is established between viewer and stylised eye. But there are other results, one being to draw attention to differentiations between versions of the 'eye' motif: to highlight, for example, the melodramatic unravelling of the 'lids' or the lines which bisect the central, circular plane. A conventionalised language is being used, with a degree of expressivity that increases according to the number of uses to which we see it can be put. Finally, as in the case of the people, we look 'into' and 'through' these eyes.

Davey's favourite technique is dislocation. Two elements of the same work turn out to vary slightly in size; appearance and reality are constantly mismatched; recognisable objects are magnified and the organic and the inorganic rub shoulders. Dislocation also means displacement; his sculptures allude to real objects without ever representing them realistically. Frequent doubling of the same form makes viewers particularly aware of differences, however slight. Though geometry becomes deformed and the symmetrical turns asymmetrical, sometimes there are even hints of the surreal – don't the lower parts of *Trommel* resemble elephants' feet? – the dependence on subdivisions of a language is total. But though works fall into obvious subdivisions, these can and do relate. After all, languages change constantly. And the eye series, like other subdivisions of the entire output, continues to alter gradually. After the intertwined, rotating effect of *Eye* (1991), with its apparent references to the shutter of a camera, and the disturbing sense of slipping and loss, dramatised in *Castellated Eye* (1989-90) by the emergence of lips of metal as what seemed to be separate parts seemed to fail to engage, Davey's thoughts seemed to take a swerve in a different direction. Taller than a human being and placed so that the lines made by the internal patterns are all at an angle, the new works in painted steel and MDF include layers of painted wallpaper, applied one after the other and torn when wet, sometimes with the left and right hand alternately, so that much of what is there is buried. A new interest in process was evident from the time of the making of *Idiot Wind* (1990), a two-part work

weathered by rain and hydrochloric acid, with watermarks running around and meeting at a ridge on the back, and another pair called *Two Rules*, differently sized containers made in the same way. The new, disc-shaped works resemble machine-made, industrial parts. But that is the most obvious suggestion. As usual, they banish and even counter it, in this case by references to painting, though for paintings, they are unwieldy, balanced against the wall so that, long as they are, they can look almost accidental until approached head on. When their interior surfaces, levels and means of division come into view, they speak, as ever, of paradox and deception. Papering metal, then painting the paper, means applying warm to cool, absorbency to resistance, and, in Davey's terms, rough to smooth. It means showing that despite their appearance of perfection, they have been worked on with care, stage by stage, layer by layer. Despite their air of having been factory made, they reveal marks of the hand, and, coming so soon after *Idiot Wind*, these count as time spent, time registered on a surface like wrinkles on skin. As eyes, they are open, passive despite their air of fortification, sensitised (it seems) to register everything inscribed in lines upon surfaces which gradually obscure what is not already hidden. Though the eye is directly in touch with the brain and the nervous system, these eyes in particular remain monumental, passive, ready for inscription by light, time and memory. The surfaces of the 'drum' sculptures are bound to be associated with the sound, hence the communication, they might make. Similarly, the round, framed surfaces of these 'eye' works resonate by seeming responsive to the play of light. That these, most recent Davey sculptures hover between animate and inanimate, between industrial and organic, observer and observed, should not surprise us. Nor, after all this time, that they resemble both 'object' and 'sculpture'. Humanising the industrial, dehumanising the natural, takes place on a cusp between the two: a division which, like Bugs Bunny's rabbit-hole, is no more than a circular device, a mere convention. Distant relatives of those 'manhole-covers' of the late eighties, these weighty medallions seem less self-devouring, more a testament to the richness of an ongoing act of perception.

1. Stuart Morgan 'Grenville Davey: Degree Zero' *Artscribe,* January-February 1988, pp.42-44.
2. Marjorie Allthorpe-Guyton 'Labil' in *Grenville Davey,* London: Lisson Gallery 1990, n.p.

Thanks for the Memories

An account of the Hayward Gallery's exhibition 'Doubletake:
Collective Memory and Current Art', published in frieze 4, 1992

For weeks, travellers on the London underground kept catching sight of small posters with no words at all. Only images: of what resembled a small toy, for instance, or a man's leg stuck through a wall, or part of a diagram or a fuzzy surveillance image of a bare-chested boy. Noticing things out of the corner of one's eye may be enough to reveal all the facts we need. Information can be registered before it is understood, after all. (Doesn't any assertion of understanding derive from private bumptiousness or a pact with oneself to be content not to know any more for the time being?) Simple surprise might have been the initial reaction to these and other unexplained additions to the cityscape. And to others: a wordless hoarding – obviously not an advertisement – opposite Waterloo station; an inscriptionless monument just west of Hungerford Bridge and, in the Thames itself, a raft moored in mid-river, with what looked like a man bobbing about on top. Gradually, surprise gave way to bafflement. During the same two weeks, bookshop browsers began to come across piles of heavy, red books with the words and music of a song printed all over them. The song was 'Those Were the Days', made famous by Mary Hopkin.

'Once upon a time there was a tavern...' With its bittersweet lyric about backward glances, dashed hopes and missed opportunities, the song hovers between major and minor, killing time before a rousing, gipsified chorus, all clapping and la-la-la's. *'Ou sont les neiges d'antan?'* the words enquire. Or, more prosaically, 'Whatever happened to old Thingummy?' At the turning-point of the song, the narrator gazes at her own reflection in a glass and discovers that she has turned *into* Old Thingummy. 'Is that lonely woman really me?' she asks herself,

knowing the answer only too well. In the nick of time an old friend enters the tavern, calls her name and as they take 'a glass or two' they realise that looking back over one's shoulder is a permanent affliction, just another aspect of a present tense which includes us whether we like it or not. As the chorus strikes up for the last time and the song is put on automatic pilot, its title takes on a new significance: as both source of and meditation on the lyric impulse, combining an Audenesque 'We must love one another or die' with an aspect of mindless, plug-in reverie. Regardless of occasion or age, the merest hint of a Good Old-Fashioned Singsong is enough to summon a raucous crowd, living for the moment, raising a glass or two, rememb'ring how they whiled away the hours, and... Like the song itself, its interpretation is circular, turning listeners into a Brueghel painting of a rugby scrum, consigned to that infinity of pleasure the song proposes, ready to kermess till they drop. Like medieval rabble, they are easily manipulated by push-button cues. But so, indeed, are we.

Nostalgia accounted for some of the exhibits in 'Doubletake', like the sounds issuing from a terrace near the Waterloo Bridge, where an oversized music-box-cum-medieval-torture-instrument droned forth an amplified and hideously distorted version of 'Those Were the Days', the official anthem of the exhibition, for which the large red tome served as catalogue and the carved figure (by Stephan Balkenhol), the monument (by Juan Muñoz), the hoarding (by Boyd Webb) and the music-machine (by Jon Kessler) formed components. Juan Muñoz's inscriptionless cenotaph, for example, presented a blank face to passing boats but a line of bronze flags to pedestrians. Edward Woodman, invited by the Hayward Gallery to photograph it, complained that as he tried to work, passers-by would bombard him with explanations. It was a war memorial, some told him, or a tribute to victims of last year's riverboat disaster. They were all so convinced that their version of events was correct that it never occurred to them to ask him if he knew the truth. In terms of the exhibition as a whole, their eagerness to jump to conclusions was crucial. Current art, the curators seemed to be suggesting, exists as a means of awakening dormant responses or stimulating other, private reactions – not exactly 'interpretations', which presupposes too high a degree of focus. Indeed, the very idea of precision seemed under attack in that hefty catalogue. Instead, art would first surprise, then promote a state of reverie, a process which could be regarded as circular, for reverie may have been its source. And more specifically metropolitan reverie: the city's equivalent of cue-lines on the backs of props to help actors or verses inscribed on seats in 18th-century landscape gardens. In this case the city's existing sights would be augmented: by reminders of Mr and Mrs Koons at home,

for instance, or signs by Jenny Holzer (those small, wordless black-and-white posters all over London proved to be integral to the meaning of the entire event). The shirtless youth approaching a cashpoint at night in a big city, unaware of being photographed by Sophie Calle; an ambiguous Saint Clair Cemin sculpture, a huge Simon Patterson wall-drawing, all related to artworks on display at the Hayward Gallery. In addition, they were works in their own right.

Not surprisingly, 'Doubletake' was designed by Aldo Rossi, for whom the essence of cities lies in their history. As Rossi sees it, the city is a repository of memories, negotiated by an individual mind. As recollection replaces history, however, individual buildings serve as cues and the city comes to resemble an updated equivalent of the Renaissance memory theatre. In Rossi's architecture, monumentality replaces context and typology rules. 'Typology is life', he once declared. [1] His floating *Teatrum Mundi*, for example, in 1980 in Venice, has the same pyramidal lid as the giant coffee-pot, which like lighthouses, bathing huts, barns and chimneys, takes precedence over other shapes in drawings which recall the work of de Chirico and Morandi. Perhaps this pervasive visual research undoes the actuality of his buildings. It is also possible that it alters the way they deal with meaning. ('Some of his best buildings are paintings,' wrote Charles Jencks.) [2] Rossi has theorised about an 'analogical' architecture – 'analogical' in its Jungian, not its Freudian sense – which touches on what is 'archaic, unexpressed and practically inexplicable in words'. [3] Critics have not always regarded his work in such near-mystic terms. Manfredo Tafuri, for example, called Rossi's architecture dead, tautologous and lacking in interest and marvelled at his naïveté in supposing that Italian Fascist architecture can be plundered for its form alone, as if it were possible to jettison historical significance at will. [4] Rossi's work exists on a cusp between 'meaning' and 'abstraction', formal beauty connected with or divorced from politics. His housing estates have been confused with mental hospitals and the chimney form in his Modena cemetery with a concentration camp gas oven. What continues to attract us to the drawings and plans is their compulsive repetition and variation of motifs, and the emerging relations between history and the present, dream and reality, the pace of perception of the city seen on foot and the relative rate of its registration in a drawing.

In a similar way the art in 'Doubletake' communicated on two levels at once: one eye-catching and subject to change and context, the other evocative and far-reaching. The history of eighties art could be described as a debate between the 'new subjectivism' which led to increasingly complex, fractured definitions of the first-person singular, and an art that was overtaken by varieties of simulation, both

sophisticated and naive, which resuscitated that object nature of sculpture which conceptualism seemed to have threatened, while fighting to preserve its conceptual integrity. In this exhibition the former position was taken by (among others) Julio Galán, the secretive Mexican painter whose mental universe hinges on fantasy, disguise and complex sexual references and elisions, messages he may not want to be understood. Boys weep magnolias, his sister's skirt becomes a landscape and longing creates its own private spaces. In Galán space and time (or place and period) seem initially untethered, but ultimately at the service of erotic desire. The second position was taken by Katherina Fritsch, whose room contained blank, painting-like metal shapes, a cheap bookshelf, two religious statuettes (all works by Fritsch herself, not readymades) accompanied by a gentle soundtrack of toads. Aimed at a general public, it seems – recent projects have included plans for parks – Fritsch's room looked like a room, was filled with objects that related to objects people have in rooms, but ended by looking like a set from *Star Trek*. The cues were there, they met with a response, yet the response was wrong. Fear and emptiness resulted, which not even the sound of toads could dispel. In Fritsch's work, meaning seems conjured by objects despite its refusal to inhere in them. In the course of the last decade the resuscitation of the object nature of an art which is conceptual by definition left it emptier than ever: the artwork as a source of curiosity and a reflector of common values. Faced with this idea of culture as conduit, curators found their attitudes to the display of contemporary art tending in opposite directions: outwards to the culture which confers meaning on it and inwards to the peculiar qualities of the objects themselves, often qualities of artisanship, bogus or genuine.

Differing views on the qualities of objects were reflected in a polarisation of the ways in which those objects were displayed. In 1988 Stephen Greenblatt described two main responses to art in a museum setting: 'resonance' and 'wonder'. [5] 'Wonder' he defined as 'the power of the displayed object to stop the viewer in his or her tracks, to convey an arresting sense of uniqueness, to evoke an exalted attention.' On the other hand, 'resonance' could be understood as 'the power of the displayed object to reach out beyond its formal boundaries to a larger world, to evoke in a viewer the complex, dynamic forces from which it has emerged and for which it may be taken by the viewer to stand.' In 'Doubletake', the resonance without qualified the wonder within, while Rossi's design served as a reminder that private meets public in the space around the artwork, whether that space was a forum, like the large open area in front of Simon Patterson's blue wall, or a broken shell of a house, designed for more intimate confrontation with Rachel Whiteread's

strange 'ghosts' of domestic objects, or simply a door, part of Fischli/Weiss's installation. From the Middle Ages to the Baroque, great rulers collected rarities. 'In those old collections,' wrote Umberto Eco, 'a unicorn's horn would be found next to a copy of a great statue, and, later, among mechanical crèches and wondrous automata, cocks of precious metal that sang, clocks with a collection of little figures that paraded at noon.'[6] Consciously or not, Fischli and Weiss were making a parody of a *Wunderkammer* – a life-size re-creation of their work-room – to be viewed through a door, accessible to only one or two viewers at a time. And in so doing, they succeeded in combining wonder and resonance. In the same way, Robert Gober guided visitors down a flight of stairs through a room with nothing but a pair of hairy male legs, complete with socks, shoes and trousers, appearing out of the wall at angles, hinting that the missing body was being tortured or that thousands of people were strolling through the (invisible) crack between its (invisible) buttocks, a prospect that brought together comments on casual, zoo-like promenading and specific admiration for the modelling technique, a depressive observation about lack of intimacy in public spaces where intimacy is necessary, and the visual equivalent of a gang-bang. Here, as elsewhere, the disturbing combination of high focus and a far-reaching sense of relevance to the workings of culture were allowed to exist side by side.

With luck, art can challenge both. Simon Patterson's three works extended his earlier preoccupation with words and their positioning. In each case, the words were names, well or less well known, drawn from what used to be called General Knowledge. The connecting devices were also borrowed – the periodic table, a Delta Airlines flight chart and the London Underground map, with the help of which travellers can now journey on lines where every station bore the name of a Renaissance painter or a British comedian. ('I'm just leaving Tommy Cooper,' a man tells his wife on the telephone, 'Meet me at 3.30 at Fra Lippo Lippi.') Looking like the Trevi Fountains drawn by Walt Disney, the Delta Airlines map, previously shown on a smaller scale at Transmission in Glasgow, was Patterson's most complex work so far. Pensive or laughing by turns, viewers would collect in groups to puzzle out the relations between the stops on each route and to put their memories to the test. Can *you* remember who Fred Quimby is? A similar test, carried out in purely visual terms, was provided by the work of Saint Clair Cemin. Cemin has said that he devotes himself to 'The question of the Identity of the Mental Object translating itself again and again through the processing mind.'[7] How this translation process operates is complex. In 1988, for example, he made a bronze sculpture called *This is a Pipe*. Admittedly, it *looked* like a pipe. But it also

looked like a clog, a cradle, a brontosaurus rising out of water. If there are portmanteau words, there must be portmanteau objects, models of liminal states: between identities, between states of mind, permanently adolescent. Cemin's conceptual approach to materials explains the sadness of *Washdog*; dabbily modelled and cast in bronze, a kneeling statue with what look like handles, and parts of an animal, a lamp, a bowl and a semi-human figure. There was something deeply demeaning about its posture, constantly abasing itself before you, a large and potentially savage creature reduced to this. Its loss of sharp outline may have indicated that it was unfinished; an eternity of demeaning chores lay ahead. Yet, as with any object that is used and grows old in service, it gained a perverse dignity, even a kind of definition.

Is it possible to analyse works from 'Doubletake' to arrive at what Dan Cameron has called 'a sociocultural notion of form'?[8] First, the most obvious candidates must be eliminated. Ann Hamilton's installation, for example, provided an example of social theory touted in as didactic a way as possible. Advocating seriousness, hard work, vegetarianism and animal rights simultaneously, her worthy installation provided a 20th-century equivalent of Victorian genre painting. ('And was it all done by hand?' asked Oscar Wilde loudly, on being taken to see Frith's *Derby Day*.) In Hamilton's work everything means something, even the way it is constructed, in this case by teams of unacknowledged workers, asked to weave pigskins with wire and needing tetanus jabs to do so. A more adventurous example would be Boyd Webb, whose poster was placed opposite the front steps of Waterloo station, in a no-man's land near what used to be Cardboard City, where hundreds of homeless survive by sleeping in boxes. Begging thrives in this area, and there is no way of reaching the South Bank centre from this direction without encountering the homeless face to face, and registering their plight before listening to great music or looking at art objects with 'houses' made for them by a world-famous Italian architect. For the entrance to this patch of misrule, in which law and order are held in permanent abeyance, Webb made a poster without words. A deflated globe lay on its side, against a hazy background. Gradually it became evident that it was a damaged beach ball, losing its shape but crowned, in cartoon fashion, by a golden laurel wreath, an aptly placed touch of millennial sentiment. Webb's use of humble materials always had political overtones. In this case they seemed especially potent.

As Webb made clear, the notion that what we see is tied, in Greg Hilty's words, to 'a fine network of associations', affected by 'hundreds of value systems' which overlap incoherently may mean that art arises at intersections between previously

distinct social sectors.[9] Or it can derive from hitherto incompatible contexts. Philip Taaffe's paintings involved complex overlays that recall Op art, terrazzo pavements and much else. 'Painting concerns the use of memory in the most palpable of ways,' he wrote in 1992. 'Ornamentation … elaboration … longing for place.' The same set of notes contains a question: 'Exuberant ornamentation as a substitute for clear, purposeful thought?'[10] Since in theory it can go on for ever, pattern-making is founded on postponement. Refusal to condense or define suggests that it is homeless, vagrant, possible only on boundaries. 'Doubletake' dealt with many of the same preoccupations; its main proposal could have been that meaning in current art occurs on thresholds, whether physical, mental or social. The artist courts the viewer – often by techniques of dislocation – and keeps his or her attention by the use of devices and subtle variation. Intricate surfaces in 'Doubletake' – Narelle Jubelin's *petit point*, Philip Taaffe's Op homages, Tim Rollins and K.O.S.'s gridded comic books, Gary Hill's video of nude bodies, with complex jumps from screen to screen – hinted at workmanship, craft, complexity of surface incident, the communicated pleasure of making. That making meaning is a communal activity, was clear in (for example) the work of Patterson or Balkenhol, whose river-based statue caused havoc as more and more Londoners contacted the police to complain about a man marooned in mid-Thames. It was even evident with Koons, refused permission to display his work on the underground. Bored with life, the boozy art critics from London newspapers called the whole affair incoherent. Admittedly, the entire event raised more questions than it solved. But it asked about how art occurs to us, how it impinges on everyday life, how we make it mean, matters of subjectivity, communal aspects of interpretation, and what it is to be a person: all matters about which we should think at least twice.

1. Heinrich Klotz *A History of Post-Modern Architecture* tr. R. Donnell, Massachusetts 1988, p.250

2. Charles Jencks *The New Moderns,* London 1990, p.122

3. A. Rossi 'An Analogical Architecture' in A. Papadakis & H. Watson *New Classicism,* London 1990, pp.133-5

4. Manfred Tafuri *A History of Italian Architecture* tr. J. Levine, Massachusetts & London 1989, pp.44ff

5. S. Greenblatt 'Resonance and Wonder' in I. Karp, S. D. Levine ed. *Exhibiting Cultures* Washington & London 1991, p.42

6. Umberto Eco *Travels in Hyperreality* tr. W. Weaver, London 1986, p.5

7. Press Release, Daniel Newburg Gallery 1986, quoted by Lucio Pozzi 'Ceminal Art' *Artforum* May 1988, 109

8. Dan Cameron 'Setting Standards' *Parkett,* 25, 1990

9. *Doubletake: Collective Memory & Current Art,* South Bank Centre/Parkett: London 1992, p.15

10. *Philip Taaffe*, Gagosian Gallery exhibition catalogue, New York 1992 n.p.

Deep and Low:
The Jeff Koons Handbook and Madonna's *Sex*

Published in frieze 8, 1993

In his novella *The Day of the Locust*, Nathanael West described a bordello in which the girls wore national costumes and entertained clients in bedrooms decorated in the style of each particular nation. Such a brothel really existed. At Mae's in Hollywood, inmates were chosen for their resemblance to film stars. Having slept with one who looked like Carole Lombard, Garson Kanin proceeded to tell the real Carole Lombard. 'Lombard laughed and said she would tell Clark Gable, to whom she was married, but then said she wouldn't, because he would want to go to bed with the girl himself.' Quoting this story in *The Frenzy of Renown*, Leo Braudy suggests that because even for a star, his or her body – screened, in photographs, onstage – is divorced from an actual personality, dissatisfaction is bound to set in. 'My body is not me,' stars say. 'Now accept the real me.' Of course, that 'real me' also has to be displayed before being noticed. So, Braudy argues, it, in its turn, follows the body into the discard pile, 'corrupted because it had to be visible, rather than innately appreciated.' An act of faith was called for, but in vain. Or could it be that post-Modernism has reached the mass market at last, with the result that audiences search not for the 'real' but for a continual play of the fictive?

DOCTOR: *Have you ever been mistaken for a prostitute?*
DITA: *Every time anyone reviews anything I do, I'm mistaken for a prostitute.*
– Madonna

Drawing in particular on Cindy Sherman, Madonna's book *Sex* serves as an extension of the persona she and her publicists have developed. Bound in metal, it features elaborately staged photographs and erotic fantasies bearing the name 'Dita Parlo'. Is this a complex pun on *'Dîtes-moi'*, an invitation to tell all? Does Dita refer to Perdita, Shakespeare's lost girl? Or to Dita Paolo, star of Jean Vigo's *L'Atalante*, a figure on whom Madonna once modelled herself? The question remains open, as questions do in *Sex*. 'Any similarity between characters and events is not only purely coincidental, it's ridiculous. Nothing in this book is true. I made it all up.' The evidence of one's eyes, and even the haziest knowledge of Madonna's personal life as recorded in the press, tell a different story. For her fans, for example, knowing about her supposed fling with Vanilla Ice might give a certain voyeuristic *frisson* to the photographs in which the two stars pretend to be making love, while rumours of lesbian dalliance will hardly be dispelled by photographs of our heroine naked in swimming pools, embracing Isabella Rossellini or Naomi Campbell. Despite such treats, not much really happens. Rather than being a centre of attention, Dita often has the air of a lonely woman who has wandered into bedrooms where people were having a good time and insisted on joining in. If love is depicted, it results from Madonna's endless affair with her own body.

'What is it?' is also a question that springs to mind about *The Jeff Koons Handbook*, a publication which resembles a catalogue for an exhibition that has yet to take place. Could it be a prelude to Koons's d'Offay *début,* an event which threatens to push censorship laws to or past their limits, since in some cases his cameraman registers nothing more than part of a penis and the vagina into which it has been thrust? Interesting though Koons's readings of his own work may be, they are not criticism. Nor, we may decide, is Robert Rosenblum's essay, based as it is on the belief that financial success and artistic quality go hand in hand. Few critics have attempted a full-scale reading of Koons' work, and Rosenblum does nothing to change that state of affairs. But imagine his prose forming ideas instead of platitudes. Take sentences like 'No matter where we look he figures large' and imagine how that flabby tissue might turn into hard muscle.

In an interview in the first issue of *Journal of Contemporary Art,* Jeff Koons described his idea of pleasure. Dining with a group of friends, he recalled, he was moved to propose a toast. How lucky he was, he announced, to be in a beautiful place, surrounded by people he liked – and as he stood there, he remembered, in a state of bliss, it was like being in an advertisement. Here, then,

was the ultimate experience: to live in his dreams. That they might resemble other people's dreams was irrelevant, as irrelevant as the fact that in sharing them his own identity might totter or blur. Not only did he refuse to manifest the slightest fear of this, he advanced towards it with giant steps. This approach has distinguished Americans from Europeans for centuries.

Yet doesn't his attitude to identity as a rough diamond which needs cutting seem antithetical to the pioneer image, in which wilderness was tamed by men as wild as the frontier itself? A better metaphor would be of America as a land where ideals could assume three-dimensional form. Little wonder that American culture seethes with images of the new man – that new man which, for example, Shakespeare's Prospero failed to become. Or that an artist like Barnett Newman won debates with old-world scholars even as he proclaimed his title, *Vir Heroicus Sublimis*. Or that an artist like Jeff Koons should begin by honouring 'the new', with objects which, metaphorically speaking, drew breath, but in his displays existed as perfect, breathless, sterile and unused. (Shades of Poe, whose heroines achieved perfection only in death.) This is the world as one wants it – devoid of anything busy or accidental, there for complete visual possession.

And physical possession too. With the advent of Cicciolina, Koons's work immediately became more American, attempting to grasp an earthly Paradise. And here he is at his most characteristic and funny. Prefaced by a phase of 'Baroque', where sexual ambiguity and childhood fumblings were offset by the use of animals, either photographed (pigs, seals and a donkey, all live) or sculpted, like the Pink Panther or the wretched *Popples* of 1988, the advertising for *Made in Heaven* and the work that immediately follows it combines pastoral idyll with the trappings of striptease and advertising. Amid *papier-mâché* rocks, against an obviously painted backdrop of waves breaking on the shore, Mrs Koons lies waiting to be possessed by her new husband. *Jeff in the Position of Adam* is the title, yet in Koons's Eden, Adam remains unfallen. Was *Naked* of 1988 a previous 'incarnation' of Jeff and Cicciolina, as the blurb on the dustjacket of the handbook maintains? Hardly. Nevertheless, it did manifest for the first time the almost terrifying urge to combine an art naively dedicated to great themes – Good, Beauty, Love – with all the panoply of media hype, bad taste and marketing. While curators at the Museum of Modern Art, New York were wasting time debating high or low culture, Koons was ascending to a self-made heaven as the saviour of kitsch, not only forgiving its sins but concentrating on that nasty little *frisson* it gives us, that sudden rush of

excitement that only comes from breaking rules. Is it pornography? In one way, yes. It is meant to have the impact of pornography, at least: something as powerful as it is shocking, something repellent but nonetheless attractive, something (in Koons's terms) that liberates people. What makes Koons the greatest naive artist and/or the greatest art satirist is the question of means and ends.

Koons's lengthy run-up to the *Made in Heaven* series makes Madonna look like an amateur. Yet her work too has involved changes of identity constant enough to satisfy the needs of the market, in other words a certain level of continuity accompanied by a certain degree of apparent change. Is this different from any other business? Does it matter that the audience for popular culture has reached a level of sophistication at which it believes nothing, sees hype for what it is and adopts an ironic stance at all times? If Koons and Madonna picture themselves as porn stars, isn't this by implication an indictment of the system within which they are forced to operate? If so, they are following in the footsteps of one of last century's most distinguished self-saboteurs. Seeing that the publicity would kill him, Braudy argues, Oscar Wilde needlessly took up the gauntlet thrown by the Marquess of Queensberry, who accused him of being a 'sodomist'. Knowing that he would lose, he saw his hours in the dock as a one-man performance, his final masterpiece.

Neither Koons nor Madonna is a pornographer nor a porn star. Their use of the metaphor of pornography, however, could be interpreted as a cry for help, even help in the form of open attack. 'I do not say you are it,' Queensberry told Wilde, 'But you look it, and you pose as it, which is just as bad.' Maybe he was right. Maybe it is even worse, and the work of each conceals a cry for help, help in the return to depth and meaning in a way that is not compromised by the system within which artists are forced to operate. But there is a final possibility, of a complete dissolution of values and expectations, an art that will unite aesthetes and sensation-seekers, the educated and the uneducated, and blow the old arguments to smithereens. Rearrange the pseudonym 'Dita Parlo' phonetically and it speaks of what we need: 'A low, deep art'.

First there is a mountain: an interview with Bill Viola

Published in frieze *11, 1993*

Stuart Morgan: Often set in distant locations, your classic video works are concerned with particular qualities of vision and state of mind. The video installations take images as a focus for sculptural constructs. Now, following your tremendous success at Documenta, comes a travelling retrospective, a long film *(The Passing)*, and an approach which seems more personal, more compendious and appealing to a wider audience. Here in Düsseldorf, for example, you are repeating the continuous video installation you made in Seattle.

Bill Viola: Yes. *To Pray Without Ceasing* is the only piece I've made which runs for 24 hours. Shown on a screen added to the glass of a window facing the street, it's a projection from a densely edited tape that takes twelve hours to play one cycle. It's a compendium of everything I've ever done in the sense that it's a personal cosmology: human life, nature, cosmic life, a movement from light and fire to darkness and water, through stages like barren to lush landscape; animals; birth; then human beings; childhood; the individual; the body; decay and disintegration; underwater; darkness. That takes twelve hours. And it's dependent on the geographical position of where it's shown, when the sun rises and sets, so that as the sun goes down and it gets darker, the image gradually appears. It's very rich at night, while in the daytime it gets washed out. So during the day all you see is a blank screen, but there are two speakers, one inside the building and one outside and you hear a voice quietly whispering extracts from Walt Whitman's *Song of Myself*. When it was shown in Seattle people became familiar with the time cycle and started turning up at night to see particular things.

At the same time you seem intent on exploring your own identity, as in the new work with the moving screen.

Yes, *Slowly Turning Narrative*. That's a four metres wide, by three metres high rotating screen, spinning on a central axis. One side is mirrored and the other is the screen, with two video projectors pointing at it from opposite sides of the room. The image is constantly distorted by the changing angle of the screen and when it's perpendicular the projections appear as large, out-of-focus images on the far walls. But as the mirror side turns around, it takes the light from the projections and moves an image around the wall, so the whole room becomes a screen. When you enter and watch, you get projected onto it. Then when the mirror side comes round you see yourself reflected too. It's about identity. One projector is showing a black and white image of my face with a strange light; a wide-angle lens is moving in very close and a voice is chanting about an imaginary state, the potential states of the human being. It's a stream-of-consciousness chant: 'The one who lies, the one who steals, the one who succeeds, the one who fails…' It's speaking of states of the individual. On the other side are colour projections of chaotic images of people at a carnival – kids on a merry-go-round, a turning image, then walking down the street at night, lighting fireworks, memories (a house burning down, the interiors of rooms) and as the screen is turning, those images are edited a little more densely, so, as you begin to see a new image, it's gone.

These seem designed to give not only an immediate perception of the work but to operate on other levels too. You have said that the important thing is not the moment-by-moment experience but the viewer's recollection of it. Certainly, you have always experimented with long sequences of imagery. Do the roots of that method lie in music (like La Monte Young's week-long pieces), or film or meditation?

When I look back, it's a blur. I knew of La Monte Young and Steve Reich and was beginning to learn about Eastern philosophy, which starts from the cultural as the basis of reality rather than the physical, as Western thought proposes. I remember being in Indonesia and seeing shadow puppet shows that would go on all night. But even as a child I would spend long periods of time alone. So it was a combination of things. At the beginning I did a lot of my work with a live camera, and live camera is eternal; potentially, at least. There are closed-circuit cameras that have been running for 20 years or more. Imagine an eye that stays open for 20 years, night and day. What kind of knowledge is on that tube? When you work with live camera, you realise that until you turn it off it's not blinking.

So recording something means putting around it the temporal equivalent of a visual frame. And even though it might not be surrounded, it has a beginning and an end. So, to speculate, working with live camera was showing time. Also, when I left rock and became involved in electronic music, I found that you can turn on an oscillator in a synthesiser which generates a tone, and that that oscillator will generate that tone perpetually because vibrating electrons in a current are resonating – it's not a vibrating current that will die down. If you keep bowing it there's a variation, but an electronic tone will go on indefinitely. It seems to be a feature of the electronic system that it has a constant state that you can embellish. Working with sound at the beginning was connected with that.

It makes me think of medieval plainsong or Oriental music, which moves around a fixed point.

More germane is the notion of the drone in Irish music. As part of an ethnographic project in New York in the seventies, I recorded a singer called Joe Heaney. Interviewed about the drone, he said he heard it all the time. He was singing against this mental drone that had to be there for the music to exist. In Indian music the interesting thing is the tamboura, like the second fiddle playing in the background but heard first before the sitar and other instruments. The tamboura is a drone, meant to keep playing the notes in that particular raga. Because of the design of the bridge, strings are set in such a way that they vibrate and generate the harmonics of the fundamental note of the string. In the course of the tuning of the instrument those harmonics become the notes in the scales that the music is being played in. Imagine John Coltrane playing a solo when at the very beginning of the music there was an instrument like a set of saxophones – however many they would need, say 20 or 50 – that came up first, quietly underneath, playing every note he was going to play.

Change all that and it becomes a different piece of music.

The interesting thing is the idea that it's all there, ready. You're not creating it from nothing, but embracing it from something. Because it's there first, you can think in terms of eternal essences.

It seems that your approach to form is as a whole, then, demanding not concentration but something akin to meditation.

The reason I was interested at first in studying perception and psychology as valid skills for an artist was that before I became aware of Eastern philosophy and older religious practices, I realised, intuitively at first, that the body is connected with the mind and that a way to change thought is through the body.

So if you sit completely immobile for hours, your legs will hurt and your body will ache but your mind will change too. It always amazes me that so much extreme and complex intellectual thought has been derived from something like cinema, that in essence is so physical. Music is the same: so physical as an experience that it doesn't go into your intellect first but into your body. You can have a head-and-shoulders shot of a philosopher talking, but what you're seeing is a face and how it takes the light, so it's a physical experience. Viewers' bodies are changing, their breathing is affected. We know these things from tests in perception. This is a palette to work with.

The two versions of *Reasons for Knocking at an Empty House* are studies in what you are describing. In one I look at you, thinking 'I can't bear to watch this poor man' and in the other you get knocked on the head repeatedly. In one way this makes things easier for me. Why on earth did you make a tape like that?

It was so important for me to make. It was a process of shooting something for completely different reasons from the ones I ended up using the material for. I shot this story – I say 'story' but it wasn't a dramatic narrative – about a person who wasn't going to be able to leave this room. I had this thing arranged in a clear, neat structure and there was going to be this recurring motif of an empty chair. I even took the trouble to construct the entire room in the back of a trailer truck, glued a glass and a pitcher of water on the table. It was sloshing about and I was getting bounced around but all the objects and the room were in the fixed frame and it was going from colour to black and white. Then I put it away because I didn't like it. Three and a half years later I pulled it off the shelf and started looking at just the raw footage of the black and white stuff. Here was a piece I made with an opening onto some other world. The opening might be the beginning of the tape, the closing might be the end of the tape, and that refused you any more access to that world. It was important to me that there was no real conclusion.

So it could only happen again. That sounds like *He Weeps For You*.

Which was done with a live action camera. And in a way the motif of that piece is the closed circuit video camera. The implication in the image is that it is the camera on the wall of a bank looking constantly at a parking lot.

How does all this relate to your new work?

There is still and probably always will be the notion of the solitary eye, detached from the normal social situation of being in the presence of others interacting together. It's as if you're just absorbing this perception of the world that's

coming on to you and through you and is not being mediated through, or shared with, or described to, or interrupted by any other person, whether friend or acquaintance or whoever. I think that's still there.

Are you talking about the essential gesture of looking at a work of art?

In a way. It's a solitary process, yes. And I think cinema is too, even if you're in a room with thousands of people. The curious thing about cinema is the notion of a movie theatre, where the idea is to obliterate individual experience. When you turn off the lights – even though a lot of people make out in a movie theatre (there's a social function there) – it gets rid of everyone else. You're all looking in one direction. It's as close as the social order will come to a subjective situation.

Psychoanalytic theorists have argued that when we dream, we dream on a surface called a 'dream screen'. But what shape is the dream screen? Recently in France, one expert said it resembled a shallow theatre set. In Kleinian fashion, an American psychoanalyst in the forties said that because it curved forward in the centre and away at the edges, it resembled a giant breast. He argued that it had to be because for so many months of life we dream (nocturnally and diurnally) pressed against the mother's breast. At the same time Parker Tyler was arguing strongly for the Surrealist qualities of commercial cinema and the Surrealists themselves had been stressing it too. Now although some of your works can be shown in auditoria this large, these days you're not making cinema because if I enter an environment you have designed, like *Passage* at the Centre Pompidou in Paris, I have a real size and the fact that I'm standing and where I'm standing makes a huge difference.

Yes, that's true. And in a way that is the ultimate scale. Until we figure out a way to leave our bodies, we are left with two fundamental things. One of them you've just mentioned: the question of scale. Even in the darkest room that factor is there. The other one, until we go into outer space, will be the only domain of nature that we can't obliterate. We can pave over all the dirt and cut down all the trees but we're still going to shit and piss.

Could you describe how the body features in your work?

When I was realising the physiological aspects of the medium and starting to study perception just in and just out of university, I guess I was unconsciously realising that the body is the neglected key of our contemporary lives. It's the thing that's forgotten and put out of the way, not incorporated into anything we could consider to be coincident with the pursuit of knowledge, but something

completely different, more related to sports and recreation. When you realise the tremendous hang-ups Western culture, particularly white European culture, has about the body – sex, proximity, touching and so on – you are aware that something fundamental is being left out, though the sixties emphasis on massage and movement and the kind of research that went on at Esalen tried to put this to rights.

What happened to all that?

It's still there. Not as dominantly now, since academia has refused to acknowledge that side of things. Something like meditation is fundamental. It's not even a cultural thing; animals do it. It's a fundamental part of sentience.

Do you see the looking part of your work as a kind of meditation?

I think that there are ways to use the medium to force someone to look at something in a certain way, more intently, or more continuously, or longer than they're normally used to doing. In my own life a camera will allow me, or force me to look at a common object or something simple for a long period of time. In front of us is a table with a bottle of mineral water. As Hollis Frampton pointed out when he started working with video, if the nature of film is montage, the hard cut, the line between two disparate images, in video a merger or melt seems natural. But because this is common, it is used and abused. In the early 70s I found that there was another way of doing it: that I could hold the mineral water bottle on the screen for two straight minutes and it would transform anyway.

You mean I transform it.

Not necessarily you as a person. There's a constant transformation going on, and when you look at something for a long time it will take effect. 'First there is a mountain/ Then there is no mountain/ Then there is.' That's an ancient philosophical statement...

By Donovan, that Oriental sage...

But it's true. The human mind can synthesise disparate things because it seems to work on some fundamental level of comparison and metaphor. Beautiful to read, tragic as they are, are the U.S. army stenographers' transcriptions of the statements of the tribal elders in the American West when their land was taken from them. These people talked about what to us is poetry. This seems lost to us as a way of speech, but the loss is comparatively recent.

Again and again in *The Passing* there are images of sleep and night, and the different modes of perception that prevail for half of our lives, when ratiocination is put on hold. This is also the case in the Düsseldorf retrospective, isn't it?

There's one piece called *The Sleepers* which is seven 55-gallon metal barrels like the kind you put oil in and they're painted white. They are in a dark room, filled to the top with water and each one has a video monitor inside, with an image of a separate sleeping person's face in close-up, recorded in real time with a black and white low light-level camera. They lie under water in their individual containers, moving, touching and doing things sleeping people do. Then the blue light from the black and white screens filters up and diffuses the space. The piece with *Sleepers* is called *Threshold*. There's a wall and built into it is a large, outdoor electronic sign scrolling the news of the moment across on a daily news feed in big letters, set for outdoor illumination so that it seems intensely bright indoors, like truck headlights glaring at you. And this text is moving across an electronic sign that's broken by a thin black doorway, so you have to pass between, break the stream of news and enter an inner room that's completely dark. Right at the edge of perception are very dim, large, blurry projections, black and white, of people sleeping – three faces.

You used to be the man who would travel any distance to see unfamiliar things and places, and to experience other states of mind. Now you stay at home making work about life and death. Why?

I have one son who is nearly five and another who is one year old. My mother died nine months before my second son was born.

And it's footage of your mother that you use in your triptych, isn't it?

Yes, immediately after the work for Documenta I made the *Nantes Triptych*. (I was too insecure to call it *Untitled*.) The left panel shows an image of a woman in labour – the whole piece is 30 minutes long – and at the very end the baby emerges, the camera observes the baby's face and the baby opens its eyes for the first time. The right panel has an image of my mother who passed away last year, in a coma during the last hours of her life, and the last image is a close-up of her face, almost two hours before she died. The central panel is not a normal video image like the others; it's on very thin cotton and the image is held by the surface of the material. Some of the light passes through, and behind that screen is a room, a real one, which is almost seven inches deep and as big as the screen. Because of the passage of the light the image becomes unfocused as if there is a cloud behind the image. The whole thing looks like a three-dimensional space where an image lies on the surface and a cloud is underneath, as if it were underwater. That figure is slowly turning, and every once in a while moves out of the frame as these other two panels go on in more or less real time. All three panels together measure ten or eleven metres across.

Why the emphasis on childbirth?

Having my first son overwhelmed me; it was one of the most extraordinary experiences of my life. After the death of my mother, I started making pieces with birth and death intertwining.

Listening to you talking about your work makes me wonder how memory functions. We have no memory of birth or death. With other people we watch them die, but that's not memory exactly, it's visual registration and all that is available to us. You can't do anything except see it. So you seem to be working with the distances between me and you, and between what is seen and what is understood. The distances seem to be incommensurable.

People have mentioned an ultimate frustration in the work. That's another thing *Reasons for Knocking* is about: you can never get inside another person. Sex is an attempt to merge, but you can't become someone else.

Nor are you born for somebody else.

The negative side of it is that you're ultimately alone. That's why we need each other so much.

Niek Kemps: Playing Blind

Published in the catalogue of the Niek Kemps retrospective,
Venice Biennale 1993

Art discourse depends on terms which relate to availability; a work is 'exhibited' or 'shown', an exhibition is 'opened'. No such principles motivated Niek Kemps when he began making sculpture. Rather than regarding art as open to visual negotiation, he developed an aesthetic in which the idea of a visible kernel had no place and the notion of artwork as object was incidental. Not that his pieces lacked tangible manifestation; on the contrary, his elaborate, highly polished sculptures might have been read as a parody of what traditional art was expected to be. With highly polished surfaces, designed to include the viewer's image, these demanded a post-Duchampian reading. Like the *Large Glass*, they also dropped hints of combat. When people fall in love, they lose all sense of proportion, see things 'through a glass, darkly' and feel so deeply involved that equilibrium is forgotten. At one moment they seem to be fighting for their lives, while at the next they are on top of the world. How much of this is narcissism? Or theatricality? Consider a medieval altarpiece, with its sheer, polished surface. As the donor saw himself both gazing at and appearing in the depicted scene, such a situation must have corresponded to his own spirit of self-aggrandisement. And in that split second, when the skin of the painting turned into a mirror, the experience was one of hubris as much as humility. Similarly, the images which lay below the skin of Kemps's sculptures were triply obscured: by the dazzle of reflected light, the layer of colour and the curved surfaces. In short, the main tactic was 'delay' by means of the rebuff of light, the distortion of space and all the resulting spatio-temporal adjustments, as if the duty of art was to serve as a critique of polite, museal habits of mind.

Yet Kemps did not stop at reflection. 'There are no ordinary mirrors in my work,' he stated in 1988, explaining that because wood lacquered with different colours gives an effect of skin thicker than real skin, the result is a certain immateriality, leading to physical and emotional disorientation. In a deliberate attempt to make a contemporary equivalent to Baroque art, he aimed at complexity, a sense of mobility, and at an imperceptible revolution of the type carried out earlier by Uccello or Pisanello, artists who quietly, privately effected paradigm shifts, seducing then disorienting viewers. In *Stella Ejecta* of 1985, a set of curved, lacquered vertical elements of different heights arranged in the shape of an infinity sign, the viewer suddenly caught sight of an image: a woman's face, partly hidden by a veil. The idea of an insight which would both charm and disorientate the viewer, with a title which meant an exploding star – after such an explosion the particles realign in a new state – resembled a manifesto for that bloodless *coup* which Kemps was intent on effecting. In future, he insisted, the 18th-century term 'Sublime' would be applied to a black hole in space, a phenomenon which seems liable to be overlooked in terms of its potential impact on visual culture. 'Panoramas still exist,' wrote Kemps, 'It's just that they are no longer where they are always assumed to be.' Despite his use of photographs to illustrate his written texts, no reader could have been left in doubt about the mystery of such a 'hole': its size, distance and properties, the suggestion that it lay inside, not outside our minds required little rhetoric on Kemps' part.

How meaning is conveyed by indirection has long been a preoccupation of Kemps. In his retrospective at Eindhoven in 1992, he showed a selection of previous work from 1987 onwards. In many ways this was a study in closure. For during that period words had been inscribed on circular, transparent, coloured discs, fixed in horizontal rows of other such discs so that visibility was partially obscured; in the *Datavault* series from 1991, photographs proved unreadable despite a title which suggested that reference might be possible. Similarly, *Orbita I* and *Orbita II* of 1989 and *Coup de foudre (homage to R.)* of 1988 used the idea of cages, preventing a clear reading of the photographic images behind them. The result was a sense of frustration at the enforced secrecy of one tactic after another, and a growing need to penetrate that prevailing mystery. Yet a second strain also pervaded the retrospective: of immediate, tactile sensation that had been withheld from the viewer for so long. A new material – polystyrene – was used, and in two wall-mounted works offered a physical satisfaction which steel, glass and photography failed to

provide. Resembling breasts, they swelled from the wall as bodies swell, inviting touch and absorbing light, providing an antidote to that sense of visual impotence that prevailed throughout the remainder of the exhibition: an event which seemed dedicated to dead ends and interiority. 'Not even light can escape', a phrase used to describe black holes, seemed an apt summary of Kemps's ideal sculpture, still (considered from a traditional point of view) more frame than art. Under consideration was the usual concept of an artwork as comprising 'frame' and 'content'; hence the black *Closed Circuit* series, forms shaped like parentheses into which the viewer wandered, as if into the stacks of a library, finding information which proved inaccessible. Kemps embraced this feeling of inaccessibility, regarding obscurity as simply another way of seeing. In a series called *Folie à deux*, the title itself, a reference to a kind of double, introverted madness, took the form of black, polished containers like coffins or boxes for treasure. One had names of great sights of the world listed on its side, as if, like some anti-tourist device, this had absorbed or annihilated them all, or as if the images of these places had been allowed in but never released. Another was vertical, like an upright coffin, suggesting that people can also be treasured or memorialised in such a way. Oddest of all was a statement made in an interview, in which Kemps suggested an entire theory of perception based on secrecy, or at least on individual initiative.

> In Montpellier is a very small museum in which there are boxes piled high
> and locked. The curator opens one and inside there are drawings behind
> glass panels. The problem is that you can't look at them for very long
> because the woman is standing behind you as if to say 'Haven't you
> finished yet?' My idea is to make a space like a museum, but hidden
> underground. There would be a small entrance and people would walk
> through a system of tunnels, coming up at different spots where artists had
> made works. Because there would be a single entrance and you would
> have to ask a specific person in order to enter, it would take a great effort to
> get in.

From the idea of private sensation, another idea arose: of a place of rest and concealment, designed for only one person, shielded from involvement with the world, a place with the kind of intimacy that a urinal or a bathing machine might create: a place of rest and disengagement. 'One-Man Museum' was Kemps's original title; the theme of such a museum is what one person needs. The

dispersion of light is of prime importance; for sculpture to become a space, it needs to surround itself with light. So indirect light is crucial, light which creates privacy and the possibility of being independent, blocking from one's view less important features in the vicinity, those things there is no need to recognise. The result is a diminution of the drama of sculpture as object and an accentuation of space in and for itself. ('Helplessness is still needing sculpture standing there. I'm definitely not interested in sculpture.') The first idea, one large polyester room, was rejected as overly 'physical'. The second was of the status of the 'art' itself in this personal museum; it should not hang from the walls or ceiling or stand on the floor. Instead it was to stand on legs, ensuring that it operated at eye-level. Designed to take the light, the 'Boîtes' would resemble simple architectural models – though they were not sufficiently large to qualify as architecture themselves, rather as a type of elementary cabin. (Kemps speaks of the cardboard used to make *clochards*, houses found on the coast of Belgium where the structure is elongated because only a small frontage is possible.) But does this explain the sense of trauma that the ensemble conveys in the adjacent rooms of Kemps's 'One-Man Museum'?

A recent set of works called *Sevillanas* began with basic propositions of traditional painting and sabotaged them – the idea of perfect visibility, for example, and the clarity that results. For in these pictures, made not by painting but by computer, an opaque surface intervened between viewer and image, blurring edges that seemed blurred already. Instead of unreadable messages sunk into layered glass and devices to prevent photographs from being read realistically, as in previous works, the works made for the city of Seville were traps for the viewer, whose curiosity, raised by the indistinct edges of images like dark flames or tumbling crowds, was not assuaged by the discovery that the picture surface was of a type which permitted no interrogation, and which was fixed at a distance from the wall which did not allow prying, though in theory a glimpse 'behind the scenes' might have solved the double riddle of what it was and what it depicted. In Venice, the associations of libertinage and chaos which marked the *Sevillanas* are replaced with those of surgery: standards of manual precision abetted by science. (Indeed, surgery is a metaphor for the replacement for traditional painting in which Kemps indulges.) Using a computer to select from and rearrange a large number of images seems precise, cunning. The image itself may change all that. And even the visibility of the image may be blocked. As before, the sense of choreographing the visitor will be unmistakable: the biscuity 'houses', taking the light, a wall-work which snakes around a corner,

making a short, then long visual rhythm; the sense of confrontation and bafflement which has become characteristic of Kemps' installations. What is untypical is the element of humility in building, a feature pitted against the sophistication of the computer. The role of the eye varies between focus and unfocus, reading images as if solving a puzzle and accepting what is on display. The appeal is less to one privileged organ than to the body as a whole, however: our size, our needs, our safety.

If one particular influence is felt, it is not strictly sculptural. It comes instead from the American Daniel Dennett, who has proposed that memory does not consist of direct reference to the past; that huge gaps exist in our consciousness; that we think in mental images; that our senses operate in between words and things. Kemps has examined problems of focus, centre and space. 'I often imagine what it would be like to be blind,' he said in a recent lecture. His ensemble for Venice shows something of the excitement and danger of relocating perception, redefining it not in terms of visual delectation or abstract values but with respect to how it functions and can be felt to function, by means of an art that aims to make us rethink thinking, re-perceive perception.

Piotr Nathan: English Versions

Published by the Whitechapel Gallery, London in 1993, and subsequently in Auschnitte/Cuttings 1981-1993, *Gesellschaft für Aktuelle Kunst, Bremen 1994*

In an essay written in 1919, Rainer Maria Rilke remembered how his old science teacher explained the principle of the phonograph by helping pupils to make their own, with a piece of funnel-shaped card, a wax-coated cylinder and the bristle from a clothes brush. Though the sound made by this primitive machine was unforgettable, what most impressed the young Rilke was the mark produced on the cylinder. Years later, as an art student in Paris, he became bored with drawing from the nude and began studying the intricacies of a human skull. By candlelight one night the coronal suture became visible, and that intricate pattern reminded him of the grooves made in the wax cylinder all those years before. What would happen, he wondered, if a needle could be placed on marks which had not been made by actual noise but which existed in and for themselves? What kind of sound would emerge? And wasn't it possible to take any contour at all and 'complete' it?

Travel and transmission inform the experience of any exile, for whom potential translatability and creativity may come to seem either identical or totally at odds. For situating oneself at a crossroads between states and languages, values and uses may mean perpetuating a kind of homelessness, or conversely examining the very notion of home, reinventing what it means to 'belong'. A willing exile, Piotr Nathan Sobieralski from Gdansk, Poland moved to Germany with his parents when his father began working there. On their return, he stayed in Hamburg and spent four years studying at the Hochschule für Bildende Kunst. From this period came *Revolution in Mind* (1982) consisting of a record player, speaker and a jar containing the

workings of the machine. Attached to the arm of the player was the wing of a stuffed bird. 'As the record revolves,' Nathan wrote, 'the stylus jumps back and forth between the two cables I have glued onto the record. This movement – at the same time the movement of wings – alters the content': a speech by Lenin bought ten years earlier on a visit to Moscow. The words change constantly, because as the arm/wing jumps, without either rising into the air or flapping, it lands with a bang on a different spot, making nonsense of Lenin's speech as well as gradually destroying the record. Single words are audible – 'work', 'Russian nation', 'comrade'. In Hamburg the machine was displayed on a table in a room with a red cloth covering the floor – unable to find the correct red, Nathan dyed the cloth himself – while the interior was visible only through wooden slats. The most disturbing addition was another door to the right, fixed open at an angle and padded on the inside, with its overtones of incarceration and madness. Revised, the work seemed angrier; silencing is a fate that overwhelms politicians and artists alike.

Transferring information from one medium to another became a preoccupation of Nathan's. Telephone numbers were translated into musical notes, paintings were given titles which consisted of newspaper advertisements for accommodation, and in *A Very Long and Unbelievably Boring Piece*, a concert at the Kunstlerhaus Bethanien in Berlin, Nathan and Elina Hume played his *Guitar School* series, half drawing, half musical notation. (Interruption of sound remained as important as rendition; in a later performance with a saxophonist, Nathan broke into the auditorium dressed as Liberace and proceeded to blow into Hume's instrument as she was blowing out.) Messages not delivered were the focus of an autobiographical sculpture called *My Grandmother Cannot Use the Telephone*. For Nathan, readymades served as not-yet-readymades; painted canvases were painted over or covered with squares of records, for example, while books ceased to be vehicles of consecutive or even piecemeal communication and were turned into sculptures which were totally visually available yet at the same time unreadable. Pieces in different media were allotted identical titles (*A Very Long and Unbelievably Boring Piece* also existed as an object); above all, materials were constantly recycled. For the *Snowflakes* series, Nathan used a jigsaw to make records into silhouettes, displayed in grid formation across the walls of rooms. Later, the artist was to speak of an 'equally weighted presence of fiction and reality' in his work. (Perhaps it was no accident that so many of his records that he carved into

black snowflakes were of children's songs and fairy stories.) Behind these experiments lay a worldly equivalent of the principle of synaesthesia. For every shift of medium, a little is lost or altered, Nathan seemed to imply, and far from being an exact science, translation can be a way of generating new meanings. Never shown in groups of fewer than one hundred, *Snowflakes* resists definition. Turning what resembles language into not quite three-dimensional objects, it exists as a testament to work, the marking of time, a refusal to coalesce into anything other than abstraction, music. And at the heart of Nathan's art lies the idea that significance is inherent in the objects and routines of daily life.

His pursuit of meaning through one language after another gives the impression that everything is subject to change, literal or otherwise. In *A House Abandoned In Haste* (1985), silhouettes of the previous owners made from photographs that Nathan came across when he moved into a new home were cut into carpets in that very house. Twelve months afterwards, he printed photographs of these onto plates. Four years later, these plates had become paintings. Similarly, while continuing the *Snowflakes*, Nathan began showing 'negatives' of the snowflakes: the records from which the shapes were cut, mounted on the beaks of tacky wooden storks. Yet as in the case of those kitsch ornaments, a levelling sensibility was at work; 'high' and 'low' taste were equated, as were standards of seriousness, things and images of things. This ceaseless play – perhaps what Nathan meant by calling one of his works *Hocus-pocus, A Fundamental Sculpture* (1985) – results in equal emphasis, with every part of equivalent weight and importance. Similarly, a state of suspension, as when objects hang in space from hundreds of threads (a habit dating from *Hanging Up a Book* in 1985), gives the impression that use, meaning, content and context are all held in abeyance. An air of timelessness results from Nathan's use of grids and fabric. In 1989 in an installation dedicated to the memory of Karl-Egon Vester, for example, rows of lace curtains, each row painted a different colour – orange, yellow, white, dark blue, light blue, green and red – they formed an elementary maze which, combined with the title, *A Crack In the Water*, suggested the confusion a maze produces, a hide-and-seek effect, and a machine, like those layers of gauze used by Victorian theatre designers to make actors appear or disappear. Not only was this a work with no focus; it was a study in dematerialisation, an idea which has a history in Nathan's work. In 1984 a complex work called *The Middle of the Picture Is Uninteresting to the Eye*

included a painting which consisted of one great spiral. The same work also contained a vice which clamped open a copy of *Stern* magazine. (The effect of perverse surgery performed on a missing 'centre' was also evident in a project for *Artscribe* magazine four years later, a homage to the 'gutter' where the pages meet and meaning is lost.) Perhaps the idea of centrelessness as an absorption or annihilation of meaning ushered in ideas of death in Nathan's work.

As the invitation for an exhibition in 1992, Nathan used a card showing a urine stain on a mattress. The occasion was impending death, yet death regarded once more in terms of a superimposition of abstract patterns of languages. Precisely because it is made in a position of complete powerlessness, a natural emanation may be regarded as a kind of signature, perhaps even as a parallel to the painterly mark. In this case, as with the curtains, the result seemed to delay time, to beg questions of individual existence. Perhaps both are best regarded as silhouettes, which in Nathan's work are permanently evocative (like the *Snowflakes*). Liable to flip between positive and negative at any moment, they may seem to gain or lose materiality, or, like the shadow of the past inhabitants on the printed plate, be subsumed into some grander design. Meanwhile an interrupted pattern featured in a parallel strand of Nathan's activity: casts of bullet holes made during World War II on the walls of houses in Berlin. In works such as *The outline of the place that was bombed in the last days of war follows the enlarged contour of a urine mark that emerged on the mattress of a person dying of AIDS,* the parts spread across the floor to make an outline were those casts, each like a miniature mountain placed on the floor, forcing visitors to take an overview. (In a recent catalogue, a bullet-hole piece was printed alongside a photograph by Nathan of a landscape seen from a plane.)

By a circuitous route, a preoccupation with language had led to works where the idea of home was under attack. And 'home' is a place where one feels comfortable despite the surroundings – lace curtains, defunct record players, books, copies of *Stern*, even records of speeches by Lenin, a telephone to communicate with a grandmother who is uncertain how to use it. ('I see her now,' Nathan told an interviewer, 'as she holds the receiver far away from her ear. She never knows what to say. Probably she is shocked that suddenly a voice without a body is in her room.') 'Home' defies translation because it needs none. The gap between that cosiness which has always existed without being forced to submit to changes of tense comes as no

surprise; a certain patience governs both. For as mark-making, read alternately as art and evidence, suggests links between the bombing of houses and the rash on a body, the problems of where people go when their dwellings abandon them provokes anger, an unproductive, if natural, reaction. For some time Nathan has kept a table of flowers in his studio, in various stages of decay (for cut flowers are severed from their roots by definition). Like these flowers, the circular forms or loops that appear in his recent work may exist as an assuagement, a denial of definition, such as 'life' or 'death'. Extremes meet, after all; the old, like the young, wet their beds. If extremes meet in a circle or loop, nothing can be done but to shift one's frame of reference, to reconsider the meaning of 'life' or 'death'. Like Rilke's skull, Nathan's fragments of evidence must be translated if we are to hear what they say.

Steven Pippin: The Waiting Game

Published by the ICA, London in Steven Pippin:
The Rigmarole of Photography, *1993*

Camera: a closed room. A door flicks open, then shuts again, and in that moment the lineaments of the world have been snatched and imprisoned. That is the first stage. Then, in an elaborate play of light and shadow, time is regained, the fugitive is reproduced, and a kind of mirror image is presented: fixed, lifeless. Snapshots bridge the gap between appearance and reality, it seems. They tell us how we look, not how we feel we look. That is one version of what photography can do. If only things were that simple. The potential of the photograph, its talismanic power, lies in some obscure collaboration between us and an insubstantial square of light and shadow, which serves as a reminder of loss. Eugène Atget, Walker Evans, Diane Arbus… a list of great photographers is a record of dispossession, their own if not other people's; a record of a search for 'home', defined simply, perhaps, as some reconciliation between reality and depiction, however bleak the consequences.

For ten years Steven Pippin has considered the conditions of photography, a project as playful as it is forensic. Beginning with two conventional genres, the nude and the seaside snapshot, he embarked on two related projects: to convert his bath into a camera and to take it out of doors. Standing still and naked for 20 minutes by his bath, now a pin-hole camera loaded with photographic paper, then lying on Brighton beach, again without clothes, to be photographed by a folding version of his bathtub camera, seemed a Surrealist proposition. Yet the apparent lightness of the idea was deceptive, for Pippin had begun a full-scale investigation of photography – epistemological rather than social, practical rather than theoretical, developing according to the changes in himself as much

as the questions to be answered. They were questions which altered very little as time elapsed. At the outset, the camera was compared to or superimposed on other closed spaces. In the enamelled bath form, the shapes of font and womb united, while the addition of a wooden covering made it resemble a coffin. As a tribute to rather than a reproduction of presence, any photograph has at least one mythical counterpart in the phenomenon of St Veronica's veil. Many other features of the New Testament account of the buried and risen Christ were involved in Pippin's tangle of images: the camera as womb and tomb; the transmission of images as a waiting game, un-Western in its total passivity; the figure as either horizontal or vertical; the photographic image as a token of faith; the process of reproduction as self-generating and the loneliness of this realisation. That mixture of clownage and tragedy involved in Pippin's solitary vigil derives from the solipsism of a process which results in no more than a ghost, an inverted shadow, an absent presence. Lonely and in traditional terms uncreative, the process of the generation of the image is reminiscent of the attitude of Beckett's heroes, even of the cynical dandyism of Duchamp's 'bachelor machines'. Instead of analysing the product, Pippin's viewers are drawn to the preparation: on the one hand a hushed, deliberate process, like an exorcist waiting for a ghost, on the other a barmy, seaside escapade, all sunbathing and snapshots.

Memories of student digs or seaside boarding houses might have inspired Pippin's *Wardrobe/Camera Obscura*, a disturbing object with the combined characteristics of a *pissotière*, an upright coffin and a boat, his *Lavatory Camera* of the same year and his *Washing Machine Camera* four years later. The wardrobe had an aperture like a spy-hole and a strange, semicircular addition on top. Standing flat, the front on two tiny legs, it was only just body-sized, like a lavatory. Time spent in constricted spaces, a familiar aspect of childhood play, acquires sinister overtones in adolescence, that cocoon phase before emerging as capable of and responsible for reproduction. The paraphernalia of abeyance in these early works by Pippin recall that reclusive phase, with its fear of being looked at or its need for privacy. Pippin adds another metaphor: espionage, which slowly invades our privacy and restricts our freedom. Yet over-emphasis on props might be misguided; Pippin's works posit a state of affairs of which the objects are merely parts. Items like wardrobes, cupboards, and cameras mimic daily life itself, with its manic emphasis on small, separate rooms where others cannot bother us; an untruth and an unjustifiable one. British art before the expansive eighties did not neglect such social niceties. In one Anthony Howell

performance, he walked over furniture and at one point entered a wardrobe and pushed it over while he was still inside, while the first solo exhibition by Rachel Whiteread featured casts of the interior of pieces of utility furniture. Pippin's approach is at once more private and more theatrical than this; an apt comparison would be with Boyd Webb's insistence on the cheapness and flimsiness of his sets and props. In the work of both men, performance became closet drama. Whether we examine the apparatus, the finished photographs, the documentation or the entire conception is the main critical problem in dealing with Pippin's work. All claim one's attention, as indeed do written accounts of the making. In a significant sense, however, at this stage Pippin's art can be described as performance, so private it is comprehensible only by means of documentation.

As a line of washing machines, a photo booth, even an entire house become cameras, the closed spaces expand as if, instead of being confronted by a lens the figure (always the artist himself) is observed by a space. As this happens, however, a mood of exile is inevitable. Now the artist exists only to engineer a process in which, still naked in the laundromat, he activates cameras by means of tripwires in order to represent movement. The aim is not self-portraiture, perhaps, but a situation in which the already passive situation of a model is confirmed while, by manoeuvres of his own, he can remain as nearly passive as possible. As perverse as it is ingenious, Pippin's tactic consists of limiting his participation to merely appearing. The motive, it could be argued, is narcissism; he is his own model. Yet his presence does much more than this; it provides continuity, denotes a *genre* (self-portraiture), registers persistence and in particular a will to go on.

Some sense of perfection impels Pippin. Two recent types of work, one the installation at the ICA in London where one half of a room appears as a photograph on the opposite wall, by means of an enormous pinhole camera between the two areas, the other Pippin's experiments with the concept of *Flat Field,* and in *Wow & Flutter*, of sound focus so hard on problems of loss or distortion that the entire problem of the communication of images or messages is highlighted. Suddenly, the role of the artist himself is clear; it is simply to be there, to go on being there, and by various means of recording his own presence, to convey the depth of his concern for his own survival. From this point of view, Pippin's forebears are clear: conceptualists who measure space or mark time – Hanne Darboven's acts of inscription and counting; On Kawara's persistent use of temporal and spatial co-ordinates – combined with less directed artists such

as inventors. The blend of *naïveté* and sophistication betokens a certainty that has nothing to do with vicissitudes of fashion. Above all, Pippin is as steadfast and unchanging as his two major concerns: first, the everyday; second, the truth. And since they are bound so closely so often, it may not be fanciful to suppose that for Pippin they are connected. That the problem of representation itself seems to reduce to an issue of 'genuine' and 'artificial' might be the submerged theme of the ICA experiment. Yet in this case the division between the 'fake' and 'real' may be unusual, for in this, as in his last few works, his own image has not appeared. Instead, he concentrates on the obscure workings of reproductive machinery, drawing attention to distortion and incipient falsehood. In retrospect, it becomes easier to explain the role of self-portraiture in the earlier works. Why *was* that figure always there? To bear witness, to provide mute testimony, to see fair play (like some cosmic cricket umpire) and, as distortion and age set in, to be destroyed as the work is destroyed, losing the light it gathered and the images it registered.

Schwarzkogler:
The Mystery of St. Rudolf

Published in Art Monthly *167, 1993*

There are artists and there are saints, Christian Boltanski once told me in his half-joking way. Perhaps he was right; in art there are worthy careers, interesting careers but also exemplary ones. Alongside the Matisse retrospective at the Centre Pompidou in Paris, a display of photographs constitutes a temporary shrine to one mysterious exemplar, Rudolf Schwarzkogler. Schwarzkogler was to the sixties what the inventor of the headband was, or whoever stacked the first heel. His influence has been so great that probably every country in Europe can boast at least one Schwarzkogler epigone, unhindered by any first-hand understanding or experience of his career.

When the name Schwarzkogler crops up in conversation, most people say the same thing: 'Wasn't he the man who cut his **** off?' (Here you insert your pet term for the male member. 'Winkle', perhaps. Or 'todger'.) Even that is wrong; the cause of Schwarzkogler's death was defenestration following severe dieting. Not many people know that. The question is whether they really want to. If the answer is obvious, the reasons for that answer remain obscure.

With only the numbers and dates of the performances to which they refer, large photographs were mounted in a line, so that viewers read them from left to right, in chronological order. When mounted even two deep, the sense of time is lost. Another problem was the choice of shots. Do they serve as a record of main movements? Do they constitute an interpretation by the photographer in question? Or are they attempts to steal the artist's thunder? The question becomes blurry when record, interpretation and photo-opportunity coincide, as they often do with Schwarzkogler. How much he had to do with the choice of

poses or composition is unclear, though the differences between the eight sets displayed at the Centre Pompidou reveal an attempt to convey atmosphere and to record main 'events' or changes. When there *are* changes, that is, for *Aktion 5* (for example) seems almost entirely static: two figures, their faces and bodies covered with matted hair and plaster, lumber slowly about with only one prop, the bandaged plaster ball that appears in so many Schwarzkogler pieces. The problem broached is one of documentation. How should performance be recorded? And doesn't the sensitivity of the record demand an equally high degree of sensitivity from the observer? This can happen, but there is no guarantee that it will.

Does scholarship help? For English or German readers the main source of information on Viennese Actionism in general is Hubert Klocker's imposing two-volume work, designed to accompany a large exhibition in Edinburgh, cancelled shortly before the opening for reasons that have never been fully explained. Though Klocker is excellent on dates, events and relationships between the artists, tracing the movement from its sources in tachisme, Abstract Expressionism and other types of 'action' painting to its apogee in Gustav Metzger's London symposium on destruction in art, it offers little in the way of analysis. And since writing about live art has always posed problems, this leaves the Viennese Actionists documented but seldom analysed. To make matters worse, though Brus, Nitsch and other protagonists are still alive, however far they may have proceeded from their beginnings, Schwarzkogler's early death puts him in a minority of one. So his mythic status, even more than Pollock's, must be the result of photography alone, isolated versions in magazines of those prints on show in Paris.

The intensity of the events in the photographs is obvious. Detached from the viewer by means of bandages and make-up, in most of these events Schwarzkogler works alone, using other people to (seem to) torture him or to be tortured. Only *Aktion 1* has a title: *Marriage*. After slicing dead fish and placing flowers in the slits, a man in a dark suit moves to another part of his studio where a bride has her wedding dress pulled down to her waist and is being spattered with blue paint by a bird, as it struggles in the man's hand. Since this has been preceded by one photograph of what seems to be a collage – a piece of canvas slit and lifted to reveal a veil topped by real daisies, and a bride's face almost totally obscured by a sponge dripping blue paint – the links are clarified: everyday activities (cooking, marriage, posing for photographs) conceal ritualised sex and death: crucifixion, eating animal flesh, menstruation and

consummation of marriage. Each seems to relate to the others and, however obscurely, to art-making. As attention focuses increasingly on the artist himself, images of weakness, sacrifice and dehumanisation continue. Hints of the sacrifice of fish (a symbol of Christ) continue, and far more than a suggestion of rituals such as circumcision. In the last and one of the largest sets of photographs the artist, bandaged all over, employs two dead chickens, a black rectangle, live light-bulbs and the ubiquitous white sphere. Shifting from vertical to horizontal position, he ends contorted with pain, apparently left for dead.

Could these references to animality, slaughter and physicality in general be token disgust and self-loathing? Finally, narcissism or solipsism, a major theme of sixties culture, seems to devour everything else in Schwarzkogler's world. As his horizons narrow, what is left? One unusual series shows the artist lying with his shirt off, playing childish bondage games which end with a moment of mild eroticism, as he rolls over and a woman's hand is seen touching his back, reminding him that there is something outside himself. This thought encroaches to such an extent as the series continues that a strange reversal takes place; what passed for torture begins to resemble a form of self-possession so intoxicating that it ends by dominating everything else. At this point, gesture or language may begin to break down, of course, and with it communication in general. The overall feeling is of a strange, sweet aestheticism: the artist as dandy, concealed, bound, flirting with danger. If he had lived, the severe disciplines in which Schwarzkogler ended by indulging might have resulted in ever more private moves. As it was, he finished with the most private move of all.

Rebecca Horn: The Bastille
Interviews II

Published in Rebecca Horn *by the Guggenheim Museum, New York, 1993*

Stuart Morgan: What are you going to make for your retrospective at the Guggenheim?

Rebecca Horn: Have you seen my installation *High Moon* which I showed in New York in 1991? In it, two Winchester rifles hanging at about the height of a person's heart move in the gallery space. First, they focus on the people coming into the gallery. Then they move until they face each other. Finally they shoot red liquid. I've always wanted to make two rival guns shoot each other with bullets that melt, like a kiss of death. From this idea I developed a new piece for the dome of the Guggenheim Museum, *Paradiso*. Since the building has been renovated, and the new tower galleries integrated with the rest, the place has a much stronger yin/yang feeling. When I began the piece, I was reading a lot of Gurdjieff, a man whose ideas influenced Frank Lloyd Wright and his family at a certain time. Wright constructed a little fountain downstairs, near the entrance to the museum, which he wanted painted ultramarine. When you're upstairs on the top ramp, looking down, it looks like the Turkish third eye. In the middle of the space, this little water spurt shoots out, trying to reach the apex of the dome like a hopeless salmon. The idea I developed is similar to one I used in Münster for *Concert in Reverse*: every few seconds one drop of milky liquid will fall through the building from two large breast-like funnels suspended in the building's cupola, onto the tip of the jet of water in the fountain below. The sculpture will go right through the building with every drop. Above the funnels will be a sort of Dantesque Paradiso sky, with flashes of lightning zig-zagging over the ceiling. All the energies that are taking form result in this single drop.

The other pieces will spiral like an orchestra up the ramps. Around the spiral there will be separate works, in this paradise/dawn/well/metropolis.

But I also wanted another aspect. Here the dark side is missing. So the exhibition will have a second part in the basement of the Guggenheim Museum SoHo, a rotten place like Dante's Inferno, home to the heating and the pipes and the darkness. Black liquid will drop 15 metres from an old hospital bed hanging on the ceiling into a still pond of black water below. Emerging from the pool will be a tower of approximately 18 hospital beds without mattresses, and through this, like the veined branches of a tree, will shoot flashes of lightning. It is important to me that this downtown space will be free to the public and and open every Thursday through Saturday until 10 p.m. The two parts should open on the same night. I like the idea of having to travel to catch both sides of the energy.

You use the word energy a lot. What kind of energy are you talking about?
For example, there's the energy that comes at you from outside, moves through you, and then goes somewhere else. In New York, for example, I found a pair of shoes that had three owners. All that energy must have passed through those shoes.

How did you know that there were three?
First of all, they were very expensive, handmade shoes that the first owner had given to someone else after they wore out. The last owner was a tiny black man named Moses who had just died. His feet were so small that he had to put newspaper in the toes, and when it rained, they would curl up. I wanted to make something with those shoes, like an opera piece with these three energies going through them, as in life. So I called the shoes *Moses*.

You used Buster Keaton's shoes in an installation, didn't you?
Yes.

How on earth did you get hold of them?
I found them in the house of a friend of Keaton's, who also had some of his hats and suits.

Your new book, *La lune rebelle*, seems to be about other kinds of energy: 'The four-year-old child in her long party dress pitched high up in the branches of a walnut tree, secretly observing the wedding guests. The guests danced to the melodies of a violinist in black tails. Under her nested dress, far below, the head of the violinist swayed with the violin. Her tender melodies flowed though the child's body and beyond to the stars. The child held onto the tree, trembling all night until the violinist released her from

the branches, carrying her barefoot across the moist fields.' Your work seems to depend on such transference of energy. But at the end of the book you enter a sanatorium.

At the age of 20 I got sick for two years. I developed bad lung trouble because I had been working a lot with fibreglass. It was complicated because, as a student, I had been living in Barcelona, where I had a strange, destructive time. I had no money and lived in a very cheap hotel, the kind where you rent rooms by the hour. It was there, in Barcelona, that I last saw my father.

Was your relationship with your father close?

Yes, but I hardly ever saw him.

Why not?

I was at boarding school. He worked abroad and I lived with my aunt.

What happened when you became ill?

My life really changed.

How?

I was isolated in a sanatorium for almost a year! My parents died. There was a feeling of timelessness. In the sanatorium they would say, 'Why don't you stay for another six months? By that time we might have different medicines.' As a result I developed totally different ways of making art. That's when I started to produce my first body-sculptures. I could sew lying in bed. The idea was to work with the body having connections with another body. In fact, my tense relationship with performance art began at this time.

The use of the word 'energies' to describe this early work seems particularly apt. Your pieces were about rituals peformed in order to allow the characteristics of people to flare out, and when that happens, they are most and least themselves. They're like courtship rituals, in which we are out of control. Can such energies be harnessed?

Somehow. At least in my work. More and more.

You seem to be inviting danger. The danger seems to come, and then everything is alright again.

But very often it's a shock. You're moving through an experience. Suddenly, there's a flash of lightning and everything becomes very clear. Or you're so frightened you can't breathe, the same flash happens, and you see things in a totally fresh and different way.

Just after this you made the film with the cockatoo, whose behaviour is just as you describe.

I was in a room in Berlin. The idea was that every day I would set myself a task

and then document it on 16mm film. This one was to be titled *Dreaming Underwater to See Things Very Far Away*. The second day I spent mimicking and winking at the cockatoo. I was longing to go back to New York, but for some reason I had to stay in Berlin. I watched this cockatoo for some a while, and as I was imitating his sounds, he became very excited. His feathers puffed up and he jumped and flew toward the mirror. Thinking the reflection was another bird he became very aggressive and started to attack it. It was the first time the bird had seen his own reflection. That's what this piece *Twinkling* is about, how to have a conversation, or not, with this bird.

The gestures you choose for your machines are like animal movements, aren't they? Movements of display that happen very quietly or, conversely, in a rush.

They react as we react. My machines are not washing machines or cars. They have a human quality and they must change. They get nervous and must stop sometimes. If a machine stops, it doesn't mean it's broken. It's just tired. The tragic or melancholic aspect of machines is very important to me. I don't want them to run forever. It's part of their life that they stop and faint.

Do you think that your reaction has to do with our historical perspective? After all, we're at the end of the Machine Age. Perhaps that's the reason that old machinery seems so sad and outdated.

Maybe. On the other hand, when I use machines, people start to dance. They start to move with a new rhythm that they can't control. So the 36 typewriters in *Chorus of the Locust I* hung from the ceiling, each typing to its own particular rhythm. People came into the gallery and reacted to this sound with their bodies and their own interior rhythms.

In the film *Der Eintänzer*, things happen the other way around.

Yes, there are table dances. The idea was that two people, a blind man and a Russian ballerina, would dance a perfect Argentinian tango. Then, when they leave the impromptu dance school, the table continues their tango in a stiff, shy way, with the same rhythm, night and day. They are already somewhere else, but the table has picked up their energy and goes on indefinitely, almost catatonically. Somewhere else, someone else will start dancing…

In the same way I came to the idea for my piece for Documenta 9 in Kassel. Jan Hoet's office was in a building that had been an elementary school. Like every other school of its kind in the world, it has a strange smell: a combination of disinfectant, piss and chalk. It was the only place that touched me, so I made a piece there. We got these old school benches-cum-desks like the ones I had in

school, which was in a little village in the mountains in Heidelberg. We had a teacher with a wooden leg and gold glasses. Every day at the end of the class, one child or another had to lead the prayers. I was five years old and did not know how to pray because I lived with a Romanian governess and she had never taught me how. One day it was my turn. I was standing there sweating and stammering and I started to pee. The little warm river started to trickle down in front of the class, forming a small lake round the big, black polished boot of the teacher's wooden leg. Later, I was made to walk home with him, uphill for miles, carrying his heavy books. All the way he threatened to tell my mother. Since she often was not living with us anyway, I simply ran away. He never asked me to pray again. I hated him so much ... For Documenta, I put benches upside down on the ceiling of the classroom. Connected to the inkwells were lead tubes that ran out of the fifth-floor window and down the front of the building, like a forest of chained roots, and into the asphalt of the playground. Inside the tubes was black ink that dripped and circulated throughout the building, inside and outside, before disappearing into the earth of the playground. Playground of the earth. That was the piece, and everybody who saw it understood it, even without knowing the story. I named it *The Moon, the Child, and the River of Anarchy*.

You have a habit of elaborating on work you are asked to do. Something similar happened in Barcelona.

Yes. I had two shows running simultaneously there last year. I've always had a love-hate relationship with that city. I loved it when I was there as a student, reading Antonin Artaud and Jean Genet and living what I was reading. Just off the Ramblas I found one of those 'hour' hotels I'd lived in, rented seven rooms, and made a three-month-long installation in each of them. The other show was on the outskirts of the city, in an old hat factory turned into an art foundation of sorts. Inside, rivers of mercury ran through endless lead veins out through the walls, trying to reach the sea. But the mercury was pumped back into a seven-chambered heart machine, controlled yet kept flowing, as if each chamber might have one of the keys for one of the seven rooms in that hotel on the other side of the city.

You also made a monument in Barcelona.

Yes, to the old community of little restaurants, or *chiringuitos*, that were once the heart and soul of the Barcelona beach front. They were violently destroyed after over one hundred years of existence in order to 'clean up' the beach for the month of the Olympic Games. The tower was made to look like a makeshift shack, just like a *chiringuito*, only it's of industrial steel and twelve metres tall.

The tower is lit day and night by flashes of lightning. Outside a voice like the wind whispers the names of the restaurants and of the evicted people who ran and served in them.

When did you first get the idea for making full-length feature films?

I'm fascinated by cinema, by the idea of having a full illusion on a screen in front of you. For me, it's a real balance to work in these different media.

Have you ever been criticised for deserting art for film?

More and more, I hate this word 'art', this limitation on what art is. Duchamp already exploded it. I can't constantly paint or make machines. I get to a limit and want to do something else. Because I'm not constantly working in cinema, I love cinema. I love the precision. It's almost the same as constructing a machine. There are steps to go through to articulate every single function. You have a story, and you have the privilege of working with actors. Then you go through this whole technical process of shooting and editing, and finally after a year, you might have five rolls of film. The good thing is that you can show the film everywhere, whereas when there is an exhibition or installation, only a few people get to see it before it disappears.

Buster's Bedroom was named for Buster Keaton, who I know has been a great inspiration for you. But there are things in that film that seem reminiscent of your sculpture, like the whisky-driven wheelchair Geraldine Chapman is strapped into.

Her character, Diana Daniels, is old Hollywood. Out of love for her sadistic idol, a snake-obsessed doctor played by Donald Sutherland, she has made herself paralysed and just sits in a wheelchair, drinking constantly, complaining about life and being immobilised. You can love someone so much that you paralyse yourself. That's what I'm interested in, the extremes you can go to.

What has this to do with Buster Keaton, whose name provides the title for the film?

Well, hadn't Keaton done the same? In his early work he was a shy young man with a dream of what he wanted to be in the world. He falls in love but has to fight for the girl. He has to invent the apparatus to achieve what he wants, and becomes completely obsessed by his mad world of imaginary things. Although he gets what he wants he must use his entire powers of fantasy, his whole imagination, in order to do so. In the end, when he gets the girl – love – he doesn't know what to do with her – love – and remains completely helpless. It's very touching how he fights. It's always the same story. In fact, he seems to have used himself for inspiration. When he got married and wasn't getting on with his

wife, he made a movie about how he couldn't manage to construct a house. Keaton transformed his own life in a very beautiful way. Risk played a large part in his creativity. For example, he was constantly building absurd machines.

Is that true?

Yes. His wife told me that, in their garden, he had constructed a railway track for a little train. It went around the swimming pool, coming back into the garage through the kitchen. He had parties where he made hamburgers, and each little wagon would have a hamburger or a banana or something in it. He would cook all day and serve people in this way. There's also the immense, Heath Robinsonesque nutcracker he built on the MGM lot, but that's another story.

You were too late to cast Keaton in one of your films, but I'm interested to know who will be in the next.

The ideal cast would be Donald Sutherland again, and Charlotte Rampling and Willem Dafoe.

And what will it be about?

Don't ask me. I don't want to give away too much of the plot. It's a true story, that's my problem.

Is it the story you've just been telling me?

Yes. You've been hearing about my childhood and then going to Barcelona and ending up in the sanatorium.

So this is the plot of the next film?

Not me. It's about a woman. And I'm writing it for an audience. But everyone has certain experiences in their personal luggage that make them who they are at any given time. I'm talking about things I wouldn't have talked about 15 years ago.

Miroslaw Balka: Last Rites

Published in frieze *14, 1994*

In recent years, Minimalism has become the *lingua franca* of contemporary sculpture. Yet since the Richard Serra *Tilted Arc* hearings in 1985, a tendency to associate the style with cold, masculine intransigence has been inevitable. [1] That very year saw the first major work by an artist whose Minimalist variations would be devoid of coercive overtones. The sculpture of the young Polish artist Miroslaw Balka evokes a sense of dignity and strength, but does so simply and modestly. Jerzy Grotowski coined the term 'poor theatre' to describe his vision of a new drama. And the adjective 'poor' in the sense both of humility and of paring down, also summarises Balka's art.

His materials are all too familiar; for example, visitors to his latest installation *Die Rampe* (1993) in Zürich are confronted first by an entire room containing only two small, roughly semicircular pieces of used, patterned linoleum. And materials are often old and worn. Visible on the floor of the adjacent, larger space is a rectangle of grey powder: fine ash from the hearth, arranged with infinite care, since for Balka, vulnerability is a fact of life. And, as art and daily life coalesce, Balka's use of space reconciles apparent contradictions; overtones of museum and home are felt simultaneously. While this is happening, a third influence prevails. As wretchedness and grandeur are brought together, a sense of the sacred is felt. Perhaps it is Balka's humble means that succeed in evoking reverence in the viewer, a state where life and death are separated by an existence which is precious, however wretched. The more that is excluded, it seems, the more powerful the feeling that floods in. With Balka it has always been like this.

Beside a table stands a small boy in short trousers, wearing long socks which are about to fall down. He is trying to muster courage for the ordeal to come. And he is right to be apprehensive: his first communion is not simply a matter of religion, it is also an initiation into manhood, into society. As sculpture, the work seems awkward and old fashioned, not because of the material (tinted cement mixed with artificial stone and crushed marble), nor the tableauesque aspect of the display, but because of its obvious sincerity. It is even more sincere than it seems, however, for its first showing coincided with a rite of passage for the artist himself, and one in which he seized every opportunity to heighten the element of risk. Indeed, he stopped at nothing to dramatise his own predicament. Required to travel to a space outside the official Academy building (an abandoned house in Zukov), the examiners were invited to look at the statue while listening to a tape of a religious procession, quiet at first, swelling as the procession approached, then fading into silence as it moved away. As they did so, each, one at a time, had to take a needle and plunge it into the heart of the cement boy; or, at least, into a pincushion exposed in his chest standing in for a heart. Theatrical, kitsch even, the graduation sculpture and its installation seemed devoid of irony and proud of it, as if a first person account were being given of that miniature crucifixion the budding artist was undergoing. As Balka's career progressed, abstraction replaced figuration, theatricality became more muted and the means became sparer. But two elements remained: ensemble installation and a sense of poignant emotion. Or perhaps three; for Balka has continued to pursue his career as an exercise in self-definition as a Pole, as a member of his family and as an artist.

Balka's sense of space is now so personal that he takes his measurements from the dimensions of his own body. (He was delighted to discover that his own foot measures exactly a foot.) So the spaces he creates are primarily housing for his own frame, and the humblest kind of housing at that. In the space he was allotted in the Aperto section of the 1990 Venice Biennale, he placed a low bed form, and added dirt from the floor in Venice mixed with pine needles, which he then brushed away tidily behind a low shelf. Not for the first time in his work, the bed resembled a grave; here dying and living spaces coincided. Nor for the first time did the bed, the hearth and other features of the house in which he was brought up cast long shadows. And as always, there were references to daily routine, a state that Eliot called 'living and partly living'. In the Venice Biennale of 1993, where the Polish pavilion was devoted entirely to Balka's sculpture, he based his installation on the small house he inherited from his grandmother, the

place where he now works. Since Balka tends to turn viewing spaces into comparable areas, a feeling of physical and emotional proximity characterises his sculpture. And choreographed step by step, visitors encounter not single items but environments. Even the shape of the gallery must sometimes be adjusted or altered. (In Boston earlier this year, he had a scale model of his studio constructed, and visitors put on slippers before entering.) For frequently, Balka's work is fragile and transient; responsive to temperature, touch, even a light breeze, it not only recalls, but may even consist of the remains of daily activities to which scant respect is attached. It is these to which Balka is determined to draw his viewers' attention. The ash from his hearth; terrazzo (or 'poor man's marble') from which humble graves are made; cheap soap of the kind found in public washrooms; even old linoleum from the floor. All these find their way into Balka's work and are made to seem dignified, timeless, infinitely precious.

For Balka is essentially a monumental artist. At Sonsbeek this year he made three sculptures – two outdoors, one inside. On the ground floor of a house at the end of a street, high above a main railway line in the middle of the city of Arnhem, a door opened to reveal a room empty except for a double bed with high metal sides, on which rested two primitive electric blankets at body temperature. On a patch of grass at the side of a tree-lined street adjoining the local cemetery, a similarly shaped, two-chambered concrete trough had been sunk, and in the middle of one of the longer sides a pair of angular seats, also made of concrete, had been fixed side by side like thrones. Finally, at ground level on the bank of the river next to the bridge which the British army tried so valiantly and for so long to defend against the Germans in the Battle of Arnhem, Balka built a concrete pit with a powerful searchlight inside it, set in the middle of a base shaped like a concave parachute. It was tempting to regard the three as a trilogy, one set in some distant past, another in the present, the third in a period pivotal to both. The way the bridge monument inflected the other two works in Arnhem, bringing together marriage bed and grave, people of high and low rank, safety and vulnerability – for a searchlight catching the inside of a parachute signals instant death – suggested that the thematic pivot of Balka's work might indeed be the last war. Sleep and wakefulness, burial and birth, a sense that the most extreme events of life in peacetime have taken precedence over routine, happiness and order and that between cradle and grave only a situation of constant emergency can be expected; most of all perhaps the idea of being singled out from the crowd, from loved ones, for special treatment. The

sinister act of recognition that the parachute monument seems to commemorate has already been identified in Balka's sculpture. It appeared once more in *Die Rampe*.

As usual, it began sparely, controlling the path of the visitor, encouraging an accumulation of meaning from one item to the next, and ending with the most dramatic touch of all, so subtle an alteration of the ground floor gallery itself that it might be passed by. Indeed, it scarcely qualified as a separate artwork. The ramp of the title led up to a high door, one of the final elements to be encountered in a walk that, as usual, had turned back on itself, gaining significance and, indeed, becoming more dense as it continued. The door was ajar, and behind it a powerful light had been placed, implying that the further the door opened, the more light would flood in, as also the access intruders might gain would increase. The ramp itself, a permanent feature of the building – a former warehouse – carried the powerful suggestion of robbery or desecration, danger of some sinister kind. By this time the entire scope of the exhibition had become clear. Indeed, the visitor was about to turn and walk back through works already encountered: two matching boxes made of old linoleum from the family home, placed side by side, both revealing the spaces from which the introductory pair of arc-shaped offcuts had been removed; a rectangle of ash; a pair of low, terrazzo 'beds', just above the ground, heated gently; a pair of angled metal plates on the wall, covered with and smelling strongly of soap, like the panels on both sides of the Polish pavilion in Venice, through which viewers walked before gaining access to smaller, horizontal works. The high value placed on continuity – literal continuity in the installations and temporal continuity in historical terms – may offer some insight into the thematic basis of Balka's work. Isn't the 'art' on display in a Balka installation in the nature of a collection of relics, remnants of what purport to be remnants of everyday life? And, as was the case even as early as the statue of the lad preparing for his first communion, aren't transience and ordeal high on Balka's list of thematic priorities?

The first and last things done with the body are its washing and ceremonial presentation. Minimalist slabs in Balka's work are often pierced with holes: for nipples, navel, anus and penis. For the body is always evoked but never represented. It is non-specific, male or female, often half of a pair. It breathes and washes, it performs daily rituals and may gain strength from these. Above all, it persists. One reading of Balka's work would stress this sheer persistence, the national characteristic of a traumatised country with an unrivalled experience of Nazi cruelty. In the face of this, conventional means of self-identification have

collapsed. (Since death-camps like Auschwitz, Majdanek and Treblinka were to have begun by killing Jews before proceeding to kill Poles, it has been argued that the mass murder of Jews and Poles has coalesced into a single event in the collective memory.) [2] At this point representation breaks down, and bins of prisoners' shoes at Majdanek or suitcases at Auschwitz, inscribed with their names and numbers by the owners themselves, assume a significance beyond any that art can achieve in a time of mourning. Balka's half-life, one of ablutions and wakeful sleep, in which disturbance is expected at any moment and identification means death, has its heroes: boys prepared to shoulder responsibility and confront adulthood; a hooded shepherdess in another early work, using a torch to seek her lost lamb; the single airman prepared to risk his life to prevent the enemy from invading. Private acts of care which have an added social dimension provide the basis for a return to peace and continuity. The threat of invasion in *Die Rampe,* as the partly open door reveals a spotlight which nothing and no one can escape, resembles the danger portrayed by the military memorial. For a second, it will be impossible to know whether the invader is friend or foe, Saviour or Antichrist. Then everything we know and have will be taken away.

1. Anna C. Chave, 'Minimalism and the Rhetoric of Power' in *Arts*, vol. 64, no. 5, January 1990, pp.44-63, reprinted in edited form in F. Frascina and J. Harris ed., *Art in Modern Culture,* London 1992, pp.264-281.
2. James E. Young, *Holocaust Memorials and Meaning*, Yale: New Haven and London 1993, pp.113-152.

Paul Thek:
The Man Who Couldn't Get Up

Published in frieze *24, 1995*

There are artists who grit their teeth, plot their strategy, make their work and become successful. And there are artists like Paul Thek. Fugitive, unworldly, Thek collaborated with others for much of his life and died in 1988, a disillusioned man. Now a retrospective exhibition, originating at Rotterdam's Witte de With, re-examines his career with the help of photographs, film, diaries, sculptures, installations and paintings. As a project, it is fraught with difficulties. Not that Thek's initial success and eventual failure were part of a period which is lost. It is the meaning of that life at that time which is lost: a life of travel, communes and festivals, of drugs and promiscuity, but above all, perhaps, of expectations of the future. Now we feel we know better; the high hopes of the sixties were unfounded. Worse still, with the passage of time, what Thek called 'The Wonderful World That Almost Was' became a joke, a dream, a hieroglyph without a key.

The year is 1963. In the catacombs at Palermo a good-looking young man is standing, arms folded, with skeletons ranged behind him. As a portrait, the snapshot seems far from successful: the subject seems out of place because his mind is elsewhere. The second attempt by the same photographer, a head and shoulders shot taken eleven years later, shows the subject, still handsome in his way but baggy-eyed, with thinning hair and a lined forehead. Only one clue reveals that it is the same person. For by now the loss of focus that had previously seemed charming has become an inevitability; he looks straight through us because he cannot escape his own mind. Perhaps he is still in Palermo, among the catacombs. 'There are about 8,000 corpses,' he wrote, 'Not

skeletons, corpses decorating the walls, and the corridors are filled with windowed coffins. I opened one and picked up what I thought was a piece of paper; it was a piece of dried thigh.' As always his reaction was unusual: 'I felt strangely relieved and free,' he wrote. 'It delighted me that bodies could be used to decorate a room, like flowers.'

By the late sixties everyone knew the work of Paul Thek. Pictures of his work appeared in art magazines. Critics interviewed him. In 1966 Susan Sontag even dedicated her greatest book, *Against Interpretation*, to him. But then what? 'He fell wounded,' reads one of his notebook entries from 1979. 'Some tried to help him up, but he was wounded to the core, they tried – then, one by one – they left him, drifted away into their own lives, their own hoped-for successes, and failures, but he had fallen, they (some of them) urged him on, urged him UP, tried even to SEDUCE him once again into living, and Life as always knew what she was doing; the Pleroma lit up in his brain, like a vaginal dentifrice.' Half farce, half pathos, the tone recalls the sick humour of the sixties: the tone of Joseph Heller or Terry Southern, with Nathanael West lurking in the distance. It is also the work of a self-dramatising figure, someone carried away by the sheer theatre of it all. Yet despite the fact that the strain and self-pity seem calculated, no amount of artifice can conceal the truth: this is a cry for help.

Signs of strangled emotion were evident from the first, with decorative paintings in bilious colours reminiscent of early, fairytale Kandinsky. They reappeared in chastened form in a series of paintings called *Television Analyzations,* begun in 1963. One image is of a society woman – all mouth, bosom and necklace – leading what looks like a growing procession of clones, all, like her, giving cheesy grins and making cathedrals with their long fingernails. Everything is grey except for her vivid, red necklace, only part of which is visible. In another 'analyzation', again of only part of a woman's face, her open mouth and fleshy tongue are featured, while another shows a hand cradling a fruit bat. His notebooks leave readers in no doubt of Thek's attitude to women; a mistrust so deep it verged on loathing. Regard the paintings as glimpses of the vagina, and the distancing effects – the sense of protection offered by the *regressus in infinitum,* the painted equivalent of interference on a television screen, the sense of flesh tightly furled or gaping, like an open mouth – all become explicable. So do the bared fangs, as if the viewer (or the painter himself) is confronting some animal force. The preliminary to eating is baring one's teeth, after all, or smiling. Thek used eating as a way of understanding consumption and society in general with an attack so audacious that it ranks as a masterstroke.

A container lies on its side, bearing the same lettering as all the others. 'New', it tells us, '24 Giant Size Pkings / Brillo Soap Pads with Rust Resister / Brillo Mfg. Co. Inc. N.Y. / Made in U.S.A.' Gazing into the plexiglass bottom of the case, we are appalled. The motifs of the mouth with tongue and the television as framing device have shifted to three dimensions in order to mount a full-scale attack on consumer culture. 'No ideas but in things,' Warhol implied. 'No ideas but in flesh,' Thek countered. In the *Technological Reliquaries* series, to which this piece belongs, elaborate containers, often of coloured plastic, house lumps of what resemble raw meat. The choice of the Brillo box was deliberate. Yet though Thek had visited the Factory and met Warhol, there can be little doubt that he meant this as a reproach, not only on Warhol himself but also on his particular interpretation of Pop, a reading which would become Conceptual Art.

Another ritual which underlay Thek's work was that of the funeral service. ('My work is about time,' he wrote in a notebook, 'An inevitable impurity from which we all suffer.') *The Tomb* (1967), one of the best-known installations of the sixties, featured a ziggurat-shaped room in which a life-sized model of the artist himself was presented like a corpse lying in state, surrounded by relics of his life. The work was personal to a degree. (Thek's bedroom as a child had been ziggurat-shaped and as a grown-up he had even made cases for his work which contained transparent, upturned ziggurats to be looked through like a framing device.) Interpreted as a farewell to sixties culture, or even a monument to the Vietnam War, it was wrongly subtitled *Death of a Hippie* by the Whitney Museum when included in a group exhibition. To Thek's annoyance the name stuck. It marked the climax of a period of casting body parts – a wax arm and hand in armour, for example, decorated with butterfly wings. *The Tomb's* beeswax cast of the artist's own body, with plaited hair, gold adornments, personal letters and a bowl was succeeded by another Thek surrogate: *Fishman* (1968), a religious icon cast from his own body, of a flying or prone male covered with fish. ('And I shall make you fishes of men,' Jesus told his disciples on the shores of Lake Galilee.) *Fishman* was shown a second time face down on the underside of a table high above the viewer's head. By then Thek's supporters were beginning to realise that their interpretations and the artist's own were poles apart, or that some other, larger significance was intended. There was another problem: now that the relation between Thek and his work was becoming clearer, viewers were rejecting his insistence on the first-person singular.

But another artistic confrontation helped strengthen Thek's resolve. In 1968, he had been invited to show at the Galerie M.E. Thelen in Essen, but his work had been damaged in transit. Even so, he decided to open the gallery and sit day after day, mending the pieces. *A Procession in Honour of Aesthetic Progress: Objects to Theoretically Wear, Carry, Pull or Wave* marked the beginning of his interest in process and the word 'procession', which he used to describe subsequent group activities. The sheer oddness of the Essen presentation is hard to convey. Chairs were adapted to be worn so that the wearer's head protruded through the seat, and, for the first time, newspapers littered the ground. (These would enter his artistic vocabulary on a permanent basis.) Thek had recently seen Beuys's work for the first time, and, as in the case of Warhol, had reacted strongly, less with his artist's mind than with his untethered sexuality: 'It seemed to me that all it needed was glamour and worth and charm and a woman's touch,' he commented. Yet there was less separating them than he imagined. Beuys was striving to make a visual language. So was Thek, though his way of doing so seemed more like adopting a family. Removed from the *Tomb,* the figure of the hippie became a main protagonist. So did *Fishman,* and so did a giant latex dwarf called 'Assurbanipal' because of his Assyrian beard... In the same way Thek was adopting people, living and making work with them by constantly adapting and re-adapting existing elements and aiming for fullness of meaning using a Jungian approach to world myth.

Only photographs remain of the *Processions.* Influenced by the films of Jack Smith and the theatre of Robert Wilson, Thek pushed improvisation to its limits. The word 'procession' – a stabilisation of the term 'process' – and the journey taken through his installations referred to the liturgical and celebratory in equal measure. (Led by Assurbanipal, *The Procession/ The Artist's Co-op* (1969) consisted of a line of chairs, a table with bottles and serviettes and the remains of a night's drinking, while *The Procession/ Easter in a Pear Tree* (1969) even included a large cross.) Thek, who enjoyed the fiesta mentality and the way Italian homes were decorated for holidays, refused to recognise any dichotomy between worship and celebration, religious and secular. Another *Pyramid* (1971) followed, this time life-size, with trees and washing hanging out to dry; a table and chairs; more newspapers; another procession led by Assurbanipal; the Fishman hanging from the ceiling, a fountain, a pink volcano... There seemed to be no boundaries.

Biographers might argue that Thek's distressing early life led to a need for family, security, comfort, faith, above all a stable domestic environment, that he

found these in the company of the changing members of his co-operative, but moreover, that the kind of stability he craved seemed almost medieval, with a calendar that was cyclical rather than linear. This approach might possibly have led to an antiquated, even static attitude to art. On the one hand, the *Processions* offered a permanent opportunity for the team to recycle its own works. On the other, they might have provided chances for the employment of principles of repetition akin to those of (say) Indian ragas. In addition, like pre-20th century artists, Thek and his team seem to have made decisions according to a shared theory of beauty, though, in contrast to those of pre-20th century artists, their aesthetic was their own invention.

The urge to solve the problem of vocation seems to have troubled Thek for years. 'Thicker. Deeper,' he wrote in a letter to his longtime collaborator Franz Deckwitz early in 1972. 'I want to make a real place to rest and worship in, not just art.' Indeed, at stages in his life a powerful tension existed between his career as an artist and his urge to retire from the world. By this time his faith was being buttressed by periods of meditation in a Benedictine monastery in Vermont. Despite his failure to make a living and letters from museums saying they could no longer manage to keep his installations in permanent storage, it still seemed to him that with his large scale retrospective organised by Suzanne Delahanty at the ICA in Philadelphia the tide might have turned. He was wrong. Around 1975-6, his luck gave out. By 1978 he was working in a New York supermarket, then cleaning in a hospital. After that, his hopes of entering a monastery were dashed by a doctor's confirmation of his status; he was HIV positive.

By this time Thek had been reasserting his dedication to the naive, as a means of making art as well as leading one's life, with the series of bronze sculptures called *The Personal Effects of the Pied Piper,* regarded as a lay saint who allowed the rats to devour his possessions. As usual, his hyper-active mind refused to settle on a single theme for very long, and the Piper became confused with Mr Bojangles (from the song by Jerry Jeff Walker) and Uncle Tom's Cabin. Somehow the Tar Baby (from Uncle Remus) also became part of the mix. By this time the newspapers which had been a permanent feature of the installations were being used as a paint surface. Sometimes religious, usually satirical, frequently apocalyptic, permanently disillusioned in its vision of a New York that featured the half-built World Trade Center towers he called Sodom and Gomorrah, Thek's approach was that of a man at the end of his tether. (Ten years later he presented his own completely unrealistic Richard Serra's *Tilted Arc* project, titled *Revised Ark,* with holes bored through it in the shape of stars,

a small zoo and a park with flowers.) Yet the uneven standard of the paintings should not blind us to the genuineness of the vision: *Uncle Tom's Cabin in Flames* and *Bo Jangles in Flames* (1979) are premonitions of an American apocalypse; by 1980, Thek was making paintings with titles like *Turquoise Potato Peelings in a Sea of Piss and Shit*. (His titles are a delight. Who could forget *Church of the Holy Molar, Fascist Grapes* or *Neolithic Porno?)*

But there is no point in pretending that the last years of Thek's life gave rise to his finest art. Forget the last years of bitterness and disillusion and illness and return to his retrospective in Philadelphia in 1977. Imagine the camp and tacky raised to the point of intellectuality and far beyond: to a state of childlike belief, as viewers encountered a sea of sand – 'It's water you can walk on; it's time', Thek explained unhelpfully – a barge with kitsch forests and stuffed animals, the wooden model for Tatlin's tower, King Kong, a homage to Picasso, the *Warhol Brillo Box* again, a bathroom and a shanty and a stuffed bird and... If people had told him to stop, Thek would have taken no notice. For, as his paintings show, he already felt that time was running out. He was right. He never retired to a monastery as he had planned, nor did he make peace with those who had hurt or ignored him. (Like Dr Johnson, he was 'a good hater'.) Did he ever relax into the situation as it was, or did he continue to look straight through it to something else, somewhere else, as he seemed to have done for the whole of his strange, confused, cryptic, inspiring life?

Index of Names

Acconci, Vito 26

Acker, Kathy 213

Ackerman, Al 70

Adams, Brooks 115

Adams, Mac 80

Adams, Robert Martin 53

Adorno, Theodor W. 231

Allen, Woody 68

Allington, Edward 136-141

Alloway, Lawrence 39

Allthorpe-Guyton, Marjorie 261

Anderson, Laurie 80, 122, 123, 193

Andre, Carl 26

de Antonio, Emile 178

Apollinaire, Guillaume 114

Arbus, Diane 60, 291

Armstrong, Louis 16, 217

Armst, Skot 70

Art & Language 136n.

Artaud, Antonin 186, 240, 302

Ashbery, John 24

Ashley, Robert 113

Atget, Eugène 291

Attali, Jacques 17, 224

Auden, W.H. 176, 263

Aycock, Alice 42-54, 159, 171

Bachelard, Gaston 54, 89, 90

Bach, J.S. 124, 185

Bacon, Francis 63

Bainbridge, Eric 142-145

Baker, Kenneth 23

Bakhtin, Mikhail 28, 241

Balka, Miroslaw 305-9

Balkenhol, Stephan 263, 268

Ball, Edward 216

Barnes, Mr 45

Barnes, Mr 246, 251

Barthes, Roland 93, 212

Baselitz, Georg 218, 244

Bataille, Georges 41

Baudelaire, Charles 44

Baudrillard, Jean 212

Bausch, Pina 123

Baxter, Glen 16, 79-86

Beckett, Samuel 33, 76, 182, 292

Beckley, Bill 82

Bellini, Giovanni 150

Belloc, Hilaire 119

Benetton 211

Benjamin, Walter 53n., 85, 90, 157

Benny, Jack 57

Berger, John 118

Bergson, Henri 255

Bernini 139

Beuys, Joseph 131-135, 175, 226, 251, 313

Blazwick, Iwona 215

Bleckner, Ross 171

Blom, Ansuya 16-17, 217-225

Bloom, Norman 47

Bochner, Mel 32, 38

Bohm, David 209-10

Boiffard 240

Boltanski, Christian 16, 195-201, 295

Borges, Jorge Luis 77, 141, 230

Borromini 105

Boullée 34

Bourgeois, Louise 159-170, 236-8

Bourn, Ian 125-6

Bowie, David 71n.

Braque, Georges 148

Braudy, Leo 269

Brecht, Bertolt 57, 129, 157

Breton, André 39

Brisley, Stuart 122, 124-5

Brodsky, Joseph 194

Broonzy, Big Bill 219

Brouwn, Stanley 252

Brown, Capability 98

Brueghel, Pieter 263

Brus, Gunther 296

Buckley, Stephen 112

Burden, Chris 26

Burroughs, William 65

Burnham, Jack 23

Burns, Robert 240

Burton, Richard 19

Butor, Michel 85

Calle, Sophie 264

Calvino, Italo 47, 50

Campbell, Naomi 270

Campbell, Steven 16, 110-121, 186

Cameron, Dan 267

Camus, Albert 96

Canetti, Elias 16, 29, 222

Capote, Truman 178

Capra, Fritjov 210

Caro, Anthony 145

Carroll, Lewis 119

Carter, Chris 65

Castelli, Leo 178

Cavafy, Constantine 19

Cazzara, Monte 70

Celant, Germano 213

Cellini, Benvenuto 172

Cemin, Saint Claire 266, 263

de Certeau, Michel 156-7

Chadwick, Helen 125

Chapman, Geraldine 303

Chaimowicz, Marc Camille 87-97, 122

Chave, Anna C. 309n.

Chapman, Ethel 60-1, 70-1

Chekhov, Anton 127

Chesterton, G.W. 119

de Chirico, Giorgio 179, 263

Christie, Agatha 100

Christopherson, Peter 62, 65

Cicciolina 271

Coleridge, S.T. 46

Collins, Judy 20

Coltrane, John 275

Conrad, Joseph 16, 222

Cooper, Tommy 266

Cornell, Joseph 247

COUM 65-71

Cox, Paul 16, 219

Cragg, Tony 145

Crary, Jonathan 23, 238

Crimp, Douglas 231

Cross, Gary 207

Dafoe, Willem 304

Dali, Salvador 179

Darboven, Hanne 293

Darling, Candy 176

Darrow, Whitney 202

Davey, Grenville 256-60

Davis, Sammy Junior 19, 20

Debord, Guy 211, 212

Deckwitz, Franz 314

Dee, Sandra 209

Delahanty, Susan 314

Dennett, Daniel 285

Dickens, Charles 76

Diderot, Denis 100

Dietrich, Marlene 241

Diogenes 15

Disney, Walt 149

Doisneau, Robert 105

Donahue, Troy 209

Donovan 278

Douglas, Mary 17, 217, 224

Dowland, John 180

Duchamp, Marcel 24, 55, 80, 160, 186, 227, 281, 292, 303

Dürer, Albrecht 157

Eckland, Britt 68

Eco, Umberto 265

Edmundson, Simon 171

Eliot, T.S. 48, 241 257, 306

Ellington, Duke 17, 223

Ellison, Ralph 17, 224

Empson, William 233, 239

Ernst, Max 244

Espaliú, Pepe 188-191

Evans, Walker 291

Everage, Edna 68

Exploding Galaxy, 66

Faubus, Orville 224

Feck, Sid 35

Fellini, Federico 139

Ferdinand of Bohemia 184

Ferigno, Lou 20

Fischli-Weiss 265

Fitzgerald, Scott 63

Frank, Peter 23

Foucault, Michel 68, 229

Frampton, Hollis 278

Freud, Sigmund 61, 163, 176, 228, 251

Fried, Michael 50

Frith, William Powell 266

Fritsch, Katherina 264

Fuller, Peter 210

Gable, Clark 269

Galán, Julio 264

Galileo, 210

Genet, Jean 179, 189, 190 191, 238, 302

Gide, André 96

Gilbert & George 122

Ginsberg, Allen 29

Girard, René 141

Glass, Philip 114

Gleick, James 210

Gluck, Nathan 176

Gober, Robert 265

Godard, Jean-Luc 21, 48

Goethe, J.W. 249, 251-2

Gogol, Nikolai Vasilievich 81

Goldstein, Jack 122

Gombrich, E.H. 163

Gorky, Arshile 91n.

Graham, Roberta 125

Greenaway, Peter 98-104

Greenberg, Clement 138, 172

Greenblatt, Stephen 264

Grotowski, Jerzy 305

Grünfeld, Thomas 226-31

Gurdjieff, G.I. 298

Halley, Peter 212

Hamilton, Ann 267

Hancock, Tony 144

Handke, Peter 258

Handy, W.C. 30

Haring, Keith 122

Hartman, Geoffrey 87

Heaney, Joe 275

Heidegger, Martin 258

Heller, Joseph 242, 311

Hesse, Eva 33, 38

Highsmith, Patricia 113

Hill, Gary 268

Hiller, Susan 171

Hilty, Greg 267

Hirst, Damien, 247-253

Hitler, Adolf 208

Hockney, David 81

Hoet, Jan 301

Hofmann, Hans 150

Hogarth, William 111, 118

Holt, Nancy 35

Holzer, Jenny 264

Hood, Mantle 225

Hopkin, Mary 261

Horn, Rebecca 298-304

Howell, Anthony 126-130, 292

Howell, John 122

Hughes, Langston 16, 219

Hume, Cardinal Basil 96

Hume, David 111, 117, 120, 121

Hume, Elina 287

Hunt, Stan 202

Huxley, Julian 17, 223

Huysmans, J-K. 229

Ice, Vanilla 270

Immendorf, Jörg 218

Indiana, Gary 214

Jackson Michael 240

Jahn, Janheinz 17, 225

James, Henry 24

James I 184

Jefferson, Thomas 215

Jencks, Charles 264

Jesus Christ, 73, 179

Jewell, Dick 62-3, 68, 69

Johns Jasper 29, 91, 176

Johnson, Samuel 315

Jones, David 155

Jones, Leroi (Amiri Baraka) 225n.

Jones, Ronald 216

Joplin, Janis 30

Joyce, James 45, 48, 131, 137, 239

Jubelin, Narelle 315

Kafka, Franz 77, 182, 189

Kahlo, Frida 222

Kanin, Garson 269

Karsh of Ottawa 21

Kawabata, Yusunari 16, 221

Kawara, On 252, 293

Keaton, Buster 299, 303-4

Keats, John 37

Keil, Charles 32

Kemps, Niek 239, 281-85

Kennedy, Jackie 174

Kenner, Hugh 54

Kermode, Sir Frank 163

Khan, Jenghir 226

Kiefer, Anselm 218

Klocker, Hubert 296

Klein, Yves 175

Knight, Charles 39

Koons, Jeff 263, 268, 269-72

Kray, Reggie and Ronnie 125

Kris, Ernst 167

Kristeva, Julia 16, 219

Kubler, George 32, 37, 163n.

Landseer, Edwin 111

Lane, Abbe 19

Lang, Fritz 243

Lateef, Yusef 17, 224

Lawrence D.H. 162

Lear, Edward 119

Lebrun, Chistopher 186

Lefèbvre, Henri 211

Lelouch, Claude 199

Lenin, V.I. 61, 287, 289

Lennon, John 104

Le Va, Barry 26

Lévi-Strauss, Claude 45

Levin, Kim 23

Lewis, Jerry 16, 18-22

Lewty, Simon, 151-155

Liberace 69

Lindsay, Jennifer 225

Linich, Billy 176

Linke, Simon 171-173

Lippi, Fra Lippo 266

Lombard, Carole 269

Lisanby, Charles 179

Longhi, Pietro 111, 127

Longhurst, Henry 235-8

Longo, Robert 122, 193

Lorenz, Edward 253

Lukács, Georg 47

Lutyens, Edwin 105

Lyotard, Jean-François 214

Madonna 240, 269-72

Mahler, Gustav 114

Mailer, Norman 28

Man Ray 55-59

Mandelbrot, Benoit 210

Manzoni, Piero 175

Mao Zedong 177

Mapplethorpe, Robert 192-4

Marais, Eugène 17, 223

Marcus, Greil, 215n.

Martin, Dean 20

Marx, Karl 215

Masi, Denis 68-70, 125

Masson, André 240

Matisse, Henri 91, 179, 295

McCahon, Colin 146-50

McCartney, Paul 19

McCune, Billy 61

McEvilley, Thomas 214-5

McKay, Winsor 245

McLean, Bruce 122

McMahon, Ed 18, 21

Mead, Margaret 84

Mellers, Wilfred 225n.

Melville, Sam 217

Merleau-Ponty, Maurice 49

Messager, Annette 199

Metzger, Gustav 296

Michals, Duane 82

Michaels, Leonard 60

Michelangelo 56

Midgette, Alan 178

Miller, Lynn F. 163

Milton, John 49

Minelli, Liza 19

Mingus, Charles 17, 223-4

Miró, Joan 153, 159, 171

Mishima, Yukio 140, 242

Moles, Abraham 123

Mondrian, Piet 132, 148, 217

Monet, Claude 126

Montaigne, Michel de 235

Montez, Maria 177

Moore, Henry 105

Moore, Marianne 62

Morandi, Luigi 127-9, 264

Morris, Robert 42, 46

Morrissey, Paul 176

Mucha, Reinhard 226

Muñoz, Juan 263

Murdoch, Rupert, 61

Nabokov, Vladimir 182

Nail, Jimmy 144

Nathan, Piotr 286-90

Nauman, Bruce 29

Newman, Barnett 149, 162, 271

Newton, Isaac 210

Nietzsche, Friedrich 143

Nitsch, Hermann 296

Nozière, Violette 113, 118

Oldenburg, Claes 105

Olmsted, Frederick Law 34

Ondine, Pope 176

Oppenheim, Dennis 16, 23-31, 56

Orridge, Genesis P- 62, 65-71

Oulton, Thérèse 16, 180-7

Pane, Gina 61

Paolo, Dita 270

Parker, Charlie 17, 224

Parton, Dolly 68

Pater, Walter 238

Patterson, Simon 264-8

Paz, Octavio 41

Pearce, T.N. 226

Penck, A.R. 218

Periton, Simon, 208

Picabia, Francis 179

Picasso, Pablo 81, 105, 114, 315

Piero della Francesca 124

Pinot-Gallizio, Giuseppe 211

Pippin, Steven 291-94

Pisanello 282
Plath, Sylvia 17, 222
Plato, 138, 243
Poe, Edgar Allan 271
Poirier, Richard 52
Pollock, Jackson 33, 126, 127, 162, 296
Pop, Iggy 61
Pope, Alexander 119
Popper, Sir Karl 13
Poulet, Georges 91
Pound, Ezra 48
Prince, Richard 202-7, 214
Princess Michael of Kent 74
Proust, Marcel 94-5, 133, 199
Pynchon, Thomas 177
Queensberry, John Sholto, 9th Marquess of 272
Quimby, Fred 266
Rabelais, François 100, 241
Rae, Fiona 16, 244-6
Rainer, Yvonne 42, 51
Rampling, Charlotte 304
Ransom, John Crowe 242
Raphael 135
Rauschenberg, Robert 176
Reagan, Ronald 178, 212
Red Herrings 101
Reich, Steve 274
Reinhardt, Ad 33, 37
Rembrandt 227
Renoir, Jean 103
Resnais, Alain 101
Reynolds, Burt 19
Richter, Gerhard 244
Rilke, Rainer Maria 97, 286, 290
Rimbaud, Arthur 96
Robbe-Grillet, Alain 101
Rollins, Tim & K.O.S. 268
Rosenberg, Harold 228
Rosenblum, Robert 270

Rossellini, Isabella 270
Rossi, Aldo 264-8
Rousseau, Henri 150
Roussel, Raymond 84, 129
Rubin, William 162
Rudolf, Emperor 183
Rumney, Ralph 211
Ruscha, Ed 56
Sale, Mike E. 208
Salle, David 244
Samaras, Lucas 171
Sant'Elia 34
Sartre, Jean-Paul 94
Schnabel, Julian 122
Schwartz, Delmore 16, 219
Schwarzkogler, Rudolf 61, 295-7
Schweigert, Alphons 229
Schwitters, Kurt 248
Sendak, Maurice 81
Serra, Richard 305, 314
Sewell, Elizabeth 119
Sex Pistols, The 250
Shakespeare, William 124, 192, 234, 270, 271
Shattuck, Roger 83, 97n.
Shepp, Archie 16, 217, 224
Sherman, Cindy 122, 214, 270
Sherman, Stuart 123
Shields, Brooke 206-7
Siddall, Lizzie 256
Simone, Nina 16, 219
Skinner, B.F. 126
Smith, David 258
Smith, Jack 313
Smith, Paul 179
Smith, Tony 50
Smithson, Robert 16, 29, 32-41, 42
Sondheim, Alan 80
Sontag, Susan 71, 157, 178, 311
Southern, Terry 311
Stein, Gertrude 16, 218

Steiner, George 53n.

Sternberg, Josef von 242

Sterne, Laurence 49, 100

Stewart, Rod 68

Still, Clyfford 33, 162

Stoker, Bram 117

Storr, Anthony 63

Storr, Robert 164n

Starobinski, Jean 161n

Stieglitz, Alfred 207

Straus, Erwin W. 45

Sturgeon, Theodore 19

Superstar, Ingrid 176

Sutherland, Donald 303-4

Sutherland, Joan 110

Taaffe, Philip 268

Tafuri, Manfredo 264

Tàpies, Antoni 171

Tati, Jacques 105

Tatlin, Vladimir 315

St. Thomas Aquinas, 120

Tessai, Tomioka 149, 150

Thatcher, Margaret 208, 212

Thek, Paul 310-5

Thiebaud, Wayne 172

Throbbing Gristle 65-70

Trengove, Kerry 125

Tretchikoff 227

Trilling, Lionel 71

Trotsky, Leon 35

Tyler Parker, 277

Tutti, Cosey Fanni 65

Uccello 282

Vaché, Jacques, 39

Valéry, Paul 91

Vaneigem, Raoul 211

Varela, Francisco 256

Velden, Petrus van den 150

Vester, Karl-Egon 288

Vigo, Jean 270

Viola, Bill 273-80

Vreeland, Diana 178

Warhol, Andy 58, 68, 89, 135, 174-9, 312-3

Washington, George 174

Webb, Boyd 72-75, 76-78, 263, 267, 293

Webern, Anton von 104

Wegman, William 55-9

Weil, Simone 17, 222

Welch, Raquel 241

Wells, H.G. 229

Wentworth, Richard 16, 105-9

West, Nathanael 269, 311

White, Lynn Jr. 51

White T.H. 119

Whiteread, Rachel 254-6, 265, 293

Whitman, Walt 213, 273

Wilde, Oscar 14, 178, 266, 272

Wiley, William 82

Wilson, Edmund 14

Wilson, Robert 114, 123, 313

Wimsatt and Beardsley 15

Winters, Robin 171

Wittgenstein, Ludwig 85

Wodehouse, P.G. 116-7, 120-1

Woodlawn, Holly 176

Woodman, Edward 263

Wölfflin, Heinrich 157

Wright, Frank Lloyd 105, 298

Wright, Richard, 225

Young, James E. 309

Young, La Monte 274

Yorkin, Bud 22

Zukav, Gary 210

9253451.